Knitting
WITH
Disney

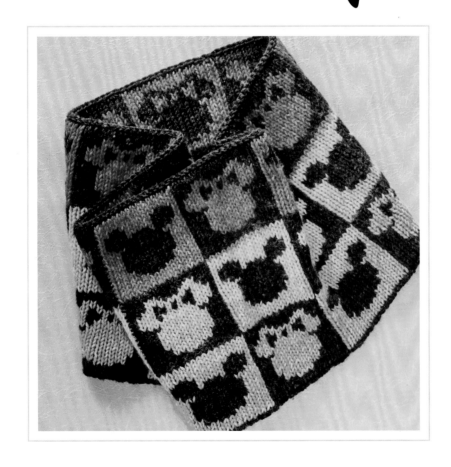

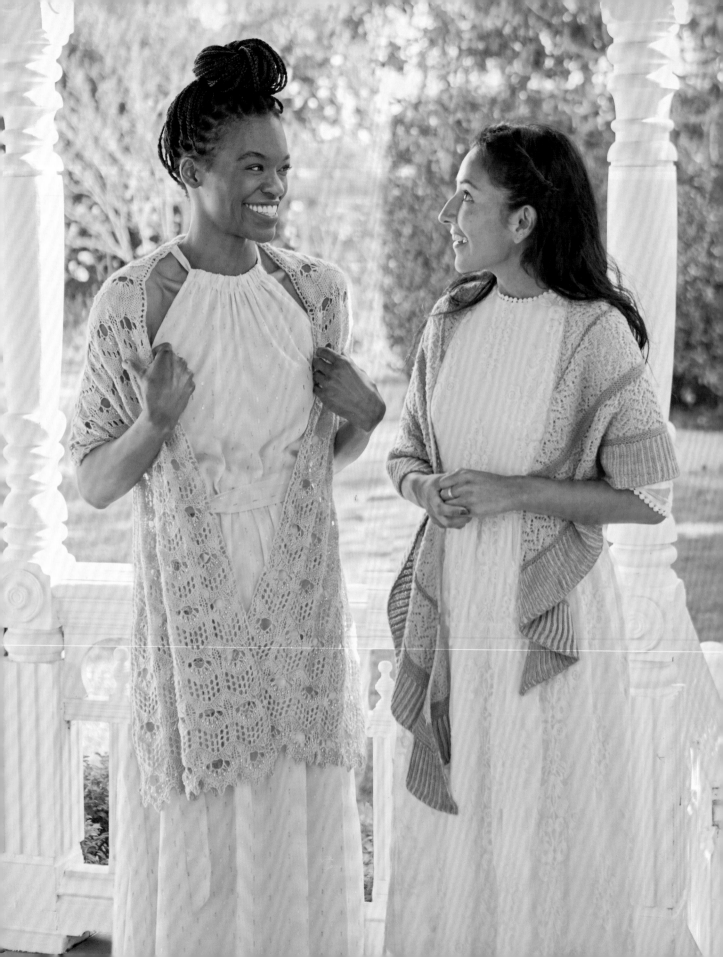

Knitting
WITH

28 OFFICIAL PATTERNS INSPIRED BY MICKEY MOUSE,
THE LITTLE MERMAID, AND MORE!

TANIS GRAY

INSIGHT
EDITIONS

San Rafael • Los Angeles • London

Contents

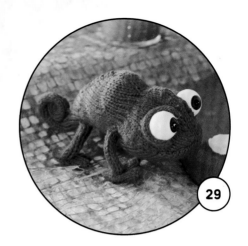

29

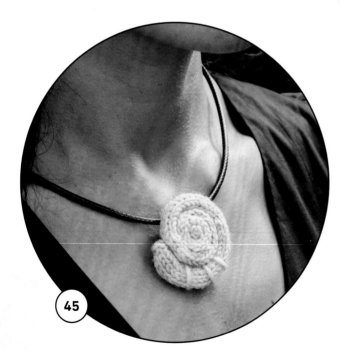

45

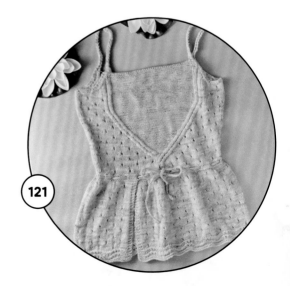

121

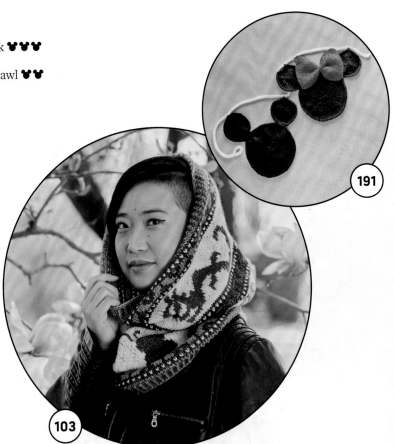

191

103

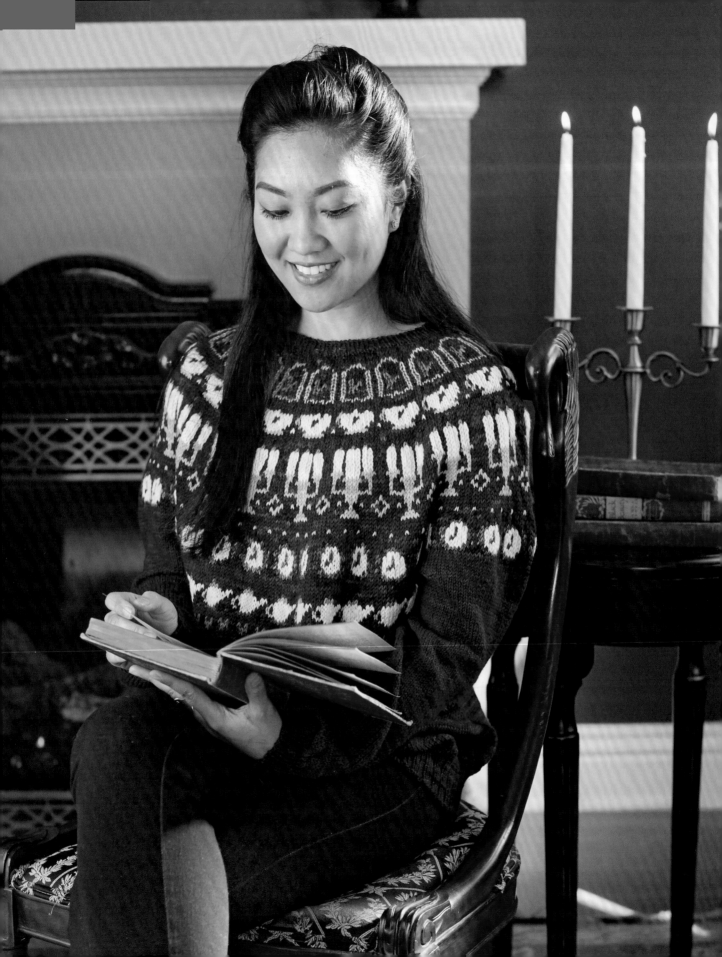

Introduction

I remember sitting in a dark movie theater watching the blue background with the white castle come onto the screen. The opening credits for *The Little Mermaid* (1989) started, and I was mesmerized. I sat on the edge of my seat the entire film, tuning everything out except the movie, utterly captivated. My mom and I were the only ones in the theater after everyone had left and they had switched on the lights. I turned to her and told her that when I grew up, I wanted to work for Disney.

I'm not the only one with a childhood filled with fond memories of these animated films. From the first-of-its-kind *Snow White and the Seven Dwarfs* (1937) to the groundbreaking *The Lion King* (1994) to more recent blockbusters like *Moana* (2016), everyone has a favorite Disney movie. Disney is so much more than a film collection, theme parks, a television network, and merchandise. To many of us, Disney represents the American dream, and how even as far back as 1928 a little mouse named Mickey could change the world. As Walt said, "When you're curious, you find lots of interesting things to do. And one thing it takes to accomplish something is courage."

A creative, driven man, Walt Disney had high expectations and vast plans for all of his projects and worked tirelessly to realize them. After starting his own animation studio with his brother Roy O., Walt began captivating audiences with his brilliant retellings of fairy tales that were also moving works of art. First bringing us the story of a young princess with a jealous stepmother obsessed with beauty, he gave the world *Snow White and the Seven Dwarfs* in 1937, a gamble that completely changed the film industry and cemented his place in history. Adults and children alike were dazzled, just as I was all those years ago in that dark theater. And that was just the beginning. From early hits like *Cinderella* (1950) and *Peter Pan* (1953) through the Disney Renaissance of the 1980s and 1990s with movies like *Beauty and the Beast* (1991) and *Aladdin* (1992) to modern favorites like *Tangled* (2010) and *Brave* (2012), Disney has remained a household name, making dreams come true for kids and adults across the country.

With the help of designers worldwide, I'm elated to bring you this enchanting collection of knitwear, accessories, home decor, and toys inspired by some of Disney's most iconic characters and films. Go back to where it all began with Snow White and knit yourself a Poison Apple Pullover (page 69), let evil flow through your knitting needles as you knit up a pair of gorgeous Mistress of Evil Socks (page 151), waltz around the room in an elegant beaded lace shawl inspired by Belle (page 147), or snuggle up with your very own adorable Tinker Bell (page 11). Like Tiana says in *The Princess and the Frog* (2009), "The only way to get what you want in this world is through hard work," so grab your knitting needles (and of course some pixie dust) and get knitting! We've pulled together a magical collection for Disney fans in an extensive size, skill, and fiber range for all.

As I've gotten older, my love for Disney has grown, and making this book was my own dream come true. I hope this collection brings you the same joy I feel when watching the films that inspired these projects with my family. There's a dreamer inside us all, no matter what age. Dream big, fellow knitters.

—TANIS

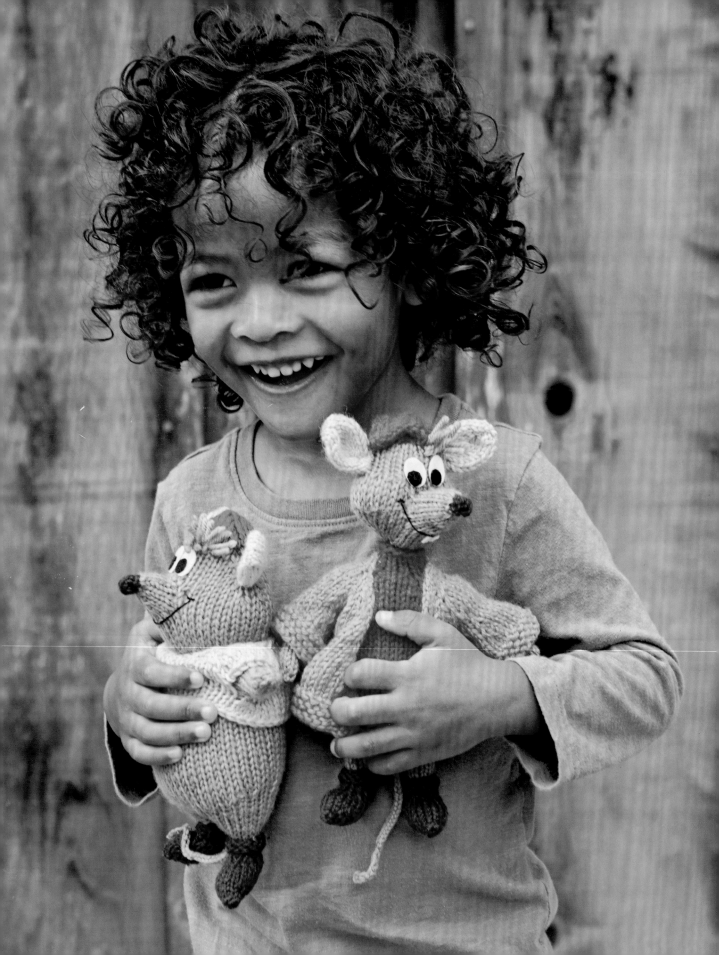

Cozy Companions

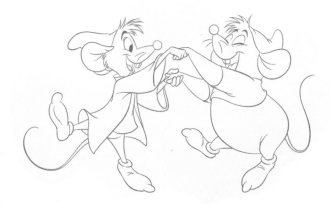

Gus: "I'll cut it with these scissors!"

Jaq: "And I can do the sewing!"

Cinderella (1950)

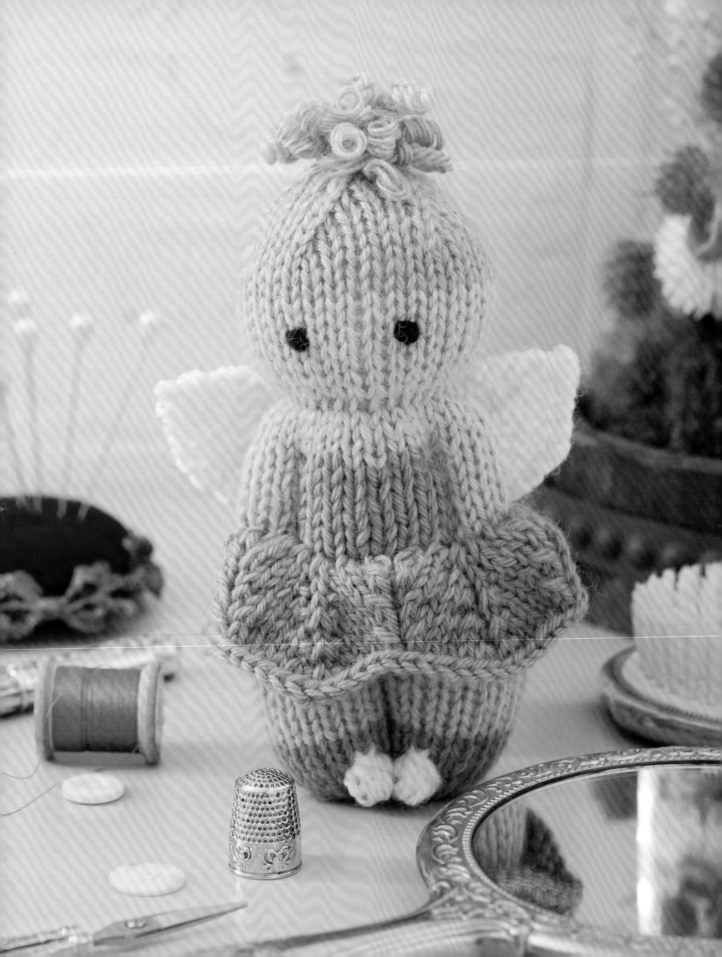

Tinker Bell

Designed by ESTHER BRAITHWAITE

SKILL LEVEL ❦

Tinker Bell is the fiercely loyal (and occasionally jealous) pint-size pixie sidekick to Peter Pan in the 1953 film adapted from J. M. Barrie's classic play. Bold, clever, and fashionable, Tinker Bell has a lot of personality and a taste for adventure that matches Peter's own. With the ability to offer flight to anyone sprinkled with her pixie dust, Tink speaks in jingles that sound like a tinkling bell, a language only those from Never Land can understand. Animator Marc Davis, one of Walt's Nine Old Men, referenced live-action models, including actress Margaret Kerry, when designing the fairy, giving Tinker Bell a bright green dress, blonde hair in a bun, an exaggerated hourglass figure, and a trail of pixie dust that follows wherever she flies. Based on the fairy from the original play, Tinker Bell has proved to be an enduringly popular character, eventually inspiring her own series of books, TV shows, movies, and more.

Sprinkle some fairy dust on your needles! This adorable amigurumi Tinker Bell is worked in the round in one piece from the bottom up as a tube, with simple sewing added to define her arms and legs postknitting. Her skirt is added by picking up and knitting easy lace along the waist, while her bodice is duplicate stitched on after stuffing. Her wings are knit flat and attached, and her eyes are added using basic embroidery. Make one and keep her as a sidekick like Peter Pan did, or create a whole fairy colony!

SIZE
One size

FINISHED MEASUREMENTS
Height: 6 in. / 15 cm
Width: 3 in. / 7.5 cm

YARN
Worsted weight (medium #4) yarn, shown in Plymouth Yarn *Galway Worsted* (100% wool; 210 yd. / 192 m per 3½ oz. / 100 g skein)
Color A: #145 Happy Green, 1 skein
Color B: #8 Bleach, 1 skein
Color C: #112 Almond, 1 skein
Color D: #202 Grasshopper, 1 skein

NEEDLES
- US 5 / 3.75 mm set of 6 double-pointed needles

NOTIONS
- Stitch marker
- Locking stitch marker (1)
- Tapestry needle
- Polyester stuffing (approx 1 oz. / 29 g per doll)
- US D-3 / 3.25 mm crochet hook
- Wooden dowel or single US 8 / 5 mm bamboo dpn
- 2¼ yd. / 2 m of black worsted weight yarn to embroider eyes

GAUGE
24 sts and 28 rnds = 4 in. / 10 cm over St st, unblocked, taken before stuffing doll
Gauge is not critical for a toy; just ensure the stitches are tight enough so the stuffing will not show through your finished project.

continued on page 12

NOTES

- Doll is worked in one piece, in the round, from the bottom up.
- Skirt is knit from stitches picked up and knit outward from the doll's body.
- Wings are knit flat and attached to the finished doll.
- Bodice is worked in duplicate stitch after stuffing the doll.
- Simple sewing techniques are used to define the arms and legs after knitting.
- Final details for the eyes are added with embroidery.
- Written and charted instructions are provided for the entirety of main body of the doll. Note that the chart will also be used in the finishing of the entire doll for the definition of legs, arms, and neck, as well as embroidery.
- To embroider the eyes, use three horizontal bars across both legs of the indicated stitch.

SHOES

Using color A, loosely CO 32 sts using the Long Tail CO method, leaving a 16 in. / 40.5 cm tail for seaming. Distribute the sts so you have 8 sts on each of 4 needles. Pm for BOR and join to work in the rnd, being careful not to twist the sts.

Rnds 1–2: Knit.

Rnd 3: K13 with color A, join color B, MB with color B, k4 with color A, MB with color B, break color B, knit with color A to end of rnd.

Rnds 4–5: Knit.

Break color A.

LEGS

Join color C.

Rnds 6–16: Knit.

Break color C.

SHORTS

Rejoin color A.

Rnds 17–20: Knit.

Break color A.

TORSO

Rejoin color C.

Rnds 21–30: Knit. At the end of Row 30, clip a locking marker to indicate the location for defining the neck and stuffing the head.

FACE

Rnds 31–38: Knit.

Break color C.

HAIR

Join color D.

Rnds 39–42: Knit.

Rnd 43 (dec): K1, *k4, k2tog; rep from * to last st, k1—27 sts.

Rnd 44 (and all even rnds): Knit.

Rnd 45 (dec): K1, *k3, k2tog; rep from * to last st, k1—22 sts.

Rnd 47 (dec): K1, *k2, k2tog; rep from * to last st, k1—17 sts.

Rnd 49 (dec): K1, *k1, k2tog; rep from * to last st, k1—12 sts.

Rnd 51 (dec): K1, *k2tog; rep from * to last st, k1—7 sts.

Break yarn, leaving an 8 in. / 20 cm tail. Thread the tapestry needle and weave tail through rem sts, cinch shut, and secure on WS.

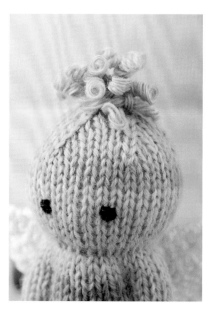

SKIRT

Beginning at the back of the doll, pick up the right leg of the 32 sts from the last row of color A shorts. Distribute the sts so you have 8 sts on each of 4 needles. Pm for BOR and join to work in the rnd, being careful not to twist the sts.

Join color A to the right edge of the picked-up sts with doll held upside down.

Rnd 1 (inc): *K1, kfb in next 7 sts; rep from * to end of rnd—60 sts.

Rnd 2: Knit, redistributing sts so you have 12 sts on each of 5 needles.

Rnd 3: *Kfb, k3, ssk, k2tog, k3, kfb; rep from * to end of rnd.

Rnd 4: Knit.

Rep [Rnds 3 and 4] 3 times more.

BO all sts knitwise.

WINGS (MAKE 2)

Using color B, CO 11 sts onto 1 dpn using the Long Tail CO method. Do not join to work in the rnd.

Row 1 (WS): K5, p1, k5.

Row 2 (RS): K1, M1BL, k3, s2kp, k3, M1BL, k1.

Row 3: K5, p1, k5.

Row 4: K1, M1BL, k3, s2kp, k3, M1BL, k1.

Row 5: K5, p1, k5.

Row 6: K1, M1BL, k3, s2kp, k3, M1BL, k1.

Row 7: K5, p1, k5.

Row 8 (dec): K4, s2kp, k4—9 sts.

Row 9: K4, p1, k4.

Row 10 (dec): K3, s2kp, k3—7 sts.

Row 11: K3, p1, k3.

Row 12 (dec): K2, s2kp, k2—5 sts.

Row 13: K2, p1, k2.

Row 14 (dec): K1, s2kp, k1—3 sts.

Row 15: K1, p1, k1.

Row 16 (dec): S2kp—1 st.

Break yarn and draw tail through last st to bind off.

FINISHING

Leaving CO tail at feet for sewing, weave in all other ends securely to the WS. Use the chart as a guide for the following instructions:

STUFF HEAD

Using color C, thread the tapestry needle with a length of yarn approximately 24 in. / 61 cm long. Sew a running st across the first face rnd (Rnd 31, starting just above the locking marker placed at the end of Rnd 30), then stuff the head firmly. Cinch up the yarn to form neck and knot securely at the back of the neck. Do not cut ends as you will use these to define arms as noted below.

STUFF BODY

Thread the tapestry needle with the remaining tail from the CO. Sew a running st across CO edge, then stuff the body loosely. Cinch up the yarn to close bottom of doll and knot securely. Do not cut ends as you will use these to define the legs.

DEFINE LEGS

Using the tail of color A remaining from the Stuff Body instruction, begin at the back middle seam and sew small vertical sts through to the front middle. Pull snugly to create leg definition as you continue to a few rows below the doll's waist. Fasten yarn securely. Weave all remaining ends to the inside.

DEFINE ARMS

Using the tails of color C remaining from the Stuff Head instruction, sew small vertical sts from back to front to create arms that are 8 sts wide. Fasten yarn securely. Weave all remaining ends to the inside.

EMBROIDER EYES

Embroider eyes using the black worsted weight yarn and the tapestry needle, using the chart for placement. Weave all remaining ends to the inside.

EMBROIDER BODICE

Work bodice with duplicate stitch in color A, using the chart for placement. Weave all remaining ends to the inside.

ATTACH WINGS

Using color B, sew wings to center back of doll along the first 5 sts of CO wing edge. Tack into place at shoulders. Weave all remaining ends to the inside.

HAIR

Cut one 60 in. / 101.5 cm strand of color D. Wrap the yarn tightly in a single layer around a wooden dowel or US 8 / 5 mm wooden/bamboo dpn. Wet yarn and dowel/dpn thoroughly. Place on cookie sheet and dry in 200-degree Fahrenheit / 93-degree Celsius oven for 30 minutes.

Cool. Remove curled strand from dowel. Cut into 8 equal-length pieces.

Insert the crochet hook under both legs of a knit st in the last rnd of hair. Fold 1 strand of hair in half and pull through the knitted st, keeping the loop on your crochet hook. Wrap both ends of the strand of hair around your crochet hook and pull through your loop to secure. Attach 1 strand of yarn in every st.

Style by tying a 12 in. / 30.5 cm strand of color A around the base of the hair strands and fasten into a bow. Trim extra length of tails once desired bow size is determined.

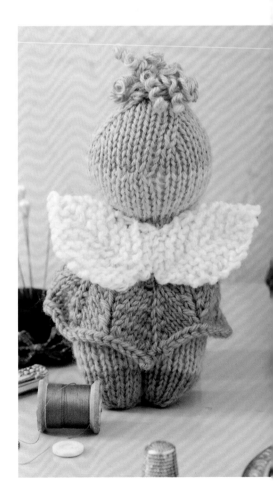

CHART

KEY

☐	Knit
☒	Duplicate stitch
╱	k2tog
■	Color A
☐	Color B
■	Color C
■	Color D
■	Color E
E	Embroider eye (Color E)
●	Make bobble (Color B)
– – – –	Arm/Leg seam
– – – –	Neck seam

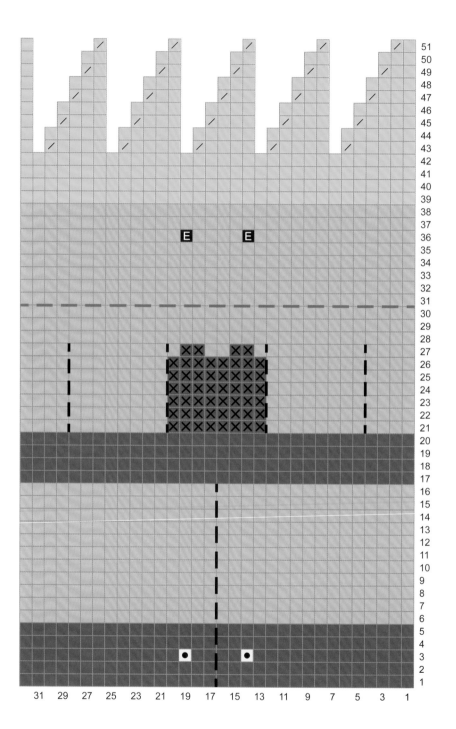

"All it takes is faith and trust.
Oh, and something I forgot! Dust."

Peter Pan, *Peter Pan* (1953)

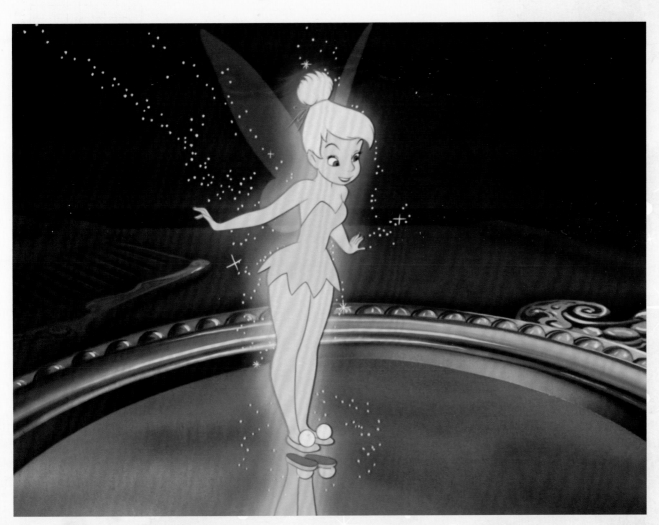

ABOVE: Tinker Bell admiring her relfection in the Darlings' hand mirror in an early scene from *Peter Pan* (1953).

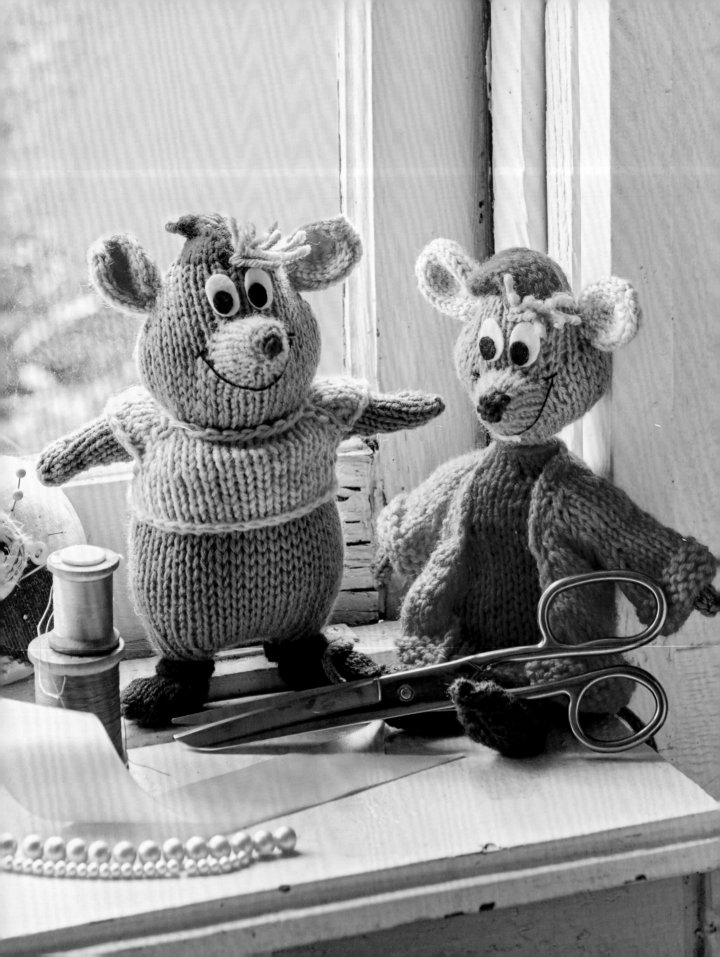

Jaq and Gus

Designed by SARA KELLNER

SKILL LEVEL ♥♥

Inspired by Charles Perrault's fairy tale, Disney chose to have his version of *Cinderella* take place in France as an ode to the original author. In this film, released in 1950, a kind and gentle beauty named Cinderella is forced by her stepmother to work as a maid in her own house after the death of her father. Her only friends are the animals that live in the house and barn. She protects the community of mice living in the manor from the malicious cat, Lucifer, feeding the mice and making them clothes in her spare time. Two of these mice—Jaq and Gus—prove to be unlikely heroes later in the film when they retrieve the key to Cinderella's locked attic door from her stepmother's pocket, hauling it up multiple staircases and ultimately freeing the young girl so that she may prove she is the maiden the prince loves. Brave and true, Jaq and Gus were some of the first featured animal sidekicks to a Disney princess and have remained popular with fans since the film's release.

Made in the round in sections, all but the ears and clothing of Cinderella's loyal companions are worked in one piece. Starting at the neckline and working downward through the body, live stitches are set aside for the arms, left leg, and nose, then placed back on the needles to be completed later. Stitches are picked up from the original cast on and below the neckline in the front to shape their faces. Details such as eyes, hair, and embroidery are added postknitting to bring these little friends to life!

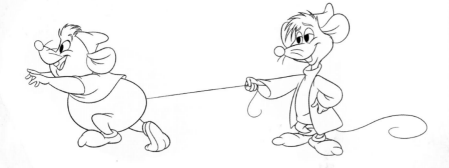

SIZE
One size

FINISHED MEASUREMENTS
Jaq
> Height: approx 8 in. / 20 cm

Gus
> Height: approx 7 in. / 18 cm

YARN
Jaq

DK weight (light #3) yarn, shown in Cascade Yarns 220 *Superwash* (100% superwash wool; 220 yd. / 200 m per 3½ oz. / 100 g ball)

Color A: #1961 Camel, 1 ball
Color B: #211 Cocoa, 1 ball
Color C: #809 Really Red, 1 ball
Color D: #1941 Salmon, 1 ball
Color E: #1952 Blaze, 1 ball

Gus

DK weight (light #3) yarn, shown in Cascade Yarns 220 *Superwash* (100% superwash wool; 220 yd. / 200 m per 100 g ball)

Color A: #1961 Camel, 1 ball
Color B: #211 Cocoa, 1 ball
Color C: #864 Christmas Green, 1 ball
Color D: #1941 Salmon, 1 ball
Color E: #821 Daffodil, 1 ball

NEEDLES
- US 3 / 3.25 mm set of 5 double-pointed needles
- US 5 / 3.75 mm set of 5 double-pointed needles and 16 in. / 40 cm long circular needle

NOTIONS
- Stitch markers
- Waste yarn for placing stitches on hold
- Stuffing (approx 3 oz. / 85 g)

continued on page 18

- Scraps of white and black felt for eyes
- Small crochet hook or tapestry needle
- Black and white embroidery floss for eyes and mouth
- White waste yarn or scrap of white felt for teeth
- 4 in. / 10 cm dowel or spare dpn to provide structure for Jaq's neck (optional)
- Sewing needle and white thread

GAUGE

23 sts and 30 rows = 4 in. / 10 cm over St st on smaller needle, taken without blocking

Adjust needle sizes as necessary to match gauge. The larger needles should be 2 sizes larger than the gauge-size needle when gauge is met.

NOTES

- Gus and Jaq are worked in the round and in sections. Everything but their ears, shirt (jacket for Jaq), and tails are worked all in one piece.
- Work begins at the neckline and proceeds downward through the body. Live stitches are set aside for the arms, left leg, nose, and hat, then placed back onto the needles to work later. For Jaq, stitches are picked up from the original cast-on stitches to form his head. For Gus, stitches are picked up from the original cast-on stitches and below the neckline in front to shape his chubby face.
- It is recommended that the sections be worked in the order written. Right and left refer to Jaq's/Gus's right and left.
- When starting a row with slipped stitches: slip all stitches with yarn in front on the wrong side and with yarn in back on the right side.

Rnd 3 (dec): K2tog, k8, ssk—10 sts.

Rnds 4–6: Knit.

Rnd 7 (dec): K2tog, k6, ssk—8 sts.

Rnds 8–10: Knit.

Break color A.

RIGHT SHOE

Join color B. Work begins with a rolled cuff.

Rnd 1 (inc): (LR1, k4) twice—10 sts.

Rnds 2–5: Knit.

Bind off all sts knitwise; break color B. Roll edge outward and down so that the WS is showing.

Sts will now be picked up inside the opening of the rolled edge to work the shoe. It is critical to begin picking up sts in the right place, as that is where the heel will be. Begin in the back of the leg, between the inner leg seam and the center/back of leg. Positioning the heel here will make him slightly pigeon-toed.

With neck (the cast on) pointed down and leg pointed up, and with gauge-size dpns, pick up and knit 10 sts around the inside of the opening of the rolled edge. Distribute the sts evenly over the needles. Pm for BOR and join to work in the rnd. Short rows are used to shape the heel.

Note: Sts are not wrapped for the short rows in this section.

Rnd 1: Knit.

Short Row 2 (RS): K1, turn.

Short Row 3 (WS): Sl1, p1, turn.

Short Row 4: Sl1, k2, turn.

Short Row 5: Sl1, p3, turn.

Short Row 6: Sl1, k4, turn.

Short Row 7: Sl1, p5, turn.

Short Row 8: Sl1, k6, turn.

Short Row 9: Sl1, p7, turn.

Short Row 10: Sl1, k3 (BOR). Resume working in the rnd.

Rnd 11 (inc): K4, M1R in the gap, k2, M1L in the gap, k4—12 sts.

JAQ
BODY

Note: Work begins at neckline on center/back of neck.

With color A and gauge-size dpns, CO 9 sts using the Long Tail CO method. Distribute the sts so you have 3 sts on each of 3 dpns. Join in the rnd by slipping the first CO st onto Needle 3, then pull the 2nd st (formerly the last st) over it and off the needle; 8 sts rem. Pm for BOR.

Rnds 1–5: Knit.

Rnd 6 (inc): (K1, LR1) 3 times, k2, (LR1, k1) 3 times—14 sts.

Rnd 7 (and all odd rnds until noted otherwise): Knit.

Rnd 8 (inc): K2, LR1, k3, LR1, k4, LR1, k3, LR1, k2—18 sts.

Rnd 10 (inc): (K3, LR1) twice, k6, (LR1, k3) twice—22 sts.

Rnd 12 (inc): K4, LR1, k3, LR1, k8, LR1, k3, LR1, k4—26 sts.

Rnd 14 (inc): K5, LR1, k3, LR1, k10, LR1, k3, LR1, k5—30 sts.

Rnd 16: K5, place 4 sts onto waste yarn, k12, place 4 sts onto waste yarn, k5—22 sts.

Rnd 18 (inc): K6, LR1, k10, LR1, k6—24 sts.

Rnds 19–32: Knit.

RIGHT LEG

Setup Rnd: K12, place rem 12 sts onto waste yarn. Redistribute the sts so there are 4 sts on each of 3 dpns and rejoin to work in the rnd (the BOR will remain the same).

Rnds 1 and 2: Knit.

Rnd 12: Knit.

Rnd 13 (inc): K4, (LR1, k1) 4 times, k4—16 sts.

Rnds 14 and 15: Knit.

Rnd 16 (dec): (K2tog) twice, k8, (ssk) twice—12 sts.

Rnd 17: Knit.

Rnd 18 (dec): (K2tog) twice, k4, (ssk) twice—8 sts.

Rnd 19 (dec): K2tog, k4, ssk—6 sts.

Rnd 20: Knit.

Break color B. Thread the tapestry needle with the tail, pull through remaining live sts, and pull to cinch closed. Weave in loose ends to the inside of the shoe. Shoes should be flattened top to bottom, with increases/decreases on the center/bottom. Shoes can now be stuffed, only slightly, and shaped more flat than round.

Note: It is recommended that you stuff each leg and shoe after working them. Add a small amount of stuffing to body through the hole between legs, then shift it down carefully into the shoe first by using a dpn from the outside. Don't stuff the body at this point; this would make knitting the arms and head more difficult.

LEFT LEG

Setup Rnd: Place the 12 sts from waste yarn (placed on hold at the start of the right leg) onto 3 gauge-size dpns, distributing sts evenly. With RS facing, rejoin color A at the first st and knit across the live sts. Pm for BOR and join to work in the rnd.

Beginning with Rnd 1, work as for the right leg.

LEFT SHOE

Join color B. Work Rnds 1–5 and the bind off as for the right shoe.

Sts are now picked up inside the opening of the rolled edge to work the shoe. When picking up sts in the cuff for the left shoe, this time it will be to the left of the center.

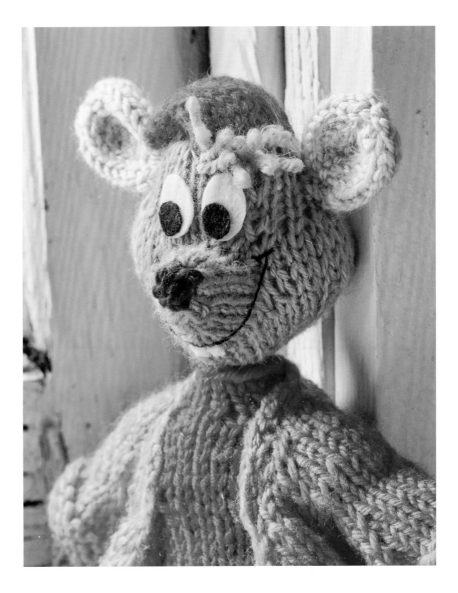

Beginning with the picking up of the sts, work the remainder as for the right shoe (including the stuffing).

ARMS (WORK BOTH THE SAME)

Place 4 sts from the waste yarn (placed on Rnd 16 of the body section) onto 2 gauge-size dpns (2 sts on each). With RS facing, rejoin color A at the third st and k2. Pick up and knit 6 sts around edge of armhole opening, knit the remaining 2 sts. Pm for BOR and join to work in the rnd—10 sts. Redistribute the sts over 3 or 4 dpns for comfort.

Note: The arms can be stuffed a little at a time as they are worked. If you forget to do this, they can still be stuffed after knitting by adding a small amount of stuffing through the second armhole (if it hasn't been knit yet), or through the hole between legs, then shift it down into the hands and arms by using a dpn from the outside. For the tiniest of spaces, a tapestry needle works very well in place of a dpn.

Rnds 1–5: Knit.

Rnd 6 (dec): K3, ssk, k2tog, k3—8 sts.

Rnds 7–11: Knit.

"We like you. Cinderelly likes you, too."

Jaq to Gus, *Cinderella* (1950)

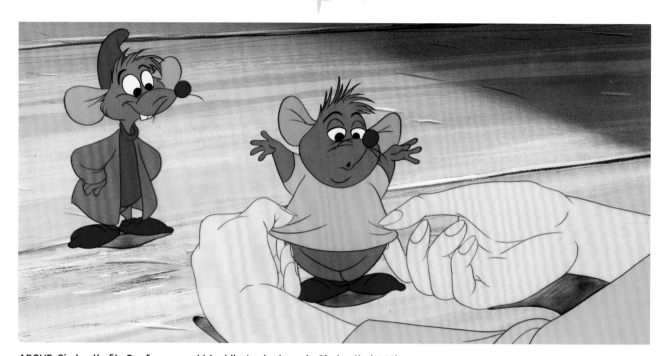

ABOVE: Cinderella fits Gus for a new shirt while Jaq looks on in *Cinderella* (1950).

Rnd 12 (**dec**): K2, ssk, k2tog, k2—6 sts.

Rnds 13–17: Knit.

Rnd 18 (**inc**): (LR1, k3) twice—8 sts.

Rnds 19–21: Knit.

Break color A. Thread the tapestry needle with the tail, pull through remaining live sts, and pull to cinch closed. Weave in loose ends to the inside of the arm.

Repeat all instructions for the second arm.

HEAD

Sts are now picked up in the original CO sts at the neck opening to form the head.

Using the CO tail as an indicator, starting at the center/back of neck, and using color A and the gauge-size dpns, pick up and knit 8 sts. Pm for BOR and begin working in the rnd.

Note: Once all the sts are picked up, check to make sure that sts 4 and 5 are centered across the front of the body.

On Rnd 7, short rows are worked simultaneously with st count increases to shape Jaq's cheeks. At each w&t, you will turn the work to the opposite side so both RS and WS rows are worked to complete the entirety of Rnd 7.

Rnd 1 (**inc**): *Kfb; rep from * to end of rnd—16 sts.

Rnd 2: Knit.

Rnd 3 (**inc**): K3, (LR1, k1) 3 times, k4, (k1, LR1) 3 times, k3—22 sts.

Rnd 4: Knit.

Rnd 5 (**inc**): K3, (LR1, k1) 3 times, k10, (k1, LR1) 3 times, k3—28 sts.

Rnd 6: Knit.

Rnd 7 (**short rows, inc**): K10, w&t, p7, w&t, k1, LR1, k1, (LR1, kfb) twice, LR1, k2, w&t, p11, w&t, k27, w&t, p7, w&t, k2, LR1, (kfb, LR1) twice, k1, LR1, k1, w&t, p11, w&t, knit to BOR—40 sts.

Rnd 8 (**dec**): K17, place 6 sts onto waste yarn, CO 4 sts to working needle using the Backward Loop method, knit to BOR—38 sts.

Rnd 9: Knit.

Rnd 10 (**dec**): K2, (k2tog) 8 times, k2, (k2tog) 8 times, k2—22 sts.

Rnd 11: Knit.

Rnd 12 (dec): K2tog, k18, ssk—20 sts.

Rnds 13 and 14: Knit.

Rnd 15 (dec): K2tog, k16, ssk—18 sts.

Rnd 16: Knit.

Break color A. Place remaining live sts onto a piece of waste yarn while nose is worked.

NOSE

Place 6 sts from waste yarn (placed on Rnd 8 of the head section) onto 2 gauge-size dpns. With RS facing, rejoin color A at the 4th st and k3. Pick up and knit 8 sts around edge of the nose opening, knit the remaining 3 sts. Pm for BOR and join to work in the rnd—14 sts. Redistribute the sts over 3 or 4 dpns for comfort.

Rnds 1 and 2: Knit.

Rnd 3 (dec): K2tog, k10, ssk—12 sts.

Rnds 4 and 5: Knit.

Rnd 6 (dec): K2tog, k8, ssk—10 sts.

Rnds 7 and 8: Knit.

Rnd 9 (dec): K2tog, k6, ssk—8 sts.

Break color A; join color B to work the tip of the nose.

Rnd 10: Knit.

Row 11 (RS, dec): *K2tog; rep from * to end of rnd (arrange all sts on 1 dpn), turn—4 sts.

Row 12 (WS): P4, turn.

Row 13: K4, turn.

Row 14: P4.

Break color B. Thread the tapestry needle with the tail, pull through remaining live sts, and pull to cinch closed. With the tail of color B still on the tapestry needle, pull down (toward the neck) and insert the tapestry needle into the first row of color B on the bottom of the nose and out the top of the nose in the same first row of color B to create a bobble-shaped tip of the nose. Use the tails of color A to close any holes around the nose (if needed). The nose will naturally point upward.

Stuff the body by adding it through the hole between the legs. Stuff the head and neck from the top, shifting the stuffing down from his head to fill the neck.

HAT

Place 18 live sts from waste yarn (placed at the end of the head section) onto 3 of the larger dpns (distribute sts evenly). With RS facing, using the tail of color A as an indicator, join color C at 1st st in center/back of head.

Rnd 1 (inc): *LR1, k3; rep from * to end of rnd—24 sts.

Rnd 2 (and all even rnds until noted otherwise): Knit.

Rnd 3 (dec): *K2tog, k4; rep from * to end of rnd—20 sts.

Rnd 5 (dec): *K2tog, k3; rep from * to end of rnd—16 sts.

Rnd 7 (dec): *K2tog, k2; rep from * to end of rnd—12 sts.

Rnd 9 (dec): *K2tog, k1; rep from * to end of rnd—8 sts.

Stuff top of head, before hat is completed.

Rnd 11 (dec): *K2tog; rep from * to end of rnd—4 sts.

Rnd 12: Knit.

Break color C. Thread the tapestry needle with the tail, pull through remaining live sts, and pull to cinch closed. Hat should not be stuffed. To keep the stuffing in the head from moving into the hat, using color C, thread the tapestry needle and create a horizontal grid at the base of the hat by passing the tapestry needle back and forth from various directions. Secure the tail to the inside.

Secure the top of Jaq's hat by pulling it to 1 side and, using the tail from closing the hat, stitch it into place. Weave in any tails to the WS of the head.

EARS (WORK BOTH THE SAME)

With color D, CO 10 sts using the Long Tail CO method evenly over 3 gauge-size dpns. Pm for BOR and join to work in the rnd, being careful not to twist the sts.

Rnd 1 (and all odd rnds until noted otherwise): Knit.

Rnd 2 (inc): M1L, k10, M1R—12 sts.

Rnd 4 (inc): M1L, k12, M1R—14 sts.

Rnd 6 (inc): M1L, k14, M1R—16 sts.

Rnd 8 (dec): K2tog, k12, ssk—14 sts.

Rnd 9 (dec): K2tog, k10, ssk—12 sts.

Rnd 10 (dec): K2tog, k8, ssk—10 sts.

Rnd 11: K2 (leave 8 sts unworked).

Redistribute the sts, starting at the end of the just-worked rnd, so that there at 5 sts on each of 2 dpns. Holding the two needles parallel, graft all sts using Kitchener stitch.

Turn the ear inside out and weave in loose end from the top graft. Turn right side out again and flatten ear with increases and decreases in the front/center. Pinch CO edge together and stitch to hold closed, creating a shallow, concave disc shape with the ear. Stitch the CO end of the ear to head just below the hat.

SHIRT

Note: The shirt is worked flat on larger needles.

With color D and the larger needles, CO 14 sts using the Long Tail CO method. Do not join to work in the rnd.

Row 1 (WS, and all WS rows until noted otherwise): Purl.

Rows 2 and 4 (RS): Knit.

Row 6 (inc): K3, (LR1, k1) 3 times, LR1, k2, (LR1, k1) 3 times, LR1, k3—22 sts.

Row 8 (inc): K4, (LR1, k1, LR1, k3, k1, LR1, k4) twice—30 sts.

Row 10 (inc): (K5, LR1, k1, LR1) twice, k6, (LR1, k1, LR1, k5) twice—38 sts.

Row 12 (inc): K6, LR1, k1, LR1, k7, LR1, k1, LR1, k8, LR1, k1, LR1, k7, LR1, k1, LR1, k6—46 sts.

Row 14: K9, BO 6 sts knitwise, k16, BO 6 more sts knitwise, k9—34 sts.

Row 15: Purl.

Row 16: Knit.

Rep [Rows 15 and 16] 6 more times.

Row 29 (WS): Purl.

With RS facing, BO all sts loosely knitwise. Place shirt on Jaq with opening in the back; seam closed using mattress stitch.

BODY OF JACKET

Note: The body of the jacket is worked flat on larger needles.

With color E and the larger needles, CO 10 sts using the Long Tail CO method. Do not join to work in the rnd.

Row 1 (WS, and all WS rows until noted otherwise): Purl.

Row 2 (RS, inc): K2, LR1, k1, LR1, k4, LR1, k1, LR1, k2—14 sts.

Row 4 (inc): Kfb, k2, LR1, k1, LR1, k6, LR1, k1, LR1, k2, kfb—20 sts.

Row 6 (inc): K1, LR1, k1, LR1, k3, LR1, k1, LR1, k8, LR1, k1, LR1, k3, LR1, k1, LR1, k1—28 sts.

Row 8 (inc): K2, LR1, k1, LR1, k5, LR1, k1, LR1, k10, LR1, k1, LR1, k5, LR1, k1, LR1, k2—36 sts.

Row 10 (inc): K3, LR1, k1, LR1, k7, LR1, k1, LR1, k12, LR1, k1, LR1, k7, LR1, k1, LR1, k3—44 sts.

Row 12 (dec): Sl1, LR1, k6, place 8 sts on waste yarn, k14, place 8 sts on waste yarn, k6, LR1, k1—30 sts.

Row 13 (WS): Sl1, purl to end.

Row 14 (inc): Sl1, LR1, knit to last st, LR1, k1—32 sts.

Row 15: Sl1, purl to end.

Rep [Rows 14 and 15] 5 more times— 42 sts.

Row 26 (RS): Sl1, knit to end.

Rep [Row 26] 5 more times.

With RS facing, BO all sts loosely knitwise. Weave in loose ends.

SLEEVES OF JACKET
(WORK BOTH THE SAME)

Note: The sleeves are worked in the rnd on larger dpns.

Place 8 live sts from waste yarn (placed on Row 12 of the body of jacket section) onto 2 of the larger dpns. With RS facing, rejoin color E at the 5th st and k4. Pick up and knit 6 sts around the armhole-opening edge and knit the remaining 4 sts. Pm for BOR and join to work in the rnd—14 sts. Redistribute the sts over 3 or 4 dpns for comfort.

Rnds 1 and 2: Knit.

Rnd 3 (inc): K4, LR1, k6, LR1, k4—16 sts.

Rnds 4 and 5: Knit.

Rnd 6 (inc): K5, LR1, k6, LR1, k5—18 sts.

Rnds 7 and 8: Knit.

Rnd 9: Purl.

Rnd 10: Knit.

Rnd 11: Purl.

Rnd 12: Knit.

Rnd 13: Purl.

BO all sts knitwise. Weave in loose ends.

Place jacket on Jaq over shirt with opening in the front. To help it stay in place, stitch the front edge of the jacket to the shirt with color E along the front edge from shoulder to underarm. Bottom flaps of jacket can be seamed open to create a flowing look, if desired.

TAIL

With color A and the Long Tail CO method, CO 3 sts onto 1 gauge-size dpn. Work a 3-st i-cord for 1 in. / 2.5 cm.

Next row (RS, dec): K2tog, k1—2 sts.

Work a 2-st i-cord for 2 in. / 5 cm.

Next row (RS, dec): K2tog—1 st.

Make a chain (a 1-st i-cord) for 2 in. / 5 cm. The total tail length is 5 in. / 12.5 cm.

Break color A yarn and pull tail through final stitch to secure. Weave in the loose end at the narrow end of the tail. Using the loose end from the CO, sew the tail to Jaq's back, under the shirt, approx ¾ in. / 2 cm above the space between the legs.

FINISHING

Eyes can be embroidered with black and white floss or made with small pieces of white felt cut into oval shapes approx 15 x 11 mm. Add a small circle of black felt in the center. Eyes can be glued or sewn to head.

Add hair with pieces of color A between the eyes and the hat (follow the photos as a reference for placement). To attach hair: Insert a small crochet hook or tapestry needle through the stitch you wish to attach the hair to. Fold a 2 in. / 5 cm strand of yarn over the hook and pull a loop through; pull the two ends of the strand through the loop and cinch to close. Repeat for each section of hair (approx 6 strands). Trim strands to desired length.

Embroider mouth with a single ply of black yarn or embroidery floss (following the photo as a reference for placement).

Embroider teeth with white yarn or make with white felt and glue on.

Hold the two edges of the hole between legs together front to back; seam closed with color A.

Stuff shoes only slightly and more flat than round.

Tack down arms to sides with color E, if desired, after jacket is in place.

Due to Jaq's skinny neck, his head can be a little wobbly. The stability is helped somewhat by his turtleneck shirt, but if more stabilization is desired, a 4 in. / 10 cm long wooden dowel, dpn, or other small, straight stick can be inserted between the legs, up through the neck, and into the head.

GUS
BODY

Note: Work begins at neckline; center/back of neck.

With color A and gauge-size dpns, CO 23 sts using the Long Tail CO method. Distribute the sts evenly over 3 dpns. Join in the rnd by slipping the first CO st onto Needle 3, then pull the 2nd st (formerly the last st) over it and off the needle; 22 sts remain. Pm for BOR.

Rnd 1: Knit.

Rnd 2 (inc): K2, LR1, k1, LR1, k3, LR1, k1, LR1, k7, LR1, k1, LR1, k3, LR1, k1, LR1, k3—30 sts.

Rnd 3: Knit.

Rnd 4 (inc): K3, LR1, k7, LR1, k9, LR1, k7, LR1, k4—34 sts.

Rnd 5: Knit.

Rnd 6 (inc): K4, LR1, k7, LR1, k11, LR1, k7, LR1, k5—38 sts.

Rnd 7: K6, place 6 sts onto waste yarn, k14, place 6 sts onto waste yarn, k6—26 sts.

Rnd 8 (inc): K5, (LR1, k1) 7 times, (LR1, kfb) twice, (LR1, k1) 7 times, k5—44 sts.

Rnds 9–22: Knit.

Rnd 23 (dec): K5, ssk, k30, k2tog, k5—42 sts.

Rnd 24 (dec): K7, ssk, k24, k2tog, k7—40 sts.

Rnd 25 (dec): K9, ssk, k18, k2tog, k9—38 sts.

Rnd 26 (dec): K11, ssk, k12, k2tog, k11—36 sts.

Rnd 27 (dec): K13, ssk, k6, k2tog, k13—34 sts.

Rnd 28 (dec): K15, ssk, k2tog, k15—32 sts.

Rnd 29: Knit.

RIGHT LEG

Setup Rnd: K16, place rem 16 sts onto waste yarn. Redistribute the sts evenly over 3 dpns and rejoin to work in the

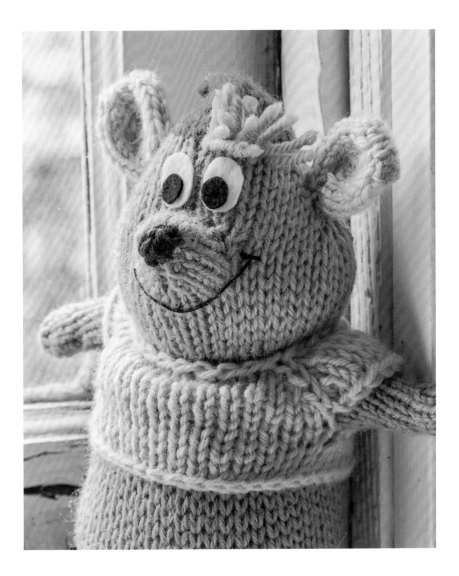

rnd (the BOR will remain the same).

Rnd 1 (dec): K1, k2tog, k11, ssk—14 sts.

Rnd 2 (dec): K1, k2tog, k9, ssk—12 sts.

Rnd 3 (dec): K1, k2tog, k7, ssk—10 sts.

Break color A.

RIGHT SHOE

Join color B. Work begins with a rolled cuff.

Knit 5 rnds then BO all sts knitwise; break color B. Roll edge outward and down so that the WS is showing.

Sts are now picked up inside the opening of the rolled edge to work the shoe. It is critical to begin picking up sts in the right place, as that is where the

heel will be. Begin in the back of the leg, between the inner leg seam and the center/back of leg. Positioning the heel here will make your Gus slightly pigeon-toed.

With neck (the CO) pointed down and leg pointed up, pick up and knit 10 sts around the inside of opening of the rolled edge with gauge-size dpns. Distribute the sts evenly over the needles. Pm for BOR and join to work in the rnd. Short rows are used to shape the heel.

Note: Sts are not wrapped for the short rows in this section.

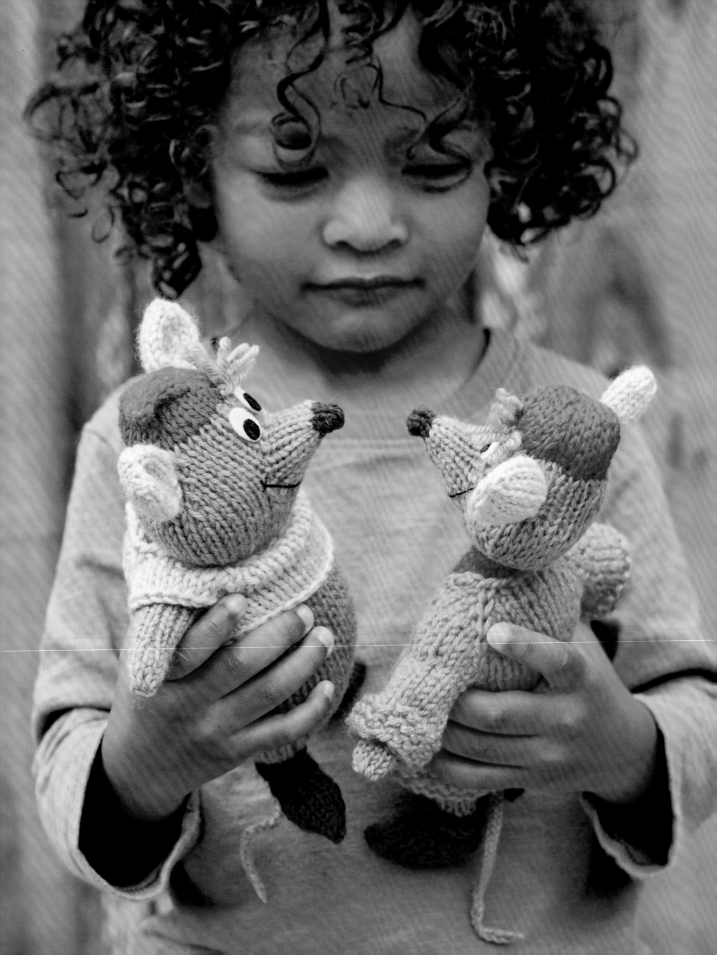

Rnd 1: Knit.

Short Row 2 (RS): K1, turn.

Short Row 3 (WS): Sl1, p1, turn.

Short Row 4: Sl1, k2, turn.

Short Row 5: Sl1, p3, turn.

Short Row 6: Sl1, k4, turn.

Short Row 7: Sl1, p5, turn.

Short Row 8: Sl1, k6, turn.

Short Row 9: Sl1, p7, turn.

Short Row 10: Sl1, k3 (BOR). Resume working in the rnd.

Rnd 11 (inc): K4, M1R in the gap, k2, M1L in the gap, k4—12 sts.

Rnd 12: Knit.

Rnd 13 (inc): K4, (LR1, k1) 4 times, k4—16 sts.

Rnds 14 and 15: Knit.

Rnd 16 (dec): (K2tog) twice, k8, (ssk) twice—12 sts.

Rnd 17: Knit.

Rnd 18 (dec): (K2tog) twice, k4, (ssk) twice—8 sts.

Rnd 19 (dec): K2tog, k4, ssk—6 sts.

Rnd 20: Knit.

Break color B. Thread the tapestry needle with the tail, pull through remaining live sts, and pull to cinch closed. Weave in loose ends to the inside of the shoe. Shoes should be flattened top to bottom, with increases/decreases on the center/bottom. Shoes can now be stuffed, only slightly, and more flat than round.

LEFT LEG

Place the 16 sts from waste yarn (placed on hold at the start of the right leg) onto 3 gauge-size dpns (distribute sts evenly). With RS facing, rejoin color A at the 1st st and knit across the live sts. Pm for BOR and join to work in the rnd.

Beginning with Rnd 1, work as for the right leg.

LEFT SHOE

Join color B and work Rnds 1–5 and the BO as 1or the right shoe.

Sts are now picked up inside the opening of the rolled edge to work the shoe. When picking up sts in the cuff for the left shoe, this time it will be to the left of the center.

Beginning with the picking up of the sts, work the remainder as for the right shoe, including the stuffing.

ARMS (WORK BOTH THE SAME)

Place 6 sts from the waste yarn (placed on Rnd 7 of the body section) onto 2 gauge-size dpns (3 sts on each). With RS facing, rejoin color A at the 4th st and k3. Pick up and knit 8 sts around edge of armhole opening, knit the remaining 3 sts. Pm for BOR and join to work in the rnd—14 sts. Redistribute the sts over 3 or 4 dpns for comfort.

Rnds 1 and 2: Knit.

Rnd 3 (dec): K5, ssk, k2tog, k5—12 sts.

Rnds 4 and 5: Knit.

Rnd 6 (dec): K4, ssk, k2tog, k4—10 sts.

Rnds 7 and 8: Knit.

Rnd 9 (dec): K3, ssk, k2tog, k3—8 sts.

Rnds 10 and 11: Knit.

Rnd 12 (dec): K2, ssk, k2tog, k2—6 sts.

Rnd 13: Knit.

Rnd 14 (inc): (LR1, k3) twice—8 sts.

Rnds 15–17: Knit.

Break color A. Thread the tapestry needle with the tail, pull through remaining live sts, and pull to cinch closed. Weave in loose ends to the inside of the arm.

Repeat all instructions for the second arm.

HEAD

Sts are now picked up in the original CO sts and along the front of the chest to begin the head.

With RS facing and using the cast on tail as an indicator, start picking up at the center/back of neck. Using color A and the gauge-size dpns, pick up and knit 22 sts as follows:

Needle 1: 7 sts (1 each into the first 7 CO sts).

Needle 2: 8 sts (1 st 2 rows below the CO edge, 6 sts 3 rows below the CO edge, and the final st 1 row below the CO edge).

Needle 3: 7 sts (1 each into the last 7 CO sts).

Pm for BOR and begin working in the rnd.

Note: On Rnd 2, short rows are worked to shape Gus's cheeks. Note that at each w&t, you will turn the work to the opposite side so both RS and WS rows are worked to complete the entirety of Rnd 2. As you pass the wrapped sts on Rnds 2 and 3, process the stitches to stay in St st (knitwise on the RS, purlwise on the WS).

Rnd 1 (inc): K2, (kfb) 18 times, k2—40 sts.

Rnd 2: K34, w&t, p28, w&t, k30, w&t, p32, w&t, k34, w&t, p36, w&t, knit to BOR.

Rnd 3 (dec): K17, place 6 sts onto waste yarn, CO 4 sts to working needle using the Backward Loop method, knit to BOR—38 sts.

Rnd 4: Knit.

Rnd 5 (dec): K6, ssk, k1, k2tog, k16, ssk, k1, k2tog, k6—34 sts.

Rnd 6: Knit.

Rnd 7 (dec): K5, ssk, k1, k2tog, k14, ssk, k1, k2tog, k5—30 sts.

Rnd 8: Knit.

Rnd 9 (dec): K4, ssk, k1, k2tog, k12, ssk, k1, k2tog, k4—26 sts.

Rnd 10: Knit.

Rnd 11 (dec): K3, ssk, k1, k2tog, k10, ssk, k1, k2tog, k3—22 sts.

Break color A. Place remaining live sts onto a piece of waste yarn while nose is worked.

NOSE

Place 6 sts from waste yarn (placed on Rnd 3 of the head section) onto 2 gauge-size dpns. With RS facing, rejoin color A at the 4th st and k3. Pick up and knit 8 sts around edge of the nose opening, knit the remaining 3 sts. Pm for BOR and join to work in the rnd—14 sts. Redistribute the sts over 3 or 4 dpns for comfort.

Rnds 1 and 2: Knit.

Rnd 3 (dec): K2tog, k10, ssk—12 sts.

Rnd 4: Knit.

Rnd 5 (dec): K2tog, k8, ssk—10 sts.

Rnd 6: Knit.

Rnd 7 (dec): K2tog, k6, ssk—8 sts.

Break color A; join color B to work the tip of the nose.

Rnd 8: Knit.

Row 9 (RS, dec): *K2tog; rep from * to end of rnd (arrange all sts on 1 dpn)—4 sts, turn.

Row 10 (WS): P4, turn.

Row 11: K4, turn.

Row 12: P4.

Break color B. Thread the tapestry needle with the tail, pull through remaining live sts, and pull to cinch closed. With the tail of color B still on the tapestry needle, pull down (toward the neck) and insert the tapestry needle into the first row of color B on the bottom of the nose and out the top of the nose in the same first row of color B to create a bobble-shaped tip of the nose. Use the tails of color A to close any holes around the nose (if needed). The nose will naturally point upward.

Stuff all parts of your project now, from the legs up to the nose. Use a dpn from the outside to help shift stuffing from the body into the arms and legs. Body and head should be stuffed fully, rounding out belly and cheeks. Stuffing to top of head is added just before finishing the hat.

HAT

Place 22 live sts from waste yarn (placed at the end of the head section) onto 3 of the larger dpns (distribute sts evenly). With RS facing, using the tail of color A as an indicator, join color C at first st in center/back of head.

Rnd 1 (inc): (LR1, k11) twice—24 sts.

Rnd 2 (and all even rnds until noted otherwise): Knit.

Rnd 3 (dec): *K2tog, k4; rep from * to end of rnd—20 sts.

Rnd 5 (dec): *K2tog, k3; rep from * to end of rnd—16 sts.

Rnd 7 (dec): *K2tog, k2; rep from * to end of rnd—12 sts.

Rnd 9 (dec): *K2tog, k1; rep from * to end of rnd—8 sts.

Stuff top of head now before hat is completed.

Rnd 11 (dec): *K2tog; rep from * to end of rnd—4 sts.

Rnd 12: Knit.

Break color C. Thread the tapestry needle with the tail, pull through remaining live sts, and pull to cinch closed. Hat should not be stuffed. Secure the top of Gus's hat by pulling it to 1 side and, using the tail from closing the hat, stitch it into place. Weave in any tails to the WS of the head. Some stuffing will unavoidably move into the hat, which is fine.

EARS (WORK BOTH THE SAME)

With color D, CO 10 sts using the Long Tail CO method evenly over 3 gauge-size dpns. Pm for BOR and join to work in the rnd, being careful not to twist the sts.

Rnd 1 (and all odd rnds until noted otherwise): Knit.

Rnd 2 (inc): M1L, k10, M1R—12 sts.

Rnd 4 (inc): M1L, k12, M1R—14 sts.

Rnd 6 (inc): M1L, k14, M1R—16 sts.

Rnd 8 (dec): K2tog, k12, ssk—14 sts.

Rnd 9 (dec): K2tog, k10, ssk—12 sts.

Rnd 10 (dec): K2tog, k8, ssk—10 sts.

Rnd 11: K2 (leave 8 sts unworked).

Redistribute the sts, starting at the end of the just-worked rnd, so that there at 5 sts on each of 2 dpns.

Holding the two needles parallel, graft all sts using Kitchener stitch.

Turn the ear inside out and weave in loose end from the top graft. Turn right side out again and flatten ear with increases and decreases in the front/center. Pinch CO edge together and stitch to hold closed, creating a shallow, concave disc shape with the ear. Stitch the CO end of the ear to head just below the hat.

SHIRT

Note: The shirt is worked flat on larger needles.

With color E and larger needles, CO 30 sts using the Long Tail CO method. Do not join to work in the rnd.

Row 1 (WS, and all WS rows until noted otherwise): Purl.

Row 2 (RS, inc): K5, LR1, k1, LR1, k4, LR1, k1, LR1, k8, LR1, k1, LR1, k4, LR1, k1, LR1, k5—38 sts.

Row 4 (inc): (K6, LR1, k1, LR1) twice, k10, (LR1, k1, LR1, k6) twice—46 sts.

Row 6 (inc): K7, LR1, k1, LR1, k8, LR1, k1, LR1, k12, LR1, k1, LR1, k8, LR1, k1, LR1, k7—54 sts.

Row 8: K9, bind off 10 sts knitwise, k16, bind off 10 more sts knitwise, k9—34 sts.

Row 10 (inc): K8, LR1, k1, LR1, k16, LR1, k1, LR1, k8—38 sts.

Row 12 (inc): K9, LR1, k1, LR1, k18, LR1, k1, LR1, k9—42 sts.

Row 13 (WS): Purl.

With RS facing, BO all sts loosely knitwise. Place shirt on Gus with opening in the back; seam closed using mattress stitch. Shirt can be tacked down to body in a few places on the bottom edge, if desired.

TAIL

With color A and the Long Tail CO method, CO 3 sts onto 1 gauge-size dpn. Work a 3-st i-cord for 1 in. / 2.5 cm.

Next row (**RS, dec**): K2tog, k1—2 sts. Work a 2-st i-cord for 2 in. / 5 cm.

Next row (**RS, dec**): K2tog—1 st.

Make a chain (a 1-st i-cord) for 2 in. / 5 cm. The total tail length is 5 in. / 12.5 cm.

Break color A and pull tail through final stitch to secure. Weave in the loose end at the narrow end of the tail. Using the loose end from the CO, sew the tail to Gus's back approx ¾ in. / 2 cm above the space between the legs.

FINISHING

Eyes can be embroidered with black floss or made with small pieces of white felt cut into oval shapes approx 15 x 11 mm. Add a small circle of black felt in the center. Eyes can be glued or sewn to head.

Add hair with pieces of Color A between the eyes and the hat (follow the photos as a reference for placement). To attach hair: Insert a small crochet hook or tapestry needle through the stitch you wish to attach the hair to. Fold a 2 in. / 5 cm strand of yarn over the hook and pull a loop through; pull the two ends of the strand through the loop and cinch to close. Repeat for each section of hair (approx 6 strands). Trim strands to desired length.

Embroider mouth with a single ply of black yarn or embroidery floss (following the photo as a reference for placement).

Hold the two edges of the hole between legs together front to back; seam closed with color A.

Tack down arms to sides with color E, if desired, after shirt is in place.

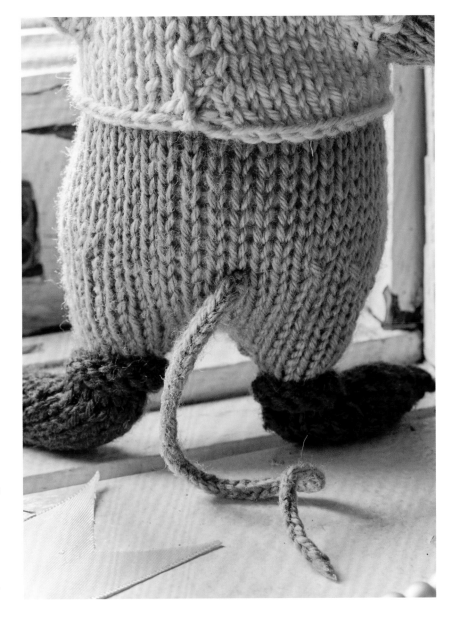

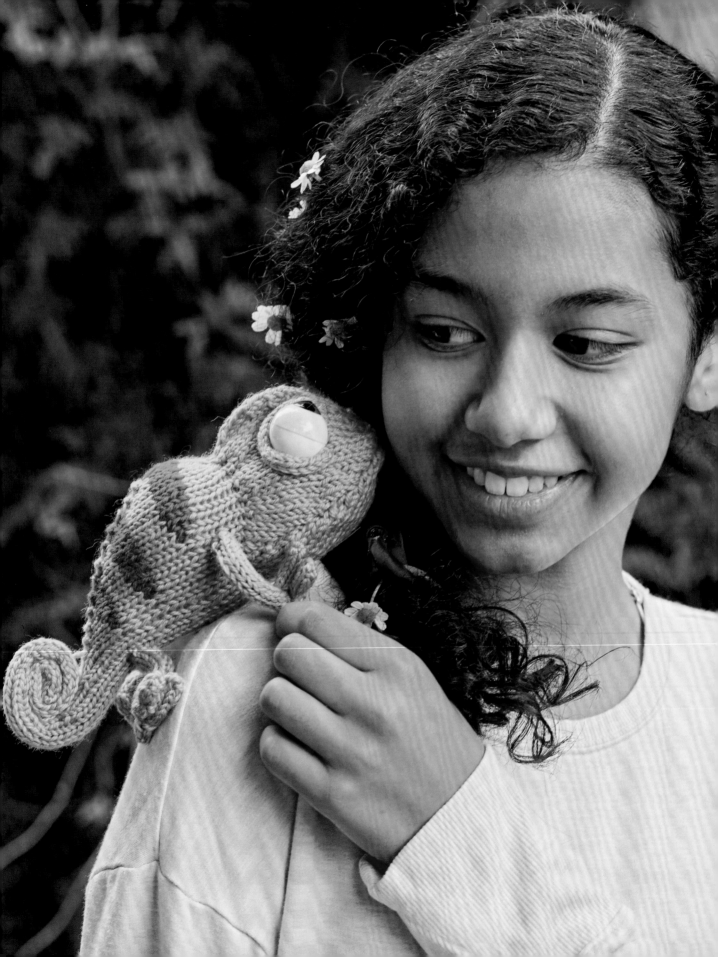

Pascal

Designed by SARA KELLNER

SKILL LEVEL ♥♥

As Rapunzel's nonverbal yet highly expressive companion and friend in *Tangled* (2010), Pascal the chameleon lets his friend use him as a mannequin, helps with chores, plays endless hide-and-seek (which he is surprisingly bad at considering he can blend in with any background), and watches over Rapunzel through thick and thin. Encouraging her to escape the tower and staying beside her when she does so, Pascal is a tiny force to be reckoned with. His color changes according to his mood, and his trust is not easily won. Pascal also assists Rapunzel in her final bid for freedom, helping her to defeat Mother Gothel so she may finally rejoin her family.

With his body and tail knit in the round and all in one piece, Pascal's back and belly are shaped with simple wrap-and-turn short rows. A variation of a double decrease creates his bumpy spine with added intarsia striping detail. After stuffing his body and rolling up and seaming his curly tail, stitches are picked up at the neckline to work his head flat in two pieces. I-cord is used to make his tail, legs, toes, and ridges around the eyes. Once completed, the pieces are seamed together to form his mouth, and felt or safety eyes are added to finish him. Knit Pascal in his original green, or chose another color like purple to make him blend into his surroundings.

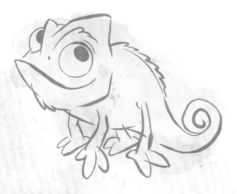

SIZE
One size

FINISHED MEASUREMENTS
Length: approx 7 in. / 18 cm
Width: 3 in. / 7.5 cm

YARN
DK weight (light #3) yarn, shown in Cascade Yarns 220 *Superwash* (100% superwash wool; 220 yd. / 200 m per 3½ oz. / 100 g ball)

Colorways:

Green Pascal
Color A: #261 Vibrant Green, 1 ball
Color B: #864 Christmas Green, 1 ball

Purple Pascal
Color A: #908 Magenta, 1 ball
Color B: #882 Plum Crazy, 1 ball

NEEDLES
- US 3 / 3.25 mm set of 4 double-pointed needles

NOTIONS
- Stitch markers
- Polyester stuffing (approx 3 oz. / 85 g)
- 1 pair 24 mm round doll eyes (optional) or scraps of white, brown, and black felt for eyes
- Hot glue gun with 1 glue stick (if using doll eyes)
- Sewing needle and white thread (if using felt eyes)
- Four 12 in. / 30 cm pipe cleaners
- Tapestry needle

GAUGE
23 sts and 30 rows = 4 in. / 10 cm over St st worked flat on smaller needle, taken without blocking
Gauge is not critical for a toy; just ensure the stitches are tight enough so the stuffing will not show through your finished project.

continued on page 30

NOTES

- Pascal's body and tail are worked in the round, all in one piece. Work begins at the neckline and proceeds backward toward the tail. After completing the tail, rolling it up, and seaming in place, the body is stuffed. Stitches are then picked up in the original cast-on stitches to begin the head, which is worked flat and in two pieces: top and bottom. Once completed, the pieces are seamed together to create the mouth.
- If the knitter decides to use round doll's eyes, they need to be adhered to the face with hot glue. Eyes made from felt can be sewn on.
- Due to his large, heavy head, Pascal is not able to stand on his own legs without falling forward. He can stand if his front legs are supported by something in front of him, and he perches nicely on a hand.
- Short rows are used to shape Pascal's body. Picking up and processing the wraps is optional in this pattern; however, it is advised that the knitter do so on the first wrap of each stripe so that the color B wrap will not be visible.
- Short rows and full rounds are worked in tandem as Pascal's body and belly shaping are created. Keep an eye on row indicators for working in the round or when working flat on the right side and wrong side.
- The intarsia method is used for adding stripes to Pascal's back, and the yarn is carried down from stripe to stripe, inside the body, without breaking to save on ends to weave in.

SPECIAL TECHNIQUES

A variation on the double decrease (s2kp) is used to create the small bumps down Pascal's spine. The 2 slipped stitches for this decrease will always be the last two stitches of the round, and the third stitch will be the first stitch of the next round. The remaining stitch after working the decrease becomes the final stitch of the round just worked. To properly work this decrease and keep the BOR marker in the correct place, slip the last 2 stitches of the round knitwise, rm, k1, psso, pm, begin next round.

BODY

Note: Work begins at neckline, center/back of neck.

With color A, CO 30 sts using the Long Tail CO method. Distribute the sts evenly over 3 dpns. Join in the rnd by slipping the first CO st onto Needle 3, then pull the 2nd st (formerly the last st) over it and off the needle; 29 sts remain. Pm for BOR.

Rnd 1: Knit.

Rnd 2 (inc): LR1, k28, LR1, k1—31 sts.

Rnd 3: Knit.

Rnd 4 (inc): LR1, k30, LR1, k1—33 sts.

Rnd 5: Knit.

Short Row 6 (RS, inc): LR1, k19, w&t.

Short Row 7 (WS): P6, w&t.

Short Row 8 (RS, inc): K19, LR1, k1—35 sts.

Drop color A; do not break. Join and begin working with color B.

Short Row 9 (RS): K8, w&t.

Short Row 10 (WS): P17, w&t.

Short Row 11 (RS): K16, w&t.

Short Row 12 (WS): P15, w&t.

Short Row 13 (RS): K8. Resume working in the rnd.

Drop color B; do not break. Resume working with color A.

Rnd 14 (dec): K33, s2kp—33 sts.

Short Row 15 (RS): K19, w&t.

Short Row 16 (WS): P6, w&t.

Short Row 17 (RS): K19, p1. Resume working in the rnd.

Rnd 18 (dec): K31, s2kp—31 sts.

Rnd 19: K30, p1.

Rnd 20 (dec): K29, s2kp—29 sts.

Drop color A; do not break. Resume working with color B.

Short Row 21 (RS): K8, w&t.

Short Row 22 (WS): P8, k1, p8, w&t.

Short Row 23 (RS, dec): K7, s2kp—27 sts.

Flynn: "Frankly, I'm too scared to ask about the frog."

Rapunzel: "Chameleon."

Flynn: "Nuance."

Tangled (2010)

Short Row 24 (RS): K6, w&t.

Short Row 25 (WS): P6, k1, p6, w&t.

Short Row 26 (RS, dec): K5, s2kp—25 sts.

Drop color B; do not break. Resume working with color A.

Short Row 27 (RS): K15, w&t.

Short Row 28 (WS): P6, w&t.

Short Row 29 (RS): K15, p1. Resume working in the rnd.

Rnd 30 (dec): K23, s2kp—23 sts.

Rnd 31: K22, p1.

Rnd 32 (dec): K21, s2kp—21 sts.

Drop color A; do not break. Resume working with color B.

Short Row 33 (RS): K5, w&t.

Short Row 34 (WS): P5, k1, p5, w&t.

Short Row 35 (RS, dec): K4, s2kp—19 sts.

Short Row 36 (RS): K3, w&t.

Short Row 37 (WS): P3, k1, p3, w&t.

Short Row 38 (RS): K2, s2kp—17 sts.

Break color B. The remainder of the project is worked with color A only.

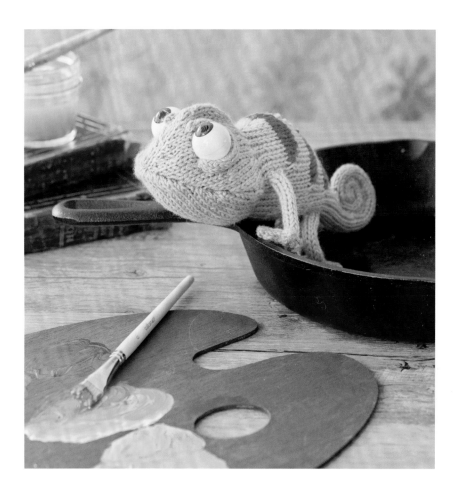

TAIL

Only the widest ⅔ of the tail needs to be stuffed. This can either be done a little at a time as you work, or afterward with a dpn from the outside, shifting a small amount of stuffing downward a little at a time.

Resume working in the rnd.

Rnd 1: K16, p1.

Rnd 2 (dec): K15, s2kp—15 sts.

Rnd 3: K14, p1.

Rnd 4 (dec): K13, s2kp—13 sts.

Rnd 5: K12, p1.

Rnd 6 (dec): K11, s2kp—11 sts.

Rnd 7: K10, p1.

Rnds 8–10: Knit.

Rnd 11 (dec): K2tog, k7, ssk—9 sts.

Rnds 12–16: Knit.

Rnd 17 (dec): K2tog, k5, ssk—7 sts.

Rnds 18–22: Knit.

Rnd 23 (dec): K2tog, k5 (arrange all sts on 1 dpn)—6 sts.

Work all of the remaining rows as an i-cord as follows:

Work a 6-st i-cord for 10 rows.

Next row (dec): K2tog, k4—5 sts.
Work a 5-st i-cord for 10 rows.

Next row (dec): K2tog, k3—4 sts.
Work a 4-st i-cord for 15 rows.

Break color A. Thread a tapestry needle with the tail, pull through the remaining live sts, and pull to secure. Weave in loose ends. Roll up tail toward body as a coil without twisting the i-cord so that the seam remains hidden. Sew in place using color A.

Stuff body.

TOP OF HEAD

Sts are now picked up to begin the top of head:

With RS facing and the tail pointed down, using the CO tail as the indicator, count 8 sts to the right of the center/back of the neck. Starting at this 8th st, and using color A and 1 dpn, pick up and knit 8 sts (1 st into each of the CO sts) until you reach the center spine, pick up and knit 1 st into the center spine. Using a second dpn, pick up and knit 8 more sts to the left of the center spine—17 sts total.

Note: After a few rows, when the work flattens, you may rearrange all sts onto 1 needle for comfort.

Setup row (WS): Purl.

Row 1 (RS, inc): K2, *k1, LR1; rep from * 5 more times, k1, **LR1, k1; rep from ** 5 more times, k2—29 sts.

Row 2 (WS, and all WS rows unless noted otherwise): Purl to end.

Row 3 (inc): K2, *k4, LR1; rep from * 2 more times, k1, **LR1, k4; rep from ** 2 more times, k2—35 sts.

Row 5: Knit.

Short Row 7 (dec): Ssk, k16, w&t—1 st dec.

Short Row 8: P1, w&t.

Short Row 9 (dec): K16, k2tog—33 sts.

Short Row 11 (dec): Ssk, k15, w&t—1 st dec.

Short Row 12: P1, w&t.

Short Row 13 (dec): K15, k2tog—31 sts.

Short Row 15 (dec): Ssk, k14, w&t—1 st dec.

Short Row 16: P1, w&t.

Short Row 17 (dec): K14, k2tog—29 sts.

Row 19 (dec): Ssk, k10, ssk, k1, k2tog, k10, k2tog—25 sts.

Row 21 (dec): Ssk, k8, ssk, k1, k2tog, k8, k2tog—21 sts.

Row 23 (dec): Ssk, k6, ssk, k1, k2tog, k6, k2tog—17 sts.

Row 25 (dec): Ssk, k4, ssk, k1, k2tog, k4, k2tog—13 sts.

Row 27 (dec): Ssk, k2, ssk, k1, k2tog, k2, k2tog—9 sts.

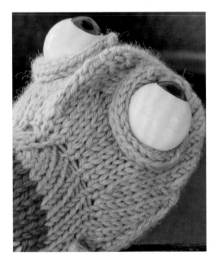

Row 29 (dec): (Ssk) twice, p2so, k1, p2so, (k2tog, p2so) twice—1 st.

Break color A and pull tail through final st to secure. Weave in loose ends.

To shape the parietal crest (bony hump) atop Pascal's head, pinch about 4 rows of fabric on each side of center and stitch closed at the bottom. This will keep the stuffing from moving into the crest and help it hold its shape. Do this prior to seaming top and bottom of head together.

BOTTOM OF HEAD

With RS facing and the tail pointed down (Pascal's belly facing you), rejoin color A. Starting in the first CO st adjacent to the final top of head st, and using 1 dpn, pick up and knit 7 sts (1 st into each of the CO sts). Using a second dpn, pick up and knit 7 more sts (the final st will be adjacent to the 1st top of head st)—14 sts total.

Note: The 2 dpns should form a V with the point inline with the center of the chest. After a few rows, when the work flattens, you may rearrange all sts onto 1 needle for comfort.

Setup row (WS): Purl.

Row 1 (RS, inc): K2, *LR1, k1; rep from * to last 2 sts, k2—24 sts.

Row 2 (WS, and all WS rows unless noted otherwise): Purl.

Rows 3, 5, and 7: Knit.

Row 9 (dec): Ssk, k20, k2tog—22 sts.

Row 11 (dec): Ssk, k18, k2tog—20 sts.

Row 13 (dec): Ssk, k16, k2tog—18 sts.

Row 15 (dec): Ssk, k14, k2tog—16 sts.

Row 17 (dec): Ssk, k12, k2tog—14 sts.

Row 19 (dec): Ssk, k10, k2tog—12 sts.

Row 21 (dec): Ssk, k8, k2tog—10 sts.

Row 23 (dec): (Ssk) twice, (p2so, k1) twice, (p2so, k2tog) twice, p2so—1 st.

Break color A and pull tail through final st to secure. Weave in loose ends.

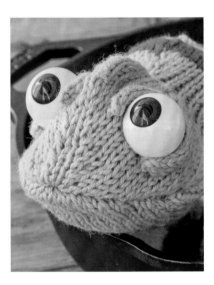

SEAMING HEAD/ MOUTH

Fold the fabric edges of each piece (top and bottom of head) toward the WS by ¼ in. / 0.5 cm and tack to the WS with color A from 1 corner of the mouth to the other. When picking up yarn to tack the edges down on the inside, only pick up 1 ply so that the tack stitches don't show on the outside of the work.

Seam the top edge of the mouth to the bottom, hiding working yarn inside the ¼ in. / 0.5 cm folds as much as possible. Stuff the head before finishing the seam. Weave in loose ends to the inside.

EYES

If doll's eyes are used, insert post between 2 sts approx 6 sts from the folded side edge and 8 rows from the picked-up sts at beginning of head. Move the eye around until you have the desired position before gluing. Eye should lie as horizontal as possible on top of the fabric so that the iris is facing forward rather than up. Secure bottom/inside of eye to the fabric with hot glue, making sure that the iris is pointing down and slightly inward toward the nose before applying the glue.

If making felt eyes, cut two circles of white felt with a diameter of 1 in. / 24 mm, two circles of brown felt about 0.5 in. / 13 mm or desired size for the irises, and two tiny circles of black felt for the pupils. Glue all pieces together and sew onto the head, adding a small amount of stuffing behind the felt prior to closing the seam.

The ridges around the eyes are made with i-cords as follows:

Using 1 dpn and color A, CO 4 sts using the Long Tail CO method.

Work a 4-st i-cord for 18 rows or approx 2½ in. / 6.5 cm.

Next row (RS, dec): K2tog, ssk—2 sts.

Break color A. Thread a tapestry needle with the tail, pull through the remaining live sts, and pull to secure. Weave in loose ends.

Lay the pointed end alongside the flat area between the eyes (using photo as a reference for placement) and wrap the remainder of the i-cord around the eye; it will not go all the way around. If using doll's eyes, this will lie directly over the post, helping to secure it inside the fabric. Attach to head by sewing it down with color A or securing with hot glue.

LEGS

The legs are made with i-cords as follows:

Using 1 dpn and color A, CO 6 sts using the Long Tail CO method.

Work a 6-st i-cord for 18 rows or approx 2½ in. / 6.5 cm.

Next row (RS, dec): K2tog, k2, ssk— 4 sts.

Break color A. Thread a tapestry needle with the tail, pull through the remaining live sts, and pull to secure. This end will be the heel, folded under, and will point in the opposite direction from the 2 longer toes. Leave the loose ends of the CO available for seaming the legs to the body.

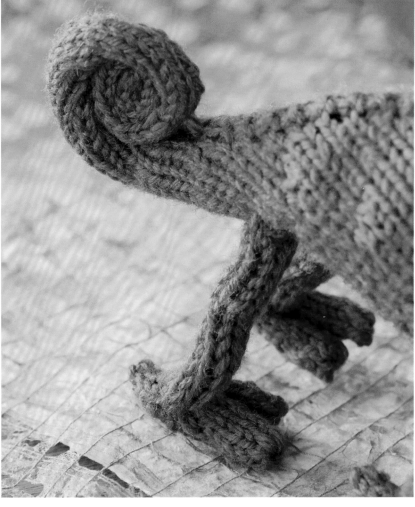

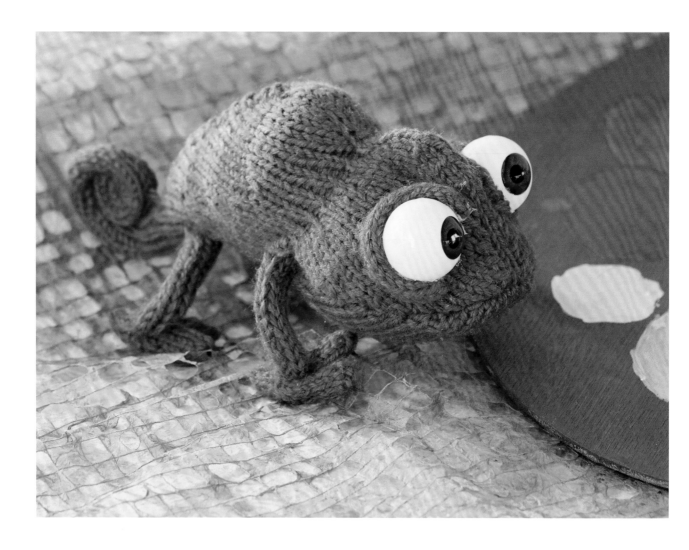

To make a toe: Using 1 dpn and color A, pick up and knit 6 sts in a horizontal line across the i-cord, 5 rows up from the tip of the heel (be sure to only cross half of the i-cord with these 6 sts).

Work a 6-st i-cord for 6 rows.

Break color A. Thread a tapestry needle with the tail, pull through the remaining live sts, and pull to secure.

Repeat for the second toe, picking up sts across the other half of the i-cord so the 2 finished toes lie side by side.

After both toes have been made, hold them together with the heel pointing in the opposite direction and use the loose ends from the CO to seam all

3 toes in place; flatten the bottom of the foot. Weave in all loose ends from the toes.

To create structure for the legs, fold 1 pipe cleaner in half and insert the folded end into the center of the leg i-cord from the top of the leg down toward the foot. Trim excess pipe cleaner approx 1½ in. / 4 cm from top of leg. Fold over the top ends of the pipe cleaner by ½ in. / 1.5 cm and insert these ends into the body between sts.

Repeat these instructions for all 4 legs.

To place the legs: The front legs stay straight and should be placed just

behind the corner of the mouth on each side. The back legs should be bent so that the knee is pointing forward. These are placed just below the end of the last stripe, closest to the tail, on the underside of the body. Stitch the CO edge of each leg to the body with the CO tails and weave in any remaining loose ends to the inside of the body.

Disney FUN FACTS

Pairing Rapunzel with an unexpected sidekick like a chameleon was purposeful. The filmmakers deliberately steered away from a more traditional companion like a chipmunk or a bird to show audiences something new and to match Rapunzel's undainty rough-and-tumble girl-next-door personality.

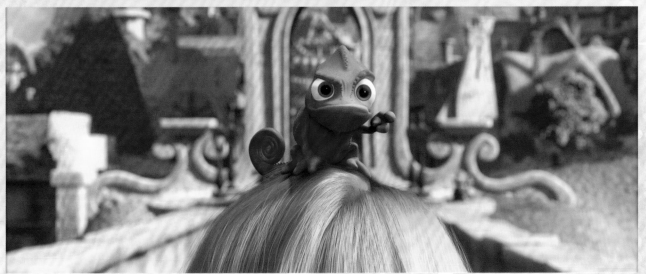

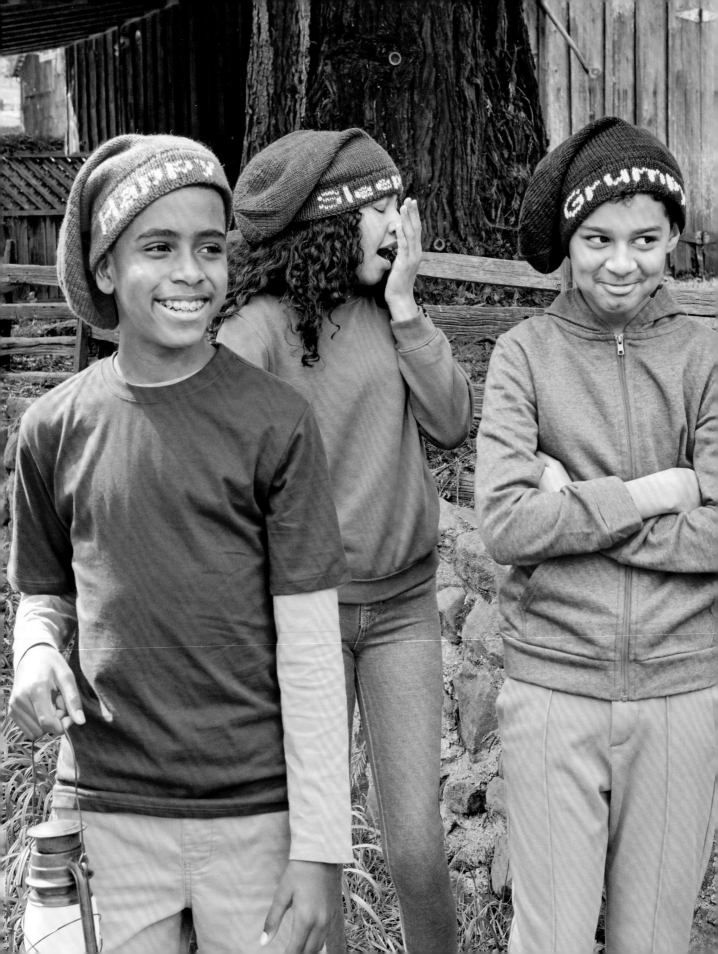

Crafty Costumes

Snow White: "I said, how do you do?"

Grumpy: "How do you do what?"

Snow White and the Seven Dwarfs (1937)

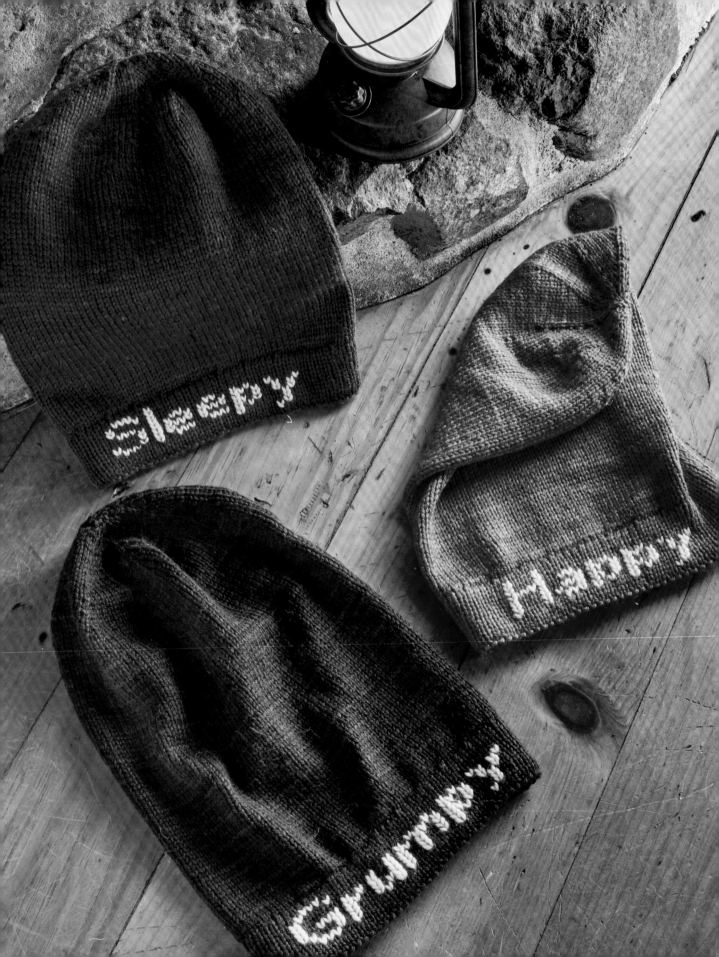

The Seven Dwarfs' Stocking Caps

Designed by MARTASCHMARTA

SKILL LEVEL ❤

The first feature-length animated film from The Walt Disney Studios, *Snow White and the Seven Dwarfs* (1937) combined full color, sound, and cel animation to create a movie experience like nothing audiences had ever seen. Centering on Snow White and her complicated relationship with her stepmother, the Queen, the kind and hard-working Seven Dwarfs provided aid to the heroine and comic relief to the audience. Before settling on Bashful, Doc, Dopey, Grumpy, Happy, Sleepy, and Sneezy, other names like Awful, Baldy, Burpy, Dizzy, Jumpy, Lazy, and Wheezy were considered for the Dwarfs. The youngest of the seven, Dopey is the only Dwarf without a beard and was also briefly considered for the role of the Sorcerer's Apprentice in *Fantasia* (1940), only to have it go to Mickey Mouse. While the film was nominated for best musical score at 1938's Academy Awards®, Walt Disney took home a special award for the film in 1939, featuring a full-size Oscar® statue for Snow White, accompanied by seven mini Oscars® representing the Seven Dwarfs.

It's off to work you go! Started from the brim up beginning with a provisional cast on, these slouchy replicas of the Seven Dwarfs' hats match the original colors in the film and commence with a turned-in hem. Letters identifying the owner of each hat are duplicate stitched on before the hem is turned and joined, allowing you to represent your favorite dwarf or personalize it with the alphabet charts provided. Knit in the round and increased out with M1s, these hats can be made as slouchy as you like. With sizing from child through adult, you can make one for all the Grumpys, Happys, or Sleepys in your clan!

SIZES

1 (2, 3, 4, 5)
To Fit: 19 (21, 22, 23, 24) in. / 48.5 (53.5, 56, 58.5, 61) cm head circumference
Average fit is for Child (Youth, Adult Small, Adult Medium, Adult Large)
Instructions are written for the smallest size, with larger sizes given in parentheses. When only one number is given, it applies to all sizes.

FINISHED MEASUREMENTS

Brim circumference: 16¾ (18½, 19½, 20¼, 21¼) in. / 42.5 (46.5, 49.5, 51.5, 54) cm
Length: 15¼ (16, 16¾, 17¾, 18¾) in. / 39 (40.5, 42.5, 45, 47.5) cm (from folded brim edge to top of crown)
Cap is designed to be worn with approx 12% (or 2¼–2¾ in. / 5.5–7 cm) negative ease to fit snuggly around head.

YARN

Worsted weight (medium #4) yarn, shown in Lorna's Laces *Shepherd Worsted* (100% superwash merino wool; 225 yd. / 205 m per 3½ oz. / 100 g hank)

Colorways:
CC (for all hats): Natural undyed, 1 hank

MC for each hat:
Grumpy: Chocolate, 2 hanks
Sleepy: Douglas Fir, 2 hanks
Happy: Courage, 2 hanks

continued on page 40

NEEDLES

- US 7 / 4.5 mm, 16 in. / 40 cm long circular needle and set of double-pointed needles or size needed to obtain gauge and extra gauge-size needle (or smaller) 16 in. / 40 cm or longer circular needle

NOTIONS

- Waste yarn
- US G-6 / 4 mm crochet hook
- Stitch marker
- Tapestry needle

GAUGE

20 sts and 28 rnds = 4 in. / 10 cm in St st, taken after blocking

Make sure to check your gauge.

NOTES

- This hat is worked in the round from the brim up with a hemmed and folded brim.
- Written instructions are provided for the entirety of the hat. Charts are provided for the duplicate stitching of the letters to customize the brim.
- When the circumference of the hat becomes too small for the circular needle during the crown shaping, change to dpns to finish the hat.
- When the hat is worn as designed, the beginning of round will be behind the head.
- The duplicate stitch customization (optional) is added before the brim is folded and seamed to ensure that no stitches show on the inside of the hat.

BRIM

With waste yarn and crochet hook, provisionally CO 84 (92, 97, 101, 106) sts. With MC and 16 in. / 40 cm needle, knit across the live sts. Pm for BOR and join to work in the rnd, being careful not to twist the sts.

Work in St st (knitting every rnd) for 2 (2¼, 2½, 2½, 2½) in. / 5 (5.5, 6.5, 6.5, 6.5) cm, making sure to work a minimum of 13 rnds if adding personalization with duplicate stitch charts.

Next rnd (Folding Rnd): Purl.

Continue in St st for 2 (2¼, 2½, 2½, 2½) in. / 5 (5.5, 6.5, 6.5, 6.5) cm. The number of rnds before and after the Folding Rnd should be the same.

CUSTOMIZATION

Before hemming the brim, use CC to duplicate stitch the name or phrase desired, centered vertically and horizontally, on the front brim above the Folding Rnd. Once complete, break CC. The remainder of the hat is worked with MC only.

HEM THE BRIM

Carefully unzip your provisional CO and place the live sts onto the spare circular needle. Fold the brim up, with WS facing each other, at the Folding Rnd; you will have 2 sets of live sts parallel to each other with the provisional CO sts on the needle to the inside.

Hem Rnd: *Knit 1 st from the outer needle (the live brim sts) and 1 st from the inner needle (the provisional CO) together as per a k2tog; rep from * to end of rnd—84 (92, 97, 101, 106) sts rem on the working needle (no sts remain on the inner/spare needle).

BODY OF HAT

Setup Rnd (inc): *K4, M1L; rep from * until 4 (0, 1, 1, 2) sts remain, k4 (0, 1, 1, 2)—104 (115, 121, 126, 132) sts.

Work in St st until the body of the hat measures 10 (10½, 11, 12, 13) in. / 25.5 (26.5, 28, 30.5, 33) cm from the Hem Rnd.

CROWN SHAPING
CROWN ADJUSTMENT RND

Sizes 1, 2, 4, and 5 Only: *K24 (21, -, 19, 64), k2tog; rep from * to EOR—100 (110, -, 120, 130) sts.

Size 3 Only: K2tog, knit to EOR—120 sts.

ALL SIZES

Rnd 1 (dec): *K8, k2tog; rep from * to EOR—90 (99, 108, 108, 117) sts.

Rnds 2 and 3: Knit.

Rnd 4 (dec): *K7, k2tog; rep from * to EOR—80 (88, 96, 96, 104) sts.

Rnds 5 and 6: Knit.

Rnd 7 (dec): *K6, k2tog; rep from * to EOR—70 (77, 84, 84, 91) sts.

Rnds 8 and 9: Knit.

Rnd 10 (dec): *K5, k2tog; rep from * to EOR—60 (66, 72, 72, 78) sts.

Rnds 11 and 12: Knit.

Rnd 13 (dec): *K4, k2tog; rep from * to EOR—50 (55, 60, 60, 65) sts.

Rnd 14: Knit.

Rnd 15 (dec): *K3, k2tog; rep from * to EOR—40 (44, 48, 48, 52) sts.

Rnd 16: Knit.

Rnd 17 (dec): *K2, k2tog; rep from * to EOR—30 (33, 36, 36, 39) sts.

Rnd 18: Knit.

Rnd 19 (dec): *K1, k2tog; rep from * to EOR—20 (22, 24, 24, 26) sts.

Rnd 20: Knit.

Rnd 21 (dec): *K2tog; rep from * to EOR—10 (11, 12, 12, 13) sts.

Rnd 22 (dec): [K2tog] 5 (5, 6, 6, 6) times, k0 (1, 0, 0, 1)—5 (6, 6, 6, 7) sts.

FINISHING

Break yarn and draw through remaining sts with a tapestry needle, pull snug, secure, and weave in any loose ends. Wet block hat flat; allow to dry completely. Trim any remaining ends.

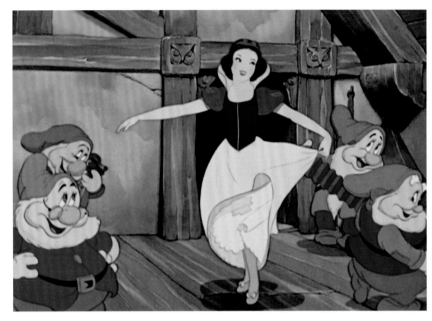

ABOVE: Snow White and the Seven Dwarfs dancing in the Dwarfs' cottage, from *Snow White and the Seven Dwarfs* (1937).

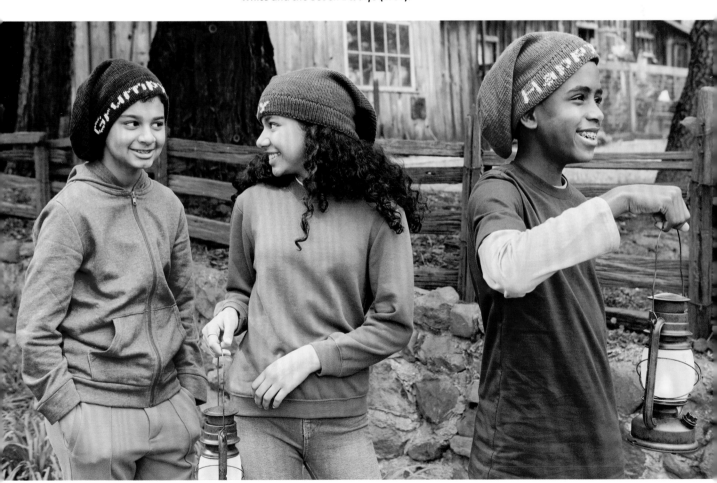

CHART

KEY

☐ Existing stitch

■ Duplicate stitch

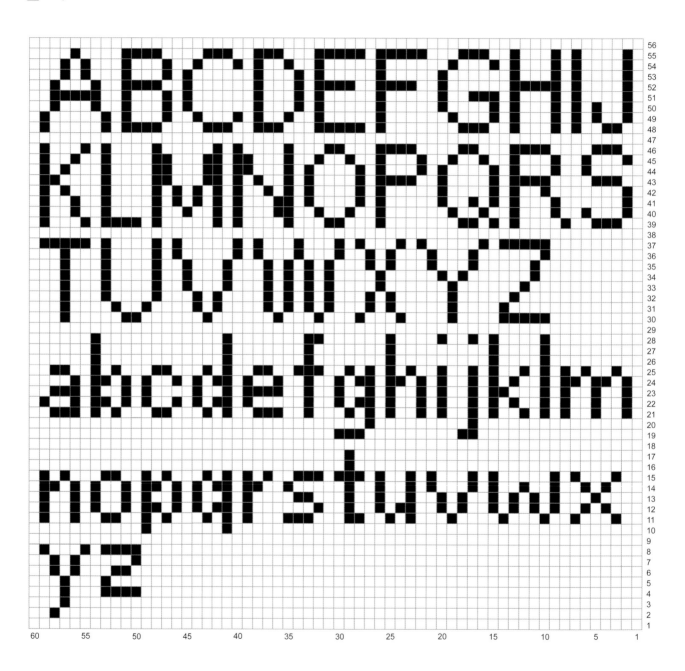

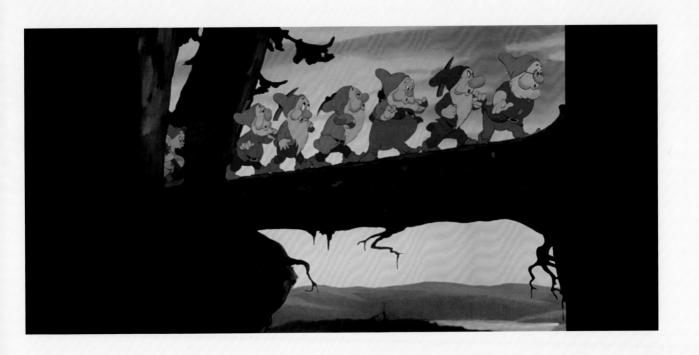

Snow White: "Supper's not quite ready. You'll just have time to wash."

Dwarfs: "Wash?"

Grumpy: "I knew there was a catch to it."

Snow White and the Seven Dwarfs (1937)

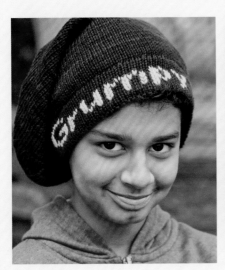
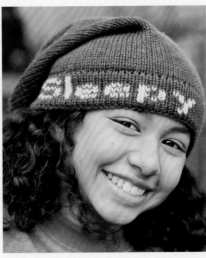
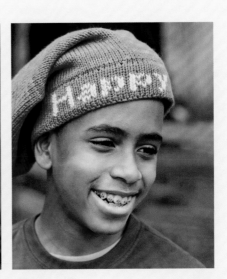

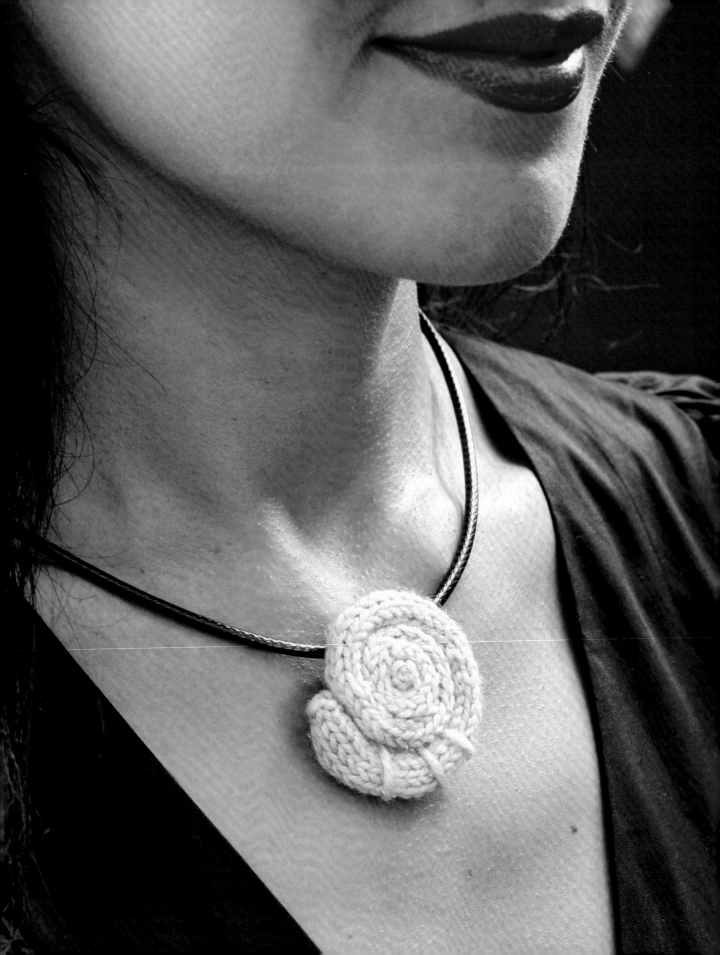

Ursula's Seashell Necklace

Designed by TANIS GRAY

SKILL LEVEL ❤

During early development for *The Little Mermaid* (1989), several different designs were considered for Ursula, the movie's antagonist, including exploratory takes inspired by manta rays and scorpion fish. It was director and screenwriter Ron Clements who ultimately made the decision to design the dramatic sea witch as an octopus with six tentacles and two arms, to make the animation less complex. Originating as a nameless character with a minimal part in the 1837 Hans Christian Andersen fairy tale, Ursula was revamped for the movie into a vengeful, manipulative villainess bent on using Ariel to overthrow King Triton and seize control of Atlantica. Brought to life through the vocal talents of actress Pat Carroll, who turned in a legendary rendition of the song "Poor Unfortunate Souls," Ursula was called the "most satisfying villainess since the witch in *Snow White and the Seven Dwarfs*" by film critic Roger Ebert.

Channel your inner sea witch by knitting yourself a replica of Ursula's magical seashell necklace, which she uses to steal Ariel's voice and later enchant Prince Eric. Starting with a two-stitch i-cord, this easy accessory is increased out quickly to six stitches, then spiraled around itself and whipstitched into place on the wrong side, forming a sparkly shell. The yarn tail is wrapped around the outer edge for added detail, then the shell is secured on black cording or the necklace of your choice.

SIZE
One size

FINISHED MEASUREMENTS
Width: 2 in. / 5 cm
Height: 2 in. / 5 cm

YARN
DK weight (light #3) yarn, shown in The Lemonade Shop *Sparkle DK* (100% superwash merino; 231 yd. / 211 m per 3½ oz. / 100 g hank), 1 hank Atomic Banana (only 10 yd. / 10 m are needed)

NEEDLES
- US 2 / 2.75 mm set of 2 double-pointed needles

NOTIONS
- Tapestry needle
- 18 in. / 46 cm black cording (or desired length) for necklace

GAUGE
24 sts and 32 rows = 4 in. / 10 cm in i-cord pattern
Gauge is not important for this project but will affect yardage used.

NOTES
- Shell is worked as a long i-cord with an increasing number of stitches.
- The shell shape is created by spiraling the i-cord while flat and sewing it into shape.

I-CORD

CO 2 sts to 1 dpn using the Long Tail CO method, leaving a 12 in. / 30.5 cm tail.

Work i-cord for 10 rows.

Next row (inc): Kfb, k1—3 sts.

Work i-cord for 15 rows.

Next row (inc): Kfb, k2—4 sts.

Work i-cord for 15 rows.

Next row (inc): Kfb, k3—5 sts.

Work i-cord for 15 rows.

Next row (inc): Kfb, k4—6 sts.

Work i-cord for 20 rows.

BO all sts knitwise. Break yarn.

FINISHING

Laying i-cord flat, with the CO in the center, wind i-cord around itself in spirals, leaving no gaps. Whipstitch edges together on WS with the CO tail. Wrap the remainder of the CO tail around the outer spiral 3 times, following photo for placement if desired.

Weave in all loose ends.

Secure shell to 18 in. / 46 cm black cording (or desired length necklace) by wrapping the yarn multiple times around the cord and securing to the WS of the shell.

Do not block. Trim all remaining ends.

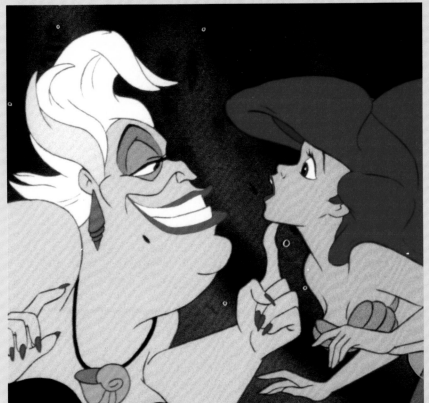

"My dear, sweet child, that's what I do. It's what I live for. To help unfortunate merfolk. Like yourself. Poor souls with no one else to turn to."

Ursula, *The Little Mermaid* (1989)

TOP: Ursula manipulates Ariel into giving up her voice in exchange for legs so she can be with her true love. ABOVE: Vanessa, Ursula's alter ego, wearing the seashell necklace she uses to enchant Prince Eric.

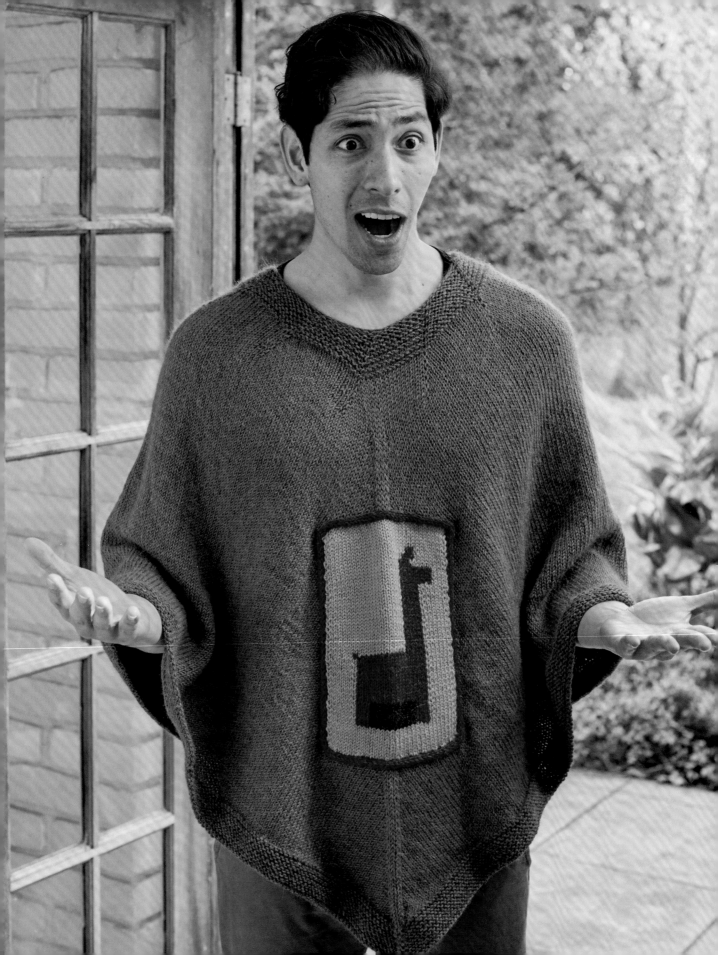

Kuzco's Poncho

Designed by CASSANDRA CRUIKSHANK

SKILL LEVEL ❤

Released in 2000 after a lengthy production process, *The Emperor's New Groove* featured a new kind of comedic animation that was a departure from the musical style of the Disney animated films of the era. Filled with quick-witted dialogue, slapstick humor, and visual gags, Disney's fortieth animated feature tells the tale of spoiled Emperor Kuzco, who is accidentally turned into a llama and must rely on kindly villager Pacha to regain both his kingdom and his humanity. Set in an ancient Andes-inspired region, animators visited Machu Picchu and surrounding Peru to draw inspiration for the rich color palette, carvings, art, architecture, and textiles in the film. Artists also visited zoos and llama farms to study the mannerisms and movements of the animals for when Kuzco undergoes his transformation from royalty to livestock courtesy of his hilarious yet vengeful ex-advisor Yzma.

A replica of the poncho Pacha's wife, Chicha, makes for Kuzco at the end of the film, this poncho is the perfect travel garment to keep you warm and comfortable while on a long hike back to the palace with your best friend! Beginning with a garter collar, the poncho is worked from the top down in the round. The stockinette body increases out with simple M1R and M1L increases, making it easy to lengthen or shorten if desired. The llama patch is done postknitting using intarsia with an i-cord bind off border worked around all sides, then sewn onto the front of the garment. Sized child through adult, make one for the whole family for your next Disney trip!

SIZES
Child (Youth, Adult Small, Adult Large)

Instructions are written for the smallest size, with larger sizes given in parentheses. When only one number is given, it applies to all sizes.

FINISHED MEASUREMENTS
Length to shortest point: 17 (20½, 24, 27½) in. / 43 (52, 61, 70) cm

Half lower edge length: 35½ (44, 51½, 59½) in. / 91 (112, 132, 151) cm

See full schematic for details.

YARN
Worsted weight (medium #4) yarn, shown in Berroco *Ultra Alpaca* (50% super fine alpaca, 50% Peruvian wool; 219 yd. / 200 m per 3½ oz. / 100 g hank)

Main Color (MC): #6275 Pea Soup Mix, 2 (3, 4, 5) hanks

Contrast Color 1 (CC1): #6273 Irwyn Green Mix, 1 (1, 2, 2) hanks

Contrast Color 2 (CC2): #6253 Dijon, 1 hank

Contrast Color 3 (CC3): #6280 Mahogany Mix, 1 hank

Contrast Color 4 (CC4): #6289 Charcoal Mix, 1 hank

NEEDLES
• US 7 / 4.5 mm, 16–40 in. / 40–101.5 cm long circular needle or size needed to obtain gauge

NOTIONS
• Stitch markers (10; 1 unique for BOR)
• Waste yarn
• US G-6 / 4 mm crochet hook
• Tapestry needle

GAUGE
18 sts and 27 rnds = 4 in. / 10 cm in St st, taken after blocking

Make sure to check your gauge.

continued on page 50

NOTES

- This poncho is worked in the round from the top down, from the collar to the bottom hem seamlessly. The BOR marker is located at the right shoulder.
- Both the collar and hem are worked in garter stitch. The body of the poncho is worked in stockinette stitch.
- The patch is worked separately using the intarsia colorwork method and then sewn to the poncho after blocking.

COLLAR

With the 16 in. / 40 cm needle and CC1, CO 50 (60, 70, 80) sts using the Twisted German method. Pm for BOR and join to work in the rnd, being careful not to twist the sts.

Setup Rnd: *P5 (6, 7, 8), pm; rep from * to end of rnd.

Note: The final marker will be the existing BOR marker.

Rnd 1 (inc): *K1, M1R, knit to m, sm; rep from * to end of rnd—10 sts inc.

Rnd 2: Purl.

Rep [Rnds 1 and 2] 4 (5, 6, 7) more times—100 4120, 140, 160) sts total.

Break CC1.

SHOULDER SHAPING

Join MC.

Rnd 1 (inc): *K1, M1R, knit to m, sm; rep from * to end of rnd—10 sts inc.

Rnd 2: Knit.

Rep [Rnds 1 and 2] 3 (4, 5, 6) more times—140 (170, 200, 230) sts total.

Next rnd (inc): *K1, M1R, knit to m, sm; rep from * to end of rnd—150 (180, 210, 240) sts.

Next rnd: Knit, rm as encountered (leaving the BOR m in place).

BODY OF PONCHO

Setup Rnd: K36 (43, 51, 58), pm, k3, pm, k72 (87, 102, 117), pm, k3, pm, knit to end of rnd.

Rnd 1 (inc): *Knit to m, M1R, sm, k3, sm, M1L; rep from * once more, knit to end of rnd—4 sts inc.

Rnd 2: Knit.

Rep [Rnds 1 and 2] 37 (47, 56, 65) more times, or until the poncho is approx 1 (1¼, 1½, 1¾) in. / 2.5 (3, 3.5, 4) cm short of the desired total length—302 (372, 438, 504) sts total. Break MC.

BOTTOM HEM

Rejoin CC1.

Rnd 1 (inc): *Knit to m, M1R, sm, k3, sm, M1L; rep from * once more, knit to end of rnd—4 sts inc.

Rnd 2: Purl.

Rep [Rnds 1 and 2] 4 (5, 6, 7) more times—322 (396, 466, 563) sts total.

LLAMA PATCH

With waste yarn and crochet hook, provisionally CO 21 (29, 31, 31) sts. Join CC2 and purl across all live sts.

Work Rows 1–38 (1–60, 1–80, 1–80) once using the intarsia method, joining CC3 and CC4 as required. When the final row is worked, cut all yarn. Do not bind off any sts.

Rejoin CC3 with the RS facing and knit across the live sts at the top of the patch. Rotate the patch 90 degrees, and pick up and knit 19 (30, 40, 40) sts down the side of the patch (1 st into each slipped edge st). Carefully undo the provisional CO and place the live sts of the bottom of the patch onto the LHN. Knit across these 21 (29, 31, 31) sts. Rotate the patch another 90 degrees and pick up and knit a final 19 (30, 40, 40) sts up the side of the patch (1 st into each slipped edge st)—80 (118, 142, 142) sts total.

Continuing with CC3, CO 3 sts using the Cable CO method. Work the i-cord BO across the top 21 (29, 31, 31) sts. Three sts will rem on the RHN. Slip these 3 sts to the LHN and work a 3-stitch i-cord for 2 rows. Slip the 3 sts back to the LHN and resume the i-cord BO down the left edge of the patch. Continue in this manner, using the i-cord BO along each edge and working a 2-row i-cord in each corner until all sts are bound off. When the final sts are bound off and 3 sts remain, work 1 final i-cord row. Break the yarn, leaving a 12 in. / 30.5 cm tail. Seam the live sts of the i-cord to the start of the i-cord at the upper right corner of the patch to create a seamless frame around the patch.

FINISHING

Weave in all ends of the poncho and the patch. Wet block the poncho and the patch separately. Allow to dry completely. Trim ends. Using CC3, sew the patch onto the front of the poncho using a running st on the underside of the i-cord and centered over the 3-st increase column, following the photo for vertical placement.

TOP RIGHT: Emperor Kuzco wearing the llama poncho that Pacha's wife Chicha makes for him at the end of *The Emperor's New Groove* (2000).

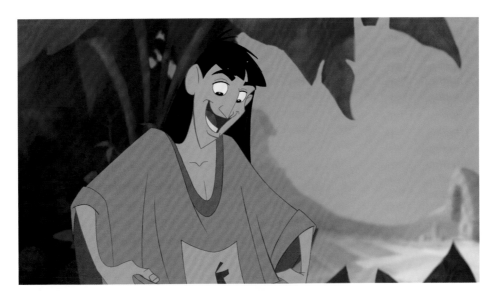

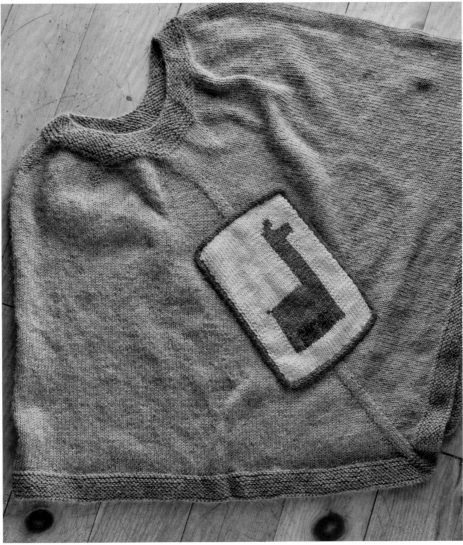

CHART

KEY

☐	Knit
☑	Slip stitch purlwise wyib
▨	CC2
▨	CC3
▨	CC4

Emperor Kuzco: "Gow!
You threw off my groove!"

Guard: "I'm sorry,
but you've thrown
off the emperor's groove."

Old Man [as he's tossed
from the window]: "Sorry!"

The Emperor's New Groove (2000)

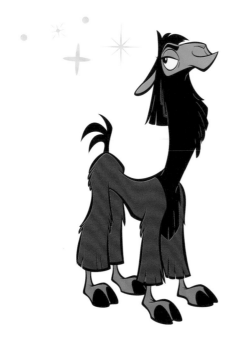

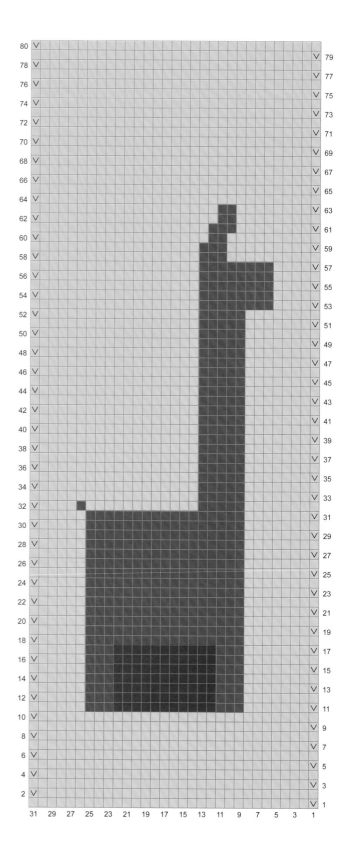

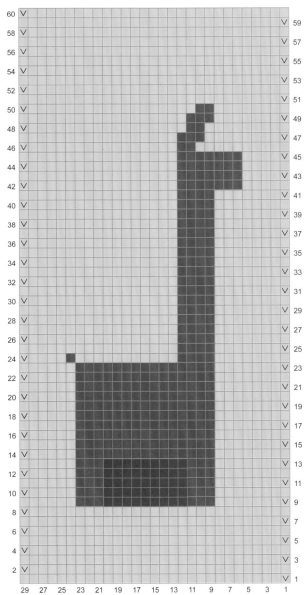

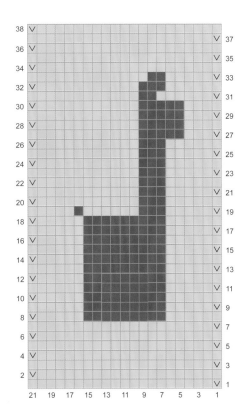

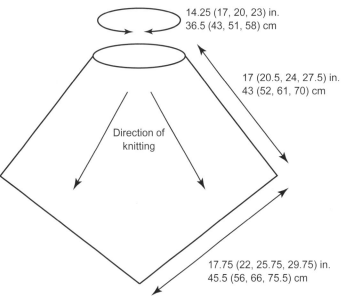

14.25 (17, 20, 23) in.
36.5 (43, 51, 58) cm

17 (20.5, 24, 27.5) in.
43 (52, 61, 70) cm

Direction of
knitting

17.75 (22, 25.75, 29.75) in.
45.5 (56, 66, 75.5) cm

Inspired Apparel

Merryweather: "It looks awful."
Flora: "That's because it's on you, dear."

Sleeping Beauty (1959)

Mickey Mouse & Minnie Mouse Ombré Cowl

Designed by JESSICA GODDARD

SKILL LEVEL 🖤🖤

L aunched in 1928, Mickey Mouse is Disney's most iconic character and mascot: a lighthearted, enthusiastic everyman who never gives up and is always willing to help his many friends. Usually dressed in red shorts with white buttons, white gloves encasing three fingers and a thumb, and yellow shoes, Mickey is one of the most recognizable characters around the world, often appearing alongside his fashionable sweetheart Minnie, recognizable by her polka dot skirt and big red bow. Appearing together in the first cartoon to feature synchronized sound, *Steamboat Willie* (1928), Mickey went on to appear in over 130 films, including *Brave Little Tailor* (1938) and *Fantasia* (1940). In 1978, Mickey became the first cartoon character to receive his very own star on the Hollywood Walk of Fame, with Minnie following in 2018.

Let the gradient yarn do the color changes for you as you make this bold Mickey and Minnie double-knit cowl in their classic colors. Knit in the round from the bottom up, the silhouettes of these two icons checkerboard each other in double knitting, creating inverted colors on the opposite side. With no visible wrong side, this extra-squishy graphic cowl is the consummate gift for anyone wanting to proclaim their love for Mickey Mouse and Minnie Mouse.

SIZE
One size

FINISHED MEASUREMENTS
Height: 8 in. / 20 cm
Circumference: 32 in. / 81.5 cm

YARN
DK weight (light #3) yarn, shown in KnitCircus Yarns *Daring* (80% superwash merino, 10% cashmere, 10% nylon; 250 yd. / 228 m per 3½ oz. / 100 g ball)
Main Color (MC): Quoth the Raven, 1 ball
Contrast Color (CC): The Cheese Stands Alone, 1 ball

NEEDLES
- US 6 / 4 mm, 32 in. / 81.5 cm long circular needle or size needed to obtain gauge

NOTIONS
- Stitch marker
- Tapestry needle

GAUGE
20 sts and 28 rnds = 4 in. / 10 cm in 2-color double knitting, taken without blocking
Make sure to check your gauge.

NOTES
- This cowl is worked in the round, from bottom to top, in a seamless loop using the Double Knitting method.
- Double knitting is a technique that produces a double thickness of fabric that looks like right-side stockinette stitch on both sides. The two sides of the knitting are inverse colors; the two sides mirror one another.

"I only hope that we never lose sight of one thing—
that it was all started by a mouse."

Walt Disney

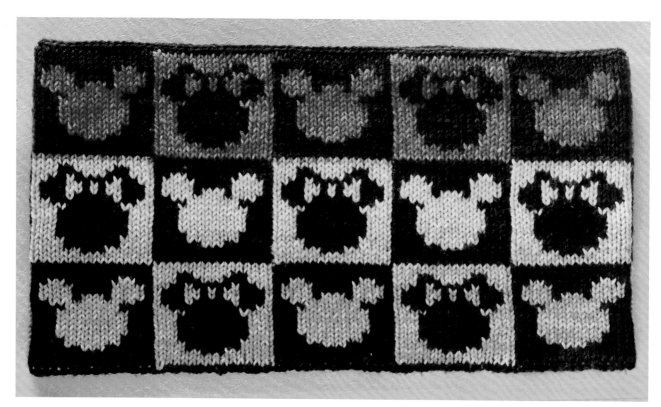

BODY

Using MC, CO 300 sts using the Knitted CO method. Pm for BOR and join to work in the rnd, being careful not to twist the sts.

Join CC.

Begin chart, reading all rows from right to left as for working in the rnd using the Double Knitting method. Work Rows 1–40 once (chart is worked 5 times across each rnd), then repeat Rows 1–20 once more—60 rows total. Break CC.

BIND OFF

Bind Off Setup Rnd 1: Knit.

Bind Off Setup Rnd 2: *K1, p1; rep from * to end of rnd.

Note: The BO is a variation on the standard method where, instead of knitting every stitch, stitches will be worked in pairs.

BO as follows: K2tog tbl, *k2tog tbl, pass 1st st over the 2nd and off the needle (1 st bound off); rep from * to end of rnd. Break yarn and pull through last st to fasten off.

FINISHING

Weave in the ends carefully by inserting the tail into the tapestry needle and weaving the tail into the "hollow" of the double knitting. The original sample was not blocked, but if you feel that you would like to smooth out your sts, you may wish to do a gentle steam block.

CHART

KEY

- ■ MC
- ▨ CC
- ☐ Pattern repeat

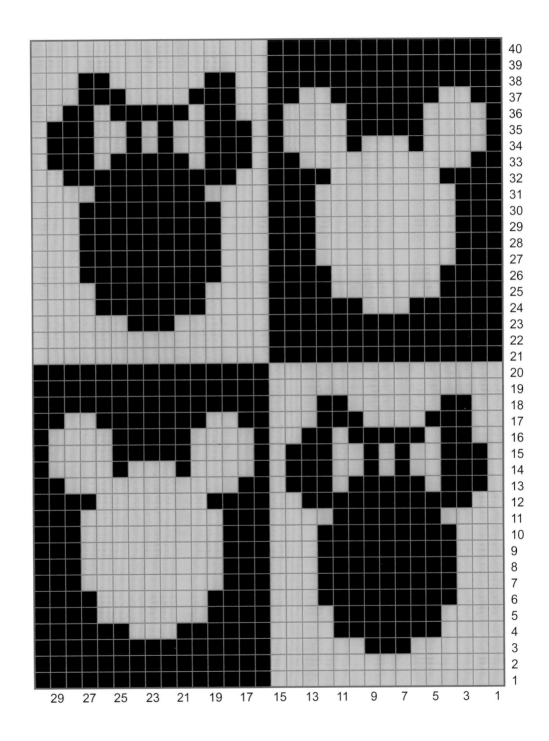

40
39
38
37
36
35
34
33
32
31
30
29
28
27
26
25
24
23
22
21
20
19
18
17
16
15
14
13
12
11
10
9
8
7
6
5
4
3
2
1

29 27 25 23 21 19 17 15 13 11 9 7 5 3 1

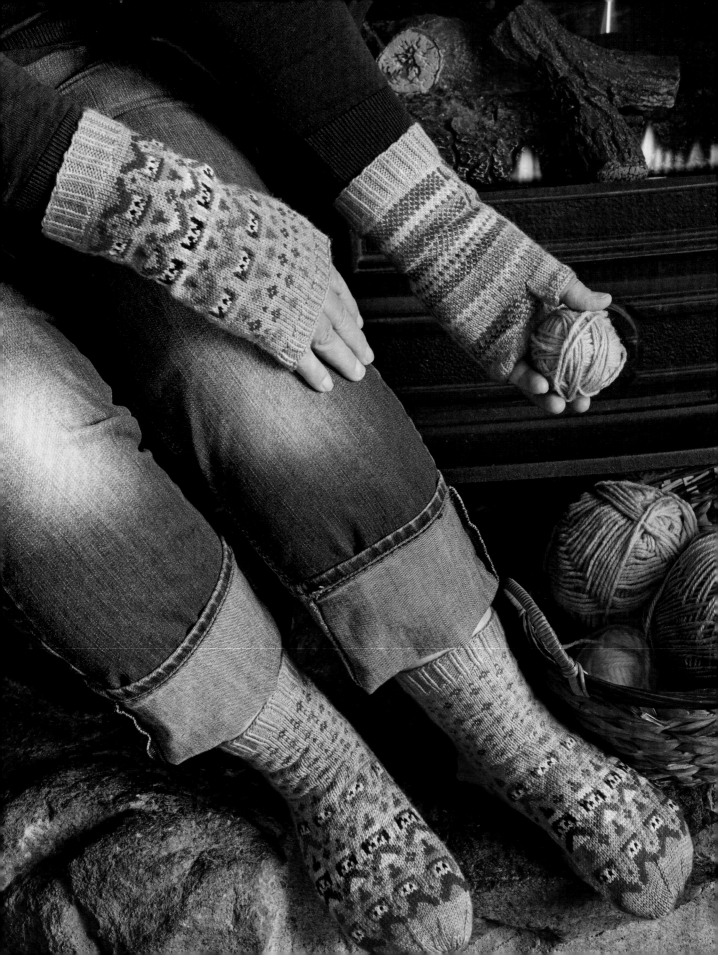

Three Fairies Socks & Mitts

Designed by SPILLYJANE

SKILL LEVEL ♥ ♥ ♥

Gifted with powerful magical abilities to bring joy and happiness, the three good fairies arrive at Aurora's christening to bestow gifts upon the baby in *Sleeping Beauty* (1959). When Maleficent appears and curses the newborn, the three fairies decide to temporarily abandon their magical ways and live as mortals for sixteen years, hiding Aurora away in the forest and raising her as their own. Dressed in medieval-inspired gowns in their signature colors—Flora in red, Fauna in green, and Merryweather in blue—the fairies wear pointy hats, have fluttering wings, and wield magical wands (when they're not disguised as peasants). While each fairy has a distinctive personality (Merryweather is pragmatic, Fauna optimistic, and Flora the leader), together they make a great team and do their best to keep Briar Rose (Aurora) secret and safe.

Inspired by Flora, Fauna, and Merryweather, this pink, green, and blue matching socks and mittens set will keep the wearer safe and warm for as many years as it takes to wait out an evil curse. The socks are knit in the round from the cuff down beginning with a twisted 2x2 rib. Stranded colorwork fairies fly across the leg with the basic shape of each fairy worked across the rounds with the hair, eyes, scarves, and petticoats added postknitting with duplicate stitching. Waste yarn is used to put heel stitches on hold, and the rest of the sock is knit to the toe with the remaining stitches grafted together. An afterthought heel is added, followed by the duplicate stitch details. The matching mittens are worked from the bottom up with a matching twisted rib cuff. Once the main part of the mitten is complete, an afterthought thumb is added, as well as duplicate stitch detailing.

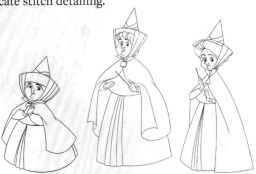

SIZES
Socks
Small (Medium, Large)

Mitts
Small (Medium, Large)

Instructions are written for the smallest size, with larger sizes given in parentheses. When only one number is given, it applies to all sizes.

FINISHED SIZES
Socks
Circumference: 7½ (8, 9) in. / 18 (20.5, 23) cm
Foot length is adjustable; minimum sock length is approx 8 (8½, 9) in. / 20.5 (21, 23.5) cm from back of heel to tip of toe.
These socks are designed to be worn with ½–1 in. / 1–2.5 cm negative ease.

Mitts
Mitt Circumference: 7½ (8, 9) in. / 18 (20.5, 23) cm
Length: 7½ (7¾, 8½) in. / 19 (20, 21) cm

YARN
Socks
Fingering weight (super fine #1) yarn, shown in SweetGeorgia Yarns *Tough Love Sock* (80% superwash merino, 20% nylon; 425 yd. / 388 m per 4 oz. / 115 g hank)
Main Color (MC): Grapefruit, 1 hank
Contrast Color 1 (CC1): Tomato, ½ hank
Contrast Color 2 (CC2): Apricot, ½ hank
Contrast Color 3 (CC3): Mellow, ½ hank
Contrast Color 4 (CC4): Sapphire, ½ hank
Contrast Color 5 (CC5): Dreamboat, ½ hank
Contrast Color 6 (CC6): Basil, ½ hank
Contrast Color 7 (CC7): Pistachio, ½ hank
Contrast Color 8 (CC8): Slate, ½ hank
Contrast Color 9 (CC9): Cauldron, ½ hank
Contrast Color 10 (CC10): Bison, ½ hank

continued on page 62

Mittens

Fingering weight (super fine #1) yarn, shown in SweetGeorgia Yarns *Tough Love Sock* (80% superwash merino, 20% nylon; 425 yd. / 388 m per 4 oz. / 115 g hank)

Main Color (MC): Grapefruit, 1 hank
Contrast Color 1 (CC1): Tomato, ½ hank
Contrast Color 2 (CC2): Apricot, ½ hank
Contrast Color 3 (CC3): Mellow, ½ hank
Contrast Color 4 (CC4): Sapphire, ½ hank
Contrast Color 5 (CC5): Dreamboat, ½ hank
Contrast Color 6 (CC6): Basil, ½ hank
Contrast Color 7 (CC7): Pistachio, ½ hank
Contrast Color 8 (CC8): Slate, ½ hank
Contrast Color 9 (CC9): Cauldron, ½ hank
Contrast Color 10 (CC10): Bison, ½ hank

NEEDLES

- US 0 / 2 mm set of 5 double-pointed needles or size needed to obtain gauge

NOTIONS

- Stitch marker
- Tapestry needle
- 36 in. / 91.5 cm length of fingering-weight waste yarn for socks
- 20 in. / 51 cm length of fingering-weight waste yarn for mittens

GAUGE

Size Small: 42 sts and 46 rnds = 4 in. / 10 cm in stranded colorwork pattern, taken after blocking
Size Medium: 40 sts and 44 rnds = 4 in. / 10 cm in stranded colorwork pattern, taken after blocking
Size Large: 36 sts and 40 rnds = 4 in. / 10 cm in stranded colorwork pattern, taken after blocking
Make sure to check your gauge.

NOTES

Socks

- In an effort to honor the original design of these socks and ensure a wider range of available fit, rather than compromise on the stitch pattern, these socks have been graded using different gauges for each size. To achieve the gauge for your finished size of sock, adjust your needle size as needed.
- These socks are worked top down in the round from cuff to toe. The cuff, heel, and toe are worked in the MC alone; colorwork knitting is done across the leg and instep.
- Waste yarn is used to place an afterthought heel once the leg is complete and before the instep begins. An afterthought heel is worked once the sock is completed.
- Stitch markers are used to mark the beginning of round, if desired.
- These socks are identical to each other. Make two the same to complete a pair.
- Each row of Socks: A chart will be worked twice per rnd.
- Each row of Socks: B chart will be worked once per rnd.
- The basic shape of the fairies is worked into the foot of the sock using stranded knitting colorwork. Additional details such as hair, eyes, scarves, and petticoats are added using the duplicate stitch method once the sock is finished.
- Colorwork will be easier and faster to work if the MC is held with the right hand while the CC is held with the left. This will also improve the look of the resulting colorwork.
- You may wish to check that the sock length is correct before beginning the toe. See Foot section of the pattern for more details.

Mittens

- In an effort to honor the original design of these fingerless mitts and ensure a wider range of available fit, rather than compromise on the stitch pattern, these fingerless mitts have been graded using different gauges for each size. To achieve the gauge for your finished size of fingerless mitt, adjust your needle size if necessary.
- These fingerless mitts are worked from the bottom up in the round from cuff to fingertips. This pattern uses a peasant thumb (afterthought thumb) to interrupt the colorwork knitting process as little as possible. The peasant thumb will be worked after the body of the mitt has been completed.
- Waste yarn will be used to hold the stitches for the afterthought thumb until the main part of the mitt is completed.
- Stitch markers are used to mark the beginning of round, if desired.
- These mitts are nearly identical to each other; the position of the thumb differentiates the two. Take care to follow the thumb placement for the opposing mitts to ensure both wear as intended.
- Each row of the chart will be worked once per round.
- The basic shape of the fairies is worked into the top of the mitt using colorwork / stranded knitting. Additional details such as hair, eyes, scarves, and petticoats are added using the duplicate stitch method once the mitt is finished.
- Colorwork will be easier and faster to work if the MC is held with the right hand while the CC is held with the left. This will also improve the look of the resulting colorwork garment.

SOCKS
CUFF

Using MC, CO 80 sts using the Long Tail CO method. Distribute sts evenly across 4 needles—20 sts per needle. Pm for BOR and join to work in the rnd, being careful not to twist the sts.

Rib Rnd: *K2 tbl, p2; rep from * to end of rnd.

Rep Rib Rnd 11 more times for a total of 12 rnds.

Next 3 rnds: Knit.

LEG

Begin Chart A, reading all rows from right to left as for working in the rnd and joining CCs as required. Work Rnds 1–40 once (chart is worked twice across each rnd). Once complete, break all yarns except MC and CC6.

AFTERTHOUGHT HEEL PLACEMENT

With waste yarn, knit 40 sts. Slide all the sts back to the other end of the needles ready to start at the BOR again. With MC, knit across these just-worked waste yarn sts and then knit to end of rnd—1 rnd is completed with a half round of waste yarn placed for the afterthought heel.

FOOT

Begin Chart B, reading all rows from right to left as for working in the rnd and joining CCs as required. Work Rnds 1–49 once (chart is worked once across each rnd). Once complete, break all yarns except MC.

Knit 1 rnd.

To ensure proper fit, it is recommended to try on the sock before working the toe. To do this, transfer the heel sts from above and below the waste yarn placed for the Afterthought Heel (per the afterthought heel instructions) to a spare set of dpns, then carefully try the sock on. When tried on in this

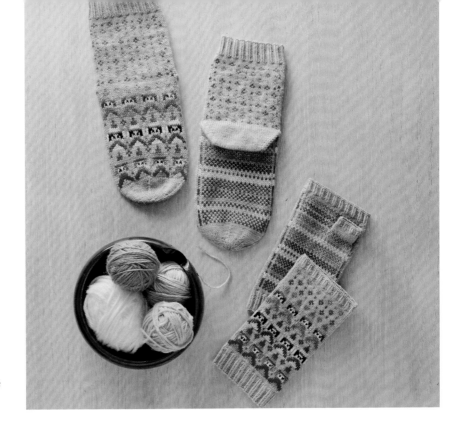

manner, the instep should measure approx 1¾ (2, 2¼) in. / 4.5 (5, 5.5) cm less than the length of the foot before starting the toe (the heel will be exposed). If the instep is still short of this target length, continue to work in St st (knitting every rnd) in MC only until this target length is reached.

TOE

Note: Before proceeding with the following instructions, it is important that the sts be divided evenly with 20 sts on each needle as the instructions are broken down per needle.

Rnd 1 (dec): *Knit to last 2 sts of needle, k2tog; rep from * 3 more times—4 sts dec.

Rnd 2: Knit.

Rep Rnds 1 and 2 two more times—68 sts rem (17 sts each needle).

Rnd 7 (dec): *K6, k2tog, k7, k2tog; rep from * 3 more times—60 sts rem (15 sts each needle).

Rnd 8: Knit.

Rnd 9 (dec): *K5, k2tog, k6, k2tog; rep from * 3 more times—52 sts rem (13 sts each needle).

Rnd 10: Knit.

Rnd 11: *K2, k2tog, k3, k2tog, k2, k2tog; rep from * 3 more times—40 sts rem (10 sts each needle).

Rnd 12: Knit.

Rnd 13 (dec): *K1, k2tog, k2, k2tog, k1, k2tog; rep from * 3 more times—28 sts rem (7 sts each needle).

Rnds 14 and 15: Knit.

Note: The remaining decreases are not worked relative to each needle but to the entire round.

Rnd 16 (dec): *K2tog; rep from * to end of rnd—14 sts rem.

Rnd 17: Knit.

Rnd 18 (dec): *K2tog; rep from * to end of rnd—7 sts rem.

Break yarn, leaving a tail to weave in. Thread the tapestry needle with this tail and draw tail through rem 7 live sts, pulling tight to cinch closed. Draw tail to inside of sock and secure on WS.

AFTERTHOUGHT HEEL

With the sole of the sock facing up and the toe pointed away from you, using 1 dpn, carefully pick up the right leg of each of the 40 sts below the waste yarn. Repeat with a second dpn for the sts above the waste yarn—80 sts total over 2 needles.

Carefully remove and discard waste yarn. Distribute these sts evenly across 4 needles—20 sts per needle.

Pm for BOR at the right edge of the picked-up sts (with the toe pointed away from you). Join MC at the BOR and *pick up and knit 1 st in the gap between Needles 1 and 4. Knit across Needles 1 and 2 and pick up and knit 1 st in the gap between needles 2 and 3; rep from * once more across needles 3 and 4—84 sts total; 21 sts on each needle. Similar to the toe, the heel shaping instructions are broken down per needle.

Setup Rnd: Knit.

Rnd 1 (1 st dec per Needle)

Needle 1: K1, ssk, knit to end.

Needle 2: Knit to last 3 sts, k2tog, k1.

Needle 3: K1, ssk, knit to end.

Needle 4: Knit to last 3 sts, k2tog, k1.

Rnd 2: Knit.

Rep Rnds 1 and 2 until 36 sts rem—9 sts on each needle.

Sl sts from Needle 2 onto Needle 1 and sts from Needle 4 onto Needle 3—18 sts on each needle. Break yarn, leaving an approx 16 in. / 40.5 cm tail.

Thread the tapestry needle with the remaining tail. Holding the 2 rem needles parallel, graft the heel closed using Kitchener stitch.

FINISHING

Weave in all ends.

Working from the Duplicate Stitch Chart, and using a tapestry needle, add additional details to the fairies such as eyes, hair, scarves, and petticoats. Weave in all ends from the duplicate stitch process. Steam block and press if desired.

MITTENS
CUFF

Using MC, CO 80 sts using the Long Tail CO method. Distribute sts evenly across 4 needles—20 sts per needle. Pm for BOR and join to work in the rnd, being careful not to twist the sts.

Rib Rnd: *K2 tbl, p2; rep from * to end of rnd.

Rep Rib Rnd 11 more times for a total of 12 rnds.

Next 3 rnds: Knit.

BODY

Begin chart, reading all rows from right to left as for working in the rnd and joining CCs as required. Work Rnds 1–49 once (Rnd 50 of chart, where there is a mark for thumb placement, will be worked in tandem with written instructions that differ for each mitt).

THUMB PLACEMENT AND BODY (CONT'D)

FOR LEFT MITT

Work across all sts on Needles 1, 2, and 3 in patt (per Row 50). Knit the first 4 sts on Needle 4 with MC. Using waste yarn, knit the next 12 sts on Needle 4. Sl these 12 sts back onto the LHN and cont to knit across the 12 sts again using MC. Knit the last 4 sts on Needle 4 with MC.

FOR RIGHT MITT

Work across all sts on Needles 1 and 2 in patt (per Row 50). Knit the first 4 sts on Needle 3 with MC. Using waste yarn, knit the next 12 sts on Needle 3. Sl these 12 sts back onto the LHN and knit across the 12 sts again using MC. Knit the last 4 sts on Needle 3 with MC. Work across all sts on Needle 4 in patt.

Cont working chart up to the end of Rnd 61. Break all CCs; the remainder of the mitt is worked with MC only.

Next 4 rnds: Knit.

Rib Rnd: *K2 tbl, p2; rep from * to end of rnd.

Rep Rib Rnd 5 more times for a total of 6 rnds.

BO all sts knitwise.

PEASANT (AFTERTHOUGHT) THUMB - WORKED THE SAME FOR BOTH THUMBS

With 1 dpn, carefully pick up the right leg of each of the 12 sts below the waste yarn—12 sts on the needle. Repeat with a second dpn for the sts above the waste yarn—24 sts total over 2 needles.

Carefully remove and discard waste yarn. Distribute these sts evenly across 4 needles—6 sts on each.

Pm for BOR at the right edge of the thumb for the left mitt, or the left edge of the thumb for the right mitt, when the palm of the mitt is facing you. Join MC at the BOR and *pick up and knit 1 st in the gap between Needles 1 and 4. Knit across Needles 1 and 2 and pick up and knit 1 st in the gap between needles 2 and 3; rep from * once more across needles 3 and 4—28 sts total; 7 sts on each needle.

Next 7 rnds: Knit.

Rib Rnd: *K2 tbl, p2; rep from * to end of rnd.

Rep Rib Rnd 2 more times for a total of 3 rnds.

BO all sts in pattern.

FINISHING

Weave in all ends.

Working from the Duplicate Stitch Chart, and using a tapestry needle, add additional details to the fairies such as eyes, hair, scarves, and petticoats. Weave in all ends from the duplicate stitch process. Steam block and press if desired.

CHARTS

DUPLICATE STITCH KEY

- ▨ Existing MC
- ▨ Existing CC1
- ☐ Existing CC2
- ▨ Existing CC3
- ▨ Existing CC4
- ▨ Existing CC5
- ▨ Existing CC6
- ▨ Existing CC7
- ☒ Duplicate stitch CC3
- ☒ Duplicate stitch CC5
- ☒ Duplicate stitch CC7
- ☒ Duplicate stitch CC8
- ☒ Duplicate stitch CC9
- ☒ Duplicate stitch CC10

COLORWORK KEY

- ☐ Knit
- ▨ MC
- ▨ CC1
- ☐ CC2
- ▨ CC3
- ▨ CC4
- ▨ CC5
- ▨ CC6
- ▨ CC7
- │ Needle divider
- ☐ Right thumb
- ☐ Left thumb

DUPLICATE STITCH

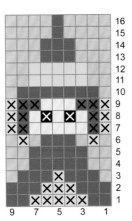
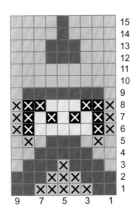
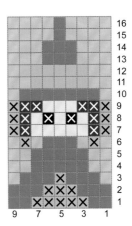

SOCKS: A

MITTENS

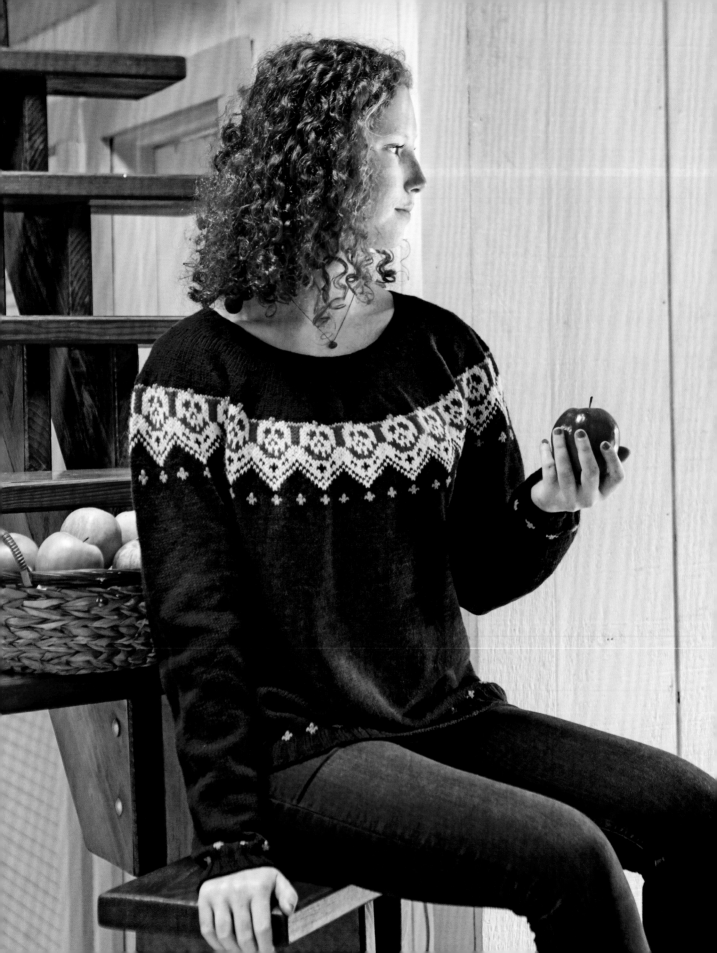

Poison Apple Pullover

Designed by EMILY O'BRIEN

SKILL LEVEL: ♥ ♥

The first of Disney's infamous feature film villains, the Queen from 1937's *Snow White and the Seven Dwarfs* is undeniably wicked, possessing a malicious heart and deep vanity. Jealous of her stepdaughter Snow White's fair beauty, red-rose lips, ebony hair, and sweet disposition, the Queen plots the princess's death with a poison apple, which will send her into a Sleeping Death. Walt Disney drew inspiration from the Big Bad Wolf from *Three Little Pigs* and Lady Macbeth for the villain, describing her as "a high collar stately beautiful type" whose "beauty is sinister, mature—she becomes ugly and menacing when scheming." Ironically, the evil, beautiful queen meets her demise as an ugly crone.

Tempt your friends with this elegant pullover featuring a ring of poison apples around the yoke. With the beginning of the round starting at the center back, this pullover is worked in the round from the top down, making it easy to adjust the length. A classic ribbed neckline flows into wrap-and-turn short row shaping to raise up the back neck, then a stranded colorwork yoke grows outward with M1L increases and poison apple motifs. Sleeve stitches are placed on waste yarn, then a simple stockinette body is knit, ending in colorwork stars and a ribbed hem. The sleeves are then picked up and worked in the round, finishing off with colorwork and ribbed cuffs to match. Put it on and you'll be the fairest one of all!

SIZES

1 (2, 3, 4, 5)[6, 7, 8, 9]{10, 11, 12, 13}
Instructions are written for the smallest size, with larger sizes given in parentheses. When only one number is given, it applies to all sizes.

FINISHED MEASUREMENTS

Chest: 33½ (38¼, 41, 44¾, 47)[50½, 53, 56, 59½]{62¾, 65¼, 68¼, 71¼} in. / 85 (97, 104, 113.5, 119.5)[128.5, 134.5, 142, 151]{159.5, 165.5, 173.5, 181} cm
Garment is designed to be worn with 1½–5 in. / 4–12.5 cm positive ease.

YARN

Fingering weight (super fine #1) yarn, shown in Brooklyn Tweed *Peerie* (100% American merino wool; 210 yd. / 192 m per 1¾ oz. / 50 g hank)
Main Color (MC): Fleet, 6 (6, 7, 7, 8)[8, 9, 9, 9]{10, 10, 11, 11} hanks
Contrast Color 1 (CC1): Tincture, 1 hank
Contrast Color 2 (CC2): Hammock, 1 hank
Contrast Color 3 (CC3): Alizarin, 1 hank

NEEDLES

- US 3 / 3.25 mm, 16 in. / 40 cm long circular needle and set of double-pointed needles
- US 5 / 3.75 mm, 16-40 in / 40-100 cm long circular needles and set of double-pointed needles or size needed to obtain gauge

NOTIONS

- Stitch marker
- Row counter (optional)
- Tapestry needle
- Waste yarn

continued on page 70

GAUGE

24 sts and 38 rnds = 4 in. / 10 cm over St st on larger needle, taken after blocking

24 sts and 30 rnds = 4 in. / 10 cm over colorwork on larger needle, taken after blocking

Make sure to check your gauge.

NOTES

- This sweater is worked top down with the beginning of the round at the center back.
- A ribbed collar is worked first, then short-row shaping forms the neckline. The yoke features a stranded colorwork motif of poison apples.
- Sleeves and body are separated after the yoke is complete. The body is worked in stockinette stitch until colorwork details resume just before the ribbed hem. Sleeves are then worked individually and also feature colorwork detailing just before the cuffs.
- Adjustments to the length of the garment will affect required yardage quantities.

"Now make a wish and take a bite."

The Witch,
Snow White and the Seven Dwarfs (1937)

COLLAR

With MC and smaller 16 in. / 40 cm circular needle, CO 100 (108, 120, 120, 124)[124, 128, 128, 132]{132, 136, 136, 140} sts using the Long Tail CO method. Pm for BOR and join to work in the rnd, being careful not to twist the sts.

Rib Rnd: *K2, p2; rep from * to end of rnd.

Rep Rib Rnd 7 more times (8 rnds total).

YOKE

Switch to larger needles.

Knit 1 rnd.

YOKE ADJUSTMENT RND

Sizes 1, 2 and 3 Only: Knit.

Sizes 4 Only: *K15, M1L; rep from * to end of rnd.

Size 5 Only: *K11, M1L, (k10, M1L) twice; rep from * to end of rnd.

Size 6 Only: *K7, M1L, (k6, M1L) 4 times; rep from * to end of rnd.

Size 7 Only: *(K5, M1L) 4 times, (k4, M1L) 3 times; rep from * to end of rnd.

Size 8 Only: *(K4, M1L) 5 times, (k3, M1L) 4 times; rep from * to end of rnd.

Size 9 Only: *(K4, M1L) 3 times, (k3, M1L) 7 times; rep from * to end of rnd.

Size 10 Only: *(K3, M1L) 3 times, k2, M1L; rep from * to end of rnd.

Size 11 Only: *(K3, M1L) 3 times, (k2, M1L) 4 times; rep from * to end of rnd.

Size 12 Only: *K3, M1L, (k2, M1L) 7 times; rep from * to end of rnd.

Size 13 Only: *K3, M1L, (k2, M1L) 16 times; rep from * to end of rnd —0 (0, 0, 8, 12)[20, 28, 36, 40]{48, 56, 64, 68} sts inc; 100 (108, 120, 128, 136)[144, 156, 164, 172]{180, 192, 200, 208} sts total.

Knit 2 rnds.

INC RND #1

*K2, M1L; rep from * to end of rnd —50 (54, 60, 64, 68)[72, 78, 82, 86]{90, 96, 100, 104} sts inc; 150 (162, 180, 192, 204)[216, 234, 246, 258]{270, 288, 300, 312} sts.

BACK OF NECK SHORT ROWS

Knit 1 rnd.

Short Row 1 (RS): K56 (61, 68, 72, 77)[81, 88, 92, 97]{101, 108, 113, 117}, w&t.

Short Row 2 (WS): Purl to BOR, sm, p56 (61, 68, 72, 77)[81, 88, 92, 97]{101, 108, 113, 117}, w&t.

Short Row 3: Knit to BOR, sm, knit to 5 sts before prev wrapped st, w&t.

Short Row 4: Purl to BOR, sm, purl to 5 sts before prev wrapped st, w&t.

Rep [Rows 3 and 4] 5 more times.

Next row (RS): Knit to BOR.

CONTINUE YOKE

Setup Rnd: Knit, processing all wrapped sts as encountered.

Knit 4 (5, 6, 7, 7)[8, 9, 9, 10]{10, 11, 12, 13} rnds.

INC RND #2

*K3, M1L; rep from * to end of rnd
—50 (54, 60, 64, 68)[72, 78, 82, 86]{90, 96, 100, 104} sts inc; 200 (216, 240, 256, 272)[288, 312, 328, 344]{360, 384, 400, 416} sts.

Knit 5 (6, 7, 8, 9)[9, 10, 11, 11]{11, 12, 13, 14} rnds.

INC RND #3

Sizes 1, 5, 9, and 13 Only: *K3, M1L; rep from * to last 2 sts, k2, M1L.

Sizes 2, 3, 6, 7, 10, and 11 Only: *K3, M1L; rep from * to end of rnd.

Sizes 4, 8, and 12 Only: *K3, M1L; rep from * to last st, k1, M1L.

—67 (72, 80, 86, 91)[96, 104, 110, 115]{120, 128, 134, 139} sts inc; 267 (288, 320, 342, 363)[384, 416, 438, 459]{480, 512, 534, 555} sts.

ALL SIZES

Knit 6 (7, 7, 9, 9)[10, 11, 11, 12]{11, 12, 14, 14} rnds.

INC RND #4

Size 1 Only: M1L, *k5, M1L; rep from * to last 2 sts, k2, M1L.

Size 2 Only: M1L, (k3, M1L) 5 times, *k5, M1L; rep from * to last 8 sts, (k3, M1L) twice, k2, M1L.

Size 3 Only: K1, *k5, M1L, k6, M1L; rep from * to end of rnd.

Size 4 Only: M1L, *k5, M1L, k6, M1L; rep from * to last 12 sts, (k4, M1L) 3 times.

Size 5 Only: M1L, (k3, M1L) 6 times, *k5, M1L, k4, M1L; rep from * to last 12 sts, (k3, M1L) 4 times.

Size 6 Only: (K6, M1L) 4 times, *k4, M1L; rep from * to last 24 sts, (k6, M1L) 4 times.

Size 7 Only: M1L, (k3, M1L) 5 times, *k5, M1L; rep from * to last 26 sts, (k4, M1L) 5 times, (k3, M1L) twice.

Size 8 Only: *K5, M1L, k4, M1L; rep from * to last 96 sts, (k5, M1L) 18 times, k6.

Size 9 Only: *(K6, M1L) 8 times, (k5, M1L) 21 times; rep from * to end of rnd.

Size 10 Only: *K5, M1L; rep from * to last 5 sts, k3, k2tog.

Size 11 Only: K1, k2tog, *k5, M1L, k6, M1L; rep from * to last 3 sts, k1, k2tog.

Size 12 Only: *K5, M1L, k6, M1L; rep from * to last 6 sts, k6.

Size 13 Only: M1L, *k5, M1L, k6, M1L; rep from * to last 5 sts, k3, M1L, k2, M1L.
—55 (62, 58, 64, 85)[92, 88, 94, 87]{94, 90, 96, 103} sts inc; 322 (350, 378, 406, 448)[476, 504, 532, 546]{574, 602, 630, 658} sts total.

ALL SIZES
Knit 1 rnd.

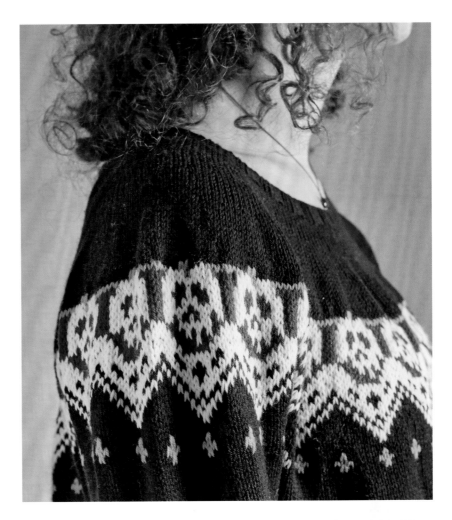

YOKE COLORWORK

Work Rows 1–26 of Chart A once, joining CCs 1, 2, and 3 as required (chart is repeated 23 (25, 27, 29, 32)[34, 36, 38, 39]{41, 43, 45, 47} times across rnd). Break all CCs once chart is complete. Cont with MC only.

Knit 1 rnd.

FINISH YOKE

Size 1 Only: Knit.

Sizes 2–4, 6, and 8–13 Only: *M1L, k-(29, 31, 25, -)[39, -, 66, 34]{47, 50, 52, 65}; rep from * to last - (2, 6, 6, -)[8, -, 4, 2]{10, 2, 6, 8} sts, knit to end of rnd.

Sizes 5 and 7 Only: *M1L, k- (-, -, -, 56)[-, 42, -, -]{-, -, -, -}; rep from * to end of rnd.

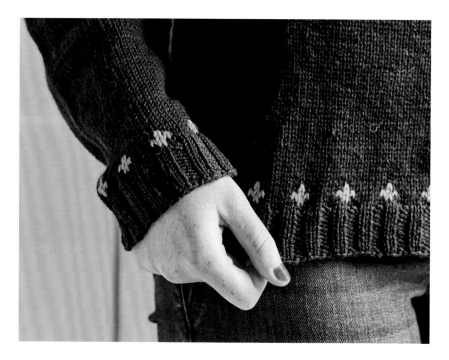

—0 (12, 12, 16, 8)[12, 12, 8, 16]{12, 12, 12, 10} sts inc; 322 (362, 390, 422, 456) [488, 516, 540, 562]{586, 614, 642, 668} sts total.

ALL SIZES

Cont in St st with no more increases until the yoke measures 7½ (7¾, 8, 8¼, 8½)[8¾, 9, 9¼, 9½]{9½, 10, 10¼, 10½} in. / 19 (19.5, 20.5, 21, 21.5)[22, 23, 23.5, 24]{24, 25.5, 26, 26.5} cm from center front CO edge.

SEPARATE BODY AND SLEEVES

K46 (53, 57, 61, 66)[70, 75, 79, 83]{88, 93, 98, 102} sts for half the back, place the next 69 (75, 81, 89, 96)[104, 108, 111, 114]{117, 120, 125, 129} sts onto waste yarn for right sleeve, CO 9 (9, 9, 12, 9)[12, 9, 9, 12]{12, 9, 9, 9} sts using the Backward Loop method for the underarm, k92 (106, 114, 122, 132)[140, 150, 159, 167]{176, 187, 196, 205} sts for the front, place the next 69 (75, 81, 89, 96)[104, 108, 111, 114]{117, 120, 125, 129} sts onto waste yarn for left sleeve, CO

9 (9, 9, 12, 9)[12, 9, 9, 12]{12, 9, 9, 9} sts using the Backward Loop method for the underarm, knit to end of rnd—202 (230, 246, 268, 282)[304, 318, 336, 358] {376, 392, 410, 428} total sts.

BODY

Cont in St st until body measures approx 12 in. / 30.5 cm from underarm (or 2 in. / 5 cm less than total desired body length).

BODY DETAIL COLORWORK ADJUSTMENT RND

Sizes 1 and 2 Only: Knit to end of rnd, M1L—1 st inc.

Sizes 3, 9, and 13 Only: Knit to last 2 sts, k2tog—1 st dec.

Sizes 4 and 5 Only: K- (-, -, 132, 139)[-, -, -, -]{-, -, -, -} k2tog, knit to last 2 sts, k2tog—2 sts dec.

Sizes 6 and 7 Only: (K- (-, -, -, -)[99, 104, -, -]{-, -, -, -} k2tog) twice, knit to last 2 sts, k2tog—3 sts dec.

Sizes 8 and 11 Only: Knit.

Size 10 Only: (K188, M1L) twice—2 sts inc.

Size 12 Only: (K136, M1L) twice, knit to last st, M1L—3 sts inc.

—203 (231, 245, 266, 280)[301, 315, 336, 357]{378, 392, 413, 427} sts total.

BODY DETAIL COLORWORK

Work Rows 1–4 of Chart B once, joining CC1 as required (chart is repeated 29 (33, 35, 38, 40)[43, 45, 48, 51]{54, 56, 59, 61} times across rnd). Break CC1 once chart is complete. Cont with MC only.

HEM

HEM RIBBING ADJUSTMENT RND

Sizes 1, 2, 7, and 13 Only: Knit to end of rnd, M1L—1 st inc.

Sizes 3, 6, 9, and 12 Only: Knit to last 2 sts, k2tog—1 st dec.

Sizes 4 and 10 Only: (K- (-, -, 133, -)[-, -, -, -]{189, -, -, -} M1L) twice—2 sts inc.

Sizes 5, 8, and 11 Only: Knit.

—204 (232, 244, 268, 280)[300, 316, 336, 356]{380, 392, 412, 428} sts total.

Continue using larger needles.

Rib Rnd: *K2, p2; rep from * to end of rnd.

Rep Rib Rnd until hem ribbing measures approx 1¼ in. / 3 cm.

Bind off all sts loosely in pattern.

SLEEVES

Place the 69 (75, 81, 89, 96)[104, 108, 111, 114]{117, 120, 125, 129} sts of 1 sleeve onto the set of larger dpns and distribute evenly (or onto the larger needle in your preferred method of small circumference knitting). With the RS facing, rejoin MC and knit across.

Pick up and knit 1 st between sleeve sts and CO underarm sts, pick up and knit 4 (4, 4, 6, 4)[6, 4, 4, 6]{6, 4, 4, 4} underarm sts, pm for BOR, pick up and knit 5 (5, 5, 6, 5)[6, 5, 5, 6]{6, 5, 5,

5} remaining underarm sts, pick up and knit 1 st between sleeve sts and underarm sts. Knit to BOR m—80 (86, 92, 103, 107)[118, 119, 122, 128]{131, 131, 136, 140} sts total.

Dec Rnd #1: K1, ssk, knit to last 3 sts, k2tog, k1—78 (84, 90, 101, 105) [116, 117, 120, 126]{129, 129, 134, 138} sts.

Knit 8 (8, 8, 6, 6)[6, 5, 5, 5]{4, 4, 4, 4} rnds.

Dec Rnd #2: K1, ssk, knit to last 3 sts, k2tog, k1—2 sts dec.

Cont in St st until the sleeve measures 16 in. / 40.5 cm from the underarm (or 2 in. / 5 cm less than the desired total sleeve length).

AT THE SAME TIME, rep Dec Rnd #2 every 9 (9, 9, 7, 7)[6, 6, 6, 5]{5, 5, 5, 5}th rnd 14 (14, 11, 17, 15)[15, 20, 20, 20]{26, 26, 25, 27} *more* times, then every - (-, 5, 5, 5)[4, 4, 4, 4]{-, -, -, -}th rnd - (-, 6, 2, 6)[11, 3, 5, 8]{-, -, -, -} times.

—30 (30, 36, 40, 44)[54, 48, 52, 58]{54, 54, 52, 56} sts dec; 50 (56, 56, 63, 63)[64, 71, 70, 70]{77, 77, 84, 84} sts total.

SLEEVE DETAIL COLORWORK ADJUSTMENT RND

Sizes 1, 6, and 7 Only: K1, ssk, knit to end of rnd—1 st dec.

Sizes 2–5 and 8–13 Only: Knit.

—49 (56, 56, 63, 63)[63, 70, 70, 70]{77, 77, 84, 84} sts total.

SLEEVE DETAIL COLORWORK

Work Rows 1–4 of Chart B once, joining CC1 as required (chart is repeated 7 (8, 8, 9, 9)[9, 10, 10, 10]{11, 11, 12, 12} times across rnd). Break CC1 once chart is complete. Cont with MC only.

CUFF
CUFF RIBBING ADJUSTMENT RND

Sizes 1, 10, and 11 Only: K1, ssk, knit to end of rnd—1 st dec.

Sizes 2, 3, 12, and 13 Only: Knit.

Sizes 4, 5, and 6 Only: K1, M1L, knit to end of rnd—1 st inc.

Size 7 and 8 Only: (K33, k2tog) twice—2 sts dec.

Size 9 Only: (K35, M1L) twice—2 sts inc. —48 (56, 56, 64, 64)[64, 68, 68, 72]{76, 76, 84, 84} sts total.

Switch to smaller needles in your preferred method of small-circumference knitting.

Rib Rnd: *K2, p2; rep from * to end of rnd.

Rep Rib Rnd until cuff ribbing measures approx. 1¼ in. / 3 cm.

BO all sts loosely in pattern.

FINISHING

Weave in all ends and wet block to dimensions provided in the schematic. Once dry, trim all ends.

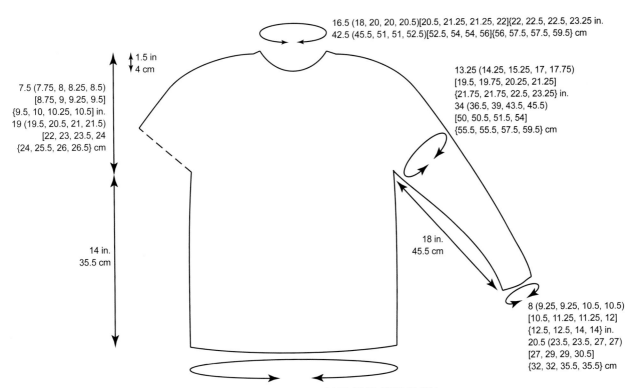

16.5 (18, 20, 20, 20.5)[20.5, 21.25, 21.25, 22]{22, 22.5, 22.5, 23.25 in. 42.5 (45.5, 51, 51, 52.5)[52.5, 54, 54, 56]{56, 57.5, 57.5, 59.5} cm

1.5 in / 4 cm

7.5 (7.75, 8, 8.25, 8.5) [8.75, 9, 9.25, 9.5] {9.5, 10, 10.25, 10.5] in. 19 (19.5, 20.5, 21, 21.5) [22, 23, 23.5, 24 {24, 25.5, 26, 26.5} cm

13.25 (14.25, 15.25, 17, 17.75) [19.5, 19.75, 20.25, 21.25] {21.75, 21.75, 22.5, 23.25} in. 34 (36.5, 39, 43.5, 45.5) [50, 50.5, 51.5, 54] {55.5, 55.5, 57.5, 59.5} cm

18 in. 45.5 cm

14 in. 35.5 cm

8 (9.25, 9.25, 10.5, 10.5) [10.5, 11.25, 11.25, 12] {12.5, 12.5, 14, 14} in. 20.5 (23.5, 23.5, 27, 27) [27, 29, 29, 30.5] {32, 32, 35.5, 35.5} cm

33.5 (38.25, 41, 44.75, 47)[50.5, 53, 56, 59.5]{62.75, 65.25, 68.25, 71.25) in. 85 (97, 104, 113.5, 119.5)[128.5, 134.5, 142, 151]{159.5, 165.5, 173.5, 181} cm

CHARTS

KEY

☐	Knit	☐	CC2
■	MC	■	CC3
▨	CC1	☐	Pattern repeat

A

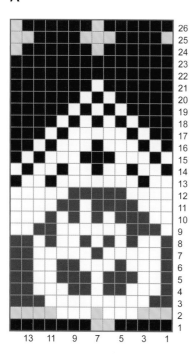

B

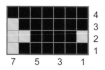

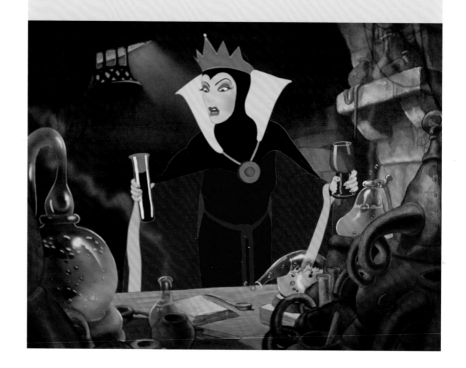

DISNEP FUN FACTS

Lucille La Verne performed the voice of both the Queen and the Witch. She reportedly achieved the latter's rough croak by removing her false teeth when reading her lines.

"When she breaks the tender peel to taste the apple in my hand, her breath will still, her blood congeal. Then I'll be fairest in the land!"

The Witch,
Snow White and the Seven Dwarfs (1937)

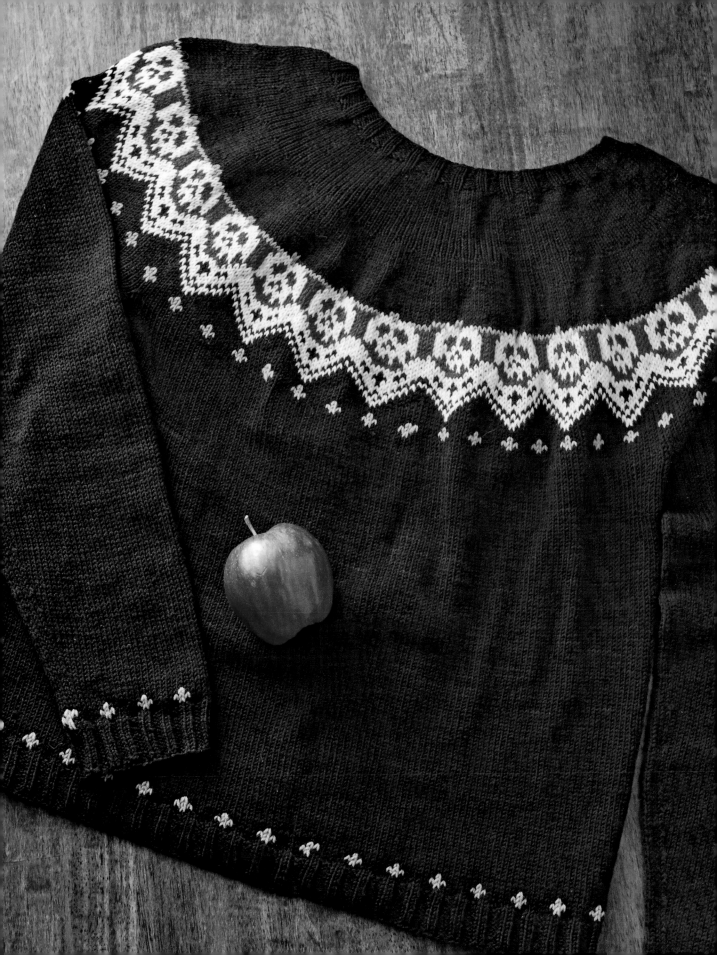

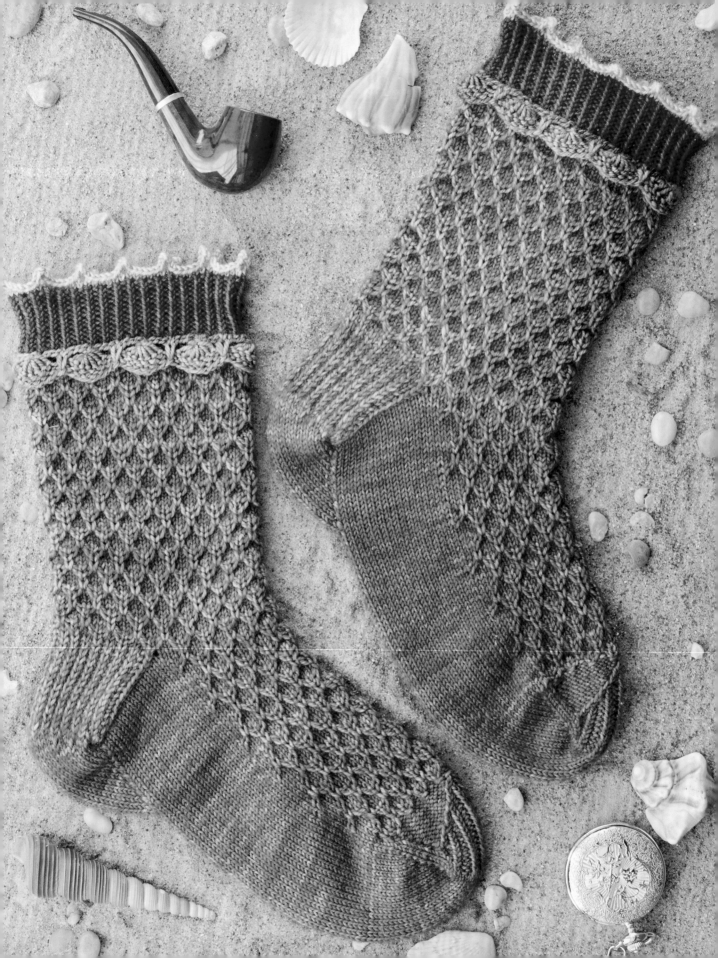

Ariel Socks

Designed by AGATA MACKIEWICZ

SKILL LEVEL ♥♥♥

Walt Disney had considered creating a film adaptation of Hans Christian Andersen's classic tale "The Little Mermaid" as early as 1941; however, it wasn't until 1989 that the story finally made it to the big screen. The courageous and independent-minded youngest daughter of King Triton, Ariel was given lavender seashells, aqua fins in a custom color named "Ariel" mixed by Disney artists, and fiery red hair. To get the movement of hair in antigravity correct, animators referenced footage of astronaut Sally Ride in space. They also resurrected the practice of using live actors for movement reference (both in and out of water!), something Walt Disney had often done in his early films. The hard work and close attention to both story and art paid off: Fans worldwide adored the singing mermaid with her rebellious nature and desire to create her own destiny. The movie became an instant Disney favorite, won multiple Oscars®, and helped usher in the Disney Renaissance of the 1990s.

Worked from the toe up in the round commencing with Judy's Magic Cast On, these Ariel-inspired socks are perfect for land dwellers. Starting with twisted stitches to mimic her fins, a textured scale pattern is worked up through the leg with a stockinette sole and slip-stitch heel. Lavender shells create a ruffled scalloped detail, followed by an elegant twisted rib cuff. Topped with a picot cuff reminiscent of her crown, these socks need to be part of every knitter's world.

SIZES

Small (Medium, Large)

Instructions are written for the smallest size, with larger sizes given in parentheses. When only one number is given, it applies to all sizes.

FINISHED MEASUREMENTS

Circumference: 6½ (7¼, 8¼) in. / 16.5 (18.5, 21) cm

Foot length is adjustable.

Socks designed to be worn with ½–1 in. / 1.5–2.5 cm negative ease at foot circumference.

YARN

Fingering weight (super fine #1) yarn, shown in Hazel Knits *Artisan Sock* (90% superwash merino, 10% nylon; 400 yd. / 366 m per 4¼ oz. / 120 g hank)

Main Color (MC): Swish, 1 hank

Fingering weight (super fine #1) yarn, shown in Hazel Knits *Artisan Sock Minis* (90% superwash merino, 10% nylon; approx 100 yd. / 91 m per 1 oz. / 30 g hank)

Contrast Color 1 (CC1): Tastes Like Purple, 1 hank

Contrast Color 2 (CC2): Poppy, 1 hank

Contrast Color 3 (CC3): Marigold, 1 hank

NEEDLES

- US 0 / 2 mm, 32 in. / 80 cm long circular needle
- US 1 / 2.25 mm, 32 in. / 80 cm long circular needle (for body of sock) or size needed to obtain gauge
- US 1½ / 2.5 mm, 32 in. / 80 cm long circular needle

NOTIONS

- 3 stitch markers (1 unique for BOR)
- Row counter (optional)
- Tapestry needle

continued on page 78

GAUGE

33 sts and 48 rnds = 4 in. / 10 cm over
St st on body of sock needles, taken
after blocking

Make sure to check your gauge.

NOTES

- These socks are worked from the toe up, in the round, using the Magic Loop method.
- The sole of the sock is worked in stockinette stitch, while the top of the sock is worked in a lovely textural pattern.
- Stitches are increased on the sole of the sock for the gusset, and the heel flap is worked in a slip-stitch pattern for durability.
- The shells ruffle is worked flat, separately, when the leg of the sock is complete. It is joined to the sock by combining live leg and shells ruffle stitches. This joining of stitches flows seamlessly into the twisted rib cuff.
- Stitch markers are used to mark the BOR, if desired.
- These socks are identical to each other. Make two the same to complete a pair.

TOE

With MC and the body of sock needle, CO 30 (30, 34) sts using Judy's Magic Cast On method. Distribute the sts evenly over the 2 needles. Pm for BOR and join to work in the rnd. The first needle of the rnd will be Needle A and will hold all the sole sts; the second needle will be Needle B and will hold all the instep sts.

Rnd 1: Knit across Needle A; work Chart A (for your size) across Needle B.

Rnd 2 (inc): K1, M1L, knit to last st of Needle A, M1R, k1; work Chart A across Needle B—4 sts inc.

Rep [Rnds 1 and 2] 5 (7, 8) more times —27 (31, 35) sts on each needle; 54 (62, 70) sts total.

SIZE SMALL ONLY

Beginning on Rnd 13 of Chart A, work 4 rnds as follows: Knit across Needle A; work Chart A across Needle B.

Chart A is now complete for all sizes.

FOOT

Note: Read through this section carefully before beginning as multiple steps happen at the same time.

Rnd 1: Knit across Needle A; work Chart B across Needle B.

Rep Rnd 1 until the foot is 2½ (2¾, 3) in. / 6.5 (7, 7.5) cm short of the desired total foot length.

AT THE SAME TIME, begin Chart B, reading all rows from right to left as for working in the rnd. The 4-st repeat will be worked 6 (7, 8) times across the instep sts. Rep Rows 1–12 as many times as necessary until the sock is 2.5 (2.75, 3) in. / 6.5 (7, 7.5) cm short of the desired total foot length ending with an odd-numbered rnd.

GUSSET

Note: As this section is worked, the st count on Needle B will not change; increased sts are on Needle A (sole) only.

Rnd 1 (inc): K13 (15, 17), pm, M1L, k1, M1R, pm, knit to end of Needle A; continue in est patt (Chart B) across Needle B—2 sts inc.

Rnd 2: Knit across Needle A; continue in est patt (Chart B) across Needle B.

Rnd 3 (inc): Knit to m, sm, M1L, knit to m, M1R, sm, knit to end of Needle A; continue in est patt (Chart B) across Needle B—2 sts inc.

Rep [Rnds 2 and 3] 9 (11, 13) more times, ending with Rnd 3—74 (86, 98) sts total; 47 (55, 63) sole sts and 27 (31, 35) instep sts.

TURN THE HEEL

Note: You will now work back and forth, flat, across Needle A only; the sts on Needle B will remain on hold while the heel is turned. On Row 1, rm as encountered (leaving BOR m in place).

Short Row 1 (RS, inc): K32 (38, 44), kfb, k1, w&t—1 st inc.

Short Row 2 (WS, inc): P20 (24, 28), pfb, p1, w&t—1 st inc.

Short Row 3 (inc): Knit to 5 sts before the prev wrap, kfb, k1, w&t—1 st inc.

Short Row 4 (inc): Purl to 5 sts before the prev wrapped st, pfb, k1, w&t—1 st inc.

Rep Short Rows 3 and 4 twice more—55 (63, 71) sts on Needle A; 27 (31, 35) sts rem on Needle B.

Next Row (RS): Knit to end of Needle A, processing wrapped sts as encountered; resume working in the rnd and work across Needle B in est patt (Chart B).

HEEL FLAP

Note: Once again you will work back and forth, flat, across Needle A only; the sts on Needle B will remain on hold while the Heel Flap is worked.

Row 1 (RS, dec): K41 (47, 53) processing wrapped sts as encountered, ssk, turn—1 st dec.

Row 2 (WS, dec): Sl1 wyif, p27 (31, 35), p2tog, turn—1 st dec.

Row 3 (dec): (Sl1 wyib, k1) 14 (16, 18) times, ssk, turn—1 st dec.

Row 4 (dec): Sl1 wyif, p27 (31, 35), p2tog, turn—1 st dec.

Rep [Rows 3 and 4] 11 (13, 15) more times—29 (33, 37) sts on Needle A; 27 (31, 35) sts rem on Needle B (56 (64, 72) sts total).

LEG

Resume working in the rnd.

Setup Rnd: Sl1 wyib, knit across Needle A and Needle B (the est patt should be an even-numbered, all-knit rnd).

Begin Chart C, working across both Needles A and B in the charted pattern, reading all rows from right to left as for working in the rnd. The 4-st repeat will be worked 14 (16, 18) times across the rnd. Work Rows 1–12 six times total, or until the leg is approx 1 in. / 2.5 cm short of the desired total length, ending with Rnd 6 or Rnd 12.

Note: As you begin Chart C, depending where you left off on Chart B, you may need to jump to the next vertical pattern repeat so that your k3tog below sts continue to stagger up the leg of the sock.

Next Rnd: Knit.

Do not bind off; break MC, leaving a tail for weaving in. Leave the live sts on the needles.

SHELLS RUFFLE

With CC1 and the shells ruffle needle, CO 57 (65, 73) sts using the Long Tail CO method. Do not join to work in the rnd.

Row 1 (WS): Sl1 wyib, k7, *sl1 wyif, k7; rep from * to last st, sl1 wyif.

Row 2 (RS): *Sl1 wyib, k7; rep from * to last st, sl1 wyib.

Row 3: *Sl1 wyif, k7 wrapping yarn twice each st; rep from * to last st, sl1 wyif.

Row 4: *K1, CO 3 sts using the Backward Loop method, (sl1 wyib letting the extra wrap drop off the needle) 7 times, move 7 elongated sts back to LHN purlwise, k7tog tbl, sl rem st back to LHN purlwise and knit it, CO 3 more sts using the Backward Loop method; rep from * to last st, k1.

Row 5: Purl.

Do not bind off; break MC, leaving a tail for weaving in. Leave the live sts on the needles.

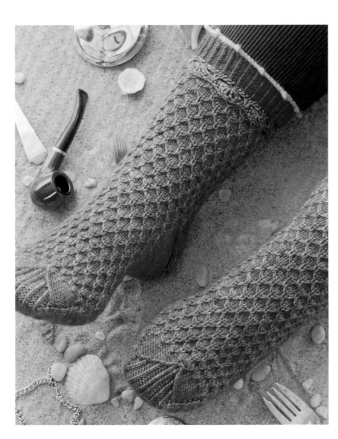

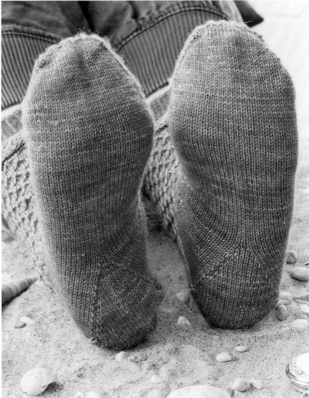

TWISTED RIB CUFF

Holding the live sts of MC (the top of the leg) and CC1 (the shells ruffle) together, with the RS of the shells ruffle facing (the leg of the sock will be behind the ruffle) and starting at the BOR of the sock, join CC2 and begin using the ribbing needles.

Joining Rnd: *Sl1 MC st from the sock purlwise to the ribbing needle, sl1 CC1 st from the ruffle purlwise to the ribbing needle, using CC2 knit these 2 sts together as a k2tog (1 st rem); rep from * to last 3 sts, sl1 MC st from the sock purlwise to the ribbing needle, sl2 CC1 sts from the ruffle purlwise to the ribbing needle, using CC2 knit these 3 sts together as a k3tog (1 st rem). All 56 (64, 72) sts should now be on your ribbing needles, ready to work in the rnd. Pm for BOR.

Rib Rnd: *K1 tbl, p1; rep from * to end of rnd.

Rep Rib Rnd until the ribbing measures 1 in. / 2.5 cm. Do not bind off; break CC2, leaving a tail for weaving in. Leave the live sts on the needles.

MODIFIED PICOT BIND OFF

Continue with the ribbing needles. Join CC2.

Setup Rnd 1: *K1 tbl, k1; rep from * to end of rnd.

Setup Rnd 2: Knit.

BO 3 sts knitwise, *sl last-worked st purlwise back to LHN, kyok, sl 3 sts purlwise back to LHN, BO 9 (10, 8) sts knitwise; rep from * to last 4 (5, 3) sts, sl last-worked st purlwise back to LHN, kyok, sl 3 sts purlwise back to LHN, BO all rem sts knitwise.

FINISHING

Weave in all ends. Sew the edges of the shells ruffle closed to form a complete ring of shells around the top of the sock.

Wet block your socks gently. Lay flat to dry in the desired shape and pin the pointy edges of the picot for emphasis.

ABOVE: Ariel with her friends Sebastian and Flounder in *The Little Mermaid* (1989).

"Flounder, don't be such a guppy."

Ariel, *The Little Mermaid* (1989)

CHARTS

A: SMALL

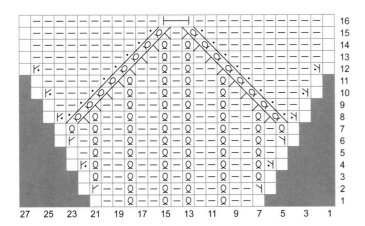

KEY

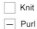

	Knit
−	Purl
�(grey)	No stitch
Q	Knit tbl
↘	M1L
↗	M1LP
↙	M1R
↖	M1RP
⟋⊘⟍	1/1 LPT
⟋⊘⟍	1/1 RPT
⊢———⊣	Cluster 3
☐	Pattern repeat

A: MEDIUM

B

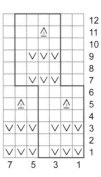

A: LARGE

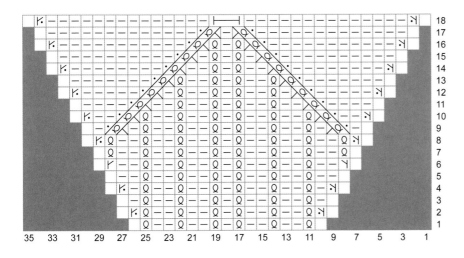

C

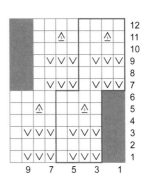

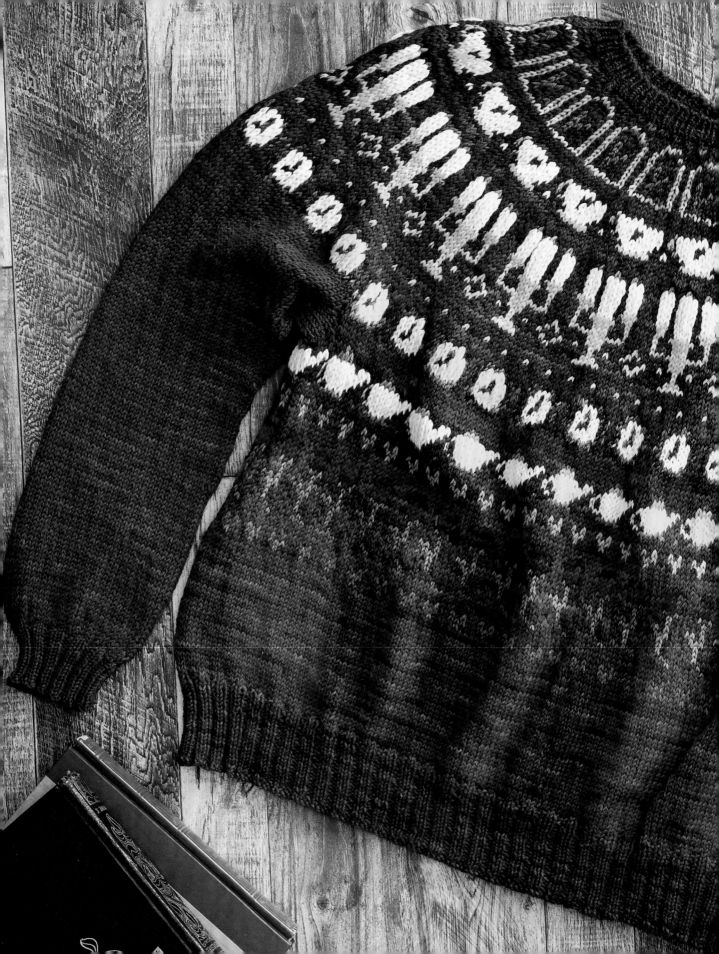

Beauty and the Beast Pullover

Designed by MEGHAN REGAN

SKILL LEVEL ♥♥♥

Inspired by the classic French fairy tale, Disney's 1991 award-winning hit *Beauty and the Beast* tells the romantic story of a beautiful, intelligent girl who falls in love with a handsome, spoiled prince-turned-beast, thus proving once and for all that true beauty is found within. After the success of *Snow White and the Seven Dwarfs*, Walt Disney toyed with the idea of doing an animated feature inspired by the classic tale in the late 1930s and early 1940s, and again in the 1950s, but it wasn't until the 1990s that the movie made it to the big screen. Adored by critics and audiences alike, the combination of an enchanting story, stellar voice cast, catchy Broadway-style music, and cutting-edge animation led to worldwide acclaim and the first ever Best Picture Oscar® nomination for an animated film.

Featuring a stunning array of *Beauty and the Beast* characters and motifs including the enchanted rose, Chip, Lumiere, Cogsworth, and Mrs. Potts in bright colors reminiscent of the stained-glass window in the opening title sequence, this is the perfect project for fans looking for adventure in the great, wide somewhere. Worked from the top down beginning with a stretchy cast on and ribbed collar, M1 increases are hidden in between the stranded colorwork. After the sleeve stitches are separated from the body and placed on waste yarn, the colorwork charts are completed in the torso, and the body is finished with a ribbed hem. Sleeve stitches are then picked up and worked in the main color only, topped with ribbed cuffs.

SIZES

1 (2, 3, 4, 5)[6, 7, 8, 9]{10, 11, 12, 13}
Instructions are written for the smallest size, with larger sizes given in parentheses. When only one number is given, it applies to all sizes.

FINISHED MEASUREMENTS

31 (34, 37, 40, 42)[45, 48, 51, 54]{57, 60, 62, 66} in. / 78.5 (86.5, 94, 101.5, 106.5) [114.5, 122, 129.5, 137]{145, 152.5, 157.5, 167.5} cm chest circumference
Garment designed to be worn with 2–4 in. / 5–10 cm positive ease.

YARN

Sport weight (fine #2) yarn, shown in Kim Dyes Yarn *Tartlet Sport* (100% superwash merino; 385 yd. / 352 m per 3.6 oz. / 113 g hank)
Main Color (MC): Lady Mary Blue, 3 (3, 3, 4, 4)[4, 5, 5, 5]{6, 6, 6, 7} hanks
Contrast Color 1 (CC1): Robin's Egg, 1 hank
Contrast Color 2 (CC2): Rhode Island Red, 1 hank
Contrast Color 3 (CC3): The Grass on the Other Side, 1 hank
Contrast Color 4 (CC4): Egg Yolk, 1 hank
Contrast Color 5 (CC5): Cream, 1 (1, 1, 1, 1)[1, 1, 1, 1]{1, 1, 2, 2} hanks
Contrast Color 6 (CC6): Boo!, 1 hank
Contrast Color 7 (CC7): Forest Floor, 1 hank
Contrast Color 8 (CC8): Berry, 1 hank
Contrast Color 9 (CC9): Light My Way, 1 hank.

continued on page 84

NEEDLES

- US 4 / 3.5 mm set of double-pointed needles and 16 in. / 40 cm and 32–40 in. / 80–100 cm long circular needles
- US 6 / 4 mm set of double-pointed needles and 16–40 in. / 40–100 cm long circular needle or size needed to obtain gauge

NOTIONS

- Tapestry needle
- Stitch markers (3, 1 unique for BOR)
- Waste yarn

GAUGE

28 sts and 36 rnds = 4 in. / 10 cm in stranded colorwork on larger needle, taken after blocking
Make sure to check your gauge.

NOTES

- Pattern is worked top down in the round in multiple stranded colorwork motifs. The motifs are continued down the body after the sleeves are split from the body. The sleeves are worked in stockinette stitch.
- Read all chart rows from right to left as for working in the round. Each chart motif will be worked once vertically.
- When working the charts, catch floats as needed, approximately every fifth stitch.
- Adjustments to the length of the garment will affect required yardage quantities.

CAST ON AND COLLAR

With MC and the smaller 16 in. / 40 cm circular needle, CO 96 (100, 104, 112, 116)[120, 128, 132, 134]{136, 140, 140, 144} sts using the Alternating Cable CO method. Pm for BOR and join to work in the rnd, being careful not to twist the sts. The BOR marker is located at the center back neck.

Rib Rnd: *K1, p1; rep from * to end of rnd.

Rep Rib Rnd 7 more times (8 rnds total).

YOKE

Change to larger needle in a circumference that comfortably fits your sts. Adjust needle lengths as needed as the yoke circumference increases.

ADJUSTMENT RND #1

Sizes 1, 2, and 4–8 Only: Knit.

Size 3 Only: (K52, M1L) twice.

Size 9 Only: (K67, M1L) twice.

Size 10 Only: *K17, M1L; rep from * to end of rnd.

Size 11 Only: *K17, M1L; rep from * to last 4 sts, k4.

Size 12 Only: *K10, M1L; rep from * to end of rnd.

Size 13 Only: *K10, M1L; rep from * to last 4 sts, k4.

—0 (0, 2, 0, 0)[0, 0, 0, 2]{8, 8, 14, 14} sts inc; 96 (100, 106, 112, 116)[120, 128, 132, 136]{144, 148, 154, 158} sts total.

Knit 1 rnd.

Inc Rnd #1: *K2, M1L; rep from * to end of rnd—48 (50, 53, 56, 58)[60, 64, 66, 68]{72, 74, 77, 79} sts inc; 144 (150, 159, 168, 174)[180, 192, 198, 204]{216, 222, 231, 237} sts total.

Knit 1 rnd.

ADJUSTMENT RND #2

Sizes 1, 4, 7, and 10 Only: Knit.

Sizes 2, 5, 8, and 11 Only: (K- (75, -, -, 87)[-, -, 99, -]{-, 111, -, -}, M1L) twice.

Size 3 and 12 Only: M1L, knit to end of rnd.

Size 6 Only: *K45, M1L; rep from * to end of rnd.

Size 9 Only: *K51, M1L; rep from * to end of rnd.

Size 13 Only: *K79, M1L; rep from * to end of rnd.

—0 (2, 1, 0, 2)[4, 0, 2, 4]{0, 2, 1, 3} sts inc; 144 (152, 160, 168, 176)[184, 192, 200, 208]{216, 224, 232, 240} sts total.

Work Rows 1–13 of Chart A once, joining CCs 1, 2, and 3 as required (chart is repeated 18 (19, 20, 21, 22)[23, 24, 25, 26]{27, 28, 29, 30} times across rnd). Break all CCs once chart is complete.

INC RND #2

*K2, M1L; rep from * to end of rnd—72 (76, 80, 84, 88)[92, 96, 100, 104]{108, 112, 116, 120} sts inc; 216 (228, 240, 252, 264)[276, 288, 300, 312]{324, 336, 348, 360} sts total.

Knit 0 (0, 0, 1, 1)[2, 2, 3, 3]{4, 4, 5, 5} rnd(s).

Work Rows 1–10 of Chart B once, joining CCs 4 and 5 as required (chart is repeated 18 (19, 20, 21, 22)[23, 24, 25, 26]{27, 28, 29, 30} times across rnd). Break all CCs once chart is complete.

INC RND #3

Sizes 1–6 Only: *K3, M1L; rep from * to end of rnd.

Sizes 7 and 8 Only: (K2, M1L) 24 times, (k3, M1L) - (-, -, -, -)[-, 64, 68, -]{-, -, -, -} times, (k2, M1L) to end of rnd.

Size 9 Only: (K2, M1L) 48 times, (k3, M1L) 40 times, (k2, M1L) to end of rnd.

Sizes 10–13 Only: (K2, M1L) 72 times, (k3, M1L) - (-, -, -, -)[-, -, -, -]{12, 16, 20, 24} times, (k2, M1L) to end of rnd.

—72 (76, 80, 84, 88)[92, 112, 116, 136]{156,

160, 164, 168} sts inc; 288 (304, 320, 336, 352)[368, 400, 416, 448]{480, 496, 512, 528} sts total.

Knit 0 (0, 0, 1, 1)[2, 2, 3, 3]{4, 4, 5, 5} rnd(s).

Work Rows 1–22 of Chart C once, joining CCs 4, 5, and 6 as required (chart is repeated 18 (19, 20, 21, 22)[23, 25, 26, 28]{30, 31, 32, 33} times across rnd). Break all CCs once chart is complete.

INC RND #4

Sizes 1–4 and 10 Only: *K4, M1L; rep from * to end of rnd.

Sizes 5–9, 11, and 12 Only: (K3, M1L) 40 times, (k4, M1L) - (-, -, -, 28)[32, 40, 44, 52]{-, 64, 68, -} times, (k3, M1L) to end of rnd.

Size 13 Only: (K4, M1L) 6 times, (k3, M1L) to last 24 sts, (k4, M1L) to end of rnd.

—72 (76, 80, 84, 108)[112, 120, 124, 132] {120, 144, 148, 172} sts inc; 360 (380, 400, 420, 460)[480, 520, 540, 580] {600, 640, 660, 700} sts total.

Knit 0 (0, 0, 1, 1)[2, 2, 3, 3]{4, 4, 5, 5} rnd(s).

Work Rows 1–10 of Chart D once, joining CCs 5 and 7 as required (chart is repeated 18 (19, 20, 21, 23)[24, 26, 27, 29]{30, 32, 33, 35} times across rnd). Break all CCs once chart is complete.

ADJUSTMENT RND #3

Sizes 1 and 2 Only: Knit.

Sizes 3–13 Only: *K- (-, 100, 35, 115)[40, 130, 45, 145]{50, 160, 55, 175}, M1L; rep from * to end of rnd.

—0 (0, 4, 12, 4)[12, 4, 12, 4]{12, 4, 12, 4} sts inc; 360 (380, 404, 432, 464)[492, 524, 552, 584]{612, 644, 672, 704} sts total.

Knit 1 rnd.

DIVIDE SLEEVES FROM THE BODY

With MC only, k54 (58, 62, 66, 71)[75, 80, 84, 89]{93, 98, 102, 107} sts for half the back, place the next 72 (74, 78, 84, 90) [96, 102, 108, 114]{120, 126, 132, 138} sts onto waste yarn for the right sleeve, CO 1 (2, 3, 4, 4)[5, 5, 6, 6]{7, 7, 8, 8} sts using the Backward Loop method, pm for right side seam, CO 1 (2, 3, 4, 4)[5, 5, 6, 6]{7, 7, 8, 8} more sts, k108 (116, 124, 132, 142) [150, 160, 168, 178]{186, 196, 204, 214} sts for the front, place the next 72 (74, 78, 84, 90)[96, 102, 108, 114]{120, 126, 132, 138} sts onto waste yarn for the left sleeve, CO 1 (2, 3, 4, 4)[5, 5, 6, 6]{7, 7, 8, 8} sts using the Backward Loop method, pm for left side seam, CO 1 (2, 3, 4, 4)[5, 5, 6, 6]{7, 7, 8, 8} more sts, knit to end of rnd— 220 (240, 260, 280, 300)[320, 340, 360, 380]{400, 420, 440, 460} total sts.

BODY

Knit 0 (0, 0, 1, 1)[2, 2, 3, 3]{4, 4, 5, 5} rnds even.

Work Rows 1–16 of Chart E once, joining CCs 4, 5, 8, and 9 as required (charts are repeated 11 (12, 13, 14, 15)[16, 17, 18, 19]{20, 21, 22, 23} times across rnd). Break CCs 4, 5, and 9.

With MC, knit 0 (0, 0, 1, 1)[2, 2, 3, 3] {4, 4, 5, 5} rnds even (break CC8 or carry it loosely up the inside of the garment as preferred).

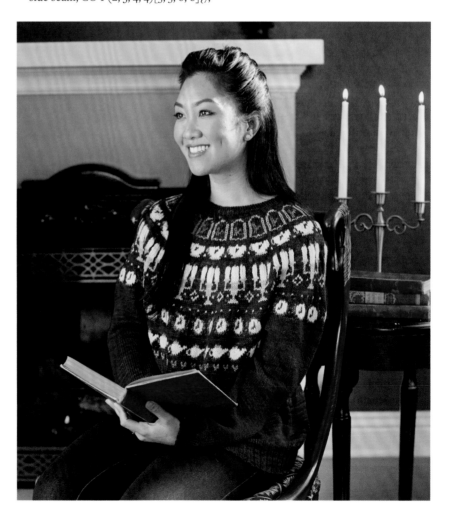

Work Rows 1–23 of Chart F once, joining

CCs 2, 3, and 8 as required (charts are repeated 11 (12, 13, 14, 15)[16, 17, 18, 19]{20, 21, 22, 23} times across rnd). Break all CC s once chart is complete.

Cont in MC only in St st (knitting every rnd) until the body measures 12½ in. / 30.5 cm from the underarm, or until the garment is 2 in. / 5 cm shorter than your desired length.

HEM

Change to smaller needle in a circumference that comfortably fits your sts.

Rib Rnd: *K2, p2; rep from * to end of rnd.

Rep Rib Rnd until the hem measures 2 in. / 5 cm. Bind off loosely in pattern.

SLEEVES

Place the 72 (74, 78, 84, 90)[96, 102, 108, 114]{120, 126, 132, 138} sts of 1 sleeve onto the larger set of dpns and distribute evenly (or onto the larger needle in your preferred method of small-circumference knitting). Rejoin MC at the center of the underarm CO sts and pick up and knit 1 (2, 3, 4, 4)[5, 5, 6, 6]{7, 7, 8, 8} sts (1 st into each CO st), knit across the live sleeve sts, and then pick up and knit another 1 (2, 3, 4, 4)[5, 5, 6, 6]{7, 7, 8, 8} sts. Pm for BOR and join to work in the rnd—74 (78, 84, 92, 98)[106, 112, 120, 126]{134, 140, 148, 154} sts total.

Knit 2 rnds.

Dec Rnd: K1, k2tog, knit to last 3 sts, ssk, k1—2 sts dec.

Cont in St st until the sleeve measures 13 in. / 33 cm from the underarm (or 2 in. / 5 cm less than the desired total sleeve length).

AT THE SAME TIME, rep the Dec Rnd every 7 (6, 5, 5, 5)[5, 4, 4, 3]{3, 3, 3, 3} rnds 14 (16, 19, 21, 22)[22, 25, 27, 30]{32, 35, 37, 40} more times—30 (34, 40, 44, 46)[46, 52, 56, 62]{66, 72, 76, 82} sts dec; 44 (44, 44, 48, 52)[60, 60, 64, 64]{68, 68, 72, 72} sts rem.

CUFF

Change to the smaller dpns (or your preferred method of small-circumference knitting).

Rib Rnd: *K1, p1; rep from * to end of rnd.

Rep Rib Rnd until the cuff measures 2 in. / 5 cm.

Using the Sewn Tubular BO method, BO all sts.

Repeat for the second sleeve.

FINISHING

Weave in ends. Wet block to measurements.

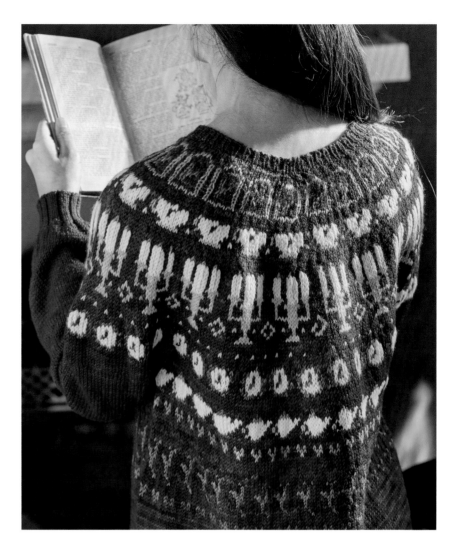

Disney FUN FACTS

Beauty and the Beast was dedicated to legendary Disney lyricist Howard Ashman, who created the music for the film with his frequent collaborator, Alan Menken, and who died in 1991. The dedication read: "To our friend, Howard, who gave a mermaid her voice and a beast his soul, we will be forever grateful."

"But she warned him not to be deceived by appearances, for beauty is found within."

Narrator, *Beauty and the Beast* (1991)

ABOVE: Mrs. Potts, Chip, and Cogsworth in *Beauty and the Beast* (1991).

CHARTS

KEY

☐	Knit	☐	CC5
■	MC	▨	CC6
▨	CC1	■	CC7
▨	CC2	▨	CC8
▨	CC3	▨	CC9
▨	CC4	☐	Pattern repeat

A

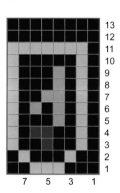

B

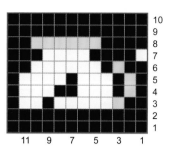

C

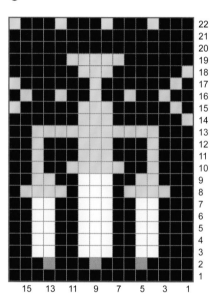

D

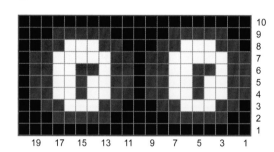

E

F

14 (14.25, 15, 16, 16.5)[17, 18.25, 18.75, 19.25]{19.5, 20, 20, 20.5} in.
35 (36.5, 38, 40.5, 42)[43.5, 46.5, 48, 48.5]{49.5, 51, 51, 52.5} cm

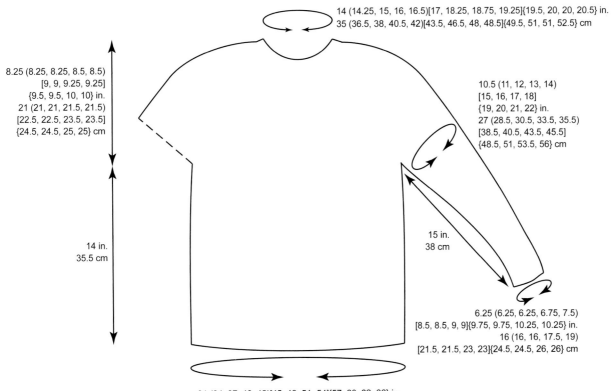

8.25 (8.25, 8.25, 8.5, 8.5)
[9, 9, 9.25, 9.25]
{9.5, 9.5, 10, 10} in.
21 (21, 21, 21.5, 21.5)
[22.5, 22.5, 23.5, 23.5]
{24.5, 24.5, 25, 25} cm

10.5 (11, 12, 13, 14)
[15, 16, 17, 18]
{19, 20, 21, 22} in.
27 (28.5, 30.5, 33.5, 35.5)
[38.5, 40.5, 43.5, 45.5]
{48.5, 51, 53.5, 56} cm

14 in.
35.5 cm

15 in.
38 cm

6.25 (6.25, 6.25, 6.75, 7.5)
[8.5, 8.5, 9, 9]{9.75, 9.75, 10.25, 10.25} in.
16 (16, 16, 17.5, 19)
[21.5, 21.5, 23, 23]{24.5, 24.5, 26, 26} cm

31 (34, 37, 40, 42)[45, 48, 51, 54]{57, 60, 62, 66} in.
79 (86.5, 94, 101.5, 106.5)[114.5, 122, 129.5, 137]{145, 152.5, 157.5, 167.5} cm

"Colors of the Wind" Infinity Cowl

Designed by TANIS GRAY

SKILL LEVEL ♥♥

Released in 1995, *Pocahontas* centers on the brave and free-spirited daughter of the chief of the Powhatan tribe whose courage, compassion, and wisdom beyond her years helps her people avoid a terrible war. The only Disney princess to be based loosely on a historical figure, Pocahontas has a unique approach to life that is encapsulated in the Academy Award®–winning song "Colors of the Wind," which according to directors Mike Gabriel and Eric Goldberg and producer James Pentecost, helped shape the film's "heart and soul." Inspired by Native American poetry and folklore, composer Alan Menken declared "Colors of the Wind" one of the most important songs he had ever written, celebrating diversity, nature, and spirituality.

Inspired by Pocahontas's iconic song, this cowl is started with a provisional cast on and knit in a tube with no visible wrong side, after which the live ends are seamlessly grafted together. Stranded colorwork leaf motifs dance around the doubly thick cowl and length can be easily added or removed for a longer or shorter version. Using a gradient yarn combined with a solid yarn, you can paint all the colors of the wind directly on your knitting needles.

SIZE
One size

FINISHED MEASUREMENTS
Width: 9½ in. / 24 cm
Circumference: 48 in. / 122 cm (after grafting)

YARN
Worsted weight (medium #4) yarn, shown in Freia *Ombré Worsted* (100% American wool; 127 yd. / 115 m per 2.64 oz. / 75 g ball)
Main Color (MC): Dirty Hippie, 4 balls

Worsted weight (medium #4) yarn, shown in Freia *Semi-Solid Worsted* (100% American wool; 170 yd. / 154 m per 3½ oz. / 100 g ball)
Contrast Color (CC): Ecru, 3 balls

NEEDLES
- 2 US 8 / 5 mm, 16 in. / 40 cm long circular needles or size needed to obtain gauge

NOTIONS
- Stitch marker
- Locking stitch markers or fabric clips (optional)
- Tapestry needle
- Waste yarn
- US H-8 / 5 mm crochet hook

GAUGE
20 sts and 29½ rnds = 4 in. / 10 cm over stranded colorwork, taken after blocking
Make sure to check your gauge.

continued on page 92

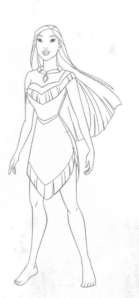

COWL

With waste yarn and crochet hook, provisionally CO 96 sts using the Crochet Provisional CO method. Join CC and knit across the cast on sts. Pm for BOR and join for working in the rnd, being careful not to twist the sts.

Starting on Row 2, begin chart, reading all rows from right to left as for working in the rnd, joining MC as required. Work Rows 2–118 once, followed by Rows 1–118 once more (chart is worked once across each rnd). Work a final repeat of Rows 1–117 once (353 total rnds worked, including the CC joining rnd).

Once the charted repeats are complete, do not bind off any sts. Place the live sts of the last rnd worked onto waste yarn for blocking.

Break CC, leaving a tail for weaving in.

Break MC, leaving a 40 in. / 101.5 cm tail for grafting.

FINISHING

Turn work inside out and weave in all loose ends with tapestry needle to WS.

Turn work right side out. Wet block flat so that the width of the tube is approx 9½ in. / 24 cm and the length from short end to short end is approx 48 in. / 122 cm.

Once fully dry, trim any remaining ends.

Place the live sts of the last worked chart rnd back onto 1 working needle.

Carefully unzip the provisional CO end and place the 96 live sts onto the second working needle.

Fold cowl so that the 2 sets of live sts are on needles held parallel. It may be helpful to secure the tube in place with fabric clips or locking stitch markers to ensure work is not twisted.

Thread the tapestry needle with the 40 in. / 101.5 cm tail of MC and graft the tube closed using Kitchener stitch. Weave the tail of the grafting yarn to the inside of the tube.

NOTES

- The cowl is started with a provisional cast on using a crochet hook and waste yarn. Once the working yarns are joined, the cowl is worked in the round in a tube.
- The two live ends of the cowl are grafted using Kitchener stitch to create a seamless join.

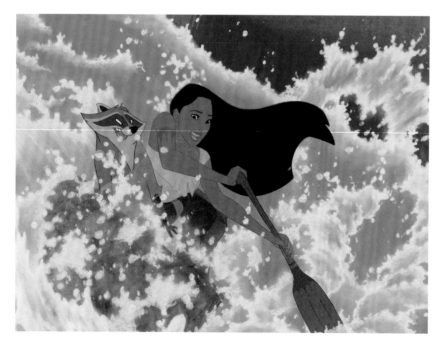

ABOVE: Pocahontas and her raccoon friend Meeko canoe through fierce rapids in *Pocahontas* (1995).

"All around you are spirits, child. They live in the earth, the water, the sky. If you listen, they will guide you."

Grandmother Willow, *Pocahontas* (1995)

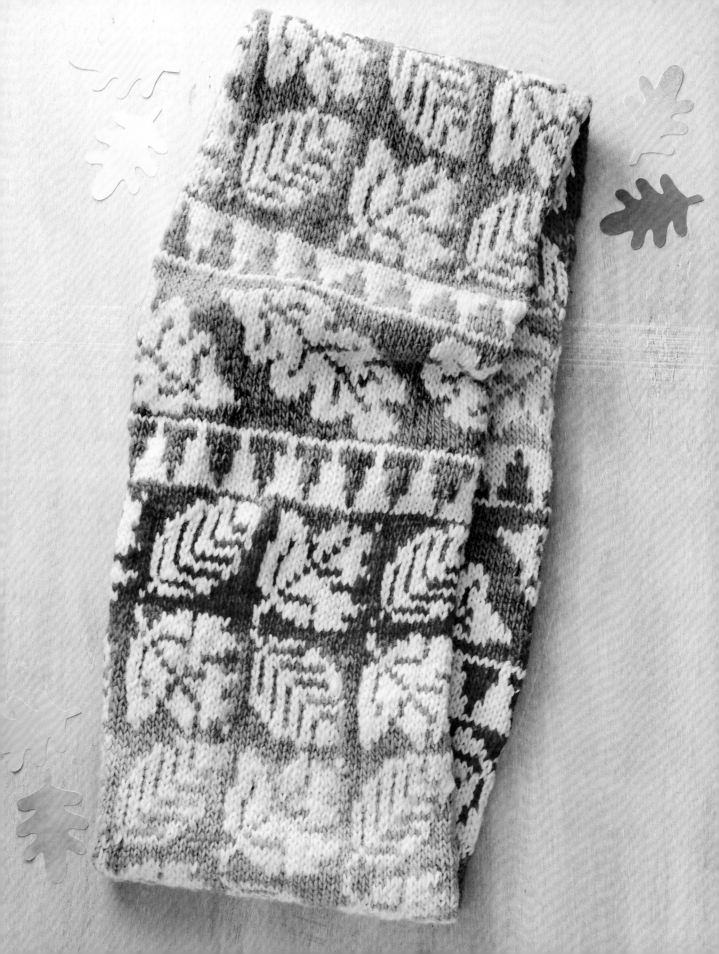

CHARTS

KEY

- ☐ Knit
- ■ MC
- ☐ CC
- ▭ Pattern repeat

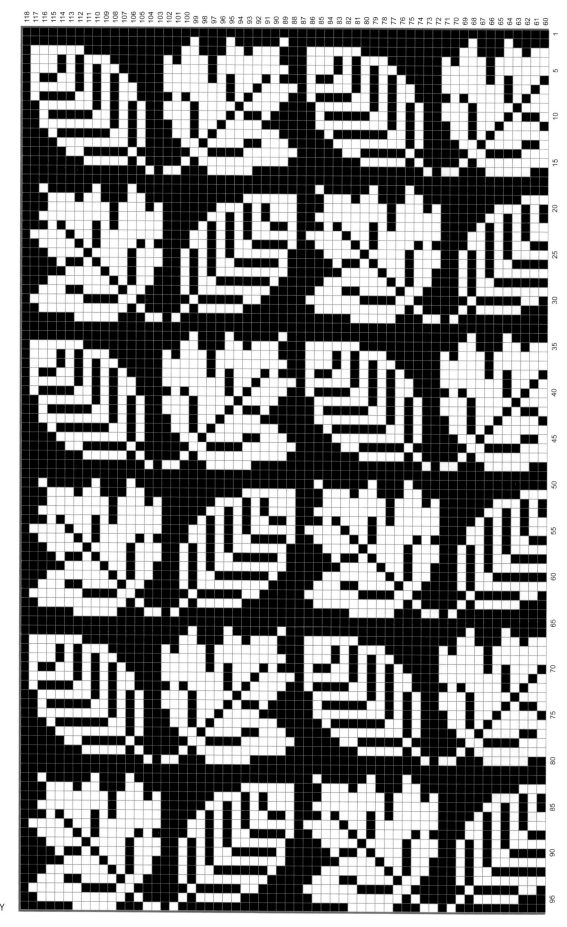

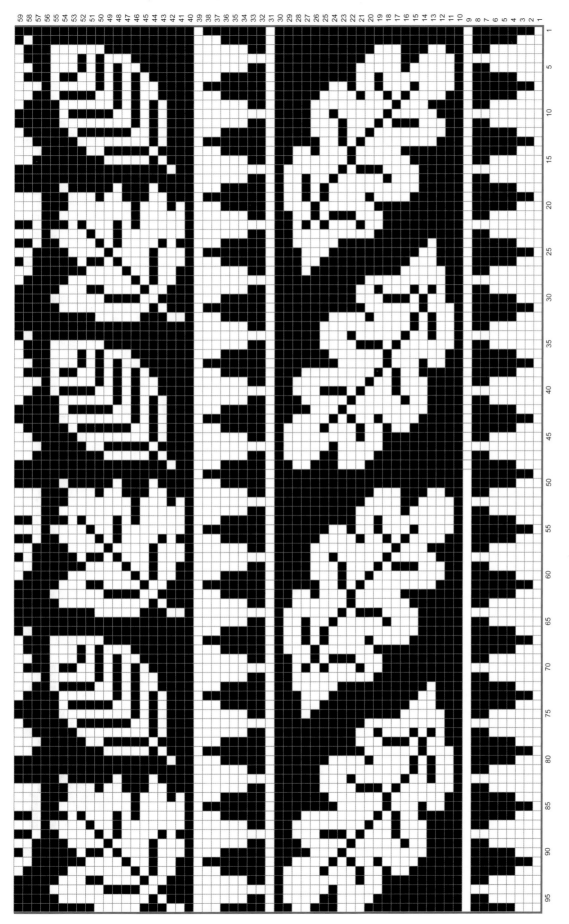

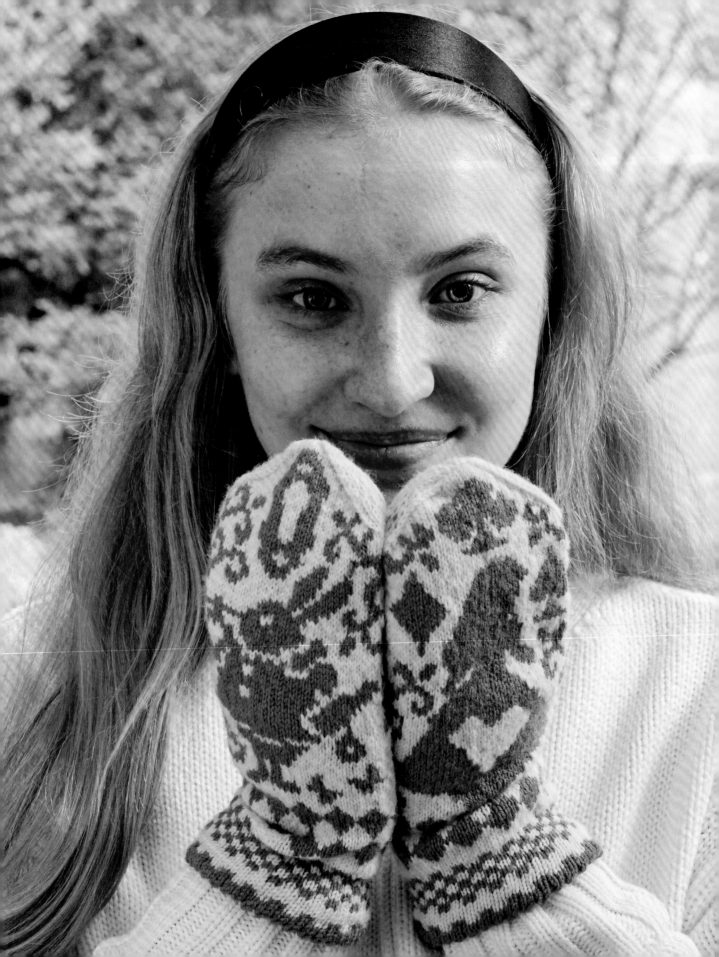

"I'm Late!" Mittens

Designed by LOTTA LUNDIN

SKILL LEVEL ♥♥♥

Based on Lewis Carroll's classic book, Walt Disney's *Alice in Wonderland* (1951) is a loopy adventure and coming-of-age story that only gets curiouser and curiouser the more times you watch it. Perhaps the most famous tidsoptimist (a person who is habitually late because they think they have more time than they actually do) in film, the White Rabbit is the catalyst for Alice's tumble down the rabbit hole, piquing her curiosity and causing her to chase after him. Bespectacled and dressed in a red waistcoat with a large gold pocket watch, the perpetually anxious and tardy rabbit is herald for the Queen of Hearts. As Alice continues to chase after him through Wonderland, she meets Tweedledee and Tweedledum, the Dodo, the Cheshire Cat, the Mad Hatter, the March Hare, the Caterpillar, and many other strange characters.

Worked in the round from the bottom up on a small gauge to allow for maximum detail, these stranded colorwork mittens are a whimsical ode to Alice, the White Rabbit, and all of Wonderland. Starting with a scalloped edge picot hem, these mittens feature a number of motifs and characters from the film: a keyhole, card suits, a pocket watch, mushroom, a grinning Cheshire Cat, the White Rabbit with his trumpet, and of course Alice herself. Put together, they make a stunning tableau of memorable moments from the film. Decreases on every round toward the top quickly bring the mittens to a point, with the remaining stitches cinched shut. An afterthought thumb is added on last. Cozy and classy, these mittens will keep you warm—and on time— through whatever adventures come your way.

SIZES

Small (Large)
Instructions are written for the smallest size, with larger sizes given in parentheses. When only one number is given, it applies to all sizes.

FINISHED MEASUREMENTS

Hand circumference: 7¾ (9) in. / 19.5 (23) cm
Length: 9½ (10¾) in. / 24 (27.5) cm
These mittens are designed to fit with 0–2 in. / 0–5 cm positive ease.

YARN

Fingering weight (super fine #1) yarn, shown in Quince & Co. *Finch* (100% American wool; 221 yd. / 202 m per 50 g hank)
Main Color (MC): Egret, 1 (2) hank(s)
Contrast Color (CC): Delft, 1 (2) hank(s)

NEEDLES

- US 0 / 2 mm set of 5 double-pointed needles or size needed to obtain gauge
- Finished sizes of mittens are relative to gauge. See pattern notes for details.

NOTIONS

- Stitch marker (optional)
- Stitch holders or waste yarn
- Tapestry needle

GAUGE

Size Small: 41 sts and 45 rnds = 4 in. / 10 cm in stranded colorwork pattern, taken after blocking
Size Large: 36 sts and 40 rnds = 4 in. / 10 cm in stranded colorwork pattern, taken after blocking
Make sure to check your gauge.

continued on page 98

NOTES

- In an effort to honor the original design of these mittens and ensure a wider range of available fit, rather than compromise on the stitch pattern, these mittens have been graded using different gauges for each size. Adjust your needle size to be sure to achieve the gauge for your finished size.
- These mittens are worked in the round on double-pointed needles from the folded cuff up.
- Take care to follow the thumb placement for the opposing mittens so that they fit as intended.

LEFT MITTEN
CUFF

Using CC, CO 68 sts using the Long Tail CO method. Divide the sts so that you have 16 sts each on Needles 1, 2, and 3 and 20 sts on Needle 4. Pm for BOR and join to work in the rnd, being careful not to twist the sts.

Rnds 1–8: Knit.

Rnd 9 (Folding Rnd): *Yo, k2tog; rep from * to end of rnd.

Rnds 10–11: Knit.

Begin Border chart, reading all rows from right to left as for working in the rnd and joining MC as required. Work Rnds 1–15 once (chart is worked 17 times across each rnd). Do not break CC; carry it loosely up the inside to save on yardage and ends to weave in.

Work the next 3 inc rnds using MC only:

Next Rnd (inc): *K17, M1L; rep from * to end of rnd—72 sts.

Next Rnd (inc): K9, *M1L, k18; rep from * to last 9 sts, M1L, k9—76 sts.

Next Rnd (inc): *M1L, k19; rep from * to end of rnd—80 sts.

Redistribute all sts so that there are 20 sts each on Needles 1 through 4.

HAND

Begin Left Mitten chart, reading all rows from right to left as for working in the rnd.

Work Rnds 1–31 of Left Mitten chart once.

THUMB PLACEMENT

Next Rnd: Work first 26 sts of Rnd 32 in patt. Place the next 13 sts on holder or waste yarn, CO 13 sts using the Backward Loop method with MC over the opening created by placing the stitches on hold. Work the remaining 41 sts in patt.

Cont working Left Mitten chart until Rnd 71.

SHAPE MITTEN

Dec Rnd: *(K2, ssk) with MC, work in patt per the chart to the last 3 sts of Needle 2, (k2tog, k1) with MC; rep from * across Needles 3 and 4—4 sts dec.

Rep the Dec Rnd every rnd 15 more times—16 sts rem.

Break CC.

Slip 4 sts from Needle 2 to Needle 1, and slip 4 sts from Needle 3 to Needle 4. With MC, graft sts together using Kitchener stitch.

THUMB

With RS facing and the cuff of the mitten pointing away from you, return 13 held thumb sts to 1 dpn (these sts will be on the far side of the thumb opening).

Rejoin MC to the right edge of the live sts and pick up and knit 2 sts in gap at the right side of the thumb opening, 13 sts along CO edge from the top of the thumb opening, and 2 more sts in the gap at the left side of the thumb opening—30 sts. Pm for BOR; the BOR is the right edge of the previously held sts with the palm facing up and the top of the mitten pointed away from you.

Redistribute the sts so that there are 7 sts each on Needles 1 and 3 and 8 sts each on Needles 2 and 4.

Begin Left Thumb chart, reading all rows from right to left as for working in the rnd and joining CC as required. Work Rnds 1–20 once. As you work Rnd 21, pm for side of thumb after the first 15 sts (there will now be 15 sts between the BOR and the side seam marker).

Break CC. The remainder of the thumb is worked with MC only.

SHAPE THUMB

Dec Rnd: *K1, ssk, knit to 3 sts before m, k2tog, k1; rep from * to end of rnd—4 sts dec.

Rep the Dec Rnd every rnd 4 more times—10 sts rem.

Break CC, leaving a tail for weaving in. Break MC, leaving a 12 in. / 30.5 cm long tail. Thread tapestry needle with the MC tail and pull tail through rem sts; pull tight to close hole. Secure on WS.

FOLD CUFF

Turn the mitten WS out. Fold the cuff at the Folding Rnd. Thread the tapestry needle with a length of CC yarn and whipstitch the CO edge of the cuff to the inside of the mitten to create a picot cuff edge. Turn the mitten RS out.

RIGHT MITTEN
CUFF

Work as for the Left Mitten.

HAND

Begin Right Mitten chart, reading all rows from right to left as for working in the rnd.

Work Rnds 1–31 of Right Mitten chart once.

THUMB PLACEMENT

Next Rnd: Place the first 13 sts on holder or waste yarn, CO 13 sts using the Backward Loop method with MC over the opening created by placing the sts on hold. Work the remaining 67 sts in patt as per Rnd 32.

Cont working Right Mitten chart until Rnd 71.

SHAPE MITTEN, THUMB, SHAPE THUMB, AND FOLD CUFF

Work as for the Left Mitten, following all charts for the Right Mitten and Thumb.

FINISHING

Weave in ends. Block to measurements.

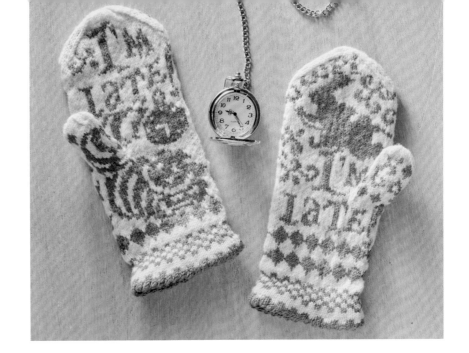

CHARTS

KEY

□	Knit	□	MC
▨	No stitch	■	CC
╱	k2tog	│	Needle divider
╲	ssk	▬	Thumb sts
		▭	Pattern repeat

BORDER

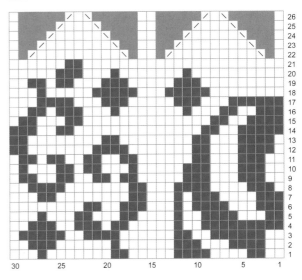

RIGHT THUMB

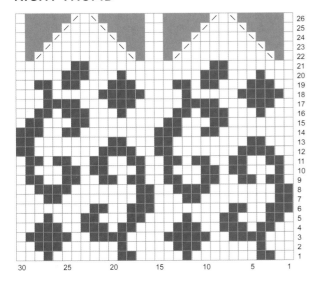

LEFT THUMB

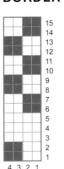

RIGHT MITTEN

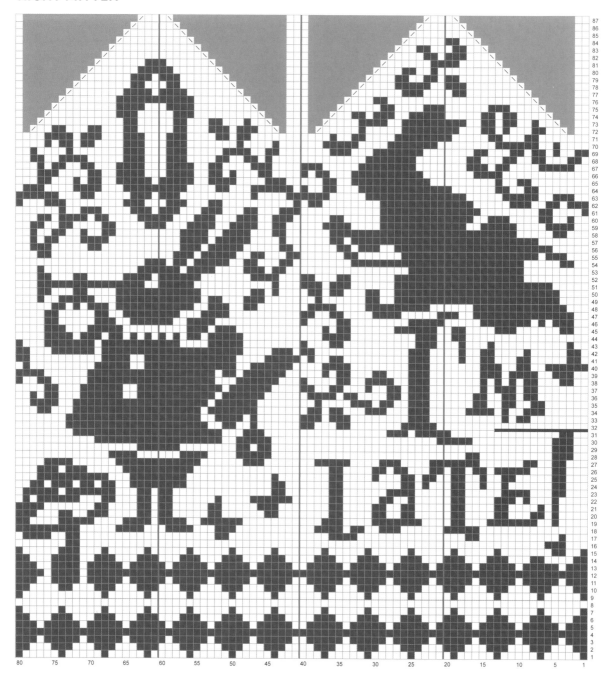

LEFT MITTEN

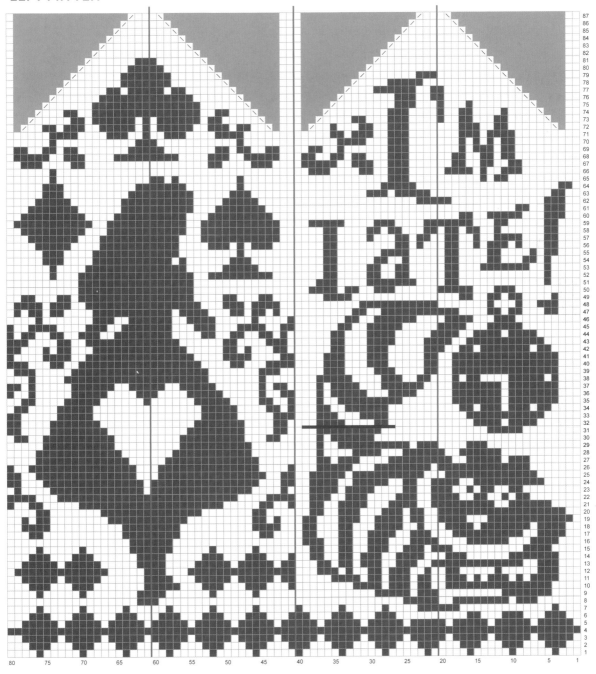

Mulan Snood

Designed by TANIS GRAY

SKILL LEVEL: ❤❤

Disney's first animated feature film to star a Chinese heroine, 1998's *Mulan* tells the story of a devoted daughter who, when her country comes under threat of war, disguises herself as a man so she may take her father's place in the army. Inspired by a traditional Chinese legend, production designer Hans Bacher and art director Ric Sluiter set the film during the Ming and Qing dynasties, using watercolor and Chinese paintings for inspiration. The addition of Mulan's dragon companion, Mushu, was suggested by Roy E. Disney after he was told that dragons can be any size in Chinese folklore. Courageous and determined, Mulan is considered a Disney princess though she is not royal by birth or marriage. A skilled warrior capable of overcoming any obstacle, she is an inspiration to anyone striving to be true to themselves.

Designed to be scooched down around the neck or pulled over the head like a hood for added coziness, this snood is worked seamlessly in the round from the bottom up. Tricolored corrugated ribbing edges flank Mulan's stranded colorwork dragon sidekick, Mushu; Cri-Kee, the lucky purple cricket given to Mulan by her grandmother; and her flowered jade comb. Combine all these motifs together, and you'll be one lucky knitter!

SIZE
One size

FINISHED MEASUREMENTS
Length: 24½ in. / 62 cm
Circumference: 28 in. / 71 cm

YARN
DK weight (light #3) yarn, shown in Little Fox *Vulpine DK* (80% superwash merino, 10% cashmere, 10% nylon; 231 yd. / 211 m per 3½ oz. / 100 g hank)
Color A: Raven's Wing, 1 hank
Color B: Petal, 1 hank
Color C: Mulberry, 1 hank
Color D: Vardo, 1 hank
Color E: Tomato-Tomahto, 1 hank

NEEDLES
- US 5 / 3.75 mm, 24 in. / 61 cm long circular needle
- US 7 / 4.5 mm, 24 in. / 61 cm long circular needle or size needed to obtain gauge

NOTIONS
- Stitch marker
- Tapestry needle

GAUGE
20½ sts and 22½ rnds = 4 in. / 10 cm over stranded colorwork on larger needle, taken after blocking
Make sure to check your gauge.

NOTES
- The snood is worked seamlessly, in the round, from the bottom up with corrugated ribbing top and bottom edgings to prevent rolling.
- When working two-color sections of the chart, it is recommended to cut the unused yarns and rejoin when next needed.

"I've heard a great deal about you, Fa Mulan. You stole your father's armor, ran away from home, impersonated a soldier, deceived your commanding officer, dishonored the Chinese Army, destroyed my palace. And you have saved us all."

The Emperor, *Mulan* (1998)

Disney
FUN FACTS

Tony Award®-winner Lea Salonga provided the singing voice for Mulan in the film, including on the hit song "Reflection." The singer previously provided the singing voice for Jasmine in *Aladdin* (1992).

BOTTOM EDGING

Using the smaller needle and color D, CO 144 sts using the Twisted German method. Pm for BOR and join to work in the rnd, being careful not to twist the sts.

Begin chart, reading all rows from right to left as for working in the rnd, and joining Colors C and E as required. Work Rows 1–6 once (chart is worked once across each rnd).

BODY

Switch to larger needles.

Beginning on Row 7, continue working from the chart, joining Colors A through E as necessary. Work Rows 7–130 once.

TOP EDGING AND BIND OFF

Switch to smaller needles.

Beginning on Row 131, continue working from the chart, joining Colors C and E as necessary. Work Rows 131–136 once.

Once the chart is complete, break Colors C and E.

BO all sts purlwise.

FINISHING

Weave in all loose ends with tapestry needle to the WS.

Wet block the snood to allow the stitches to relax. Once dry, trim all ends.

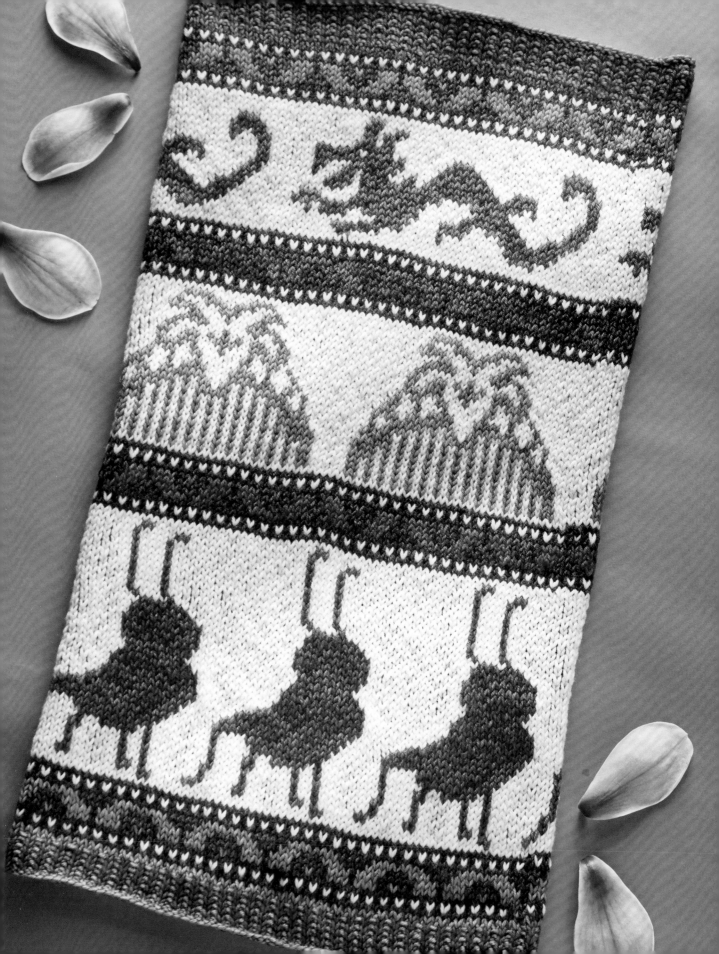

CHARTS

KEY

☐	Knit
⊟	Purl
■	Color A
☐	Color B
■	Color C
■	Color D
■	Color E

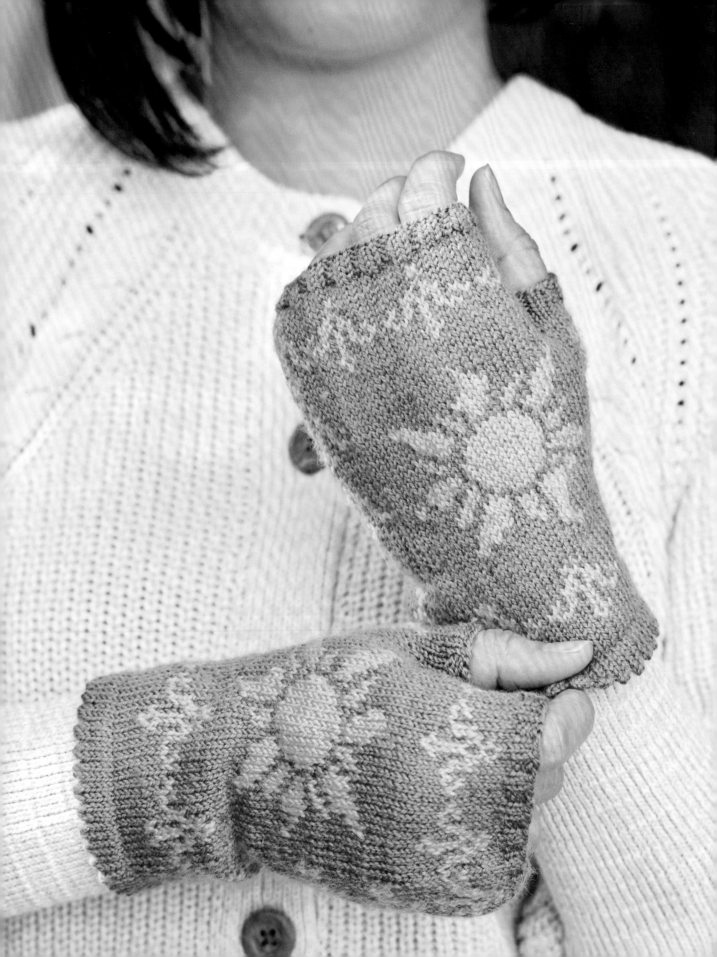

Floating Lantern Fingerless Mitts

Designed by VALORIE WIBBENS

SKILL LEVEL: ♥ ♥

𝕭 ased on the Brothers Grimm fairy tale "Rapunzel," Disney's fiftieth animated film, *Tangled* (2010), is the story of a young girl with magical glowing hair who has spent her life locked in a tower. When a charming thief accidentally stumbles upon her home, Rapunzel finally decides it's time to see the world—particularly the glowing lanterns that appear in the sky every year on her birthday. Drawing inspiration from rococo-style French painters like Fragonard, the animators wanted the film to be romantic and lush, giving the 3D style of animation a 2D feel. One of the most visually stunning scenes in the film comes during the Academy Award®–nominated song "I See the Light," when Rapunzel and Flynn Rider drift on a boat through the glowing, floating lanterns, slowly realizing they are falling in love. Lit annually by the people of the kingdom to help guide the missing princess home, the lanterns are painted with the symbol of the kingdom—a radiant sun. It is only when she returns to her tower that Rapunzel realizes she has been unconsciously painting this symbol her whole life and that she is in fact the princess the kingdom has been seeking.

Decorated with stranded colorwork sun motifs and stylized hanging lantern motifs, these fingerless mitts are worked in the round from the bottom up. An easy feminine picot trim makes for a sturdy cuff, while a thumb gusset ensures a comfortable fit. An ideal accessory for the next time you need to escape your tower or when you want to give a gift, these romantic mittens are sure to bring a ray of light to the wearer.

SIZES
Small (Medium, Large, X-Large)
Instructions are written for the smallest size, with larger sizes given in parentheses. When only one number is given, it applies to all sizes.

FINISHED MEASUREMENTS
Hand circumference: 6½ (7, 7½, 8) in. / 16.5 (18, 19, 20.5) cm
Length: approx 6¼ (6½, 7, 7½) in. / 16 (17, 18, 19) cm
Designed to be worn with 0–1 in. / 0–2.5 cm negative ease.

YARN
Fingering weight (super fine #1) yarn, shown in O-Wool *O-Wash Fingering* (100% machine washable certified organic merino; 394 yd. / 360 m per 3½ oz. / 100 g hank)
Main Color (MC): Bull Thistle, 1 hank
Contrast Color (CC): Paw Paw, 1 hank

NEEDLES
- US 0 / 2 mm, 32 in. / 81.5 cm long circular needle
- US 1 / 2.25 mm, 32 in. / 81.5 cm long circular needle or size needed to obtain gauge

NOTIONS
- Stitch markers
- Locking stitch marker
- Tapestry needle
- Waste yarn or stitch holder

GAUGE
Small: 40 sts and 48 rnds = 4 in. / 10 cm over stranded colorwork on the larger needle, taken after blocking
Medium: 37 sts and 45 rnds = 4 in. / 10 cm over stranded colorwork on the larger needle, taken after blocking

continued on page 110

Large: 35 sts and 43 rnds = 4 in. / 10 cm over stranded colorwork on the larger needle, taken after blocking

X-Large: 33 sts and 40 rnds = 4 in. / 10 cm over stranded colorwork on the larger needle, taken after blocking

Make sure to check your gauge.

NOTES

- In an effort to honor the original design of these fingerless mitts and ensure a wider range of available fit, rather than compromise on the stitch pattern, these fingerless mitts have been graded using different gauges for each size. To achieve the gauge for your finished size of fingerless mitt, adjust your needle size if necessary.

- The fingerless mitts are worked from the bottom up, in the round, using the Magic Loop method. You may use your preferred method of small-circumference knitting (such as dpns or 9 in. / 23 cm circulars).

- A picot edge is created at the bottom of the fingerless mitt. You may find it helpful to clip a locking marker into the first cast-on stitch to indicate where to join the cast-on edge to the live stitches once the picot edge is folded.

- Thumb stitches are placed on hold while the mitt is finished. These stitches are then worked in the round to create a finished thumb edge.

- When necessary, while working the colorwork charts, catch long floats every five to seven stitches.

RIGHT MITT
PICOT EDGE

Using MC, CO 66 sts using the Twisted German method. Divide the sts evenly over the needles. Clip locking marker into cast on edge to indicate BOR and to assist with the picot edge seaming, being carefully not to twist the sts.

Rnds 1–4: Knit.

Rnd 5 (Folding Rnd): *Yo, k2tog; rep from * to end of rnd.

Rnds 6–9: Knit.

Fold CO edge upward in half (toward the inside, WS together) at the Folding Rnd; the CO edge should now be in line with the live working sts. The eyelets created on the Folding Rnd will create a scalloped/picot edge.

Seaming Rnd: *Insert the RHN into the first st on the working needle knitwise, and under first loop from the CO edge (using the locking marker as an indicator); knit the 2 sts together (1 st rem); rep from * until all of the CO sts have been worked with the live rnd of sts; 66 sts rem. The locking marker can be removed once this rnd is complete.

BODY

Begin Right Mitt chart, reading all rows from right to left as for working in the rnd, joining CC as required. Work Rows 1–19 of Right Mitt chart once (pattern is worked once across each rnd). Starting on Rnd 20, sts are increased to form a thumb gusset.

Rnd 20 (inc): Work the first 33 sts of the rnd in patt, pm, M1R with MC, pm, work to end of rnd in patt—67 sts.

Work Rnds 21–46 of the chart in est patt, increasing sts between the markers as indicated. Once complete, there will be 85 sts total: 33 sts before the first m, 19 thumb gusset sts between the m, and 33 sts after the second m.

THUMB GUSSET

Rnd 47 (dec): Work to first m in patt, rm, place 19 sts on waste yarn or stitch holder, rm, CO 2 sts using the Backward Loop method with MC, work to end of rnd in patt—68 sts.

Rnd 48 (dec): Work the first 32 sts of the rnd in patt, ssk with MC, k2tog with MC, work to end of rnd in patt—66 sts.

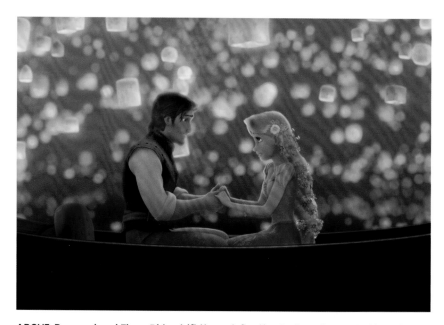

ABOVE: Rapunzel and Flynn Rider drift through floating lanterns in *Tangled* (2010).

FINISH THE BODY

Work Rows 48–65 of the Right Mitt chart. Once the chart is complete, break CC.

TOP CUFF

Setup Rnd (dec): Remove the BOR marker (if placed) and unknit the final st of the previous rnd. Slip this unworked st to the right needle purlwise. This is the new BOR. Ssk, k31, k2tog, knit to end of rnd—64 sts.

Change to smaller needle.

Rnd 1: *K2, p2; rep from * to end of rnd.

Rep Rnd 1 three *more* times.

BO all sts loosely, knitwise.

THUMB

Place the 19 live sts of the thumb gusset onto the gauge-size needle. Starting at the middle of the thumb opening, rejoin MC and pick up and knit 2 sts, knit across the 19 live sts, pick up and knit 2 more sts—23 sts total. Distribute the sts evenly over the needles. Pm for BOR and join to work in the rnd.

Rnd 1: Knit.

Rnd 2 (dec): K2tog, knit to last 2 sts, ssk—21 sts.

Rnds 3–5: Knit.

Change to smaller needles.

Rnd 6: *K2, p2; rep from * to last st, k1.

Rep Rnd 6 three more times.

BO all sts loosely, knitwise.

LEFT MITT

Work all instructions as for the Right Mitt, ref1rencing the colorwork charts for the Left Mitt.

FINISHING

Weave in all ends. Block mitts to finished measurements. Once dry, trim all ends.

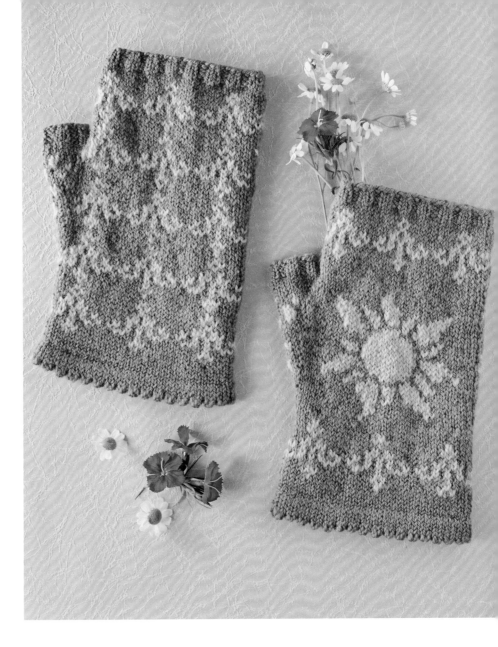

Flynn Rider: "Rapunzel . . . you were my new dream."

Rapunzel: "And you were mine."

Tangled (2010)

CHARTS

KEY

☐	Knit
▨	No stitch
■	MC
▨	CC
↘	M1L
↗	M1R
∪	Backward Loop cast on
╱	k2tog
╲	ssk
▭	Place sts on waste yarn

RIGHT MITT

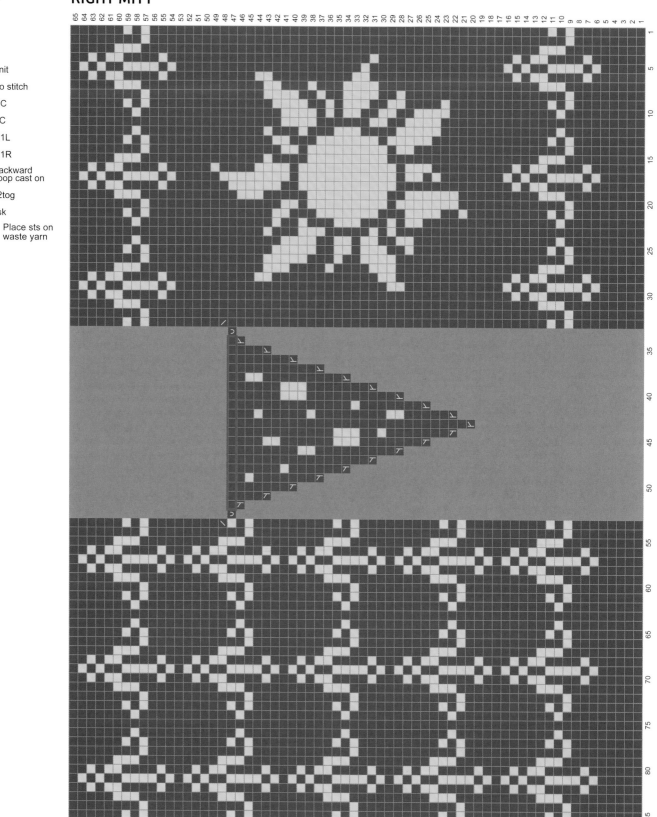

LEFT MITT

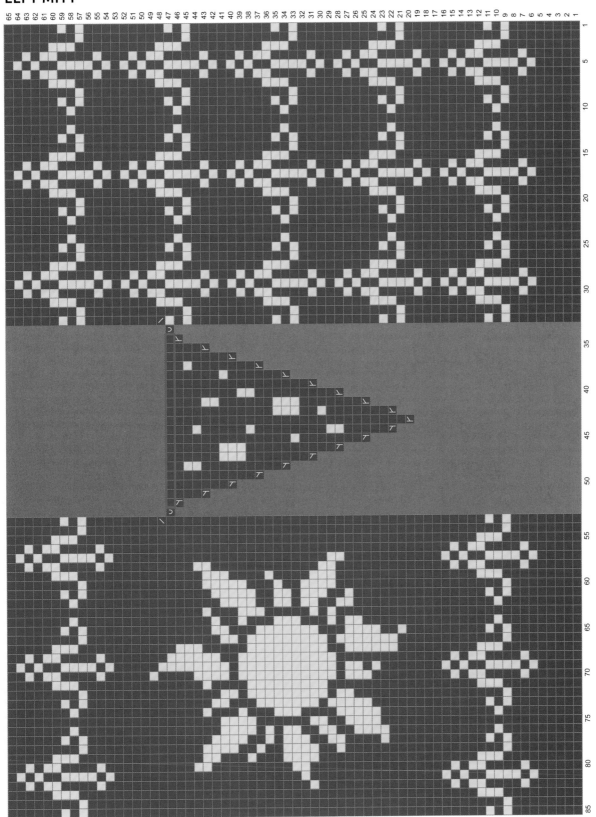

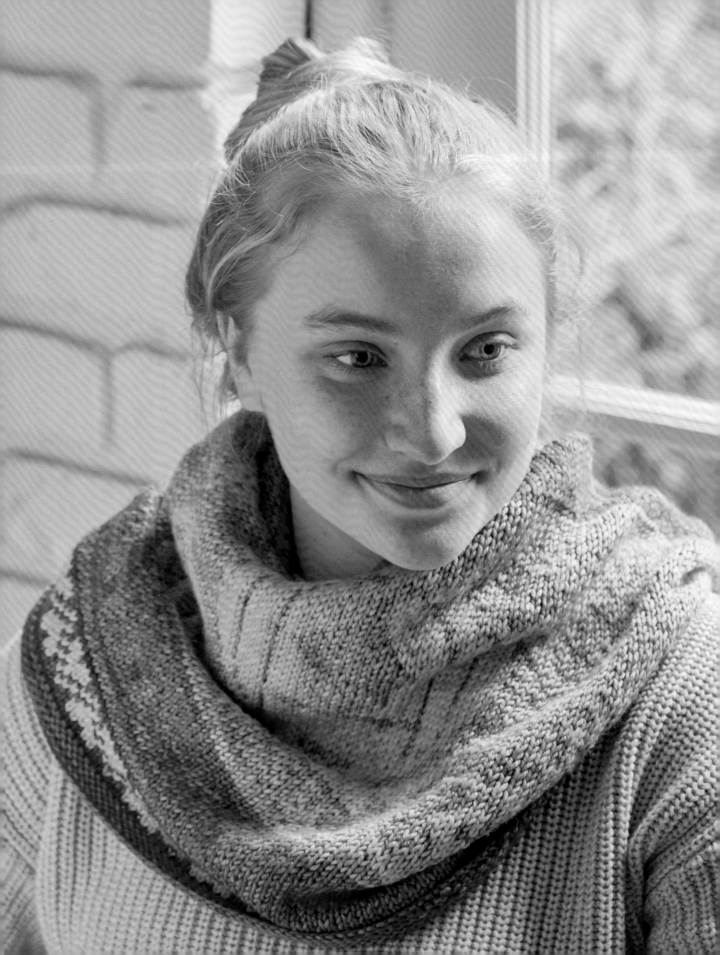

The Pumpkin Coach Cowl

Designed by TANIS GRAY

SKILL LEVEL ❤❤

With just a few flicks of her wand and some now-famous magic words, the Fairy Godmother turns a pumpkin into a coach, four gray mice into four white horses, and Cinderella's torn dress into a glittering ball gown. Scarcely able to believe her luck, Cinderella steps into her coach and rides off to the ball where her destiny, in the form of a charming prince and true love, awaits. Anchored by an incredibly catchy song ("Bibbidi-Bobbidi-Boo"), the entire transformation scene is among the most popular and iconic scenes in animation and was reportedly a particular favorite of Walt Disney himself.

Knit seamlessly in the round from the bottom up, this stranded colorwork cowl features Cinderella's coach sparkling with magic from Fairy Godmother, flanked by orange pumpkins and golden hearts. Smaller needles are used on the easy garter borders, with larger needles used in the colorwork section. Put them together and what have you got? An enchanting cowl that won't unravel at the stroke of midnight.

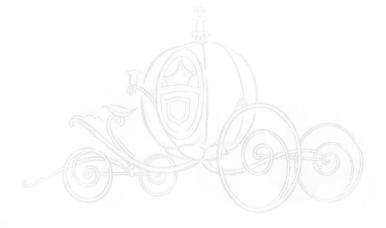

SIZE
One size

FINISHED MEASUREMENTS
Length: 18¼ in. / 46.5 cm
Circumference: 30 in. / 76 cm

YARN
DK weight (light #3) yarn, shown in
Leading Men Fiber Arts *Dramaturg*
(100% superwash merino wool; 250 yd.
/ 229 m per 4 oz. / 115 g hank)
Color A: Fishbowl, 1 hank
Color B: Sunny Side Up, 1 hank
Color C: Saffron, 1 hank
Color D: Apple Bottom, 1 hank

NEEDLES
- US 5 / 3.75 mm, 24 in. / 61 cm long
 circular needle
- US 7 / 4.5 mm, 24 in. / 61 cm long
 circular needle or size needed to
 obtain gauge

NOTIONS
- Stitch markers
- Tapestry needle

GAUGE
21 sts and 24 rnds = 4 in. / 10 cm over
stranded colorwork on larger needle,
taken after blocking
Make sure to check your gauge.

continued on page 116

NOTES

- The cowl is worked seamlessly, in the round, from the bottom up with garter top and bottom edgings to prevent rolling.
- It may be helpful to place a marker to divide the two repeats of the chart.
- You may carry the colors loosely up the inside of the cowl when not being used to save on yardage and ends to weave in. When working Rnds 23–81, however, it is recommended to cut Colors A and C until needed again.

BOTTOM EDGING

Using the smaller needle and color A, CO 160 sts using the Twisted German method. Pm for BOR and join to work in the rnd, being careful not to twist the sts.

Rnd 1: Knit.

Rnd 2: Purl.

Rep Rnds 1 and 2 twice more (6 rnds total).

BODY OF COWL

Switch to larger needles.

Begin chart, reading all rows from right to left as for working in the rnd and joining colors B, C, and D as required. Work Rows 1–103 once (chart is worked twice across each rnd).

Once the chart is complete, break Colors B, C, and D.

TOP EDGING & BIND OFF

Switch to smaller needles.

Rnd 1: Knit.

Rnd 2: Purl.

Rep Rnds 1 and 2 twice more (6 rnds total).

BO all sts purlwise.

FINISHING

Weave in all loose ends with tapestry needle to the WS.

Wet block the cowl to allow the sts to relax. Once dry, trim all ends.

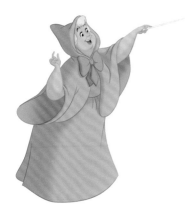

"I'd say the first thing you need is . . . a pumpkin."

The Fairy Godmother, *Cinderella* (1950)

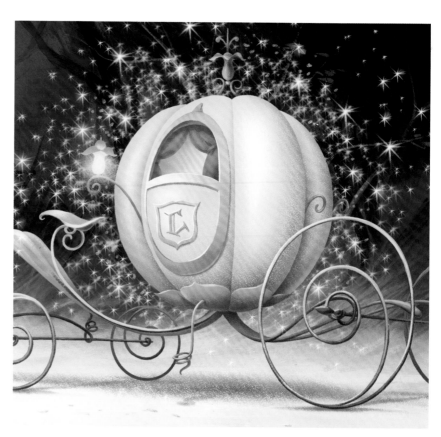

ABOVE: The pumpkin coach from *Cinderella* (1950).

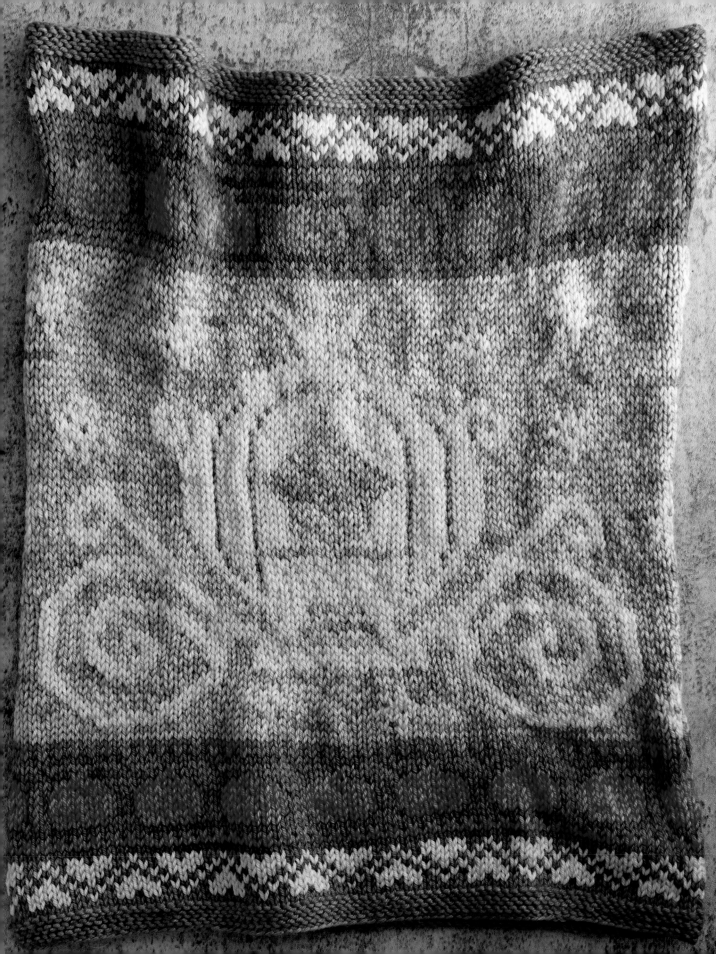

CHARTS

KEY

☐	Knit
■	Color A
▨	Color B
▨	Color C
▨	Color D
▭	Pattern repeat

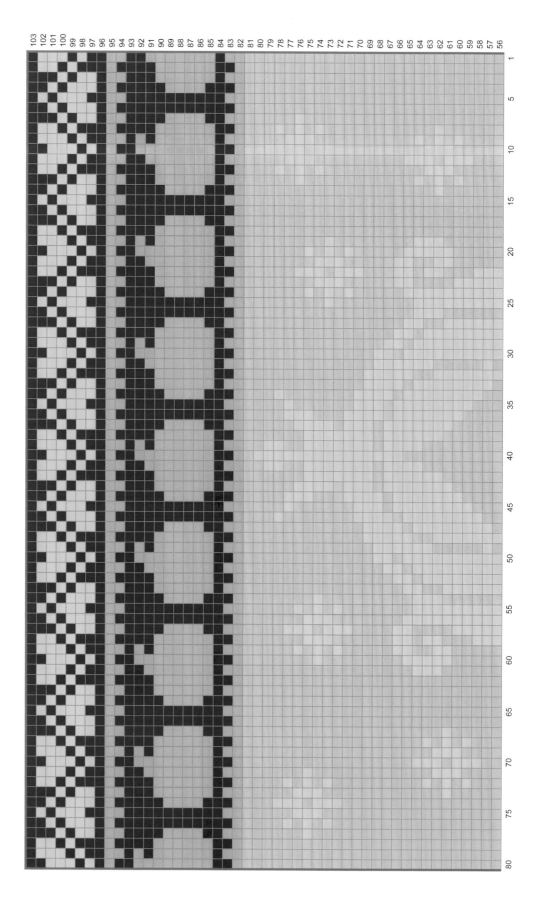

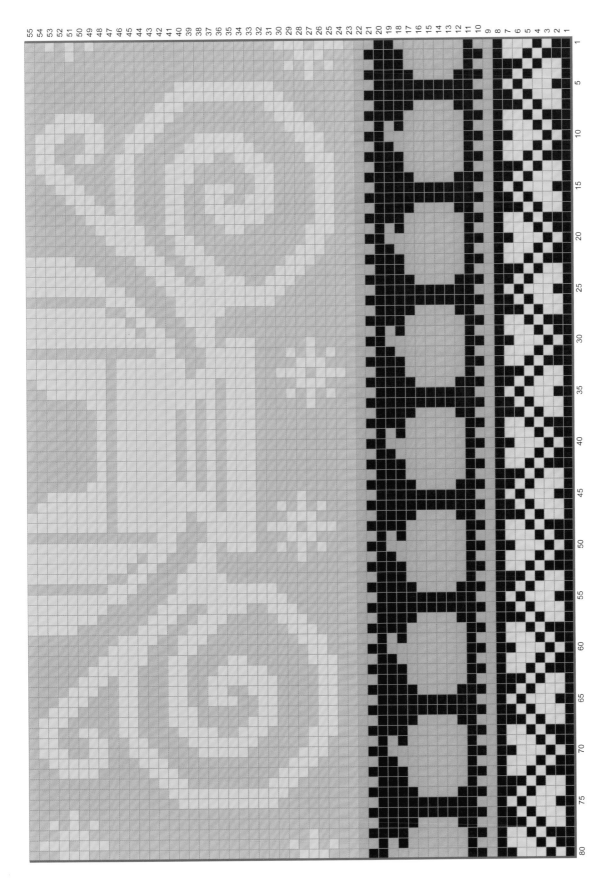

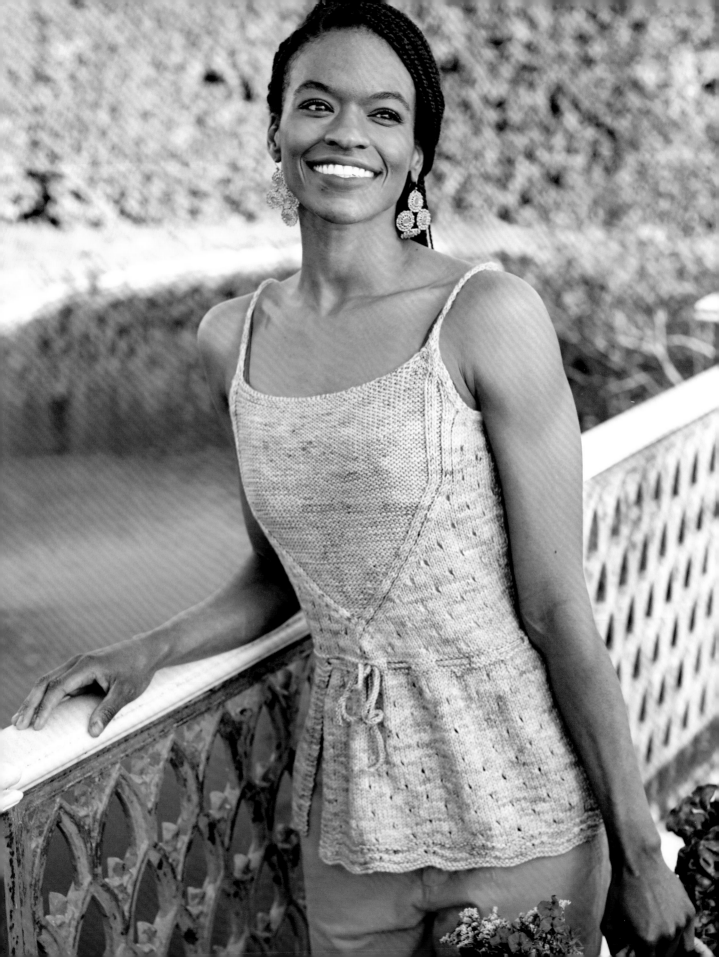

Tiana "Dreams Do Come True" Tank

Designed by SAUNIELL CONNALLY

SKILL LEVEL ♥♥♥

Grounded, hardworking, and motivated, Tiana from Disney's 2009 film *The Princess and the Frog* broke ground as the first African American Disney princess. Inspired by her father's strong work ethic and loving devotion to his family, Tiana works hard every day at her job as a waitress so she can save up enough money to own her own restaurant. Her dreams encounter a slight speed bump when she kisses an enchanted prince and is turned into a frog. Featuring Tony Award®–winner Anika Noni Rose as the voice of Tiana and set in New Orleans during the Roaring Twenties, the film featured a stunning soundtrack influenced by jazz, zydeco, gospel, and blues, all but one written by New Orleans native Randy Newman.

Inspired by the water lily petals of Tiana's fairy-tale wedding dress, this romantic peplum top will make you feel like a princess! Knit from the bottom up starting with the peplum worked flat, the peplum is joined in the round with an overlap to draw in and accentuate the waist. An eyelet-patterned bodice with cables creates a faux panel and is worked through the body until the armhole shaping. The top is then worked flat to create the armholes, neckline shaping, and straps. Finish with a crochet belt as shown or use a pretty trim or ribbon and get ready to live your dreams of knitwear perfection!

SIZES

1 (2, 3, 4, 5)[6, 7, 8, 9]{10, 11, 12, 13}
Instructions are written for the smallest size, with larger sizes given in parentheses. When only one number is given, it applies to all sizes.

FINISHED MEASUREMENTS

Bust: 32 (35, 38, 41, 44)[47, 50, 53, 56]{59, 62, 65, 68} in. / 81.5 (89, 96.5, 104, 112) [119.5, 127, 134.5, 142]{150, 157.5, 165, 172.5} cm
Garment designed to be worn with 0–2 in. / 0–5 cm positive ease.
The garment is a Size 2 modeled on a 33 in. / 84 cm. bust with 2 in. / 5 cm positive ease.

YARN

DK weight (light #3) yarn, shown in Junkyarn *DK* (100% superwash merino wool; 231 yd. / 211 m per 3½ oz. / 100 g skein) in color Tiana, 2 (3, 3, 3, 4)[4, 5, 5, 6]{6, 6, 6, 6} hanks

NEEDLES

- US 7 / 4.5 mm, 24–40 in./ 61–101.5 cm long circular needle and 1 double-pointed needle or size needed to obtain gauge

NOTIONS

- US G-6 / 4 mm crochet hook
- Stitch markers (1 unique for BOR, 2 unique for bodice cable; additional for marking eyelet pattern repeats, optional)
- Waste yarn
- Cable needle
- Row counter (optional)
- Tapestry needle

GAUGE

21 sts and 27 rows = 4 in. / 10 cm over eyelet pattern, taken after blocking
Make sure to check your gauge.

continued on page 122

NOTES

- The peplum is knit flat, first, and is placed on waste yarn and blocked before continuing with the bodice.
- The peplum is joined in the round with overlapping stitches knit together. Once joined, the bodice is knit in the round until the armhole shaping begins.
- Instructions for a crochet belt are included; however, a purchased trim or ribbon can be used if preferred.
- Several stitch markers are used to differentiate stitch pattern repeats within the bodice section of this tank. Letters and numbers are used to differentiate the markers. MA and MB can be read as Marker A and Marker B. MC1 and MC2 should be read as Cable Marker 1 and Cable Marker 2.

STITCH PATTERNS

Fan Stitch (12-st repeat)

Row 1 (RS): Knit.

Row 2 (WS): Knit.

Row 3: Knit.

Row 4: Purl.

Row 5: *(K2tog) twice, (yo, k1) 4 times, (k2tog) twice; rep from *.

Row 6: Knit.

Repeat Rows 3–6 once more.

EYELET PATTERN WORKED FLAT (8-ST REPEAT)

Row 1 (RS): Knit.

Rows 2, 4, and 6 (WS): Purl.

Row 3: *K6, yo, k2tog; rep from * to end.

Row 5: Knit.

Row 7: K2, *yo, k2tog, k6; rep from * to last 6 sts, k2tog, yo, k4.

Row 8: Purl.

EYELET PATTERN WORKED IN THE ROUND (8-ST REPEAT)

Rnds 1 and 2: Knit.

Rnd 3: *K6, yo, k2tog; rep from * to end.

Rnds 4–6: Knit.

Row 7: K2, *yo, k2tog, k6; rep from * to last 6 sts, k2tog, yo, k4.

Rnd 8: Knit.

PEPLUM

Using the circular needle, CO 204 (210, 240, 264, 294)[318, 342, 366, 390]{402, 414, 426, 438} sts using the Long Tail CO method. Do not join to work in the rnd.

Note: As the following 2 rows are worked, the Fan St pattern will be repeated 16 (17, 19, 21, 24)[26, 28, 30, 32]{33, 34, 35, 36} times across the row between the first and last sts.

Row 1 (RS): K6 (3, 6, 6, 3)[3, 3, 3, 3]{3, 3, 3, 3}, work Fan St pattern to last 6 (3, 6, 6, 3)[3, 3, 3, 3]{3, 3, 3, 3} sts, knit to end.

Row 2 (WS): K3, p3 (0, 3, 3, 0)[0, 0, 0, 0]{0, 0, 0, 0}, work Fan St pattern to last 6 (3, 6, 6, 3)[3, 3, 3, 3]{3, 3, 3, 3} sts, p3 (0, 3, 3, 0)[0, 0, 0, 0]{0, 0, 0, 0}, k3.

Rep [Rows 1 and 2] 5 more times (10 rows total; all rows and repeats of Fan St pattern are complete).

PEPLUM EYELETS

As the following rows are worked, the Eyelet pattern will be repeated 24 (25, 29, 32, 36)[39, 42, 45, 48]{49, 51, 52, 54} times across the row between the st markers.

Setup Row 1 (RS): K6 (5, 4, 4, 3)[3, 3, 3]{5, 3, 5, 3}, pm, work Eyelet pattern to last 6 (5, 4, 4, 3)[3, 3, 3, 3]{5, 3, 5, 3} sts, pm, knit to end.

Setup Row 2 (WS): K3, purl to m (where necessary), sm, work Eyelet pattern to next m, sm, purl to m (where necessary), k3.

Row 1: Knit to m, sm, work Eyelet pattern to next m, sm, knit to end.

Row 2: K3, purl to m (where necessary), sm, work Eyelet pattern to next m, sm, purl to m (where necessary), k3.

Rep Rows 1 and 2 until the peplum measures 8½ (8½, 9, 9, 9)[9½, 9½, 10, 10]{10, 10½, 10½, 10½} in. / 21.5 (21.5, 23, 23, 23)[24, 24, 25.5, 25.5]{25.5, 26.5, 26.5, 26.5} cm from the CO edge, ending with a WS row.

PEPLUM GATHERS

Note: The following 4 rows shape the top of the peplum and create lovely little gathers.

SIZE 1 ONLY

Row 1 (RS, dec): K11, (sk2p, k9) 15 times, ssk, knit to end—173 sts.

Row 2 (WS): K3, purl to last 3 sts (rm as encountered), k3.

Row 3 (dec): K10, (sk2p, k7) 15 times, ssk, knit to end—142 sts.

Row 4: K3, purl to last 3 sts, k3.

SIZE 2 ONLY

Row 1 (RS, dec): K13, (sk2p, k11) 14 times, knit to end—182 sts.

Row 2 (WS): K3, purl to last 3 sts (rm as encountered), k3.

Row 3 (dec): K12, (sk2p, k9) 14 times, knit to end—154 sts.

Row 4: K3, purl to last 3 sts, k3.

SIZE 3 ONLY

Row 1 (RS, dec): K17, (sk2p, k9) 17 times, ssk, knit to end—205 sts.

Row 2 (WS): K3, purl to last 3 sts (rm as encountered), k3.

Row 3 (dec): K16, (sk2p, k7) 17 times, ssk, knit to end—170 sts.

Row 4: K3, purl to last 3 sts, k3.

SIZE 4 ONLY

Row 1 (RS, dec): K14, (sk2p, k10) 18 times, ssk, knit to end—227 sts.

Row 2 (WS): K3, purl to last 3 sts (rm as encountered), k3.

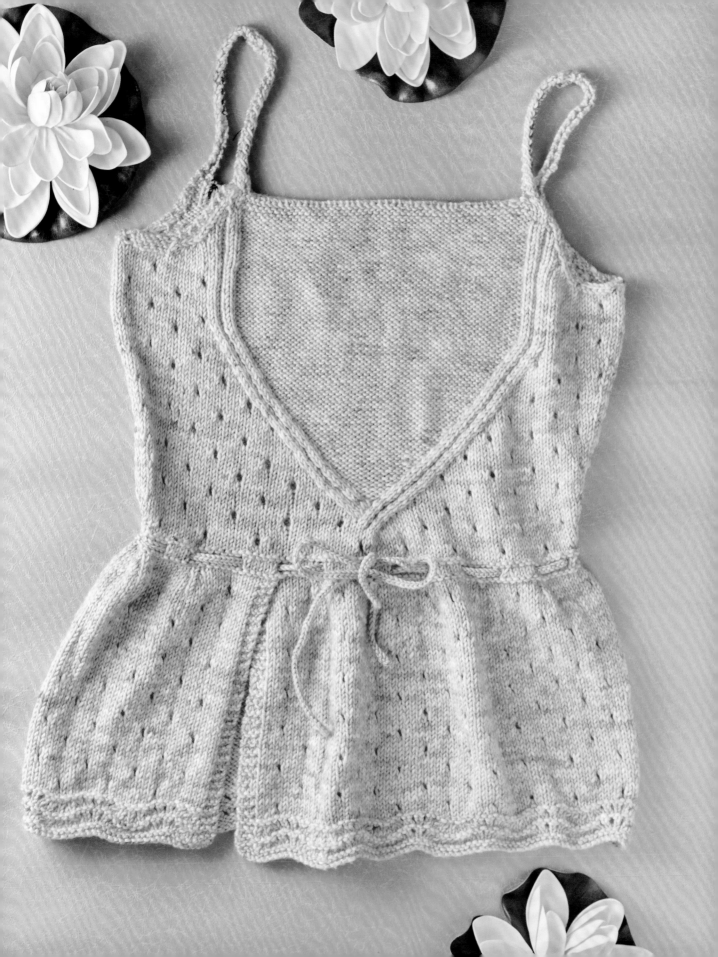

Row 3 (dec): K13, (sk2p, k8) 18 times, ssk, knit to end—190 sts.

Row 4: K3, purl to last 3 sts, k3.

SIZE 5 ONLY

Row 1 (RS, dec): K20, (sk2p, k9) 22 times, knit to end—227 sts.

Row 2 (WS): K3, purl to last 3 sts (rm as encountered), k3.

Row 3 (dec): K19, (sk2p, k7) 22 times, knit to end—206 sts.

Row 4: K3, purl to last 3 sts, k3.

SIZE 6 ONLY

Row 1 (RS, dec): K21, (sk2p, k10) 22 times, knit to end—274 sts.

Row 2 (WS): K3, purl to last 3 sts (rm as encountered), k3.

Row 3 (dec): K20, (sk2p, k8) 22 times, knit to end—230 sts.

Row 4: K3, purl to last 3 sts, k3.

SIZE 7 ONLY

Row 1 (RS, dec): K21, (sk2p, k10) 23 times, ssk, knit to end—295 sts.

Row 2 (WS): K3, purl to last 3 sts (rm as encountered), k3.

Row 3 (dec): K20, (sk2p, k8) 23 times, ssk, knit to end—248 sts.

Row 4: K3, purl to last 3 sts, k3.

SIZE 8 ONLY

Row 1 (RS, dec): K21, (sk2p, k11) 23 times, ssk, knit to end—319 sts.

Row 2 (WS): K3, purl to last 3 sts (rm as encountered), k3.

Row 3 (dec): K20, (sk2p, k9) 23 times, ssk, knit to end—272 sts.

Row 4: K3, purl to last 3 sts, k3.

SIZE 9 ONLY

Row 1 (RS, dec): K19, (sk2p, k11) 25 times, ssk, knit to end—339 sts.

Row 2 (WS): K3, purl to last 3 sts (rm as encountered), k3.

Row 3 (dec): K18, (sk2p, k9) 25 times, ssk, knit to end—288 sts.

Row 4: K3, purl to last 3 sts, k3.

SIZE 10 ONLY

Row 1 (RS, dec): K16, (sk2p, k13) 23 times, ssk, knit to end—355 sts.

Row 2 (WS): K3, purl to last 3 sts (rm as encountered), k3.

Row 3 (dec): K15, (sk2p, k11) 23 times, ssk, knit to end—308 sts.

Row 4: K3, purl to last 3 sts, k3.

SIZE 11 ONLY

Row 1 (RS, dec): K19, (sk2p, k14) 22 times, ssk, knit to end—369 sts.

Row 2 (WS): K3, purl to last 3 sts (rm as encountered), k3.

Row 3 (dec): K18, (sk2p, k12) 22 times, ssk, knit to end—324 sts.

Row 4: K3, purl to last 3 sts, k3.

SIZE 12 ONLY

Row 1 (RS, dec): K23, (sk2p, k15) 21 times, ssk, knit to end—383 sts.

Row 2 (WS): K3, purl to last 3 sts (rm as encountered), k3.

Row 3 (dec): K22, (sk2p, k13) 21 times, ssk, knit to end—340 sts.

Row 4: K3, purl to last 3 sts, k3.

SIZE 13 ONLY

Row 1 (RS, dec): K28, (sk2p, k16) 20 times, ssk, knit to end—397 sts.

Row 2 (WS): K3, purl to last 3 sts (rm as encountered), k3.

Row 3 (dec): K27, (sk2p, k14) 20 times, ssk, knit to end—356 sts.

Row 4: K3, purl to last 3 sts, k3.

ALL SIZES

Next Row (RS): Knit to last 6 (6, 6, 6, 6)[6, 8, 8, 8]{8, 8, 8, 8} sts.

Place the last 6 (6, 6, 6, 6)[6, 8, 8, 8]{8, 8, 8, 8} sts onto 1 piece of waste yarn; place the remaining 136 (148, 164, 184, 200)[224, 240, 264, 280]{300, 316, 332, 348} sts on a separate piece of waste yarn. Do not break the yarn.

Block the peplum flat.

PEPLUM JOIN

Once the peplum is dry, place the 6 (6, 6, 6, 6)[6, 8, 8, 8]{8, 8, 8, 8} sts from the end of the last row worked onto the dpn. Place the remaining main peplum sts back on the circular needle.

With the RS facing, join to work in the rnd by creating a circle, holding the sts on the dpn to the back/inside. Align the sts on the dpn with the first 6 (6, 6, 6, 6)[6, 8, 8, 8]{8, 8, 8, 8} sts of the main peplum sts.

To join, *insert the working needle into the 1st st on the circular needle and into the 1st st on the dpn knitwise; work the 2 sts together like a k2tog; 1 st joined. Repeat from * 5 (5, 5, 5, 5)[5, 7, 7, 7]{7, 7, 7, 7} more times; all sts on the dpn have been joined.

Cont to end of rnd as follows: K16 (12, 21, 21, 24)[26, 32, 34, 36]{36, 38, 40, 42}, pm for side seam, k68 (74, 82, 92, 100)[112, 120, 132, 140]{150, 158, 166, 174} back sts, pm for BOR. The remaining 46 (56, 55, 65, 70)[80, 80, 90, 96]{106, 112, 118, 124} sts will remain unworked until the waistband begins—136 (148, 164, 184, 200)[224, 240, 264, 280]{300, 316, 332, 348} sts total.

WAISTBAND

Rnd 1: Purl.

Rnd 2: Knit.

RND 3 - EYELET RND

Size 1 Only: K3, k2tog, yo, (k4, k2tog, yo) 4 times, (k3, k2tog, yo) twice, *k4, k2tog, yo; rep from * to last st, k1—23 eyelets made.

Size 2 Only: K5, k2tog, yo, (k4, k2tog, yo) 10 times, (k5, k2tog, yo) 5 times, (k4, k2tog, yo) 3 times, (k5, k2tog, yo) 4 times—23 eyelets made.

Size 3 Only: K3, k2tog, yo, (k4, k2tog, yo) 11 times, *k5, k2tog, yo; rep from * to last 2 sts, k2—25 eyelets made.

Size 4 Only: K2, k2tog, yo, (k5, k2tog, yo) 12 times, (k6, k2tog, yo) 9 times, (k5, k2tog, yo) 3 times, knit to end—25 eyelets made.

Size 5 Only: K6, k2tog, yo, (k5, k2tog, yo) 12 times, (k6, k2tog, yo), 5 times, (k5, k2tog, yo) 4 times, (k6, k2tog, yo) 5 times—27 eyelets made.

Size 6 Only: K2, k2tog, yo, (k6, k2tog, yo) 3 times, (k5, k2tog, yo) 8 times, *k6, k2tog, yo; rep from * to last 4 sts, k4—29 eyelets made.

Size 7 Only: (K6, k2tog, yo) 4 times, (k5, k2tog, yo) 8 times, *k6, k2tog, yo; rep from * to end—31 eyelets made.

Size 8 Only: K2tog, yo, *k6, k2tog, yo; rep from * to last 6 sts, k6—33 eyelets made.

Size 9 Only: K4, k2tog, yo, *k6, k2tog, yo; rep from * to last 2 sts, k2—35 eyelets made.

Size 10 Only: (K6, k2tog, yo) 5 times, (k5, k2tog, yo) 10 times, (k6, k2tog, yo) 11 times, (k5, k2tog, yo) twice, *k6, k2tog, yo; rep from * to end—39 eyelets made.

Size 11 Only: K3, k2tog, yo, (k6, k2tog, yo) 4 times, (k5, k2tog, yo) 12 times, *k6, k2tog, yo; rep from * to last 3 sts, k3—41 eyelets made.

Size 12 Only: (K6, k2tog, yo) 6 times, (k5, k2tog, yo) 10 times, (k6, k2tog, yo) 13 times, (k5, k2tog, yo) twice, *k6, k2tog, yo; rep from * to end—43 eyelets made.

Size 13 Only: K3, k2tog, yo, (k6, k2tog, yo) 5 times, (k5, k2tog, yo) 12 times, *k6, k2tog, yo; rep from * to last 6 sts, k3—45 eyelets made.

ALL SIZES

Rnd 4: Knit.
Rnd 5: Purl.
Rnd 6: K32 (35, 39, 44, 48)[54, 58, 64, 68] {73, 77, 81, 85}, pm C1, k4, pm C2, knit to end of rnd. These 2 new markers

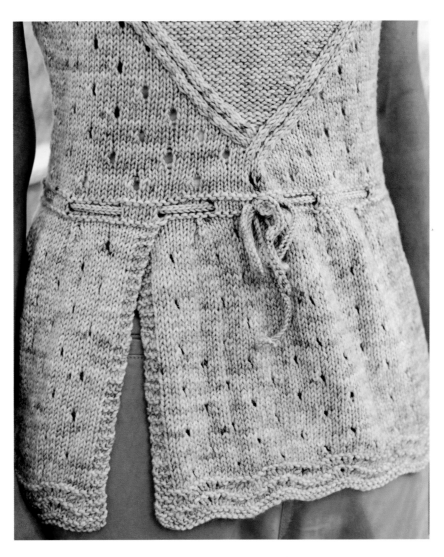

indicate the 4 center sts for the bodice cable pattern.

BODICE SHAPING AND EYELET PATTERN

Note: As you work the Setup Rnd, you may find it helpful to place markers between the repeats of the Eyelet pattern as this rnd will be used to establish the pattern for the remainder of the bodice. The Eyelet pattern will be worked 8 (9, 10, 11, 12)[13, 14, 16, 17]{18, 19, 20, 21} times across the front and back. Once the Center Cable pattern begins on the front, continue the established Eyelet pattern across the back.

Setup Rnd: *K2 (1, 1, 2, 2)[2, 2, 2, 2] {3, 3, 3, 3}, pm A, work Eyelet pattern to 2 (1, 1, 2, 2)[4, 4, 2, 2]{3, 3, 3, 3} sts before SSM (slipping MC1 and MC2 as encountered), pm B, knit to SSM, sm; rep from * once more (placing markers C and D respectively).

Inc Rnd: *K1, M1L, knit to MA, work Eyelet pattern to MB (slipping MC1 and MC2 as encountered), sm, knit to 1 st before MB, M1L, k1, sm; rep from * once more—4 sts inc.

As the bodice is worked, rep Inc Rnd every 8 (6, 6, 8, 8)[12, 12, 12, 12]{16, 16, 16, 16}th rnd, 7 (8, 8, 7, 7)[4, 4, 3, 3]{2, 2, 2, 2} more times. Upon completion of Inc Rnd repeats: 168 (184, 200, 216,

"My dream wouldn't be complete without you in it."

Tiana, *The Princess and the Frog* (2009)

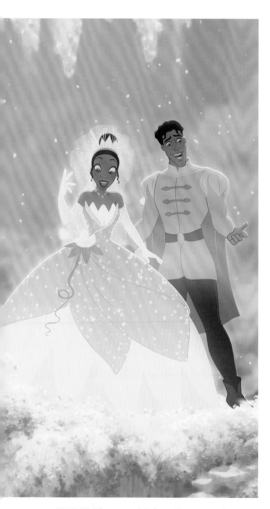

ABOVE: Tiana and Prince Naveen return to their human forms after sealing their marriage with a kiss, from *The Princess and the Frog* (2009).

232)[244, 260, 280, 296]{312, 328, 344, 360} sts total.

Rnd 1: *Knit to MA, sm, work Eyelet pattern to MB (slipping MC1 and MC2 as encountered), sm, knit to MB; rep from * once more (referencing markers C and D respectively).

Rep [Rnd 1] 5 (3, 3, 5, 5)[9, 9, 9, 9]{13, 13, 13, 13} *more* times.

BODICE CENTER CABLE PATTERN

Note: Read through this section carefully before beginning the center panel.

Each cable round has a paired rest row where you will work in est patt across the Eyelet pattern and knit the knits and purl the purls as encountered in the center cable panel. Continue to work the established shaping/inc rnds as the following cable pattern is worked. The Eyelets pattern section will get narrower as the center cable panel gets wider.

BEGIN CENTER CABLE PATTERN FOR ALL SIZES

Rnd 1: Work est patt to MC1, rm, 2/2 RC, rm, work est patt to end of rnd.

Rnds 2, 4, and 6: Work est patt to cable, knit the knits and purl the purls of the cable sts, work in est patt to end of rnd.

Rnd 3: Work est patt to 2 sts before previous cable, 2/2 RPC, 2/2 RC, work est patt to end of rnd.

Rnd 5: Work to 2 sts before first cable 2/2 RPC, 2/2 RC, 2/2 LPC, work est patt to end of rnd.

Rnd 7: Work to 2 sts before first cable, (2/2 RPC) twice, (2/2 LPC) twice, work est patt to end of rnd.

Rnd 8: Work est patt to cable, knit the knits and purl the purls of the cable sts, work in est patt to end of rnd.

Note: The following Shift rnds are the basis of the center cable pattern. They are explained in full here and referenced for each size below. Remember that each Shift rnd has a non-cable paired rnd, noted as "next rnd."

Shift 1 Rnd: Work est patt to 1 st before the cable, 2/1 RPC, p1, 2/1 RPC, purl to the 1st knit st of the next cable, 2/1 LPC, p1, 2/1 LPC, work est patt to end of rnd.

Next Rnd (non-cable pair rnd): Work est patt to cable, knit the knits and purl the purls of the cable/center sts, work in est patt to end of rnd.

Shift 2 Rnd: Work est patt to 2 sts before the cable, 2/2 RPC, 2/2 RPC, to the 1st knit st of the next cable, 2/2 LPC, 2/2 LPC, work est patt to end of rnd.

Next Rnd (non-cable pair rnd): Work est patt to cable, knit the knits and purl the purls of the cable/center sts, work in est patt to end of rnd.

CONTINUE CENTER CABLE PATTERN PER SIZE

SIZE 1

*Work Shift 1 Rnd once, work Shift 2 Rnd once; rep from * 4 *more* times (20 rnds worked).

Work Shift 1 Rnd 5 times total (10 rnds worked).

SIZE 2

*Work Shift 1 Rnd once, work Shift 2 Rnd once; repeat from * 3 *more* times (16 rnds worked).

Work Shift 1 Rnd 10 times total (20 rnds worked).

SIZE 3

Work Shift 2 Rnd 2 times total (4 rnds worked).

*Work Shift 1 Rnd once, work Shift 2 Rnd once; rep from * 2 *more* times (12 rnds worked).

Work Shift 1 Rnd 11 times total (22 rnds worked).

SIZE 4

Work Shift 2 Rnd 6 times total (12 rnds worked).

Work Shift 1 Rnd once, work Shift 2 Rnd once (4 rnds worked).

Work Shift 1 Rnd 11 times total
(22 rnds worked).

SIZE 5

Work Shift 2 Rnd 7 times total
(14 rnds worked).

Work Shift 1 Rnd once, work Shift
2 Rnd once (4 rnds worked).

Work Shift 1 Rnd 11 times total
(22 rnds worked).

SIZE 6

Work Shift 2 Rnd 10 times total
(20 rnds worked).

*Work Shift 1 Rnd once, work Shift
2 Rnd once; rep from * once more
(8 rnds worked).

Work Shift 1 Rnd 3 times total
(6 rnds worked).

SIZE 7

Work Shift 2 Rnd 10 times total
(20 rnds worked).

*Work Shift 1 Rnd once, work Shift
2 Rnd once; rep from * 2 *more* times
(12 rnds worked).

Work Shift 1 Rnd 5 times total
(10 rnds worked).

SIZE 8

Work Shift 2 Rnd 13 times total
(26 rnds worked).

*Work Shift 1 Rnd once, work Shift
2 Rnd once; rep from * 2 *more* times
(12 rnds worked).

Work Shift 1 Rnd 3 times total
(6 rnds worked).

SIZE 9

Work Shift 2 Rnd 13 times total
(26 rnds worked).

*Work Shift 1 Rnd once, work Shift
2 Rnd once; rep from * 3 *more* times
(16 rnds worked).

Work Shift 1 Rnd 2 times total
(4 rnds worked).

SIZE 10

Work Shift 2 Rnd 15 times total
(30 rnds worked).

*Work Shift 1 Rnd once, work Shift
2 Rnd once; rep from * 2 *more* times
(12 rnds worked).

Work Shift 1 Rnd 2 times total
(4 rnds worked).

SIZE 11

Work Shift 2 Rnd 15 times total
(30 rnds worked).

*Work Shift 1 Rnd once, work Shift
2 Rnd once; rep from * 2 *more* times
(12 rnds worked).

Work Shift 1 Rnd 3 times total
(6 rnds worked).

SIZE 12

Work Shift 2 Rnd 15 times total
(30 rnds worked).

*Work Shift 1 Rnd once, work Shift
2 Rnd once; rep from * 2 *more* times
(12 rnds worked).

Work Shift 1 Rnd 5 times total
(10 rnds worked).

SIZE 13

Work Shift 2 Rnd 15 times total
(30 rnds worked).

*Work Shift 1 Rnd once, work Shift
2 Rnd once; rep from * 3 *more* times
(16 rnds worked).

Work Shift 1 Rnd 4 times total
(8 rnds worked).

Cable panel width is 56 (60, 64, 68, 72)[74,
84, 92, 96]{98, 100, 104, 108} sts wide.

ALL SIZES

Next Rnd: Work est patt to 1 st before
the cable, (p1, k2, p1) twice, purl to the
next cable, k2, p2, k2, p1, work est patt
to end of rnd.

Rep this last rnd until the bodice
measures 9¼ (9¼, 9½, 9½, 9½)[10, 10,
10½, 10½]{10½, 10¾, 10¾, 10¾} in. /
23.5 (23.5, 24.5, 24.5, 24.5)[25.5, 25.5,
26.5, 26.5]{26.5, 27.5, 27.5, 27.5} cm

from the top of the waistband—168
(184, 200, 216, 232)[244, 260, 280, 296]
{312, 328, 344, 360} sts.

FRONT ARMHOLE SHAPING

Setup Row 1 (RS): Remove the BOR m,
BO 6 (6, 6, 6, 7)[7, 7, 8, 8]{8, 8, 9, 9}
sts using the K2tog Bind Off method,
work in est patt to SSM, remove SSM.
Place the rem unworked sts on waste
yarn to be worked separately (these
will make up the back)—78 (86, 94,
102, 109)[115, 123, 132, 140]{148, 156,
163, 171} sts rem for front.

Setup Row 2 (WS): BO 6 (6, 6, 6, 7)[7, 7,
8, 8]{8, 8, 9, 9} sts using the K2tog Bind
Off method, work in est patt (knitting
the knits and purling the purls) to end
of row—72 (80, 88, 96, 102)[108, 116,
124, 132]{140, 148, 154, 162} sts rem.

SIZES 4–13 ONLY

Row 1: BO - (-, -, 6, 7)[7, 7, 8, 8]{8, 8, 9, 9)
sts using the K2tog Bind Off method,
work in est patt (knitting the knits and
purling the purls) to end of row— -
(-, -, 6, 7)[7, 7, 8, 8]{8, 8, 9, 9) sts dec.

Rep [Row 1] - (-, -, 1, 1)[1, 1, 1, 1]{3, 3, 3, 3]
more time(s) (the same instructions
are worked on the RS and WS)— -
(-, -, 84, 88)[94, 102, 108, 116]{108, 116,
118, 126} total sts.

SIZES 1–9 ONLY

Row 1 (RS, dec): K2, k3tog tbl, work est
patt to last 5 sts, k3tog, k2—4 sts dec.

Row 2 (WS, dec): K2, p2tog, work est
patt to last 4 sts, p2tog tbl, k2—
2 sts dec.

Rep [Rows 1 and 2] 1 (1, 2, 1, 1)[1, 0, 1, 1]
{-, -, -, -} *more* time(s)—60 (68, 70, 72,
76)[82, 96, 96, 104]{-, -, -, -} sts rem.

SIZE 3 ONLY

Row 1 (RS, dec): K2, k2tog tbl, work
est patt to last 5 sts, k2tog, k2—
68 total sts.

Row 2 (WS): K2, work est patt to last 2 sts, k2.

SIZES 2, 6, 7 AND 9–13 ONLY

Row 1 (RS, dec): K2, k2tog tbl, work est patt to last 5 sts, k2tog, k2—2 sts dec.

Row 2 (WS, dec): K2, p2tog, work est patt to last 4 sts, p2tog tbl, k2—2 sts dec.

Rep [Rows 1 and 2] - (0, -, -, -)[0, 1, -, 1]{0, 2, 1, 2} *more* time(s)— - (64, -, -, -)[78, 88, -, 100]{104, 104, 110, 114} sts rem.

SIZES 10, 12 AND 13 ONLY

Row 1 (RS, dec): K2, k2tog tbl, work est patt to last 5 sts, k2tog, k2—2 sts dec.

Row 2 (WS): K2, work est patt to last 2 sts, k2— - (-, -, -, -)[-, -, -, -]{102, -, 108, 112} sts rem.

SIZES 7–13 ONLY

Row 1 (RS, dec): Work est patt for 7 sts, k2tog tbl, work est patt to last 9 sts, k2tog, work est patt to end—2 sts dec.

Row 2 (WS): K2, work est patt to last 2 sts, k2.

Rep [Rows 1 and 2] - (-, -, -, -){-, 2, 3, 3} [3, 3, 3, 3] *more* times— - (-, -, -, -)[-, 82, 88, 92]{94, 96, 100, 104} sts rem.

ALL SIZES

Cont in est patt, with no further decreases, until the bodice measures 12¼ (12¼, 12½, 12½, 12½)[13½, 13½, 14¼, 14¼]{14¼, 14¾, 14¾, 14¾} in. / 31 (31, 32, 32, 32)[34.5, 34.5, 36, 36]{36, 37.5, 37.5, 37.5} cm measured from the top of the waistband.

FRONT NECKLINE

Note: The top edge of the center panel will be worked in garter stitch to prevent the edge from rolling.

Row 1 (RS): Work in est patt for 8 sts, knit to last 8 sts, work to end in est patt.

Row 2 (WS): (K2, p2) twice, knit to last 8 sts, (p2, k2) twice.

Row 3 (dec): K3, k2tog tbl, k2tog, knit to last 7 sts, k2tog tbl, k2tog, k3—56 (60, 64, 68, 72)[74, 78, 84, 88]{90, 92, 96, 100} sts.

Row 4: K2, p4, knit to last 6 sts, p4, k2.

Row 5 (dec): K2, k2tog, knit to last 4 sts, k2tog tbl, k2—54 (58, 62, 66, 70)[72, 76, 82, 86]{88, 90, 94, 98} sts.

Row 6: K2, p2, knit to last 4 sts, p2, k2.

Row 7 (bind off): K6, BO 42 (46, 50, 54, 58)[60, 64, 70, 74]{76, 78, 82, 86} sts using the K2tog Bind Off method, knit to end—12 sts rem; 6 sts at end for shoulder straps.

FRONT SHOULDER STRAPS

Note: The 2 straps will be worked separately. You can place the 6 sts of the strap not currently attached to your working yarn on waste yarn to be worked separately, or you can leave them on the needle while this first strap is worked.

Row 1 (WS, dec): K2tog, p2, k2tog—4 sts.

Row 2 (RS): K1, 1/1 LC, k1.

Row 3: K1, p2, k1.

Rep Rows 2 and 3 until the strap measures 4¾ (4¾, 5, 5, 5)[5, 5, 5, 5]{5, 5, 5¼, 5¼} in. / 12 (12, 12.5, 12.5, 12.5)[12.5, 12.5, 12.5, 12.5]{12.5, 12.5, 13.5, 13.5} cm, ending with a RS row. Break yarn; place all live sts on waste yarn.

If not already on the needle, place the live sts of the other shoulder strap onto the working needle. Rejoin the working yarn with the WS facing. Work the same as for the first strap.

BACK ARMHOLE SHAPING

Place the live sts of the back onto the working needle and rejoin the yarn with the RS facing.

Setup Row 1 (RS): BO 6 (6, 6, 6, 7)[7, 7, 8, 8]{8, 8, 9, 9} sts using the K2tog Bind Off method, work in est patt to end—78 (86, 94, 102, 109)[115, 123, 132, 140]{148, 156, 163, 171} sts rem for front.

Beginning with Setup Row 2, work the remainder of the armhole shaping as per front armhole shaping section—60 (64, 68, 72, 76)[78, 82, 88, 92]{94, 96, 100, 104} sts rem.

BACK NECKLINE

Work as per the front neckline—12 sts rem; 6 sts at end for shoulder straps.

BACK SHOULDER STRAPS

Work as per front shoulder straps.

FINISHING

Place the live sts of the front and back shoulder straps for 1 strap onto 2 needles held parallel. Using a third needle, seam the live sts of each strap using the Three Needle Bind Off method. Repeat for the second strap.

Weave in all ends. Wet block tank to the dimensions provided in the schematic. Allow to dry completely. Trim any remaining ends.

CROCHET BELT

Using the Crochet Cord method, create a crochet belt that is 50 (52, 55, 59, 62)[67, 70, 73, 76]{80, 83, 86, 89} in. / 127 (132, 140, 150, 157.5)[170, 178, 185.5, 193]{203, 211, 218.5, 226} cm in length.

Starting at the center front eyelet in the waistband of the tank, weave the belt through the eyelets so that the long tails of each end of the belt enter and exit the same eyelet.

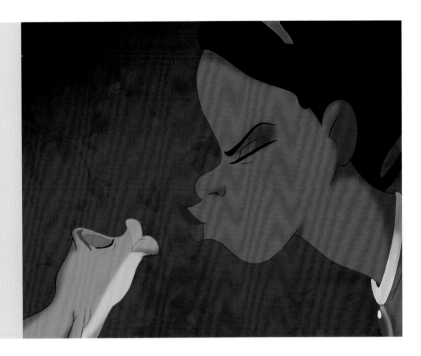

Disney

FUN FACTS

Animators used traditional pencil and paper to bring the characters of *The Princess and the Frog* to life, then scanned them into computers to have backgrounds and special effects added and colored.

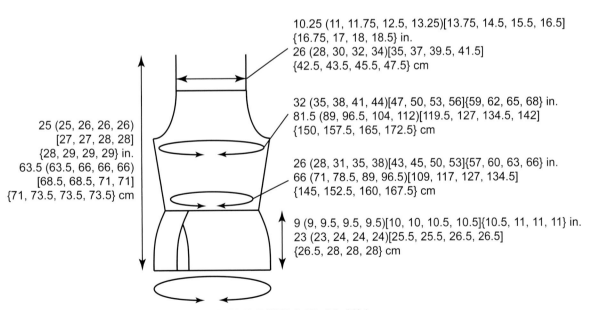

10.25 (11, 11.75, 12.5, 13.25)[13.75, 14.5, 15.5, 16.5]{16.75, 17, 18, 18.5} in.
26 (28, 30, 32, 34)[35, 37, 39.5, 41.5]{42.5, 43.5, 45.5, 47.5} cm

32 (35, 38, 41, 44)[47, 50, 53, 56]{59, 62, 65, 68} in.
81.5 (89, 96.5, 104, 112)[119.5, 127, 134.5, 142]{150, 157.5, 165, 172.5} cm

26 (28, 31, 35, 38)[43, 45, 50, 53]{57, 60, 63, 66} in.
66 (71, 78.5, 89, 96.5)[109, 117, 127, 134.5]{145, 152.5, 160, 167.5} cm

9 (9, 9.5, 9.5, 9.5)[10, 10, 10.5, 10.5]{10.5, 11, 11, 11} in.
23 (23, 24, 24, 24)[25.5, 25.5, 26.5, 26.5]{26.5, 28, 28, 28} cm

25 (25, 26, 26, 26)
[27, 27, 28, 28]
{28, 29, 29, 29} in.
63.5 (63.5, 66, 66, 66)
[68.5, 68.5, 71, 71]
{71, 73.5, 73.5, 73.5} cm

39 (40, 45.5, 50, 56)[60.5, 65, 69.5, 74]{76.5, 79, 81, 83} in.
99 (101.5, 115.5, 127, 142)[155.5, 165, 176.5, 188]{194, 200.5, 205.5, 211} cm
*Circumference / length of peplum before overlapping at waistband

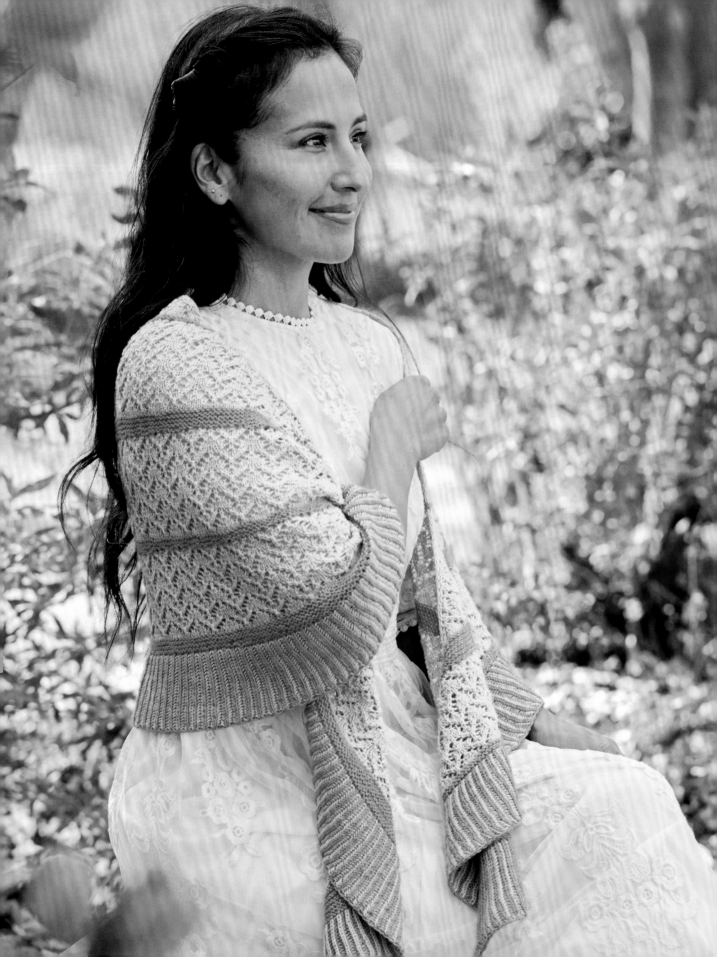

Cinderella "A Wonderful Dream" Shawl

Designed by JOAN FORGIONE

SKILL LEVEL: ❤ ❤

Cinderella is on the verge of giving up her dream of going to the ball after having her dress torn to shreds by her wicked stepsisters. But while the girl is heartbroken, her faith isn't completely destroyed, and she is rewarded by the appearance of her Fairy Godmother, who with a wave or two of her magic wand, changes everything. It is, in Cinderella's own words, a "wonderful dream come true." Likewise was the film itself for Walt Disney. With the studio struggling in the aftermath of World War II, the huge success of *Cinderella* at the box office, along with its many awards and accolades, was a much-needed win for Disney. It enabled him to greatly expand his animation studio and helped fund many other dream projects, including the start of production on Disneyland in California. After the achievement of *Cinderella*, Disney said, "There's something about that story I associate with."

Inspired by Cinderella and her unwavering faith in her dreams, this two-colored crescent shawl is worked from the top down beginning with an i-cord tab. It alternates bands of easy German short-row garter stitch and elegant simple lace, symbolizing Cinderella's transformation from humble servant girl into graceful lady ready for the ball. The border edge is worked in two-color brioche ribbing, suggesting that she is easily able to blend her two lives, all while remaining the same kindhearted and gracious person. It's the perfect accessory for a night out on the town or at the ball.

SIZE
One size

FINISHED MEASUREMENTS
Wingspan: 68 in. / 172.5 cm
Depth at center: 19 in. / 48.5 cm

YARN
Fingering weight (super fine #1) yarn, shown in Spun Right Round *Classic Sock* (100% superwash merino; 438 yd. / 401 m per 3½ oz. / 100 g hank)
Main Color (MC): Sapphire Sky, 2 hanks
Contrast Color (CC): Goldenrod, 1 hank

NEEDLES
- US 4 / 3.5 mm, 16 in. / 40 cm and 32 in. / 80 cm long circular needle or size needed to obtain gauge

NOTIONS
- Waste yarn
- US E-4 / 3.5 mm crochet hook
- Stitch markers (2)
- Row counter (optional)
- Tapestry needle

GAUGE
24 sts and 32 rows = 4 in. / 10 cm over lace pattern, taken after blocking
Make sure to check your gauge.

NOTES
- This crescent shawl is knit flat from the top down, beginning with an i-cord tab cast on, in alternating bands of lace and garter stitch. The shawl ends with two-color brioche ribbing.
- Two sts are increased every row; stitch counts are provided at the end of each row where repeats do not occur.
- Slip the first three sts of each row to form the i-cord edge along the top of the shawl.

continued on page 132

- Gauge is not critical to this project's construction; however, a change in gauge will affect the finished measurements and the yarn requirements.
- Written and charted instructions are provided for the body of the shawl. The two-color brioche border uses written instructions only.

I-CORD TAB CAST ON

With waste yarn and crochet hook, provisionally CO 3 sts. With MC and 16 in. / 40 cm circular, work a 3-st i-cord for 8 rows.

Next Row (RS): K3, do not slide. At the end of the row, pm, rotate work 90 degrees and pick up the right leg of 5 sts evenly spaced along the edge of the i-cord, pm; carefully undo the provisional CO and place the 3 live sts onto the longer gauge-size needle. With the shorter needle, k3 from the longer needle—11 sts total.

BODY

Continue with shorter knitting needle until increases require a longer needle to be used.

Setup Row (WS): Sl3 wyif, sm, p1, yo, p3, yo, p1, sm, p3—13 sts.

Work Setup Chart once or follow the written instructions:

Row 1 (RS): Sl3 wyib, sm, k1, yo, k5, yo, k1, sm, k3—15 sts.

Row 2 (WS): Sl3 wyif, sm, p1, yo, p7, yo, p1, sm, p3—17 sts.

Row 3: Sl3 wyib, sm, k1, yo, k2, k2tog, yo, k1, yo, ssk, k2, yo, k1, sm, k3—19 sts.

Row 4: Sl3 wyif, sm, p1, yo, p11, yo, p1, sm, p3—21 sts.

Row 5: Sl3 wyib, sm, k1, yo, k2tog, yo, k1, yo, ssk, k3, k2tog, yo, k1, yo, ssk, yo, k1, sm, k3—23 sts.

Row 6: Sl3 wyif, sm, p1, yo, p15, yo, p1, sm, p3—25 sts.

Row 7: Sl3 wyib, sm, k1, yo, (k1, k2tog, yo, k3, yo, ssk) twice, k1, yo, k1, sm, k3—27 sts.

Row 8: Sl3 wyif, sm, p1, yo, p19, yo, p1, sm, p3—29 sts.

Row 9: Sl3 wyib, sm, k1, yo, k1, (yo, s2kp, yo, k5) twice, yo, s2kp, (yo, k1) twice, sm, k3—31 sts.

Row 10: Sl3 wyif, sm, p1, yo, p23, yo, p1, sm, p3—33 sts.

SECTION 1 - LACE

Work Lace Chart 4 times or follow the written instructions:

Row 1 (RS): Sl3 wyib, sm, k1, yo, (k2, k2tog, yo, k1, yo, ssk, k1) to last 5 sts, k1, yo, k1, sm, k3—2 sts inc.

Rows 2, 4, and 6 (WS): Sl3 wyif, sm, p1, yo, purl to last 4 sts, yo, p1, sm, p3—2 sts inc.

Row 3: Sl3 wyib, sm, k1, yo, k2tog, yo, (k1, yo, ssk, k3, k2tog, yo) to last 7 sts, k1, yo, ssk, yo, k1, sm, k3—2 sts inc.

Row 5: Sl3 wyib, sm, k1, yo, k1, k2tog, yo, k1, (k2, yo, ssk, k1, k2tog, yo, k1) to last 9 sts, k2, yo, ssk, k1, yo, k1, sm, k3—2 sts inc.

Row 7: Sl3 wyib, sm, k1, yo, k1, (yo, s2kp, yo, k5) to last 8 sts, yo, s2kp, (yo, k1) twice, sm, k3—2 sts inc.

Row 8: Sl3 wyif, sm, p1, yo, purl to last 4 sts, yo, p1, sm, p3—2 sts inc.

Rep [Rows 1–8] 3 more times—97 sts.
Note: 16 sts are increased each repeat. Stitch counts after each repeat are as follows: 49, 65, 81, and 97.

SECTION 2 - GARTER WEDGE LEFT

Join CC. Do not break MC; carry it loosely up the edge.

Row 1 (RS): Sl3 wyib, sm, k1, yo, knit to last 4 sts, yo, k1, sm, k3—99 sts.

Row 2 (WS): Sl3 wyif, sm, k1, yo, knit to last 4 sts, yo, k1, sm, p3—101 sts.

Short Row 3: Sl3 wyib, sm, k1, yo, knit to last 20 sts, turn—102 sts.

Short Row 4: DS, knit to last 4 sts, yo, k1, sm, p3—103 sts.

Short Row 5: Sl3 wyib, sm, k1, yo, knit to 20 sts before previous DS, turn—1 st inc.

Short Row 6: DS, knit to last 4 sts, yo, k1, sm, p3—1 st inc.

Rep Short Rows 5 and 6 twice more.

Row 11 (RS): Sl3 wyib, sm, k1, yo, knit to last 4 sts processing all DS knitwise as encountered, yo, k1, sm, k3—111 sts.

Row 12 (WS): Sl3 wyif, sm, k1, yo, knit to last 4 sts, yo, k1, sm, p3—113 sts.

SECTION 3 - LACE

Change to MC. Do not break CC; carry it loosely up the edge.

Work Lace Chart 5 times or work Rows 1–8 of Section 1 - Lace written instructions 5 times—193 sts.

Note: 16 sts are increased each repeat. Stitch counts after each repeat are as follows: 129, 145, 161, 177, and 193.

SECTION 4 - GARTER WEDGE RIGHT

Change to CC. Do not break MC; carry it loosely up the edge.

Row 1 (RS): Sl3 wyib, sm, k1, yo, knit to last 4 sts, yo, k1, sm, k3—195 sts.

Row 2 (WS): Sl3 wyif, sm, k1, yo, knit to last 4 sts, yo, k1, sm, p3—197 sts.

Row 3: Work as per Row 1—199 sts.

Short Row 4: Sl3 wyif, sm, k1, yo, knit to last 40 sts, turn—200 sts.

Short Row 5: DS, knit to last 4 sts, yo, k1, sm, k3—201 sts.

Short Row 6: Sl3, wyif, sm, k1, yo, knit to 40 sts before previous DS, turn—1 st inc.

Short Row 7: DS, knit to last 4 sts, yo, k1, sm, k3—1 st inc.

Rep Short Rows 6 and 7 twice more.

Row 12 (WS): Sl3 wyif, sm, k1, yo, knit to last 4 sts processing all DS knitwise as encountered, yo, k1, sm, p3—209 sts.

SECTION 5 - LACE

Change to MC. Do not break CC; carry it loosely up the edge.

Work Lace Chart 5 times or work Rows 1–8 of Section 1 - Lace written instructions 5 times—289 sts.

Note: 16 sts are increased each repeat. Stitch counts after each repeat are as follows: 225, 241, 257, 273, and 289.

SECTION 6 - GARTER WEDGE LEFT

Change to CC. Do not break MC; carry it loosely up the edge.

Row 1 (RS): Sl3 wyib, sm, k1, yo, knit to last 4 sts, yo, k1, sm, k3—291 sts.

Row 2 (WS): Sl3 wyif, sm, k1, yo, knit to last 4 sts, yo, k1, sm, p3—293 sts.

Short Row 3: Sl3 wyib, sm, k1, yo, knit to last 59 sts, turn—294 sts.

Short Row 4: DS, knit to last 4 sts, yo, k1, sm, p3—295 sts.

Short Row 5: Sl3 wyib, sm, k1, yo, knit to 59 sts before previous DS, turn—1 st inc.

Short Row 6: DS, knit to last 4 sts, yo, k1, sm, p3—1 st inc.

Rep Short Rows 5 and 6 twice more.

Row 11 (RS): Sl3 wyib, sm, k1, yo, knit to last 4 sts processing all DS knitwise as encountered, yo, k1, sm, k3—303 sts.

Row 12 (WS): Sl3 wyif, sm, k1, yo, knit to last 4 sts, yo, k1, sm, p3—305 sts.

SECTION 7 - LACE

Change to MC. Do not break CC; carry it loosely up the edge.

Work Lace Chart 5 times or work Rows 1–8 of Section 1 - Lace written instructions 5 times—385 sts.

Note: 16 sts are increased each repeat. Stitch counts after each repeat are as follows: 321, 337, 353, 369, and 385.

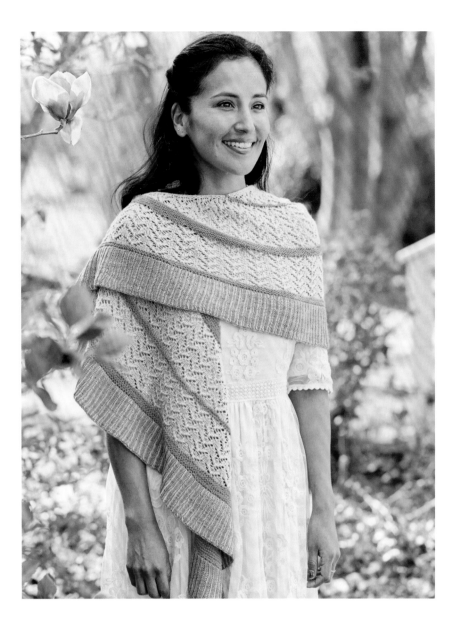

SECTION 8 - GARTER WEDGE RIGHT

Change to CC. Do not break MC; carry it loosely up the edge.

Row 1 (RS): Sl3 wyib, sm, k1, yo, knit to last 4 sts, yo, k1, sm, k3—387 sts.

Row 2 (WS): Sl3 wyif, sm, k1, yo, knit to last 4 sts, yo, k1, sm, p3—389 sts.

Row 3: Work as per Row 1—391 sts.

Short Row 4: Sl3 wyif, sm, k1, yo, knit to last 79 sts, turn—392 sts.

Short Row 5: DS, knit to last 4 sts, yo, k1, sm, k3—393 sts.

Short Row 6: Sl3, wyif, sm, k1, yo, knit to 79 sts before previous DS, turn—1 st inc.

Short Row 7: DS, knit to last 4 sts, yo, k1, sm, k3—1 st inc.

Rep Short Rows 6 and 7 twice more.

Row 12 (WS): Sl3 wyif, sm, k1, yo, knit to last 4 sts processing all DS knitwise as encountered, yo, k1, sm, p3—401 sts.

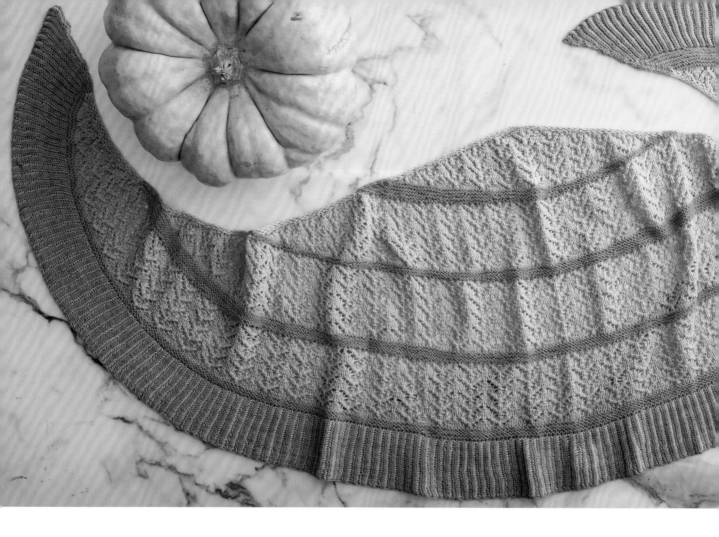

BRIOCHE RIB

In this section, following Setup Row 1, each row will be worked twice: once with CC and once with MC. Each row indicator will tell you which side of the work you are working on and which color you will use. The i-cord edging is now complete. The rate of shaping changes within this section; increased stitches are noted at the end of Row 5.

Setup Row 1 (RS, CC): Knit to end. Turn.

Setup Row 2 (WS, CC): P1, *sl1yo, p1; rep from * to end. Do not turn, slide.

Setup Row 3 (WS, MC): Sl1 wyib, *brk1, sl1yo; rep from * to last 2 sts, brk1, sl1 wyib. Turn.

Row 1 (RS, CC): K1, *sl1yo, brk1; rep from * to last 2 sts, sl1yo, k1. Do not turn, slide.

Row 2 (RS, MC): Sl1 wyif, *brp1, sl1yo; rep from * to last 2 sts, brp1, sl1 wyif. Turn.

Row 3 (WS, CC): P1, *sl1yo, brp1; rep from last 2 sts, sl1yo, p1. Do not turn, slide.

Row 4 (WS, MC): Sl1 wyib, *brk1, sl1yo; rep from * to last 2 sts, brk1, sl1 wyib. Turn.

Row 5 (RS, CC, inc): K1, sl1yo, brkyobrk, *sl1yo, brk1; rep from * to last 4 sts, sl1yo, brkyobrk, sl1yo, k1. Do not turn, slide—4 sts inc.

Row 6 (RS, MC): Sl1 wyif, brp1, sl1yo, p1, sl1yo, *brp1, sl1yo; rep from * to last 4 sts, p1, sl1yo, brp1, sl1 wyif. Turn.

Row 7 (WS, CC): P1, *sl1yo, brp1; rep from * to last 2 sts, sl1yo, p1. Do not turn, slide.

Row 8 (WS, MC): Sl1 wyib, *brk1, sl1yo; rep from * to last 2 sts, brk1, sl1 wyib. Turn.

Rep [Rows 1–8] 3 more times—417 sts. Break MC.

BIND OFF

With RS facing, BO all sts with CC using the Elastic Bind Off method, processing any remaining wrapped sts as brk1 as encountered. Break yarn.

FINISHING

Weave in all ends. The ends from the CO and introduction of the CC can be hidden within the tube of i-cord edging. Wet block to finished measurements, creating a smooth, curved top and bottom edge. Once dry, trim all ends.

CHARTS

KEY

- ☐ Knit on RS, purl on WS
- ▨ No stitch
- Ⅴ Slip stitch purlwise: wyib on RS, wyif on WS
- ╱ k2tog
- ╲ ssk
- ⋀ sk2p
- Ｏ yo
- ▭ Pattern repeat
- ▏ Stitch marker placement

SETUP

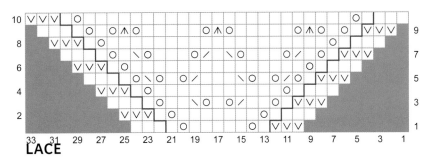

LACE

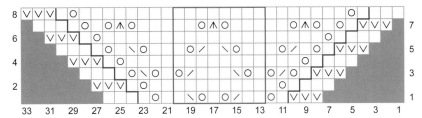

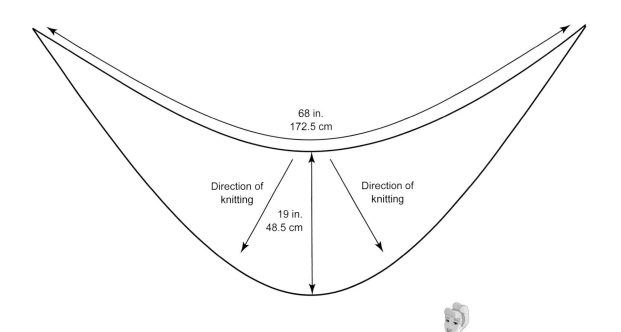

68 in.
172.5 cm

Direction of knitting

Direction of knitting

19 in.
48.5 cm

"Oh, it's a beautiful dress! Did you ever see such a beautiful dress? And look! Glass slippers. Why, it's like a dream. A wonderful dream come true."

Cinderella, *Cinderella* (1950)

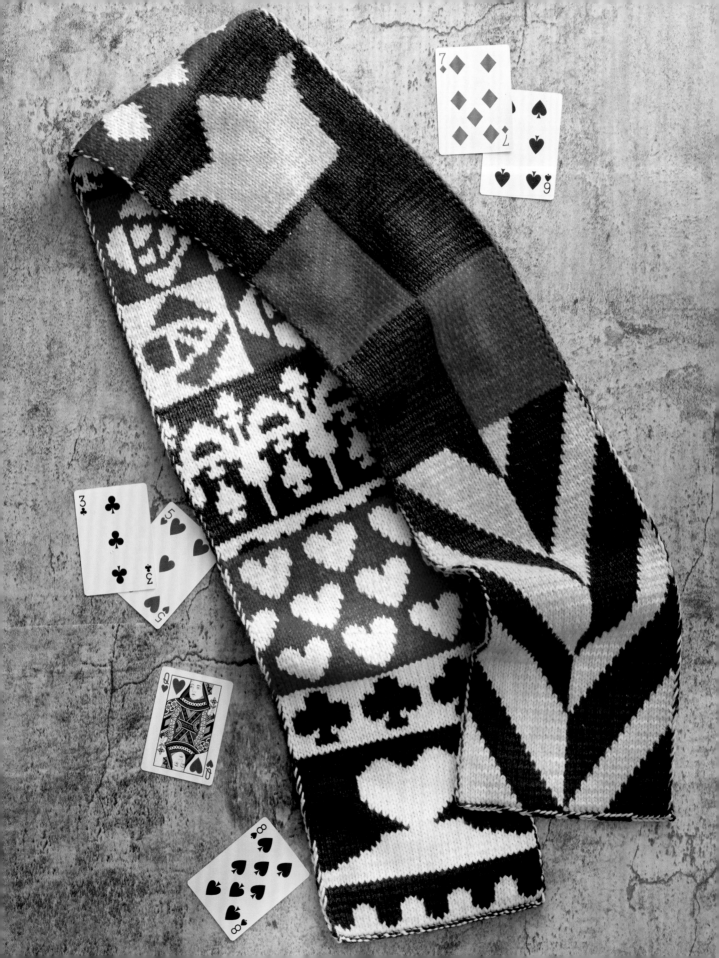

The Queen of Hearts Scarf

Designed by JESSICA GODDARD

SKILL LEVEL: ♥♥

The ruler of Wonderland and one of Disney's early villains, the Queen of Hearts from *Alice in Wonderland* is arrogant and temperamental, with a penchant for ordering beheadings when things don't go the way she wants. Living in a palace surrounded by a massive hedge maze where "all ways are her ways," the tyrannical Queen has gardens full of white roses (that should have been red), an army of terrified playing cards, and a tiny, meek king for a husband—the only person she shows any kindness toward. Recognizable by her iconic black, red, white, and yellow chevron and heart motif dress, she carries a playing card heart fan, and her head is topped by a small golden crown. Her presence is as intimidating as her uncontrollable temper, and she is justly described by Alice as "pompous, bad-tempered old tyrant."

One half of this double-knit graphic scarf is based on the Queen of Hearts's dress with bold chevrons and checks, with the other half based on the shapes found in her manicured garden. Knit flat back and forth from end to end, each individual row is worked in two colors according to the charts. The other side of the scarf works up in the opposite colors, creating an inverted effect. A border stitch is worked at each end of the row to keep the edges as tidy as the hedge maze.

SIZE
One size

FINISHED MEASUREMENTS
Width: 7 in. / 18 cm
Length: 63 in. / 160 cm

YARN
DK weight (light #3) yarn, shown in Urban Girl Yarns *Boston DK* (100% superwash merino; 230 yd. / 210 m per 3½ oz. / 100 g hank)
Main Color (MC): Black Beauty, 2 hanks
Contrast Color 1 (CC1): Bee's Knees, 1 hank
Contrast Color 2 (CC2): The Street Walker, 1 hank
Contrast Color 3 (CC3): Undyed, 1 hank

NEEDLES
• US 6 / 4 mm straight knitting needles or size needed to obtain gauge

NOTIONS
• Tapestry needle

GAUGE
21 sts and 28 rows = 4 in. / 10 cm in 2-color double knitting, taken before blocking
Make sure to check your gauge.

NOTES
• This scarf is worked flat, from end to end, using the Double Knitting method.
• Double knitting is a technique that produces a double thickness of fabric that looks like right-side stockinette stitch on both sides. The two sides of the knitting are inverse colors; the two sides mirror one another.
• The stitch count does not change for the entire length of the scarf.

continued on page 138

- All odd-numbered rows are right side rows and should be read from right to left; all even-numbered rows are wrong side rows and should be read from left to right.
- Green lines in Chart A indicate where it is recommended to swap colors.
- Edge stitches are worked at each end of charted rows to keep the edges neat; these stitches are not represented on the charts.

"Off with their heads!"

Queen of Hearts, *Alice in Wonderland* (1951)

BODY

Holding 1 strand of MC together with 1 strand of CC3, CO 38 sts using the Knitted CO method. Each loop cast on will count as 1 st; 76 sts total are now cast on. To neaten up the CO, rearrange the sts so that they alternate (1 MC st followed by 1 CC3 st) across the row.

Work all charted rows as follows: Sl2 wyif, move working yarn to the back between the needles to begin the chart. Work across the 36 sts of the charted row using the Double Knitting method. To process the final 2 sts of the row, move both working yarns to the back between the needles and work the final 2 sts of the row as a k2tog with both strands of working yarn held together. The 2 strands used to work the final k2tog will be treated as the first 2 sts of the next row (each loop will count as 1 st), so no sts are decreased.

Begin Chart A, joining CC2 as needed. Work Rows 1–219 once (the chart is worked once across each row). Break all yarns once Row 219 is complete.

Join MC and CC1.

Continue Chart A, noting that this section begins on a WS row. Work Rows 220–258 once (the chart is worked once across each row). Break CC1 but not MC once the chart is complete.

Join CC2.

Begin Chart B. Work Rows 1–72 once (the chart is worked once across each row). Break CC2 but not MC once the chart is complete.

Join CC1.

Begin Chart C. Work Rows 1–36 three times total (the chart is worked once across each row). Do not break any yarns.

BIND OFF

Note: The bind off is a variation on the standard method where, instead of knitting every stitch, stitches will be worked in pairs. The bind off will be worked holding 1 strand of MC together with 1 strand of CC1.

Bind off as follows: K2tog, *k2tog, pass 1st st over the 2nd and off the needle (1 st bound off); rep from * to end of row. Break yarn and pull through last st to fasten off.

FINISHING

Weave in the ends carefully by inserting the tail into the tapestry needle and weaving the tail into the hollow of the double knitting. The original sample was not blocked, but if you feel that you would like to smooth out your stitches, you may wish to do a gentle steam block.

Disney

FUN FACTS

Verna Felton, the voice actress for the Queen of Hearts, also lent her voice to the Fairy Godmother in *Cinderella* (1950), Flora the fairy in *Sleeping Beauty* (1959), and Aunt Sarah in *Lady and the Tramp* (1955), to name a few.

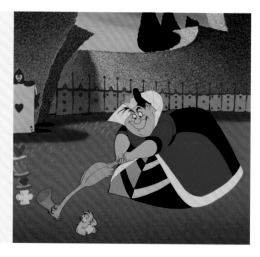

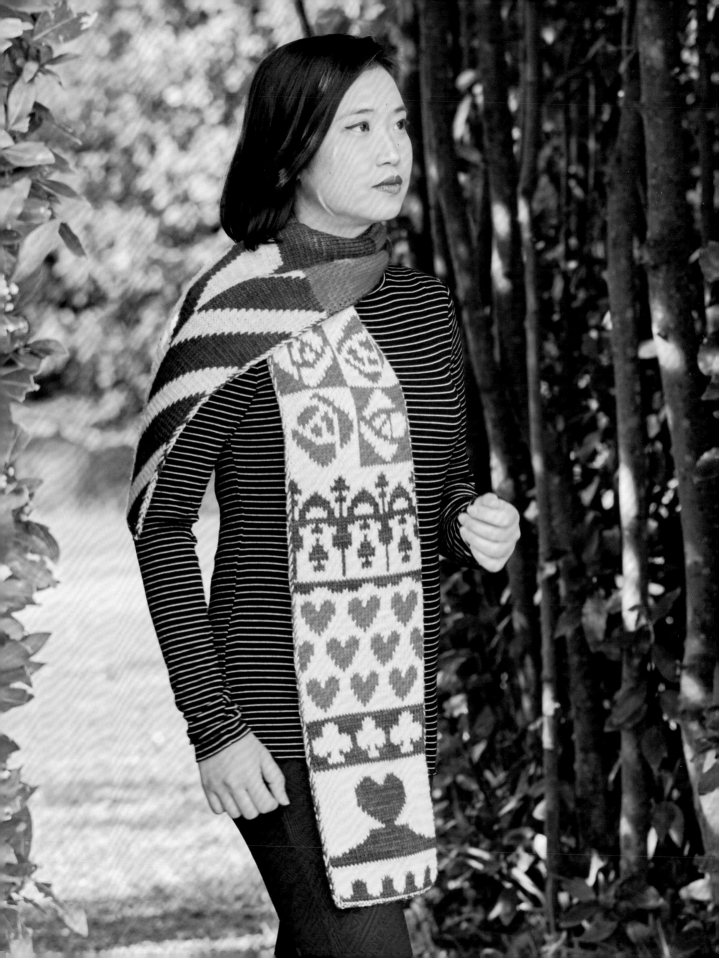

CHARTS

A

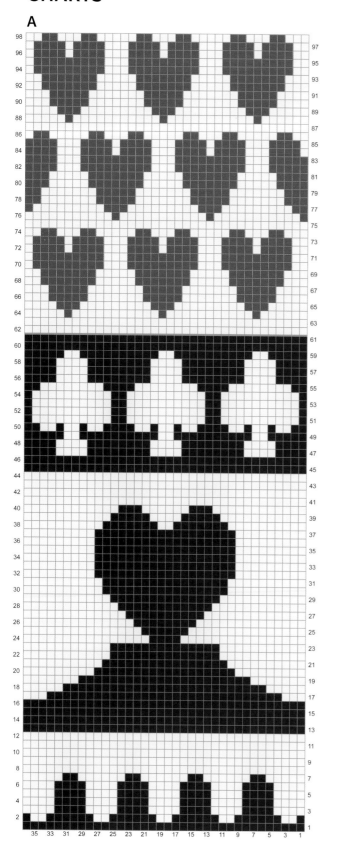

A CONTINUED

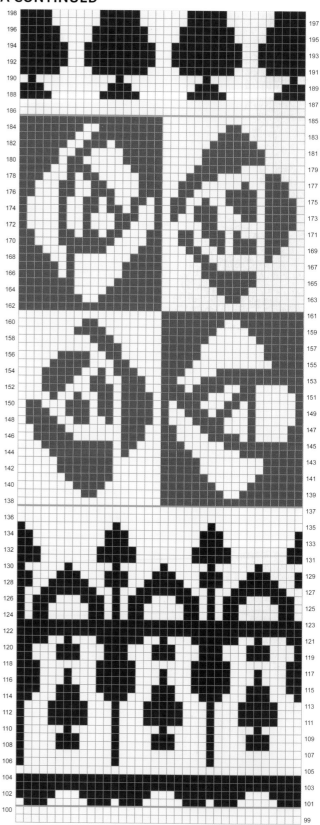

A CONTINUED

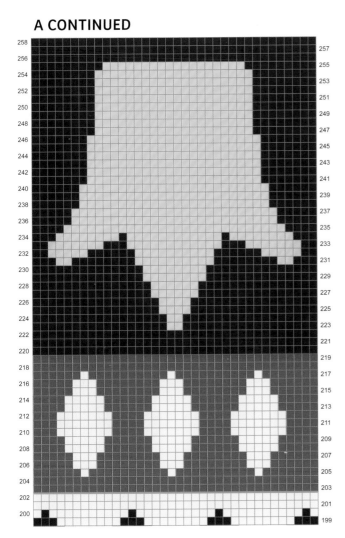

B

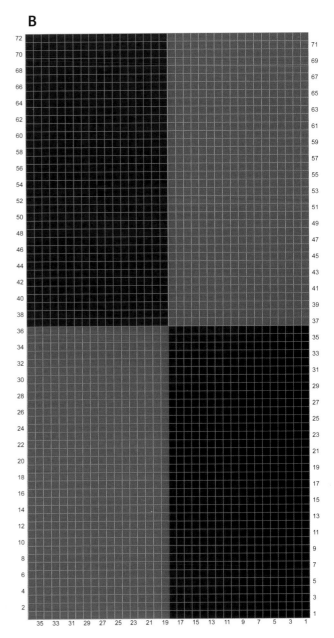

C

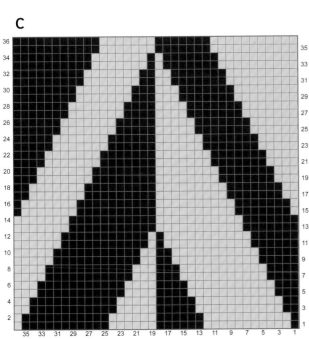

KEY

- ■ MC
- ☐ CC1
- ▨ CC2
- ☐ CC3
- ▢ Pattern repeat

"Pink!" "No, Blue!" Headband

Designed by NICOLE COUTTS

SKILL LEVEL ❤

R eleased in 1959, *Sleeping Beauty* was based on a seventeenth-century fairy tale by Charles Perrault. Walt Disney mostly kept faithful to the original story line in his adaptation save for one big difference: He pared the good fairies down from the original seven to three. According to one story, there was a disagreement in the animation studio on what color Princess Aurora's gown should be—pink or blue. This squabble was ultimately written into the script as an ongoing argument between good fairies Flora and Merryweather and their favorite colors. The result is one of the most enchanting and memorable scenes in the film, when Princess Aurora and Prince Phillip celebrate their happiness by dancing in the clouds, Aurora's gown magically changing back and forth from pink to blue.

Pink or blue? This double-sided stranded colorwork headband with magical sparkle motifs allows you to pick whichever main color you're in the mood for! Beginning with a long tail cast on, the headband is worked in the round with the colors inverted at the halfway point. The stitches are bound off, then grafted together to form a seamless join, making for a double-thick, extra-warm headband suitable for royalty.

SIZE
One size

FINISHED MEASUREMENTS
Circumference: 20 in. / 51 cm
Width: 3¼ in. / 8.5 cm
The headband is designed to be worn with 2–3 in. / 5–7.5 cm negative ease.

YARN
Fingering weight (super fine #1) yarn, shown in LolaBean Yarn Co. *Turtle Bean* (80% superwash merino, 10% cashmere, 10% nylon; 435 yd. / 398 m per 3½ oz. / 100 g hank)
Main Color (MC): Sixteen Candles, 1 hank
Contrast Color (CC): Aurora, 1 hank

NEEDLES
- US 3 / 3.25 mm, 16 in. / 40 cm long circular needle or size needed to obtain gauge

NOTIONS
- Stitch marker
- Tapestry needle

GAUGE
33½ sts and 37 rnds = 4 in. / 10 cm in stranded colorwork, taken after blocking
Make sure to check your gauge.

NOTES
- This headband is worked in the round. The two long edges (the cast on and the bind off) are seamed together to create a closed tube for a seamless headband.
- Written instructions are provided for the construction of the headband; a colorwork chart is provided to direct color changes while the headband is created.

HEADBAND

Using MC, CO 168 sts using the Long Tail CO method. Pm for BOR and join to work in the rnd, being careful not to twist the sts.

Using MC, knit 3 rnds.

Begin chart, reading all rows from right to left as for working in the rnd, joining CC as required. Work Rows 1–56 once (chart is repeated 21 times across rnd). Once complete, break MC.

Using CC, knit 3 rnds.

BO all sts loosely knitwise. Break yarn.

FINISHING

Weave in all ends (this is best done before the headband is sewn into a tube).

Fold the 2 long edges of the headband over on itself so that the RS is facing you and the CO and BO edges are parallel.

Thread the tapestry needle with approx. 1 yd. / 1 m of CC and seam the 2 edges together using the Horizontal Invisible seaming method.

Weave in the tails of the seaming yarn to the inside of the tube.

Wet block the headband to dimensions and allow to dry completely. To further smooth and finish the headband, steam the headband, making sure the seam is flat and neat the whole way around.

Merryweather: "Oh no, not pink. Make it blue."

Flora: "Merryweather! Make it pink."

Sleeping Beauty (1959)

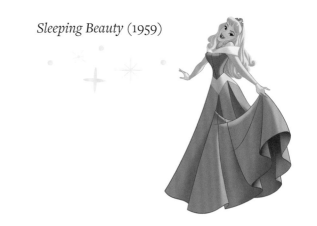

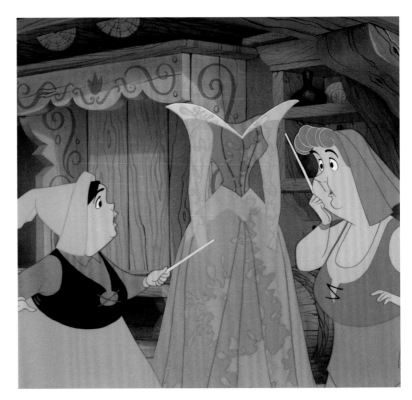

ABOVE: Flora and Merryweather's magical argument over the color of Aurora's dress results in a mishmash of pink and blue in *Sleeping Beauty* (1959).

CHARTS

KEY

⬜	Knit
🟦	MC
🟦	CC
⬜	Pattern repeat

56
55
54
53
52
51
50
49
48
47
46
45
44
43
42
41
40
39
38
37
36
35
34
33
32
31
30
29
28
27
26
25
24
23
22
21
20
19
18
17
16
15
14
13
12
11
10
9
8
7
6
5
4
3
2
1

7 5 3 1

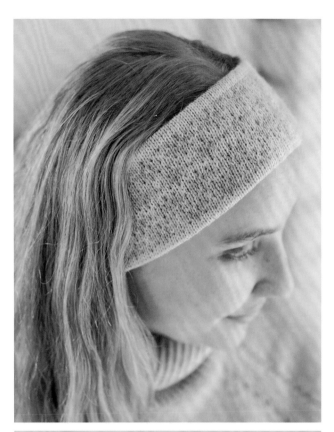

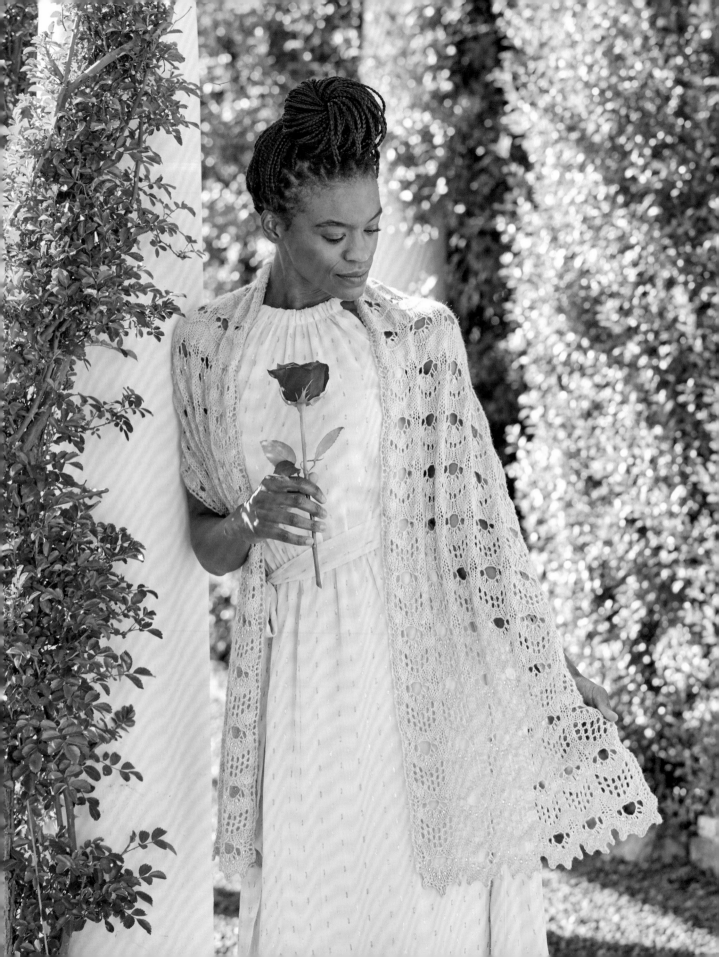

The Belle Shawl

Designed by SUSANNA IC

SKILL LEVEL: ❤ ❤

Bravely sacrificing her freedom to save her father, Belle is initially the Beast's prisoner. As she and the Beast get to know each other, the relationship begins to change, becoming friendly and then romantic. The turning point in their story is also one of the most famous sequences in the movie: the waltz scene in the grand ballroom of the Beast's castle. Belle in her famous yellow dress and the Beast in a royal blue dinner jacket dance across the gilded floor while the camera pans around them, taking in the elaborately decorated walls and gorgeous painted ceiling. The scene is set to the Academy Award®–winning song, "Beauty and the Beast," which describes the deepening relationship between the two main characters as they start to fall in love.

Worthy of any princess, this stunning lace shawl takes its inspiration from Belle's iconic golden ballroom dress with its graceful layers of elegantly ruched fabric. The interesting lace pattern mimics the undulating shapes of Belle's dress, and to further reflect the special occasion, the lace is embellished with sparkling beads. A generously sized rectangle, this shawl is worked seamlessly from a provisional cast on at the center down to both edges. The lace itself is easy to memorize and uses only simple yarn overs and basic decreases, making this project feasible even for a newer lace knitter.

SIZE
One size

FINISHED MEASUREMENTS
Length: 76 in. / 193 cm
Width: 18 in. / 45.5 cm

YARN
Fingering weight (super fine #1) yarn, shown in Anzula Luxury Fibers *Dreamy* (75% superwash merino wool, 15% cashmere, 10% silk; 385 yd. / 352 m per 4 oz. / 114 g hank) in color Canary, 2 hanks

NEEDLES
- US 6 / 4 mm, 24 in. / 60 cm long circular needle or 12 in. / 30 cm straight needles or size needed to obtain gauge

NOTIONS
- Waste yarn
- US H-8 / 5 mm crochet hook
- 410 silver-lined crystal seed beads, size 6/0 / 4 mm
- US 10 / 0.75 mm crochet hook (or smaller as needed to fit through holes of beads)
- Stitch markers (optional)
- Tapestry needle
- Blocking pins
- Blocking wires (optional)

GAUGE
20 sts and 28 rows = 4 in. / 10 cm over St st, taken after blocking
Make sure to check your gauge.

continued on page 148

NOTES

- This rectangular shawl is worked in two identical halves, starting from a provisional cast on at the center of the shawl and down to both ends. The shawl is then blocked to fully open the lace.
- Charted instructions are provided for this shawl.
- It may be helpful to place stitch markers between pattern repeats.
- All of the lace patterning and beading is worked only on the right side of the project; the wrong side rows are rest rows.

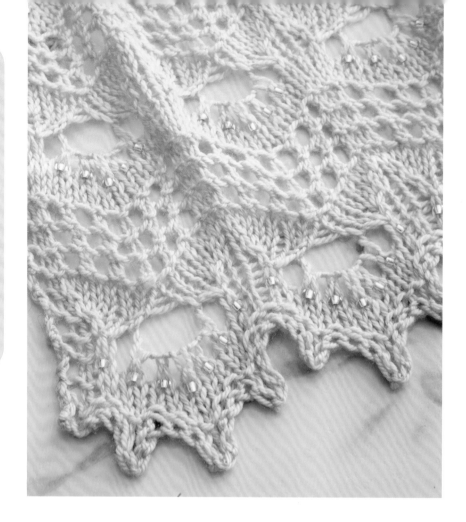

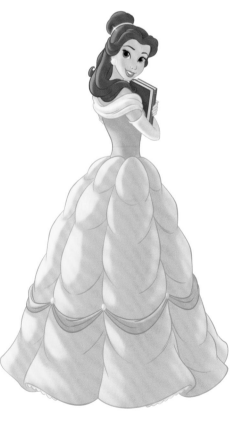

FIRST HALF

SETUP

With waste yarn and larger crochet hook, provisionally CO 89 sts using the Crochet Provisional CO method. Join the working yarn and work the following 2 setup rows:

Setup Row 1 (RS): Knit.

Setup Row 2 (WS): Purl.

BODY

Begin working from the charts as follows:

Chart A: Work Rows 1–16 three times.

Chart B: Work Rows 1–16 three times.

Chart C: Work Rows 1–16 three times.

Chart D: Work Rows 1–18 three times.

Chart E: Work Rows 1–12 once.

Next Row (RS, inc): K2tog, yo, *(k3, kyok) 3 times, k5; rep from * to last 14 sts, (kyok, k3) 3 times, yo, ssk—125 sts.

With the WS facing, BO as follows: *K2tog, k1, return these 2 sts to LHN; rep from * until all sts are bound off. Break yarn.

SECOND HALF

Carefully remove waste yarn and place the 89 live sts on the working needle. Rejoin the working yarn with the WS facing.

Setup Row 1 (WS): Purl.

Work body as for the first half.

FINISHING

Weave in all loose ends, but do not trim. Block piece to measurements. When completely dry, remove pins and trim all yarn tails.

CHARTS

KEY

☐	Knit on RS, purl on WS	╲	ssk
─	Purl on RS, knit on WS	⅄	sssk
▨	No stitch	B	Place bead
╱	k2tog	O	YO
⅄	k3tog	⟋⟍	Make 4 on WS
		☐	Pattern repeat

A

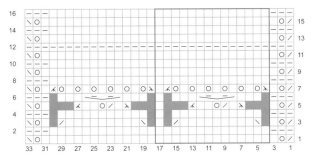

B

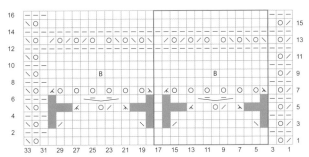

C

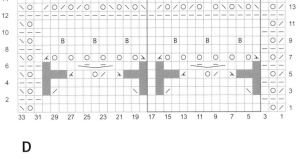

D

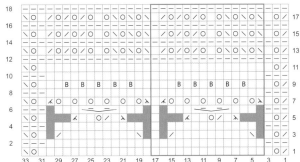

E

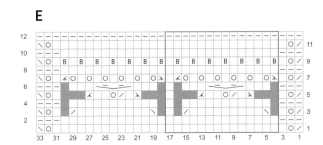

Disney FUN FACTS

In the film, the song "Beauty and the Beast" is performed by Tony Award®–winner Angela Lansbury, the voice of Mrs. Potts. Lansbury was initially hesitant to perform the song but eventually agreed to record it as a backup. She then famously recorded the song in one take, and the production team loved it so much that they kept it in the film.

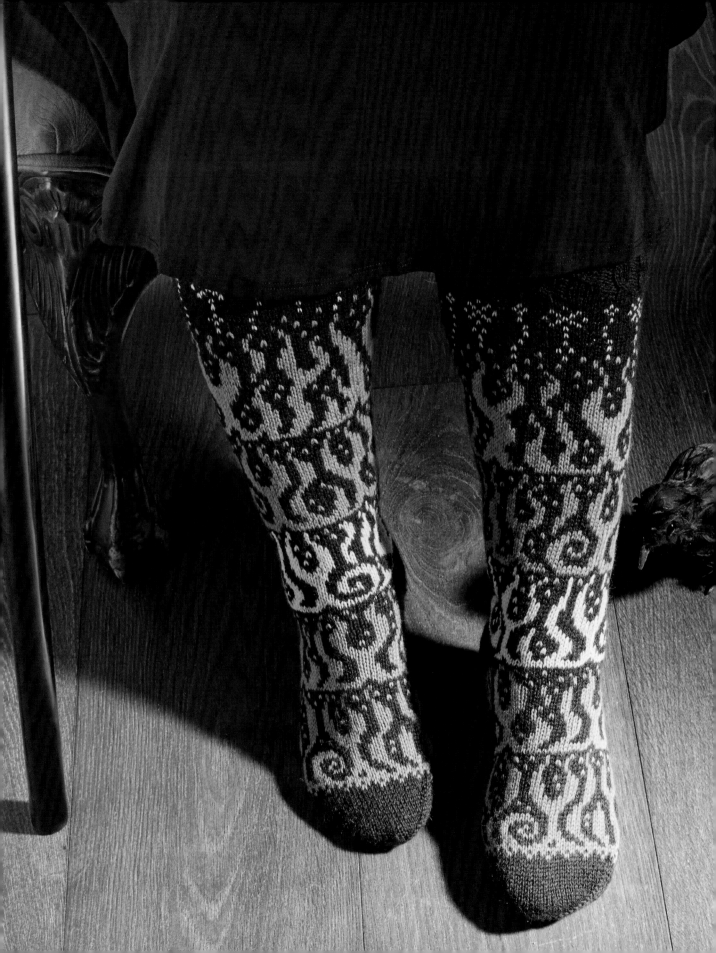

Mistress of Evil Socks

Designed by HEINI PERÄLÄ

SKILL LEVEL ♥♥♥

The self-proclaimed Mistress of All Evil, *Sleeping Beauty*'s Maleficent is one of Disney's most famous and terrifying villains, memorable for her vengeful motivation, powerful magic, and striking look. When designing Maleficent, animator Marc Davis shied away from characterizing her as an old hag with claws and warts and instead depicted her as an elegant, green-skinned, darkly beautiful evil fairy with a pet raven and the ability to shape-shift. With yellow eyes and dark horns, she is clad in green, purple, and black, colors that are commonly used in Disney films to denote the presence of evil. During her climactic battle with Prince Phillip, Maleficent changes into a towering, fire-breathing dragon. It is Phillip's Sword of Truth and Shield of Virtue combined with his true love for Princess Aurora that lead to the fairy's ultimate downfall.

Worked in the round starting with a cabled ribbed cuff, these stranded colorwork knee socks dance with fiery flames, wisps of magic, and other duplicate stitch details. While the colorwork uses four colors, reinforced heel shaping and a reinforced heel flap are worked in one color. The wide wedge toe is closed by cinching the remaining stitches together. As bold as their namesake, these socks are a striking ode to Maleficent's powerful, fiery magic and the unforgettable climax of *Sleeping Beauty*.

SIZES
Small (Medium, Large)
Instructions are written for the smallest size, with larger sizes given in parentheses. When only one number is given, it applies to all sizes.

FINISHED MEASUREMENTS
Foot circumference: 7½ (8½, 9½) in. / 19 (21.5, 24) cm
Upper calf circumference: 11¼ (12½, 14½) in. / 28.5 (32, 36.5) cm
These socks are designed to be worn with ½–1 in. / 1–2.5 cm negative ease.

YARN
Fingering weight (super fine #1) yarn, shown in Filcolana *Arwetta Classic* (80% superwash merino wool, 20% nylon; 230 yd. / 210 m per 1¾ oz. / 50 g skein)
Main Color (MC): #195 Blue Nights, 3 skeins
Contrasting Color 1 (CC1): #197 Aqua, 1 skein
Contrasting Color 2 (CC2): #268 Thistle Flower, 1 skein
Contrasting Color 3 (CC3): #250 Disco Green, 1 skein

NEEDLES
- US 1½ / 2.5 mm set of 5 double-pointed needles or size needed to obtain gauge
- *Finished sizes of socks are relative to gauge. See pattern notes for details.*

NOTIONS
- Stitch marker (optional)
- Cable needle
- Tapestry needle

continued on page 152

GAUGE

Size Small: 36 sts and 37 rnds = 4 in. /
 10 cm in stranded colorwork pattern,
 taken after blocking

Size Medium: 32 sts and 36 rnds = 4 in. /
 10 cm in stranded colorwork pattern,
 taken after blocking

Size Large: 28 sts and 34 rnds = 4 in. /
 10 cm in stranded colorwork pattern,
 taken after blocking

Make sure to check your gauge.

NOTES

- In an effort to honor the original
 design of these socks and ensure a
 wider range of available fit, rather
 than compromise on the stitch
 pattern, these socks have been graded
 using different gauges for each size.
 To achieve the gauge for your finished
 size of sock, adjust your needle size
 if necessary.
- These socks are worked in the round
 from the top down, starting with
 the cable ribbing, and feature a
 reinforced heel flap and wide
 wedge toe.

- When knitting the stranded
 colorwork, make sure you don't knit
 too tight. Use color dominance so
 the contrasting color will be the
 dominant color and the pattern will
 stand out beautifully. Try periodically
 stretching out the stitches you've just
 worked on your needle to keep the
 tension and floats even.
- Duplicate stitches are used to add
 contrast-color single stitches in
 specific sections of the sock. It is
 recommended to work these duplicate
 stitches periodically as you work up
 the leg, gusset, and foot of the sock
 to avoid having to add them all once
 the sock is complete. Each duplicate
 stitch section will use approximately
 2¼ yd. / 2 m of the specific color.
- The colorwork sections of this pattern
 (leg, gusset, and foot) are charted.
 The charts are visually broken into
 four sections representing the
 stitches held on each of the dpns used
 to work the sock.
- These socks are identical; knit two the
 same to complete a pair.

REINFORCED HEEL SHAPING

Short rows are worked to shape the
 bottom of the heel.

Row 1 (RS, dec): [Sl1 wyib, k1] 10 (11, 12)
 times, sl1 wyib, skp. Turn—1 st dec.

Row 2 (WS, dec): Sl1 wyif, p10, p2tog.
 Turn—1 st dec.

Row 3 (dec): [Sl1 wyib, k1] 5 times, sl1
 wyib, skp across the gap. Turn—1 st dec.

Row 4 (dec): Sl1 wyif, p10, p2tog across
 the gap. Turn—1 st dec.

Rep Rows 3 and 4 until only the 12 center
 sts remain.

To prepare to knit in the rnd once again,
 k6 with MC. These 6 sts will remain on
 Needle 4, and this will be the new BOR.

Slip the remaining 6 sts purlwise to
 Needle 1. You will now have a total of
 49 sts: 6 sts each on Needles 1 and 4,
 18 sts on Needle 2, and 19 sts on Needle
 3. Resume knitting in the rnd. Do not
 break MC.

GUSSET

*Note: Read through the Setup Rnd below
 carefully before beginning, to ensure you
 work the correct sts using the correct
 color. The order of colors is also reflected
 in Row 1 of the Gusset Chart.*

Join CC3.

Setup Rnd, by needle:

Needle 1: (K1 with MC, k1 with CC3) 3
 times. Pick up and knit 16 sts along
 the heel flap edge using the Twisted
 Heel Flap method (1 into each slipped
 edge st) and pick up and knit 1 st in
 the corner between the top of the heel
 flap and Needle 2 (17 total sts picked
 up). *AT THE SAME TIME*, work the
 first 14 sts picked up along the heel
 flap edge in (k1 with MC, k1 with CC3)
 pattern; the remaining 3 sts will be
 worked with MC—23 sts total.

Needle 2: K2 with MC, k1 with CC3, k4
 with MC, k1 with CC3, k10 with MC.

LEG

Using MC, CO 96 sts using the Long Tail
 CO method. Distribute the sts so you
 have 24 sts on each needle. Pm for
 BOR and join to work in the rnd, being
 careful not to twist the sts.

Begin Leg chart, reading all rows from
 right to left as for working in the rnd
 and joining CC as required. Work
 Rows 1–117 once (chart is worked
 once across each rnd), catching floats
 as needed (approx every 4th st). At
 the completion of the chart, 69 sts
 will remain. If not already the case,
 redistribute the sts so that there are 16
 sts each on Needles 1 and 4, 18 sts on
 Needle 2, and 19 sts on Needle 3.

REINFORCED HEEL FLAP

The heel flap and heel shaping are
 worked using MC only.

Start the heel flap by knitting across
 the 16 sts of Needle 1 with Needle 4;
 32 heel sts are now on Needle 4. Set
 Needle 1 aside; leave the sts of Needles
 2 and 3 on hold. Turn the work. We
 will now work the heel flap flat, on the
 RS and WS, on Needle 4 only.

Setup Row (WS): Sl1 wyif, purl to end.

Row 1 (RS): *Sl1 wyib, k1; rep from * to
 end.

Row 2 (WS): Sl1 wyif, purl to end.

Rep [Rows 1 and 2] 15 more times.

Needle 3: K3 with MC, k1 with CC3, k7 with MC, k1 with CC3, k4 with MC, k1 with CC3, k2 with MC.

Needle 4: Pick up and knit 1 st in the corner between the top of the heel flap and Needle 3, then pick up and knit 16 sts along the heel flap edge using the Twisted Heel Flap method (1 st into each slipped edge st; 17 total sts picked up). *AT THE SAME TIME*, work the first 3 sts with MC, then work (k1 with CC3, k1 with MC) 7 times. Across the remaining 6 sts from the bottom of the heel shaping, (k1 with CC3, k1 with MC) 3 times—23 sts total.

Once this rnd is complete, you will have 83 sts total.

Beginning on Row 2, reading all rows from right to left as for working in the rnd, work Rows 2–15 of the Gusset Chart once (chart is worked once across each rnd), catching floats as needed. At the completion of the chart you will have 67 sts.

FOOT

Begin Foot chart, reading all rows from right to left as for working in the rnd and joining CC2 as required (break CC3 after Row 22). Work Rows 16–51 once (chart is worked once across each rnd), catching floats as needed. At the completion of the chart, 64 sts will remain. Cut CCs 2 and 3 and, if not already the case, redistribute the sts so that there are 16 sts on each of the 4 needles. Break CC2.

Using MC, work in St st (knitting every rnd) until the foot is 1¾ (2, 2) in. / 4.5 (5, 5) cm short of the desired total length when measured from the back of the heel.

WIDE WEDGE TOE

Rnd 1 (dec): *K to last 3 sts of Needle 1, k2tog, k1, k1, ssk, knit to end of Needle 2; rep from * across Needles 3 and 4—4 sts dec.

Rnd 2: Knit.

Repeat Rnds 1 and 2 three more times—48 sts rem; 12 sts on each needle.

Then repeat Rnd 1 only, 9 more times—12 sts rem; 3 sts on each needle.

Cut MC, leaving an 8 in. / 20 cm tail. Thread the tapestry needle, pull tail through live sts, pull to cinch closed, and secure the tail on the inside of the sock.

FINISHING

Duplicate stitch any remaining sts as per the charts. Weave in all ends and block the socks gently.

"You poor, simple fools, thinking you could defeat me! Me! The mistress of all evil!"

Maleficent, *Sleeping Beauty* (1959)

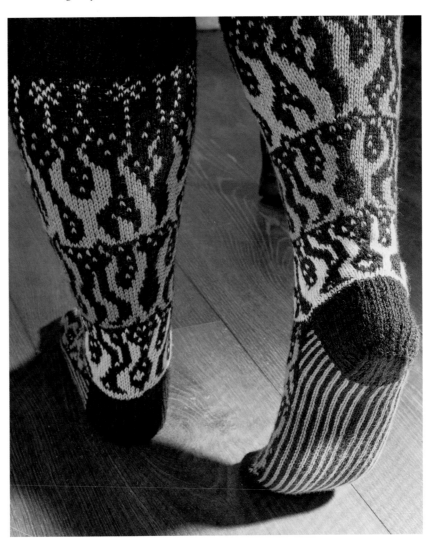

CHARTS

KEY

☐	Knit	■	MC	⟋	M1R		Needle divider
−	Purl	☐	CC1	⟋	k2tog		
☒	Duplicate stitch	■	CC2	⟍	ssk		
▨	No stitch	■	CC3	⬗	C2F		

FOOT

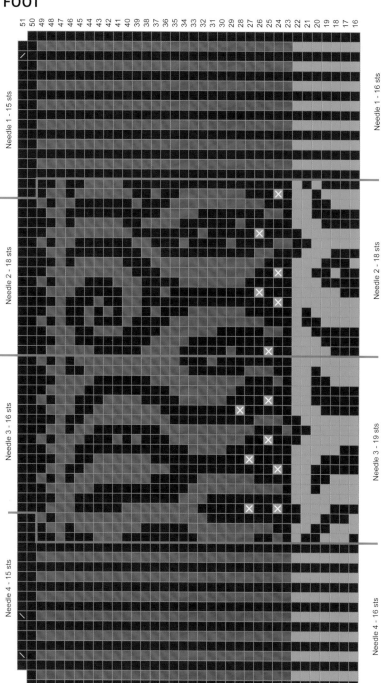

GUSSET

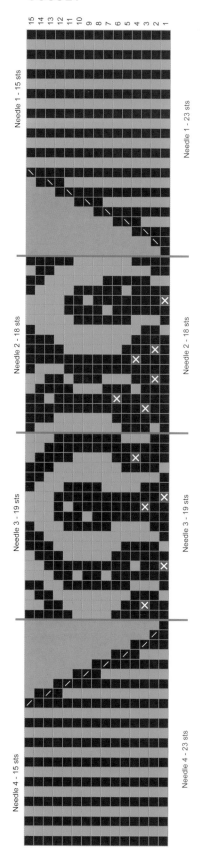

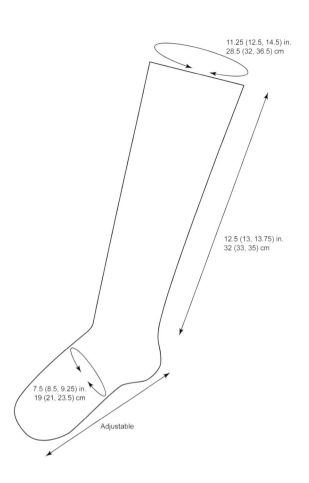

11.25 (12.5, 14.5) in.
28.5 (32, 36.5) cm

12.5 (13, 13.75) in.
32 (33, 35) cm

7.5 (8.5, 9.25) in.
19 (21, 23.5) cm

Adjustable

𝒟𝒾𝓈𝓃𝑒𝓎
FUN FACTS

Sleeping Beauty was the last animated feature hand-inked on celluloid, or cels, by studio artists before they moved to the xerography process. It was also the first animated film to be shot using Super Technirama 70.

LEG

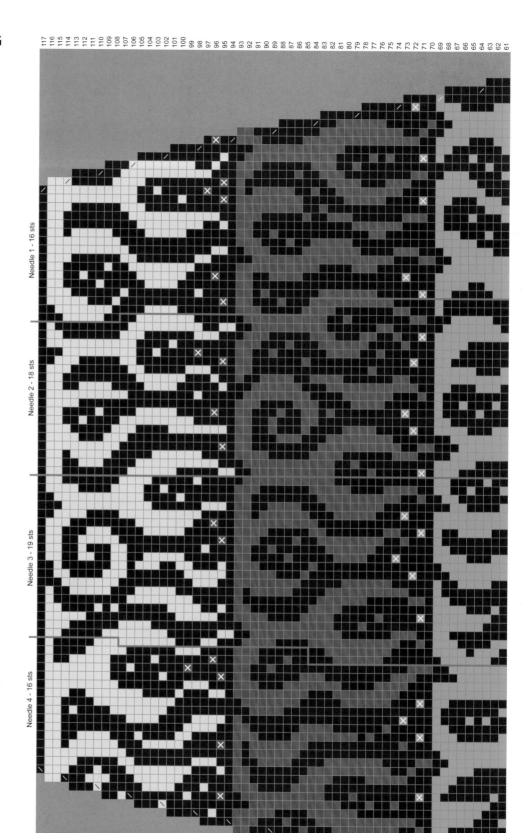

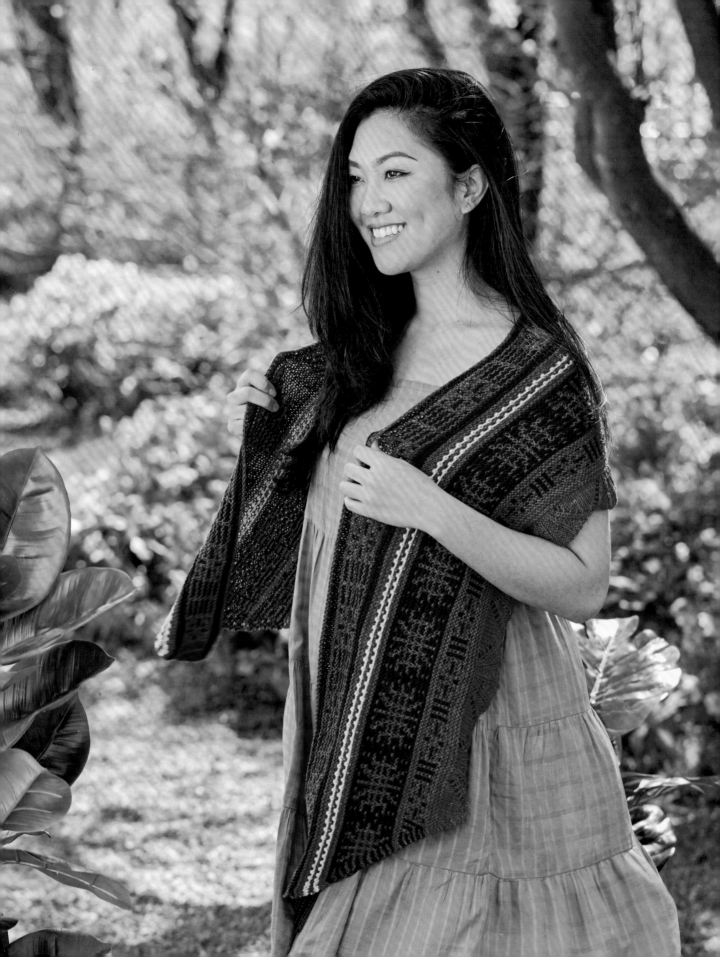

The Moana Shawl

Designed by LISA ROSS

SKILL LEVEL: ♥ ♥

In *Moana* (2016), Disney's fifty-sixth animated feature, the daughter of the Chief of Motunui is drawn again and again to the ocean that surrounds her island. Despite the fact that the island's residents are forbidden to venture beyond the reef, Moana cannot help but long to explore the vast sea, and when the needs of her people match the call of her heart, she sets sail on an adventure of a lifetime. Living in a tropical climate, Moana wears Oceanic-inspired clothing made from natural resources such as a tapa and pandanus, with embroidery and snail shells along the red bodice, symbolizing Pacific Island royalty. Visual development costume designer Neysa Bové was assisted by the Oceanic Story Trust to pay homage to the culture while ensuring historical accuracy and authenticity. Moana's necklace went through over forty revisions, ultimately connecting her to both land and sea, with stars representing her skills as a wayfinder.

In a design inspired by the top Moana wears on her journey, this mosaic shawl is worked from the bottom up. Beginning with the seashell border that naturally creates a scalloped edge, the slip stitches are patterned to give the illusion of a stranded colorwork motif but are knit with just one color at a time. Small white bobbles run the length of the shawl, mimicking her seashells. On the sea or on land, this is the perfect accessory for those charting their own course.

SIZE
One size

FINISHED MEASUREMENTS
Neckline edge length: 70 in. / 178 cm
Depth: 12 in. / 30.5 cm
See schematic for full dimensions.

YARN
Fingering weight (super fine #1) yarn, Miss Babs *Yummy 2-Ply* (100% superwash merino wool; 400 yd. / 365 m per 3.9 oz. / 110 g hank)
Main Color (MC): Londontowne, 2 hanks
Contrast Color 1 (CC1): Dark Chocolate, 1 hank
Contrast Color 2 (CC2): Plover, 1 hank

NEEDLES
- US 5 / 3.75 mm, 40 in. / 100 cm long circular needle or size needed to obtain gauge
- US 6 / 4 mm set of double pointed needles or straight needle (optional, for bind off)

NOTIONS
- Stitch markers (16; optional)
- Blocking wires and pins (for blocking; optional)
- Tapestry needle

GAUGE
21 sts and 44 rows = 4 in. / 10 cm over 2-color mosaic st with smaller needle, taken after blocking
Make sure to check your gauge.

NOTES
- This shawl is worked flat from the bottom up, beginning with a lace scalloped edge. Place markers between the pattern repeats, if desired.

continued on page 160

- When slipping stitches in the mosaic patterning, be sure the yarn is held toward the wrong side of the shawl. When slipping stitches in the shell bobbles, the yarn is held toward the right side when working along the wrong side of the shawl.
- When using multiple colors, the color that is not being used can be carried loosely up the side of the shawl. Do not break yarn unless instructed.
- Read all right side (odd-numbered) chart rows from right to left and all wrong side (even-numbered) chart rows from left to right.
- On noncharted rows where two colors are joined to the work, the color to be used is included in the row indicator [i.e., Row 1 (MC) should be worked using MC only].

SEASHELL BORDER

With MC and gauge-size needle, CO 257 sts using the Twisted German method. Do not join to work in the rnd.

Row 1 (RS): K2, *pm, k2, (p4, k1) 3 times, k4, p2; rep from * to last 2 sts, pm, k2.

Row 2 (WS): K2, sm, *p2, (k4, p1) 3 times, k4, p2, sm; rep from * to last 2 sts, k2.

Row 3 (inc): K2, M1R, sm, *k1, yo, k1, p2, p2tog, (k1, p4) twice, k1, p2tog, p2, k1, yo, k1, sm; rep from * to last 2 sts, M1L, k2—259 sts.

Row 4: K2, p1, sm, *p3, k3, (p1, k4) twice, p1, k3, p3, sm; rep from * to last 3 sts, p1, k2.

Row 5 (inc): K2, M1R, k1, sm, *k2, yo, k1, p3, k1, p2, p2tog, k1, p2tog, p2, k1, p3, k1, yo, k2, sm; rep from * to last 3 sts, k1, M1L, k2—261 sts.

Row 6: K2, p2, sm, *p4, (k3, p1) 4 times, p3, sm; rep from * to last 4 sts, p2, k2.

Row 7: K4, sm, *k3, yo, k1, p1, p2tog, (k1, p3) twice, k1, p2tog, p1, k1, yo, k3, sm; rep from * to last 4 sts, k4.

Row 8: K2, p2, sm, *p5, k2, (p1, k3) twice, p1, k2, p5, sm; rep from * to last 4 sts, p2, k2.

Row 9 (inc): K2, M1R, k2, sm, *k4, yo, k1, p2, k1, p1, p2tog, k1, p2tog, p1, k1, p2, k1, yo, k4, sm; rep from * to last 4 sts, k2, M1L, k2—263 sts.

Row 10: K2, p3, sm, *p6, (k2, p1) 4 times, p5, sm; rep from * to last 5 sts, p3, k2.

Row 11 (inc): K2, M1R, k3, *k5, yo, k1, p2tog, (k1, p2) twice, k1, p2tog, k1, yo, k5, sm; rep from * to last 5 sts, k3, M1L, k2—265 sts.

Row 12: K2, p4, sm, *p7, k1, (p1, k2) twice, p1, k1, p7, sm; rep from * to last 6 sts, p4, k2.

Row 13: K6, sm, *k6, yo, k1, p1, k1, (p2tog, k1) twice, p1, k1, yo, k6, sm; rep from * to last 6 sts, k6.

Row 14: K2, p4, sm, *p8, (k1, p1) 4 times, p7, sm; rep from * to last 6 sts, p4, k2.

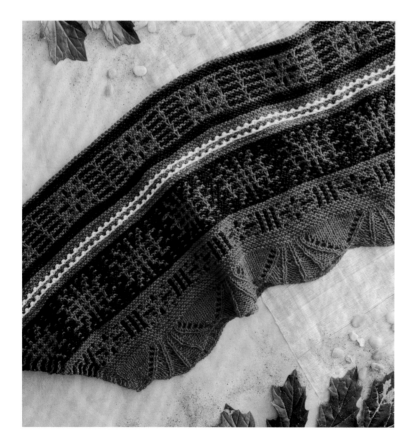

> "I am Moana of Motunui. You will board my boat, sail across the sea, and restore the heart of Te Fiti."
>
> Moana, *Moana* (2016)

Row 15 (inc): K2, M1R, knit to last 2 sts (rm as you come to them), M1L, k2—267 sts.

Row 16: Knit.

Row 17 (inc): K2, M1R, knit to last 2 sts, M1L, k2—2 sts inc.

Rows 18–20: Knit.

Rep Rows 17 and 18 once—271 sts.

MOSAIC BAND 1

Begin Chart A, joining CC1 as required. Work Rows 23–40 once (the 16-st pattern repeat is worked 16 times)—283 sts.

Row 41 (RS, MC, inc): K2, M1R, knit to last 2 sts, M1L, k2—285 sts.

Rows 42–44 (MC): Knit.

MOSAIC BAND 2

Row 45 (RS, CC1, inc): K2, M1R, knit to last 2 sts, M1L, k2—287 sts.

Row 46 (WS, CC1): Knit.

Begin Chart B. Work Rows 47–80 once (the 18-st pattern repeat is worked 15 times)—309 sts.

Row 81 (RS, CC1, inc): K2, M1R, knit to last 2 sts, M1L, k2—311 sts.

Row 82 (WS, CC1): Knit.

Break CC1.

SEASHELL BOBBLES

Row 83 (RS, MC, inc): K2, M1R, knit to last 2 sts, M1L, k2—313 sts.

Rows 84–86 (MC): Knit.

Row 87 (RS, CC2, inc): K2, M1R, *kyok, sl1 wyib; rep from * to last 3 sts, kyok, M1L, k2—315 sts. *Note: The sts that are increased as part of the kyok will be decreased out on the next row so are not included in the overall stitch count provided.*

Row 88 (WS, CC2): K3, *k3tog tbl, sl1 wyib; rep from * to last 6 sts, k3tog tbl, k3.

Row 89 (MC, inc): K2, M1R, knit to last 2 sts, M1L, k2—317 sts.

Row 90 (MC): Knit.

Row 91 (CC2): K3, *kyok, sl1 wyib; rep from * to last 4 sts, kyok, k3.

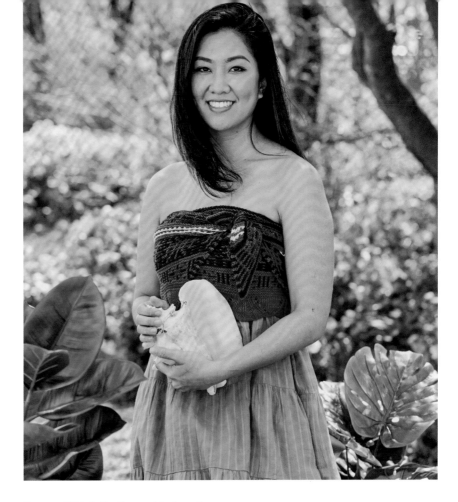

Row 92 (CC2): K3, *k3tog tbl, sl1 wyib; rep from * to last 6 sts, k3tog tbl, k3.

Break CC2.

Row 93 (RS, MC, inc): K2, M1R, knit to last 2 sts, M1L, k2—2 sts inc.

Row 94 (WS, MC): Knit.

Rep Rows 93 and 94 once—321 sts.

MOSAIC BAND 3

Rejoin CC1.

Rows 97–98 (CC1): Knit.

Row 99 (RS, CC1, inc): K2, M1R, knit to last 2 sts, M1L, k2—323 sts.

Row 100 (WS, CC1): Knit.

Row 101 (MC, inc): K2, M1R, knit to last 2 sts, M1L, k2—325 sts.

Row 102 (MC): Knit.

Begin Chart C. Work Rows 103–120 once (the 20-st pattern repeat is worked 15 times)—337 sts.

Rows 121–122 (MC): Knit.

Row 123 (RS, CC1, inc): K2, M1R, knit to last 2 sts, M1L, k2—2 sts inc.

Row 124 (WS, CC1): Knit.

Rep Rows 123 and 124 once—341 sts.

Break CC1.

Row 127 (RS, MC): Knit.

With WS facing, and using a needle 1 size larger (or gauge-size needle if preferred), bind off all sts as follows: *K2tog tbl, sl st on RHN purlwise to LHN; rep from * until all sts have been bound off. Break yarn and pull through remaining st to secure.

FINISHING

Weave in all ends. Wet block, stretching and pinning to the dimensions shown in the schematic. Blocking wires are suggested for getting straight edges along the top and sides of the shawl.

CHARTS

KEY

☐ Knit on RS, purl on WS	◼ CC1
⊟ Purl on RS, knit on WS	◹ M1L
⊻ Slip stitch purlwise: wyib on RS, wyif on WS	⊾ M1R
◼ MC	▭ Repeat

A

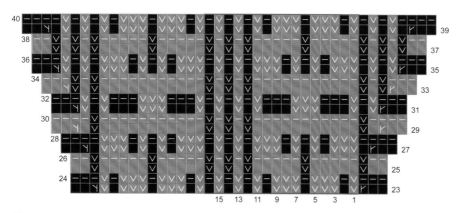

B

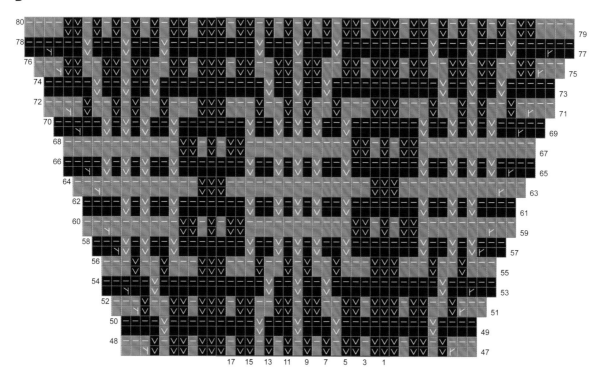

Disney

FUN FACTS

A native of Hawaii, actress and singer Auli'i Cravalho was fourteen years old and the last to audition for the voice of Moana, beating out of hundreds of other girls and women for the role.

C

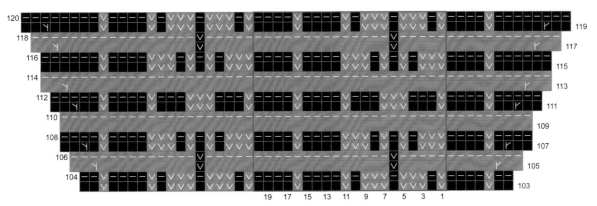

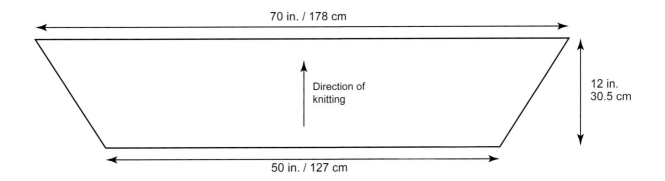

70 in. / 178 cm

Direction of knitting

12 in. 30.5 cm

50 in. / 127 cm

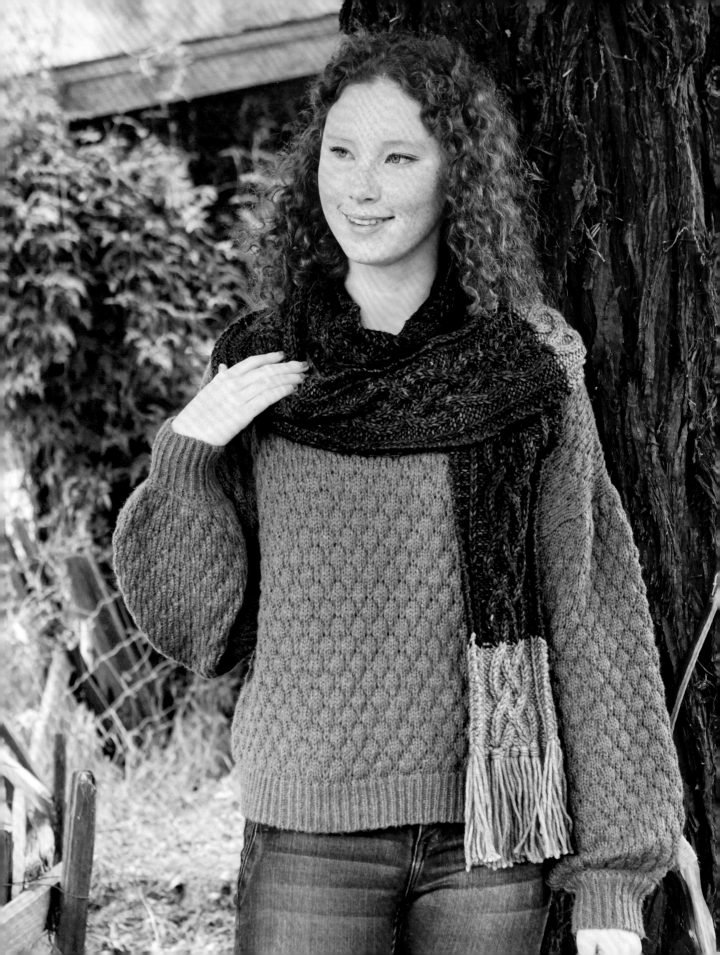

Merida Cabled Scarf

Designed by TANIS GRAY

SKILL LEVEL ❤

Free-spirited and headstrong, Merida from 2012's *Brave* is a medieval princess from Clan DunBroch in the misty Highlands of Scotland. Born with a fierce independent streak, it is Merida's stubbornness and refusal to conform to traditions that don't match her true self that lead her down a path toward changing her fate. Merida is dressed in a deep green dress for much of the film with Celtic cabling on her belt, her mother's necklace, and the bottom of her dress. Celtic cabling is also visible in many other places in the film, including costumes, jewelry, insignias, various textiles, and the film's elegant title treatment.

Grab your needles and get ready to chase the wind and touch the sky! Knit flat back and forth in rows and edged with fringe, this cabled scarf mimics the cables in the opening title credits in *Brave*. Three- and four-stitch cables weave in and out of each other on a background of reverse stockinette and columns of twisted stitches. Knit in a deep green yarn the same color as Merida's archery contest dress with golden cables running along the bottom, this scarf has an easily adjustable length and makes an excellent gift knit for anyone thinking about changing their fate.

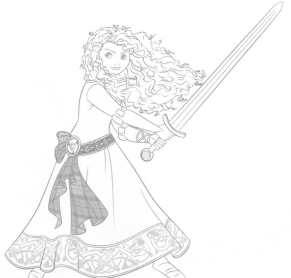

SIZE
One size

FINISHED MEASUREMENTS
Length: 68 in. / 173 cm (not including fringe)
Width: 6 in. / 15 cm wide

YARN
Chunky weight (chunky #5) yarn, shown in Neighborhood Fiber Co. *Studio Chunky* (100% organic merino; 125 yd. / 114 m per 4 oz. / 113 g hank)
Main Color (MC): Edgewood, 3 hanks
Contrast Color (CC): Oliver, 1 hank

NEEDLES
• US 9 / 5.5 mm, 16 in. / 40 cm long circular needle or size needed to obtain gauge

NOTIONS
• Cable needle
• US J-10 / 6 mm crochet hook
• Tapestry needle

GAUGE
20 sts and 20 rows = 4 in. / 10 cm over cable pattern, taken after blocking
Make sure to check your gauge.

NOTES
• This scarf is worked end to end, flat. The scarf should be blocked before applying the fringe.
• Charted and written instructions are provided for the cable pattern for this scarf.
• Cabling is only worked on right side rows.

STITCH PATTERN
CABLE PATTERN (WORKED OVER 30 STS)

Row 1 (**RS**): K2, p2, k1 tbl, (p4, 2/2 RC) twice, p4, k1 tbl, p2, k2.

Row 2 (**WS**): K4, p1 tbl, (k4, p4) twice, k4, p1 tbl, k4.

Row 3: K2, p2, k1 tbl, p1 (p2, 2/1 RPC, 2/1 LPC) twice, p3, k1 tbl, p2, k2.

Row 4: K4, p1 tbl, k3, (p2, k2) 4 times, k1, p1 tbl, k4.

Row 5: K2, p2, k1 tbl, p2, (2/1 RPC, p2, 2/1 LPC) twice, p2, k1 tbl, p2, k2.

Row 6: K4, p1 tbl, k2, p2, k4, p4, k4, p2, k2, p1 tbl, k4.

Row 7: K2, p2, k1 tbl, p2, k2, p4, 2/2 LC, p4, k2, p2, k1 tbl, p2, k2.

Row 8: Work as for Row 6.

Row 9: K2, p2, k1 tbl, p2, (2/2 LPC, 2/2 PC) twice, p2, k1 tbl, p2, k2.

Row 10: Work as for Row 2.

Row 11: Work as for Row 1.

Row 12: Work as for Row 2.

Row 13: K2, p2, k1 tbl, p2, (2/2 RPC, 2/2 LPC) twice, p2, k1 tbl, p2, k2.

Row 14: Work as for Row 6.

Row 15: Work as for Row 7.

Row 16: Work as for Row 6.

Row 17: K2, p2, k1 tbl, p2, (2/1 LPC, p2, 2/1 RPC) twice, p2, k1 tbl, p2, k2.

Row 18: Work as for Row 4.

Row 19: K2, p2, k1 tbl, p1, (p2, 2/1 LPC, 2/1 RPC) twice, p3, k1 tbl, p2, k2.

Row 20: Work as for Row 2.

Rows 1–20 form pattern repeat.

BODY OF SCARF

With CC, CO 30 sts using the Long Tail CO method. Do not join to work in the rnd.

Begin working from Cable Pattern chart or written instructions as follows:

With CC, work Rows 1–20 once. Break CC.

Join MC. Work Rows 1–20 fifteen times. Break MC.

Rejoin CC. Work Rows 1–20 once.

With RS facing, BO all sts knitwise.

FINISHING

Weave in all loose ends to the WS with tapestry needle.

Wet block the scarf to allow the sts to relax. Complete all blocking before attaching the fringe. Once dry, trim all ends.

FRINGE

*Cut forty-eight 13 in. / 33 cm lengths of CC.

**Holding 3 strands together, and using the crochet hook, pull the loop of the folded strands through the short edge of the scarf. Pass the 6 tails (2 from each folded strand) through the loop and cinch down to complete 1 section of fringe.

Repeat from ** 15 more times (16 fringe sections have been added to the end of the scarf).

Repeat from * to add fringe to the other end of the scarf.

Trim the fringe to be about 6 in. / 15 cm.

DISNEY FUN FACTS

Disney registered a tartan for three of the four main clans in *Brave*: DunBroch, Dingwall, and MacGuffin. Using light blue, maroon, hunter green, navy blue, and gray to represent the North Sea, bloodshed, the Highlands, unity, and the Scottish people, Pixar stayed historically accurate with these important patterns, sticking to hues that matched the less saturated dyeing techniques used during the period in which the film was set.

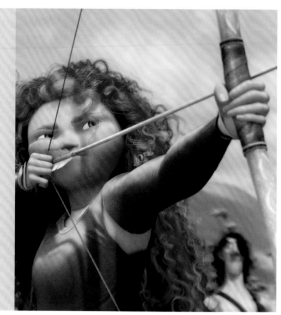

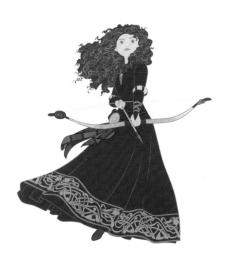

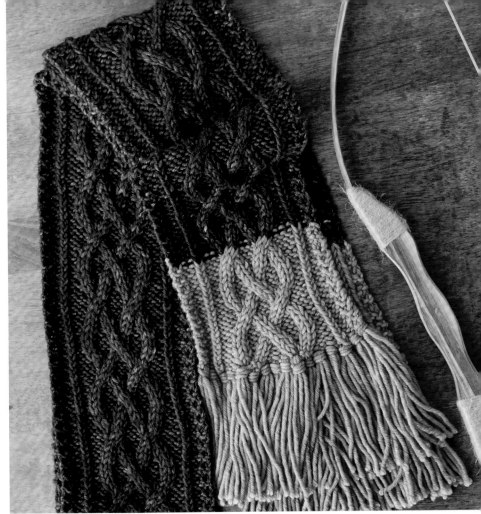

"I am Merida,
first-born descendant
of Clan DunBroch,
and I'll be shooting
for my own hand."

Merida, *Brave* (2012)

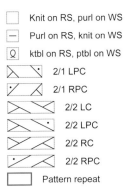

CHART

KEY

☐	Knit on RS, purl on WS
—	Purl on RS, knit on WS
Ϙ	ktbl on RS, ptbl on WS
	2/1 LPC
	2/1 RPC
	2/2 LC
	2/2 LPC
	2/2 RC
	2/2 RPC
	Pattern repeat

CABLE PATTERN

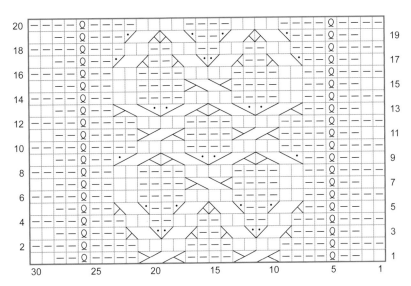

"Circle of Life" Sweater

Designed by MARITA VASSNES

SKILL LEVEL 🐭🐭🐭

The first Disney animated feature film to tell an original story not based on an existing tale, 1994's *The Lion King* was a groundbreaking, massive success. The Academy Award®–winning film tells the story of a young lion who is chased away from his pride after his father, the king, is killed by his ambitious uncle. To create the Pride Lands, Simba's home, artists visited Hell's Gate National Park in Kenya for inspiration and used various focal lengths, lenses, and artificial lens flare to make the viewer feel like they were watching a nature documentary. Art director Andy Gaskill states, "We wanted audiences to sense the vastness of the savannah and to feel the dust and the breeze swaying through the grass. In other words, to get a real sense of nature and to feel as if they were there. It's very difficult to capture something as subtle as a sunrise or rain falling on a pond, but those are the kinds of images that we tried to get." Clocking in at four minutes, the famous "Circle of Life" opening sequence featured a hit song, stunning animation, and a plethora of animals, perfectly setting the tone for the beautiful, emotional movie that followed.

Featuring motifs of favorite characters from *The Lion King*, this stranded colorwork pullover includes Simba, Timon, Pumbaa, and Rafiki, as well as parades of hyenas, giraffes, and elephants. Worked in the round in a tube from the bottom up, the sweater starts with a 1x1 ribbed hem, then moves into the colorwork. After the body of the sweater is complete, the neckline is shaped. Sleeves are worked separately in the round and fitted in after steeks are cut into the body of the sweater. Once all the pieces are assembled together, a hemmed ribbed collar is picked up and worked in the round. Wear with pride and take your place in the great circle of life.

SIZES

1 (2, 3, 4)[5, 6, 7]{8, 9, 10}

Instructions are written for the smallest size, with larger sizes given in parentheses. When only one number is given, it applies to all sizes.

FINISHED MEASUREMENTS

Chest: 35 (39¼, 43½, 48)[52½, 56¾, 61]{65½, 70, 74} in. / 88.5 (100, 111, 122)[133, 144, 155]{166, 177.5, 188.5} cm

Garment designed to be worn with 2–4 in. / 5–10 cm positive ease.

YARN

DK weight (light #3) yarn, shown in Rowan *Felted Tweed* (50% wool, 25% nylon, 25% alpaca; 191 yd. / 175 m per 1¾ oz. / 50 g ball)

Main Color (MC): #181 Mineral, 4 (5, 6, 6)[7, 7, 8]{8, 9, 10} balls

Contrast Color (CC): #211 Black, 4 (5, 5, 6)[6, 7, 7]{8, 9, 10} balls

NEEDLES

- US 4 / 3.5 mm set of double-pointed needles and 16–40 in. / 40–100 cm long circular needle
- US 6 / 4 mm set of double-pointed needles, 16–40 in. / 40–100 cm long circular needle, and 2 spare gauge-size needles or size needed to obtain gauge

NOTIONS

- Tapestry needle
- Stitch markers (1 unique for BOR)
- Row counter (optional)
- Waste yarn or stitch holders

continued on page 170

GAUGE

22 sts and 26 rnds = 4 in. / 10 cm in stranded colorwork on larger needle, taken after blocking
Make sure to check your gauge.

NOTES

- This sweater is worked from the bottom up, in the round to the armholes. The front and back are separated and worked flat up to the shoulders. Once the shoulders are seamed, the sleeves are picked up and knit outward from the body in the round. Multiple stitch motifs are worked up the entire length of the body and sleeves.
- Each chart motif will be worked once vertically.
- When working the charts, catch floats as needed, approximately every fifth stitch.
- Adjustments to the length of the garment will affect required yardage quantities.
- When the sweater is worn as designed, the BOR will be on the right side of body.

HEM

With MC and smaller circular needle, CO 192 (216, 240, 264)[288, 312, 336]{360, 384, 408} sts using the Long Tail CO method. Pm for BOR and join to work in the rnd, being careful not to twist the sts.

Rib Rnd: *K1, p1; rep from * to end of rnd.

Rep Rib Rnd until the Hem measures 2½ in. / 6 cm from the CO edge.

BODY

Setup Rnd (using MC): K96 (108, 120, 132)[144, 156, 168]{180, 192, 204}, pm for SSM, knit to EOR.
Change to larger needle.

Join CC; knit 1 rnd with CC.

Begin charts, reading all rows from right to left as for working in the rnd. Work charts continuously, in order, starting with Chart A, followed by B, C, D, E, and F until the body measures 15¾ in. / 40 cm from the CO edge (or to the desired total body length). When Chart F is complete, start the sequence over again at Chart A where necessary. The charts will be repeated 8 (9, 10, 11)[12, 13, 14]{15, 16, 17} times across each rnd.

Note: You may reach the desired total length before completing a chart. The pattern will continue up to the shoulders, so partial charts can be expected. Make a note of which row and which chart you ended on, to resume the back in the correct place.

FRONT YOKE

Note: The front and back of the sweater will now be worked flat. The sts for the back will be placed on hold to be worked later. As you continue to work the charted motifs, the charted pattern for the WS rows will be read from left to right while the RS rows will continue to be read from right to left.

Separation Row (RS): Work in est patt to SSM, rm, turn work. Place the remaining 96 (108, 120, 132)[144, 156, 168]{180, 192, 204} sts onto waste yarn for the back. You may remove the BOR m once the back sts are placed on hold.

Next Row (WS): Work in est patt to EOR (previously the BOR).
Row 1: Work in est patt to EOR.
Rep Row 1 (the same instructions are worked on the RS and WS, knitting all RS sts and purling all WS sts) until the front yoke measures 3¾ (4½, 5½, 6½)[6¾, 7, 7½]{8, 8¼, 8½} in. / 9.5 (11.5, 14, 16.5)[17, 18, 19]{20.5, 21, 21.5} cm from the Separation Row, ending with a WS row.

RIGHT FRONT

The left and right fronts will now be separated to provide some shaping for the collar.

Neckline Bind Off Row (RS): Work 42 (47, 53, 58)[63, 69, 74]{80, 85, 91} sts in est patt, place these just-worked sts on st holder or waste yarn (these will make up the left front). Break CC. Using MC, BO 12 (14, 14, 16)[18, 18, 20]{20, 22, 22} sts knitwise. Rejoin CC and work to EOR in est patt—42 (47, 53, 58)[63, 69, 74]{80, 85, 91} right front sts rem.

Next Row (WS): Work in est patt to neckline edge.

Row 1 (RS, BO): BO 2 sts knitwise, work in est patt to end of row—2 sts dec.

Row 2 (WS): Work in est patt to neckline edge.

Rep [Rows 1 and 2] 3 more times— 8 sts dec; 34 (39, 45, 50)[55, 61, 66]{72, 77, 83} sts rem.

Row 9 (RS, BO): BO 1 st knitwise, work in est patt to end of row—1 st dec.

Row 10 (WS): Work in est patt to neckline edge.

Rep [Rows 9 and 10] 2 more times— 3 sts dec; 31 (36, 42, 47)[52, 58, 63]{69, 74, 80} sts rem.

Cont in est patt even (no more decreases) until the right front measures 6¼ (7, 8, 9)[9¼, 9½, 9¾]{10½, 10¾, 11} in. / 16 (18, 20.5, 23)[23.5, 24, 25]{26.5, 27.5, 28} cm from the Separation Row, ending with a WS row. Break yarns, leaving a tail for weaving in. Place live sts on st holder or waste yarn.

LEFT FRONT

Place the 42 (47, 53, 58)[63, 69, 74]{80, 85, 91} live sts of the left front onto the larger working needle. Rejoin MC and CC with the WS facing (at the neckline edge).

Setup Row (WS, BO): BO 2 sts

purlwise, work in est patt to end of row—2 sts dec.

Row 1 (RS): Work in est patt to neckline edge.

Row 2 (WS): BO 2 sts purlwise, work in est patt to end of row—2 sts dec.

Rep [Rows 1 and 2] 2 more times—8 sts dec; 34 (39, 45, 50)[55, 61, 66]{72, 77, 83} sts rem.

Row 7 (RS, BO): Work in est patt to neckline edge.

Row 8 (WS, BO): BO 1 st purlwise, work in est patt to end of row—1 st dec.

Rep [Rows 7 and 8] 2 more times—3 sts dec; 31 (36, 42, 47)[52, 58, 63]{69, 74, 80} sts rem.

Cont in est patt even (no more decreases) until the right front measures 6¼ (7, 8, 9)[9¼, 9½, 9¾]{10½, 10¾, 11} in. / 16 (18, 20.5, 23)[23.5, 24, 25]{26.5, 27.5, 28} cm from the Separation Row, ending with a WS row (this should be the same number of rows as the right front). Break yarns, leaving a tail for weaving in. Place live sts on st holder or waste yarn.

BACK YOKE

Place the 96 (108, 120, 132)[144, 156, 168]{180, 192, 204} live sts of the back onto the larger working needle. Rejoin MC and CC with the RS facing.

Row 1: Work in est patt to EOR.

Rep Row 1 (the same instructions are worked on the RS and WS, knitting all RS sts and purling all WS sts) until the back yoke measures 6¼ (7, 8, 9)[9¼, 9½, 9¾]{10½, 10¾, 11} in. / 16 (18, 20.5, 23)[23.5, 24, 25]{26.5, 27.5, 28} cm from the Separation Row, ending with a WS row (this should be the same number of rows as the right and left fronts). Break CC yarn; do not break MC. Leave the live sts on the needle for seaming.

SEAMING THE SHOULDERS

Turn the garment inside out (the RS are together, WS facing out) and the front of the garment facing you.

Place the live sts of the left front onto a spare gauge-size needle and hold parallel with the back sts of the same shoulder. Using a third gauge-size needle and MC, BO 31 (36, 42, 47)[52, 58, 63]{69, 74, 80} left shoulder sts using the Three-Needle BO method.

Without breaking the yarn and using the remaining loop from the left shoulder to BO the first st, BO 34 (36, 36, 38)[40, 40, 42]{42, 44, 44} back neck sts purlwise contiguously.

Place the live sts of the right front onto a spare gauge-size needle and hold parallel with the remaining live sts of the back and BO the remaining sts using the Three-Needle BO method. When 1 st remains, break yarn, leaving a tail for weaving in, and draw through the remaining loop, pulling to cinch closed..

COLLAR

Using the 16 in. / 40 cm smaller circular needle and starting at the left shoulder seam, rejoin MC and pick up and knit 80 (82, 84, 86)[86, 88, 88]{90, 92, 94} sts evenly around the neckline edge, picking up 1 st into each bound off st at the front and back necklines, and approx 2 sts for every 3 rows along the front neckline shaping edges. While an exact number of sts isn't necessary, an even number of sts is required. Pm for BOR and join to work in the rnd.

Rib Rnd: *K1, p1; rep from * to end of rnd.

Rep Rib Rnd until the collar measures 1¼ in. / 3 cm from the picked-up edge.

Folding Rnd: Purl.

Rep Rib Rnd for another 1¼ in. / 3 cm so that, when folded with WS together, the live sts of the collar are in line with the picked-up edge. Bind off all sts loosely knitwise.

Break MC, leaving a tail approx 3 times the length of the collar circumference. Thread the tapestry needle with the MC tail and sew the live sts down to the picked-up edge.

SLEEVES

Note: Read carefully through all sleeve instructions before proceeding as several steps occur at the same time.

Using the larger needle in your preferred method of small-circumference knitting (sizes 4– 10 may start with a 16 in. / 40 cm circular if desired, changing to dpns as the circumference becomes smaller), join CC at the center of the underarm and pick up and knit 70 (78, 84, 100)[102, 106, 108]{116, 118, 122} sts evenly around the armhole. Pm for BOR and join to work in the rnd.

Note: The stitch patterns will not be worked evenly across every rnd of the sleeve. Before working the first rnd of the charts, it may be helpful to place a marker at the center of the sleeve sts (opposite the BOR m) and center your pattern repeats over this marker. You may also find it helpful to place markers between each chart repeat to help stay in the charted pattern down the length of the sleeve.

For the entirety of the sleeve, the first st of every rnd will be worked alternately in MC and CC. The decreases to shape the sleeves will occur on each side of this stitch and will always be worked with CC. When decreases are not worked, the stitch immediately before the marker (i.e., the end of a rnd) and the second stitch of the next rnd will always be worked in CC.

Begin charts, reading all rows from right to left as for working in the rnd. Work charts continuously, in order, starting with Chart G, followed by H, J, and K; the sleeve will measure approx 17 in. / 43 cm from the picked-up edge once Chart K is complete.

AT THE SAME TIME, work the following Dec Rnd every 9 (8, 7, 5)[5, 5, 5]{5, 5, 4} rnds a total of 11 (13, 15, 20)[20, 20, 20]{21, 21, 22} times—22 (26, 30, 40)[40, 40, 40]{42, 42, 44} sts dec; 48 (52, 54, 60)[62, 66, 68]{74, 76, 78} sts rem.

Dec Rnd: K1 in est patt, k2tog with CC, work in est patt to last 2 sts, ssk with CC—2 sts dec.

Break CC.

FINAL DEC RND

Size 1 Only: *(K3, k2tog) 4 times, k2, k2tog; rep from * to end of rnd.

Sizes 2 and 10 Only: *K3, k2tog, (k2, k2tog) twice; rep from * to end of rnd.

Size 3 Only: *K3, k2tog, k2, k2tog; rep from * to end of rnd.

Size 4 Only: (K2, k2tog) 5 times, (k3, k2tog) 4 times, (k2, k2tog) 5 times.

Size 5 Only: *(K3, k2tog) 3 times, (k2, k2tog) 4 times; rep from * to end of rnd.

Sizes 6 and 8 Only: K3, k2tog, *k2, k2tog; rep from * to last 5 sts, k3, k2tog.

Size 7 Only: *K3, k2tog, (k2, k2tog) 3 times; rep from * to end of rnd.

Size 9 Only: (K3, k2tog) twice, *k2, k2tog; rep from * to last 10 sts, *k3, k2tog) twice—10 (12, 12, 14)[14, 16, 16]{18, 18, 18} sts dec; 38 (40, 42, 46)[48, 50, 52]{56, 58, 60} sts rem.

CUFF

Change to the smaller dpns.

Rib Rnd: *K1, p1; rep from * to end of rnd.

Rep Rib Rnd until the cuff measures 2½ in. / 6 cm.

BO all sts in pattern.

Repeat for the second sleeve.

FINISHING

Weave in ends. Wet block to measurements.

"Everything you see exists together in a delicate balance. As king, you need to understand that balance and respect all the creatures, from the crawling ant to the leaping antelope."

Mufasa, *The Lion King* (1994)

CHARTS

KEY

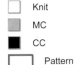

☐ Knit

▨ MC

■ CC

☐ Pattern repeat

A

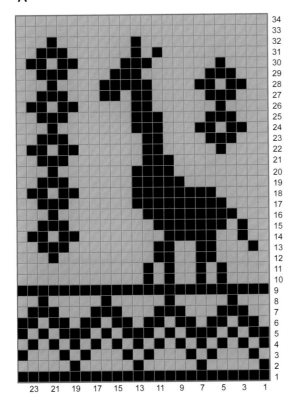

B

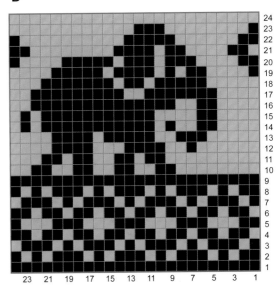

C

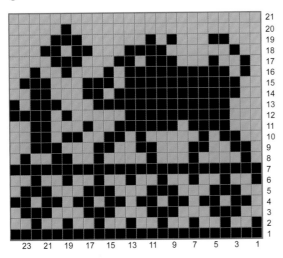

FUN FACTS

While visiting Africa for research, a tour guide introduced the production team to the term *hakuna matata* and taught them a playground song "Asante sana squash banana" that was later sung by Rafiki in the film.

D

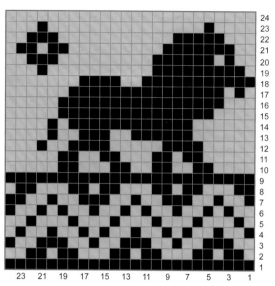

E

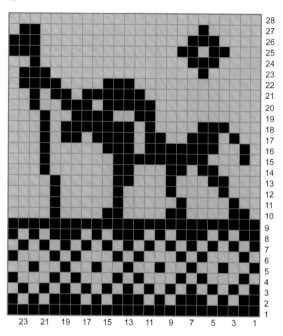

F

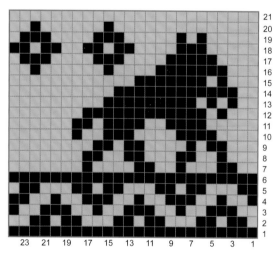

F ALTERNATE

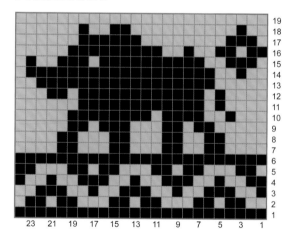

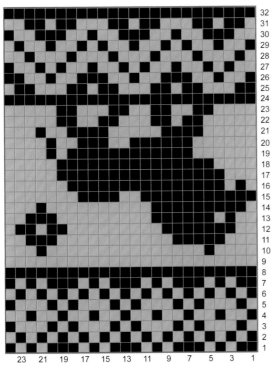

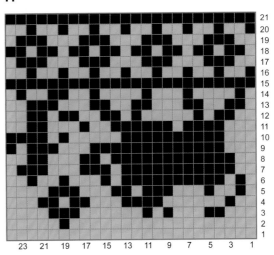

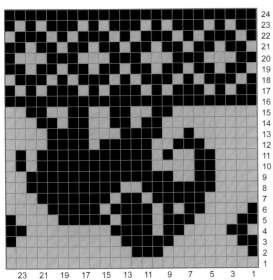

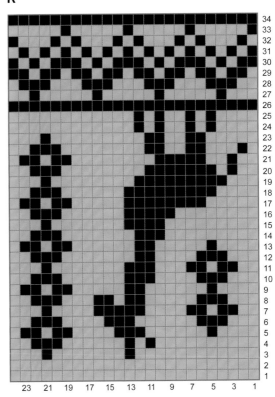

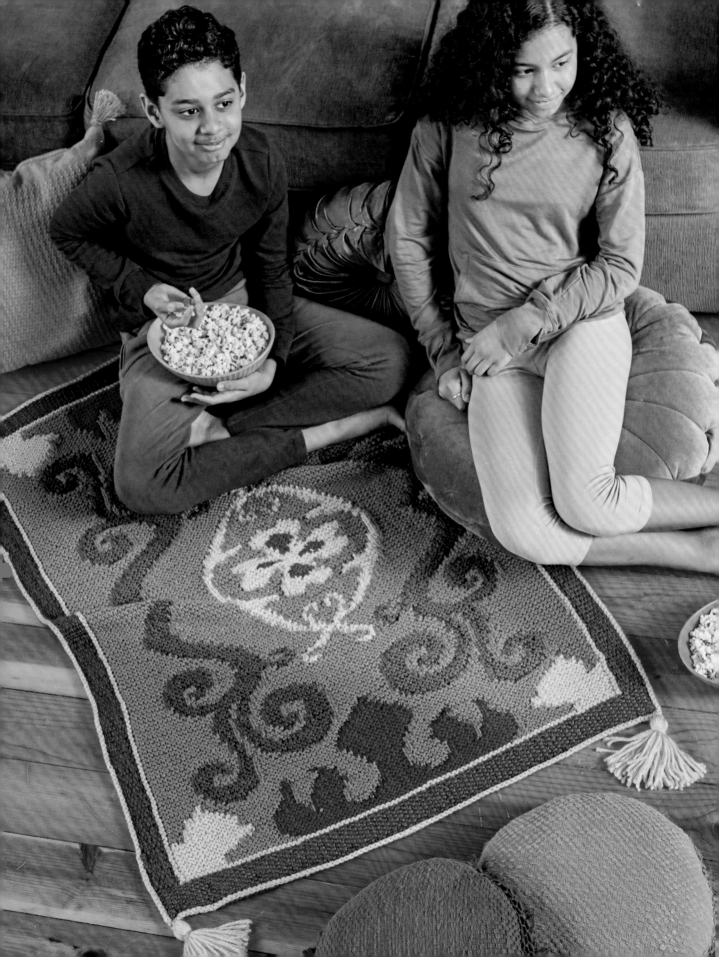

Delightful Decor

"Do you trust me?"

Aladdin, *Aladdin* (1992)

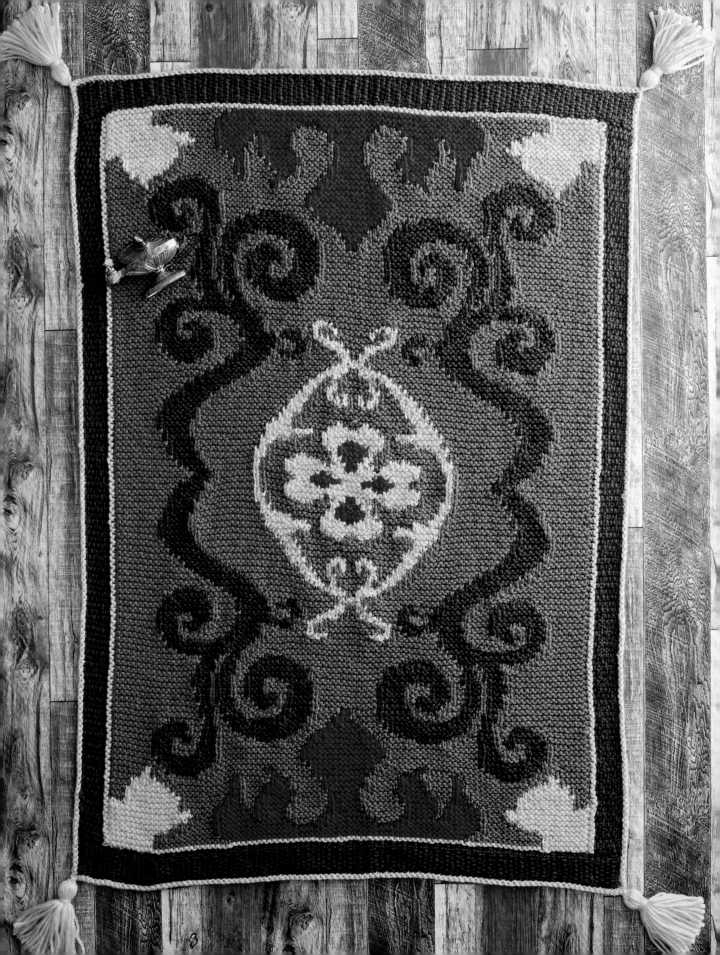

Magic Carpet Throw Blanket

Designed by HEIDI GUSTAD

SKILL LEVEL ♥ ♥ ♥

Released in 1992, *Aladdin* tells the story of a poor but kindhearted boy who discovers a magic lamp and is granted three wishes to change his life. Part of the Disney Renaissance, the film was a huge success, winning two Academy Awards® and releasing a successful soundtrack. First introduced in the Cave of Wonders on the outskirts of Agrabah, Carpet is an important ally of Aladdin, ultimately helping him defeat the evil sorcerer Jafar and win Princess Jasmine's heart. Saving Aladdin's life on more than one occasion, Magic Carpet proves to be a loyal friend, a lover of truth, and a silent hero—all with a sense of humor.

Snuggle up with your very own magic carpet! Worked flat using a combination of garter stitch and intarsia, purling is carefully incorporated on wrong-side rows to invisibly join large areas of color, despite the overall use of garter stitch. To stabilize the intarsia section, a thick border of linen stich is picked up on each side, similar to log cabin blanket construction. Top each corner with a tassel, and get ready for a whole new world of knitted fun.

SIZE
One size

FINISHED MEASUREMENTS
Width: 36 in. / 91.5 cm
Length: 48 in. / 122 cm

YARN
Chunky weight (chunky #5) yarn, shown in Cascade Yarns *Pacific Chunky* (60% acrylic, 40% superwash merino wool; 120 yd. / 110 m per 3½ oz. / 100 g skein)
Color A: #13 Gold, 3 skeins
Color B: #70 Classic Blue, 5 skeins
Color C: #43 Ruby, 1 skein
Color D: #146 Grape Juice, 4 skeins

NEEDLES
- US 10 / 6 mm, 32 in. / 81.5 cm long circular needle or size needed to obtain gauge
- US 11 / 8 mm, 48 in. / 122 cm* long circular needle
- *See pattern notes for details.*

NOTIONS
- Stitch marker (optional)
- Tapestry needle
- Tassel maker, 5¼ in. / 13.5 cm (optional)

GAUGE
13 sts and 22 rows = 4 in. / 10 cm over garter stitch **that includes intarsia** worked flat on smaller needle, taken after blocking
Make sure to check your gauge.
***See pattern notes for details.*

continued on page 180

NOTES

- This pattern is worked flat using a combination of garter stitch and intarsia.
- Every single one of the 23,500 stitches comprising the body is charted, with purling carefully incorporated on wrong side rows to invisibly join large areas of color despite the overall use of garter stitch.
- The ratio of the stitches in the chart is not representative of the finished dimension of each stitch. The squares are shown as 1:1 in the chart for ease of reading; as a result, the charts appear vertically stretched. This is not indicative of the final ratio of length to width of the throw.
- Slip all stitches purlwise with yarn in front unless otherwise noted.
- When following the written instructions, the color of yarn to use for each instruction is appended to each stitch count. For example, k49A should be read as: knit 49 stitches with Color A.
- To work from the charts, read all odd-numbered rows from right to left (across Chart D followed by Chart C for Rows 1–125; across Chart B followed by Chart A for Rows 126–250) and all even-numbered rows from left to right (across Chart C followed by Chart D for Rows 1–125; across Chart A followed by Chart B for Rows 126–250).

- It may be helpful to place markers as visual representations of the break in the charts. For those working from the written instructions rather than, or in addition to, the charted instructions, these markers are placed on Row 1 of the written instructions and should be slipped as encountered on every subsequent row. If stitches of the same color span this marker placement, you will see a divide in the written instructions. For example, you may see k13A, k12A. This is the equivalent of k25A but the total of twenty-five stitches is worked on each side of the marker.
- To stabilize the intarsia section once it is completed, a thick border of linen stitch is picked up on each edge, not unlike log cabin blanket construction.
- If you don't have a tassel maker, you can use a piece of cardboard cut down to 5¼ in. / 13.5 cm to create your own tassel.
- *The original sample of this blanket was worked with two 24 in. / 60 cm cables joined together with a connector. For comfort, or preference, use a 60 in. / 152.5 cm needle to avoid the use of a connector.
- **To accurately replicate Magic Carpet, meeting gauge for this project is quite important. Since each knitter's gauge is unique, it is strongly recommended to swatch to match gauge so that the horizontal-to-vertical aspect of this throw is correct. If both the row gauge and stitch gauge cannot be met, treat the row gauge as the dominant target gauge.

NOTES ON INTARSIA KNITTING

- When changing colors, the intarsia twist should generally occur on the wrong side of the work. For this pattern, when changing colors on a right side row, the twist will occur on a knit stitch so it ends up on the wrong side of your work. When changing colors on a wrong side row, the twist will occur on a purl stitch so it is also done on the wrong side of the work. This results in clean lines where colors come together.
- Yarn management is key in knitting intarsia. Two popular methods for managing the yarn while working intarsia are (a) measuring and guessing the amount of yarn a given section of color will need and creating bobbins, and (b) working from both ends of the same skein at once (which avoids the need to make bobbins).
- When a section of color is complete, break the yarn; do not try to carry the unused colors vertically up the back of the project. For example, after completing Row 30, you may cut Color A, rather than carrying it up the project, until it is needed again on Row 75, at which time it will be rejoined.
- It is highly recommended that knitters make use of long tails when knitting this intarsia pattern. There are many small, intricate areas of this design that benefit from having long tails to weave in, which also helps reinforce the structure of the throw.

BODY - INTARSIA SECTION

Using the smaller circular needle and color A, CO 94 sts using the Cable CO method. Do not join to work in the rnd.

Following the charts provided and/or the written instructions below, work Rows 1–250 of the Magic Carpet body once, joining Colors B, C, and D as necessary.

Row 1 (RS): Sl1A, k49A, pm, k44A.

Row 2 (WS): Sl1A, k43A, k50A.

Row 3: Sl1A, k9A, k15B, k25C, k19C, k15B, k10A.

Row 4: Sl1A, k9A, p1B, k13B, p1C, k19C, k25C, p1C, p1B, k13B, p1A, k9A.

Row 5: Sl1A, k9A, k13B, k27C, k21C, k13B, k10A.

Row 6: Sl1A, k9A, p1B, k12B, p1C, k20C, k27C, p1B, k12B, p1A, k9A.

Row 7: Sl1A, k10A, k11B, k28C, k22C, k11B, k11A.

Row 8: Sl1A, k10A, p2A, p1B, k8B, p1C, k15C, p3B, p1C, k2C, k9C, p3B, p1C, k15C, p1B, k8B, p2A, k11A.

Row 9: Sl1A, k13A, k8B, k15C, k4B, k9C, k3C, k4B, k15C, k8B, k14A.

Row 10: Sl1A, k13A, p1A, p1B, k6B, p1C, k14C, p1B, k3B, p1B, p1C, k1C, k8C, p1B, k4B, p1C, k14C, p1B, k6B, p1A, k14A.

Row 11: Sl1A, k14A, k7B, k8C, k1B, k5C, k7B, k7C, k1C, k7B, k5C, k1B, k8C, k7B, k15A.

Row 12: Sl1A, k14A, p2A, p1B, k4B, p1C, k6C, p1B, p1C, k5C, p1B, k6B, p1C, k7C, p1B, k6B, p1C, k4C, p1C, p1B, p1C, k6C, p1B, k4B, p2A, k15A.

Row 13: Sl1A, k16A, k5B, k7C, k1B, k6C, k7B, k7C, k1C, k7B, k6C, k1B, k7C, k5B, k17A.

Row 14: Sl1A, k16A, p1A, p1B, k3B, p1C, k6C, p1B, p1C, k5C, p1B, k6B, p1B, p1C, k5C, p1B, k7B, p1C, k5C, p1B, p1C, k6C, p1B, k3B, p1A, k17A.

Row 15: Sl1A, k16A, k5B, k6C, k2B, k6C, k8B, k6C, k8B, k6C, k2B, k6C, k5B, k17A.

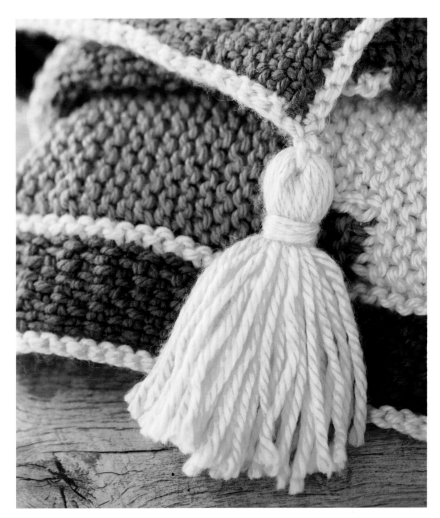

Row 16: Sl1A, k14A, p2B, k5B, p1B, p1C, k4C, p1B, k1B, p1C, k5C, p1B, k7B, p1C, k5C, p1B, k7B, p1C, k5C, p1B, k1B, p1C, k4C, p1B, k5B, p2B, p1A, k14A.

Row 17: Sl1A, k14A, k8B, k5C, k2B, k7C, k7B, k6C, k7B, k7C, k2B, k5C, k8B, k15A.

Row 18: Sl1A, p3B, p1A, k10A, p1B, k7B, p1B, p1C, k2C, p1B, k2B, p1C, k6C, p1B, k6B, p1C, k5C, p1B, k6B, p1C, k6C, p1B, k1B, p1B, p1C, k2C, p1B, k8B, p1A, k10A, p3B, k1B.

Row 19: Sl1B, k3B, k11A, k9B, k3C, k4B, k6C, k7B, k6C, k7B, k6C, k4B, k3C, k9B, k11A, k4B.

Row 20: Sl1B, k3B, p1A, k10A, p1B, k8B, p1C, k2C, p1B, k3B, p1C, k5C, p1C, p1B, k4B, p1B, p1C, k5C, p1B, k5B, p1C, k6C, p1B, k3B, p1C, k2C, p1B, k8B, p1A, k10A, p1B, k3B.

Row 21: Sl1B, k3B, k10A, k11B, k2C, k4B, k7C, k6B, k6C, k6B, k7C, k4B, k2C, k11B, k10A, k4B.

Row 22: Sl1B, k3B, p1A, k9A, p1B, k10B, p1C, k1C, p1B, k3B, p1B, p1C, k4C, p1B, k5B, p1C, k6C, p1C, p1B, k4B, p1B, p1C, k4C, p1B, k4B, p1C, k1C, p1B, k10B, p1A, k9A, p1B, k3B.

Row 23: Sl1B, k4B, k8A, k12B, k2C, k5B, k5C, k6B, k7C, k1C, k6B, k5C, k5B, k2C, k12B, k8A, k5B.

Row 24: Sl1B, k4B, p1A, k7A, p1B, k11B, p1C, k1C, p1B, k4B, p1C, k4C, p1B, k5B, p1C, k7C, p1B, k5B, p1C, k4C, p1B, k4B, p1C, k1C, p1B, k11B, p1A, k7A, p1B, k4B.

Row 25: Sl1B, k4B, k7A, k13B, k2C, k6B, k4C, k6B, k7C, k1C, k6B, k4C, k6B, k2C, k13B, k7A, k5B.

Row 26: Sl1B, k4B, p2B, p1A, k3A, p1B, k13B, p1B, p1C, p1B, k5B, p1C, k2C, p1B,

k5B, p1C, k1C, k7C, p1C, p1B, k4B, p1B, p1C, k2C, p1B, k5B, p1C, p1B, k13B, p1B, p1A, k3A, p2B, k5B.

Row 27: Sl1B, k6B, k3A, k16B, k1C, k6B, k2C, k7B, k8C, k2C, k7B, k2C, k6B, k1C, k16B, k3A, k7B.

Row 28: Sl1B, k6B, p1A, k1A, p1B, k4B, p4D, p1B, k7B, p1B, k5B, p1C, k1C, p1B, k6B, p1C, k2C, k8C, p1C, p1B, k5B, p1B, p2C, p1B, k4B, p1B, k8B, p4D, p1B, k3B, p1B, p1A, k1A, p1B, k6B.

Row 29: Sl1B, k7B, k1A, k3B, k7D, k13B, k1C, k8B, k9C, k3C, k8B, k1C, k13B, k7D, k3B, k1A, k8B.

Row 30: Sl1B, k7B, p1A, p1B, k2B, p1D, k6D, p1D, p1B, k11B, p1B, k8B, p1C, k2C, k9C, p1B, k7B, p1B, k12B, p1D, k7D, p1B, k2B, p1A, p1B, k7B.

Row 31: Sl1B, k10B, k10D, k19B, k10C, k4C, k19B, k10D, k11B.

Row 32: Sl1B, k9B, p1D, k10D, p1B, k18B, p1C, k3C, k10C, p1B, k18B, p1D, k9D, p1D, p1B, k9B.

Row 33: Sl1B, k9B, k12D, k17B, k11C, k5C, k17B, k12D, k10B.

Row 34: Sl1B, k9B, p1D, k11D, p1B, k16B, p1C, k4C, k11C, p1B, k16B, p1D, k11D, p1B, k9B.

Row 35: Sl1B, k8B, k5D, k3B, k5D, k17B, k11C, k5C, k17B, k5D, k3B, k5D, k9B.

Row 36: Sl1B, k8B, p1D, k3D, p1B, k3B, p1B, p1D, k3D, p1B, k16B, p1C, k4C, k11C, p1B, k16B, p1D, k3D, p1B, k3B, p1B, p1D, k3D, p1B, k8B.

Row 37: Sl1B, k8B, k4D, k5B, k4D, k18B, k10C, k4C, k18B, k4D, k5B, k4D, k9B.

Row 38: Sl1B, k8B, p1D, k3D, p1B, k4B, p1D, k3D, p1B, k17B, p1C, k3C, k10C, p1B, k17B, p1D, k3D, p1B, k4B, p1D, k3D, p1B, k8B.

Row 39: Sl1B, k8B, k4D, k6B, k3D, k8B, k4D, k6B, k10C, k4C, k6B, k4D, k8B, k3D, k6B, k4D, k9B.

Row 40: Sl1B, k8B, p1D, k3D, p1B, k1B, p2D, p1B, k1B, p1D, k2D, p1B, k5B, p2D, k4D, p2D, p1B, k3B, p1B, p1C, k2C, k9C, p1B, k4B, p2D, k4D, p2D, p1B, k5B, p1D, k2D, p1B, k1B, p1D, k1D, p1B, k1B, p1D, k3D, p1B, k8B.

Row 41: Sl1B, k8B, k8D, k2B, k3D, k5B, k10D, k4B, k9C, k3C, k4B, k10D, k5B, k3D, k2B, k8D, k9B.

Row 42: Sl1B, k8B, p1B, p1D, k5D, p1B, k2B, p1D, k2D, p1B, k3B, p1D, k10D, p1D, p1B, k2B, p1B, p1C, k1C, k8C, p1B, k3B, p1D, k10D, p1D, k4B, p1D, k2D, p1B, k1B, p1B, p1D, k5D, p1B, k9B.

Row 43: Sl1B, k9B, k6D, k3B, k3D, k3B, k14D, k4B, k7C, k1C, k4B, k14D, k3B, k3D, k3B, k6D, k10B.

Row 44: Sl1B, k9B, p1B, p1D, k4D, p1B, k2B, p1D, k2D, p1B, k1B, p1D, k14D, p1B, k3B, p1B, p1C, k5C, p1B, k4B, p1D, k13D, p1D, p1B, k1B, p1D, k2D, p1B, k2B, p1D, k4D, p1B, k10B.

Row 45: Sl1B, k11B, k3D, k4B, k2D, k3B, k16D, k4B, k6C, k4B, k16D, k3B, k2D, k4B, k3D, k12B.

Row 46: Sl1B, k11B, p3B, k4B, p1D, k1D, p1B, k1B, p1D, k5D, p2B, p1D, k8D, p1B, k3B, p1B, p1C, k3C, p1B, k4B, p1D, k8D, p2B, p1D, k4D, p1D, p1B, k1B, p1D, k1D, p1B, k3B, p3B, k12B.

Row 47: Sl1B, k18B, k2D, k2B, k4D, k6B, k7D, k5B, k4C, k1B, k4B, k7D, k6B, k4D, k2B, k2D, k19B.

Row 48: Sl1B, k17B, p1D, k2D, p1B, k1B, p1D, k3D, p1B, k5B, p1B, p1D, k5D, p1D, p1B, k2B, k1B, p1B, p1C, k1C, p1B, k4B, p1D, k6D, p1B, k6B, p1D, k3D, p1B, k1B, p1D, k1D, p1D, p1B, k17B.

Row 49: Sl1B, k17B, k3D, k1B, k4D, k9B, k6D, k5B, k2C, k2B, k3B, k6D, k9B, k4D, k1B, k3D, k18B.

Row 50: Sl1B, k17B, (p1D, k2D, p1B) 2 times, k4B, p2D, p1B, k2B, p1D, k5D, p1B, k2B, k2B, p1C, k1C, p1B, k4B, p1D, k5D, p1B, k2B, p2D, p1B, k3B, (p1B, p1D, k2D) 2 times, p1B, k17B.

Row 51: Sl1B, k17B, k2D, k2B, k3D, k4B, k4D, k2B, k6D, k9B, k3B, k6D, k2B, k4D, k4B, k3D, k2B, k2D, k18B.

Row 52: Sl1B, k17B, p1D, k1D, p1B, p1D, k3D, p1B, k2B, p1D, k4D, p1D, p2B, p1D, k4D, p1B, k2B, k9B, p1D, k4D, p1B, k1B, p1D, k4D, p1D, p1B, k2B, p1D, k2D, p1D, p1B, p1D, k1D, p1B, k17B.

Row 53: Sl1B, k16B, k3D, k1B, k4D, k3B, k6D, k2B, k5D, k9B, k3B, k5D, k2B, k6D, k3B, k4D, k1B, k3D, k17B.

Row 54: Sl1B, k16B, (p1D, k2D, p1B) 2 times, k2B, p1D, k6D, p1B, k1B, p1D, k4D, p1B, k2B, k9B, p1D, k4D, p1B, k1B,

p1D, k5D, p1D, p1B, k1B, (p1B, p1D, k2D) 2 times, p1B, k16B.

Row 55: Sl1B, k16B, k3D, k1B, k3D, k3B, k4D, k5B, k5D, k9B, k3B, k5D, k5B, k4D, k3B, k3D, k1B, k3D, k17B.

Row 56: Sl1B, k16B, (p1D, k2D, p1B) 2 times, k2B, p1D, k3D, p1B, k4B, p1D, k4D, p1B, k2B, k9B, p1D, k4D, p1B, k4B, p1D, k3D, p1B, k2B, (p1D, k2D, p1B) 2 times, k16B.

Row 57: Repeat Row 55.

Row 58: Sl1B, k15B, p1D, k3D, p1B, p1D, k2D, p1B, k2B, p1D, k3D, p1B, k4B, p1D, k4D, p1B, k2B, k9B, p1D, k4D, p1B, k4B, p1D, k3D, p1B, k2B, p1D, k2D, p1B, p1D, k2D, p1D, p1B, k15B.

Row 59: Sl1B, k15B, k4D, k1B, k3D, k3B, k4D, k4B, k6D, k9B, k3B, k6D, k4B, k4D, k3B, k3D, k1B, k4D, k16B.

Row 60: Sl1B, k15B, p1D, k3D, p1B, p1D, k2D, p1B, k2B, p1D, k3D, p1D, p1B, k1B, p1D, k5D, p1B, k3B, k9B, p1B, p1D, k4D, p1D, p1B, k1B, p1D, k4D, p1B, k2B, p1D, k2D, p1B, p1D, k3D, p1B, k15B.

Row 61: Sl1B, k15B, k4D, k1B, k4D, k3B, k12D, k10B, k4B, k12D, k3B, k4D, k1B, k4D, k16B.

Row 62: Sl1B, k15B, p1B, p1D, k2D, p1D, p1B, p1D, k2D, p1B, k2B, p1D, k11D, p1B, k3B, k10B, p1D, k11D, p1B, k2B, p1D, k2D, p1B, p1D, k3D, p1B, k16B.

Row 63: Sl1B, k16B, k4D, k1B, k3D, k3B, k12D, k10B, k4B, k12D, k3B, k3D, k1B, k4D, k17B.

Row 64: Sl1B, k16B, p1D, k3D, p1B, p1D, k2D, p1B, k2B, p1B, p1D, k9D, p1B, k4B, k10B, p1B, p1D, k9D, p1B, k3B, p1D, k2D, p1B, p1D, k3D, p1B, k16B.

Row 65: Sl1B, k16B, k4D, k1B, k3D, k4B, k9D, k12B, k6B, k9D, k4B, k3D, k1B, k4D, k17B.

Row 66: Sl1B, k16B, p1B, p1D, k2D, p1D, p1B, p1D, k1D, p1D, p1B, k2B, p1B, p1D, k6D, p1B, k6B, k12B, p1B, p1D, k6D, p1B, k3B, p1D, k2D, p1B, p1D, k3D, p1B, k17B.

Row 67: Sl1B, k17B, k4D, k1B, k3D, k5B, k5D, k14B, k8B, k5D, k5B, k3D, k1B, k4D, k18B.

Row 68: Sl1B, k14B, p3D, k4D, p1D, p1B, p1D, k1D, p1B, k4B, p5B, k8B, k14B,

p5B, k5B, p1D, k1D, p1B, p1D, k4D, p3D, p1B, k14B.

Row 69: Sl1B, k12B, k14D, k23B, k17B, k14D, k13B.

Row 70: Sl1B, k11B, p1D, k14D, p1B, k16B, k23B, p1D, k13D, p1D, p1B, k11B.

Row 71: Sl1B, k10B, k17D, k22B, k16B, k17D, k11B.

Row 72: Sl1B, k10B, p1D, k4D, p5B, p1D, k6D, p1D, p1B, k14B, k21B, p1D, k7D, p5B, p1D, k4D, p1B, k10B.

Row 73: Sl1B, k9B, k4D, k8B, k7D, k21B, k15B, k7D, k8B, k4D, k10B.

Row 74: Sl1B, k9B, p1D, k3D, p1B, k7B, p1B, p1D, k5D, p1D, p1B, k13B, k20B, p1D, k6D, p1B, k8B, p1D, k3D, p1B, k9B.

Row 75: Sl1B, k9B, k3D, k11B, k6D, k10B, k2A, k8B, k2B, k2A, k10B, k6D, k11B, k3D, k10B.

Row 76: Sl1B, k8B, p1D, k3D, p1B, k1B, p2D, p1B, k6B, p1D, k5D, p1B, k8B, p1A, k2A, p1A, p1B, k7B, p1A, k2A, p1A, p1B, k8B, p1D, k5D, p1B, k6B, p2D, p1B, k1B, p1D, k2D, p1D, p1B, k8B.

Row 77: Sl1B, k8B, k4D, k1B, k4D, k7B, k5D, k9B, k1A, k10B, k4B, k1A, k9B, k5D, k7B, k4D, k1B, k4D, k9B.

Row 78: Sl1B, k8B, p1D, k3D, p1B, p1D, k3D, p1D, p1B, k5B, p1D, k4D, p1B, k3B, p2D, p1B, k2B, p1A, p1B, k3B, k10B, p1A, p1B, k2B, p2D, p1B, k3B, p1D, k4D, p1B, k5B, p1D, k4D, p1B, p1D, k3D, p1B, k8B.

Row 79: Sl1B, k8B, k4D, k3B, k4D, k5B, k7D, k1B, k4D, k2B, k2A, k9B, k3B, k2A, k2B, k4D, k1B, k7D, k5B, k4D, k3B, k4D, k9B.

Row 80: Sl1B, k8B, p1D, k3D, p1B, k2B, p1D, k3D, p1B, k4B, p1D, k6D, p1D, k4D, p1B, k1B, p1B, p2A, p1B, k1B, k8B, p1A, k1A, p1B, k2B, p1D, k3D, p1D, k7D, p1B, k4B, p1D, k3D, p1B, k2B, p1D, k3D, p1B, k8B.

Row 81: Sl1B, k8B, k5D, k2B, k4D, k6B, k7D, k2B, k3D, k3B, k3A, k6B, k3A, k3B, k3D, k2B, k7D, k6B, k4D, k2B, k5D, k9B.

Row 82: Sl1B, k8B, p1D, k4D, p2D, k4D, p1B, k5B, p1D, k5D, p1B, k2B, p1B, p1D, k1D, p1B, k2B, p1B, p1A, k1A, p1A, p1B, k3B, p1A, k2A, p1B, k3B, p1D, k1D, p1B,

k2B, p1B, p1D, k5D, p1B, k5B, p1D, k3D, p2D, k5D, p1B, k8B.

Row 83: Sl1B, k9B, k10D, k5B, k7D, k4B, k2D, k5B, k2A, k4B, k1A, k1A, k5B, k2D, k4B, k7D, k5B, k10D, k10B.

Row 84: Sl1B, k9B, p1D, k9D, p1B, k4B, p1D, k5D, p1B, k1B, p3D, k2D, p1B, k4B, p1B, p2A, p1B, k1B, p1A, k1A, p1B, k5B, p1D, k1D, p3D, p2B, p1D, k5D, p1B, k4B, p1D, k9D, p1B, k9B.

Row 85: Sl1B, k9B, k10D, k5B, k6D, k3B, k3D, k7B, k2A, k2B, k2A, k7B, k3D, k3B, k6D, k5B, k10D, k10B.

Row 86: Sl1B, k9B, p1B, p1D, k7D, p1B, k5B, p1D, k5D, p1B, k2B, p1B, k2D, p1B, k6B, p1B, p3A, k1A, p1B, k7B, p1D, k1D, p1B, k3B, p1D, k5D, p1B, k4B, p1B, p1D, k7D, p1B, k10B.

Row 87: Sl1B, k10B, k8D, k5B, k6D, k15B, k4A, k1B, k14B, k6D, k5B, k8D, k11B.

Row 88: Sl1B, k10B, p1D, p1D, k5D, p1B, k4B, p1D, k6D, p1B, k13B, p1A, k4A, p1A, p1B, k13B, p1D, k5D, p1D, p1B, k3B, p1B, p1D, k5D, p1B, k11B.

Row 89: Sl1B, k12B, k3D, k6B, k7D, k14B, k3A, k2B, k2A, k1A, k14B, k7D, k6B, k3D, k13B.

Row 90: Sl1B, k12B, p3B, k6B, p1D, k6D, p1B, k12B, p1A, k1A, k2A, p1B, k1B, p1A, k2A, p1A, p1B, k12B, p1D, k6D, p1B, k5B, p3B, k13B.

Row 91: Sl1B, k19B, k8D, k13B, k4A, k4B, k1A, k3A, k13B, k8D, k20B.

Row 92: Sl1B, k18B, p1D, k7D, p1B, k12B, p1A, k1A, p1B, p1A, p1B, k4B, p1B, p1A, p1B, p2A, p1B, k11B, p1B, p1D, k6D, p1D, p1B, k18B.

Row 93: Sl1B, k17B, k8D, k13B, k2A, k2B, k1A, k6B, k1A, k2B, k2A, k13B, k8D, k18B.

Row 94: Sl1B, k16B, p1D, k7D, p1B, k12B, p1A, k1A, p1B, k2B, p1A, p1B, k5B, p1A, p1B, k1B, p1B, p2A, p1B, k11B, p1B, p1D, k6D, p1D, p1B, k16B.

Row 95: Sl1B, k15B, k8D, k14B, k2A, k2B, k2A, k6B, k2A, k2B, k2A, k14B, k8D, k16B.

Row 96: Sl1B, k14B, p1D, k7D, p1B, k13B, p1A, k1A, p1B, k2B, p1A, p1B, k6B, p1B, p1A, p1B, k1B, p1B, p2A, p1B, k12B, p1B, p1D, k6D, p1D, p1B, k14B.

Row 97: Sl1B, k13B, k8D, k15B, k2A, k3B, (k1A, k2B) 2 times, k1A, k1B, k1B, k1A, k3B, k2A, k15B, k8D, k14B.

Row 98: Sl1B, k12B, p1D, k7D, p1B, k14B, p1A, k1A, p1B, k3B, p2A, p1B, p1A, p1B, k1B, p1A, p1B, p1A, k1A, p1B, k2B, p1B, p2A, p1B, k13B, p1B, p1D, k6D, p1D, p1B, k12B.

Row 99: Sl1B, k12B, k7D, k15B, k3A, k5B, k3A, k2B, k2A, k1A, k5B, k3A, k15B, k7D, k13B.

Row 100: Sl1B, k11B, p1D, k6D, p1B, k15B, p1A, k2A, p1B, k4B, p1B, p1A, p1B, k2B, p1B, p1A, p1B, k5B, p1A, k2A, p1B, k14B, p1B, p1D, k5D, p1D, p1B, k11B.

Row 101: Sl1B, k10B, k7D, k16B, k3A, k13B, k7B, k3A, k16B, k7D, k11B.

Row 102: Sl1B, k10B, p1D, k6D, p1B, k15B, p1A, k2A, p1B, k6B, k13B, p1A, k2A, p1B, k15B, p1D, k6D, p1B, k10B.

Row 103: Sl1B, k9B, k7D, k17B, k3A, k13B, k7B, k3A, k17B, k7D, k10B.

Row 104: Sl1B, k9B, p1D, k6D, p1B, k15B, p1A, k2A, p1B, k7B, k13B, p1B, p1A, k1A, p1A, p1B, k15B, p1D, k6D, p1B, k9B.

Row 105: Sl1B, k9B, k6D, k17B, k3A, k14B, k8B, k3A, k17B, k6D, k10B.

Row 106: Sl1B, k8B, p1D, k6D, p1B, k15B, p1A, k2A, p1B, k8B, p1A, p1B, k3B, p1A, p1B, k7B, p1B, p1A, k1A, p1A, p1B, k15B, p1D, k5D, p1D, p1B, k8B.

Row 107: Sl1B, k8B, k7D, k16B, k3A, k8B, k3A, k2B, k2A, k1A, k8B, k3A, k16B, k7D, k9B.

Row 108: Sl1B, k8B, p1D, k6D, p1B, k14B, p1A, k3A, p1A, p1B, k5B, p1A, k1A, k2A, p2A, k3A, p1A, p1B, k5B, p1A, k3A, p1A, p1B, k14B, p1D, k6D, p1B, k8B.

Row 109: Sl1B, k8B, k6D, k16B, k8A, k3B, k8A, k2A, k3B, k8A, k16B, k6D, k9B.

Row 110: Sl1B, k8B, p1D, k5D, p1B, k14B, p1A, k8A, p1B, k1B, p1A, k2A, k8A, p1A, p1B, k1B, p1A, k7A, p1A, p1B, k14B, p1D, k5D, p1B, k8B.

Row 111: Sl1B, k9B, k5D, k15B, k8A, k3B, k9A, k3A, k3B, k8A, k15B, k5D, k10B.

Row 112: Sl1B, k9B, p1D, k4D, p1B, k14B, p1A, k4A, p3B, k3B, p1A, k2A, k2A, p2C, p1A, k4A, p1B, k2B, p3B, p1A, k4A, p1B, k14B, p1D, k4D, p1B, k9B.

Row 113: Sl1B, k9B, k5D, k15B, k5A, k6B, k4A, k4C, k1A, k3A, k6B, k5A, k15B, k5D, k10B.

Row 114: Sl1B, k9B, p1D, k4D, p1D, p1B, k12B, p1A, k2A, p3B, k6B, p1B, p1A, k1A, p1C, k4C, p1C, p1A, k1A, p1B, k6B, p3B, p1A, k1A, p1A, p1B, k12B, p1D, k5D, p1B, k9B.

Row 115: Sl1B, k10B, k5D, k13B, k2A, k11B, k2A, k6C, k2A, k11B, k2A, k13B, k5D, k11B.

Row 116: Sl1B, k10B, p1D, k4D, p1B, k12B, p1A, k1A, p1B, k10B, p1B, p1A, p1C, k5C, p1A, p1B, k11B, p1A, k1A, p1B, k12B, p1D, k4D, p1B, k10B.

Row 117: Sl1B, k10B, k5D, k13B, k1A, k7B, k1A, k5B, k2A, k4C, k1A, k1A, k5B, k1A, k7B, k1A, k13B, k5D, k11B.

Row 118: Sl1B, k10B, p1D, k4D, p1D, p1B, k10B, p1A, k1A, p1B, k5B, p1A, k1A, p2A, p1B, k2B, p1A, k1A, p1C, k3C, p1A, k1A, p1B, k2B, p2A, k1A, p1A, p1B, k5B, p2A, p1B, k10B, p1D, k5D, p1B, k10B.

Row 119: Sl1B, k11B, k5D, k11B, k2A, k5B, k6A, k3B, k2A, k2C, k2A, k3B, k6A, k5B, k2A, k11B, k5D, k12B.

Row 120: Sl1B, k11B, p1D, k4D, p1B, k10B, p1A, k1A, p1B, k3B, p1A, k6A, p1A, p1B, p1A, k2A, p1C, k1C, p1A, k1A, p1A, p1B, p1A, k6A, p1A, p1B, k3B, p1A, k1A, p1B, k10B, p1D, k4D, p1B, k11B.

Row 121: Sl1B, k12B, k5D, k10B, k1A, k5B, k16A, k10A, k5B, k1A, k10B, k5D, k13B.

Row 122: Sl1B, k12B, p1D, k4D, p1B, k9B, p1A, p1B, k4B, p1A, k9A, k16A, p1B, k4B, p1A, p1B, k9B, p1D, k3D, p1B, k13B.

Row 123: Sl1B, k13B, k4D, k10B, k1A, k5B, k7A, k1C, k8A, k2A, k1C, k7A, k5B, k1A, k10B, k4D, k14B.

Row 124: Sl1B, k13B, p1B, p1D, k2D, p1D, p1B, k8B, p1A, p1B, k4B, p1B, p1A, k4A, p1C, k1C, p1C, p1A, k7A, p1C, k1C, p1C, p1A, k4A, p1B, k5B, p1A, p1B, k8B, p1D, k3D, p1B, k14B.

Row 125: Sl1B, k15B, k4D, k8B, k1A, k7B, k3A, k6C, k4A, k1C, k5C, k3A, k7B, k1A, k8B, k4D, k16B.

Row 126: Sl1B, k15B, p1D, k3D, p1B, k7B, p1A, p1B, k6B, p1A, k2A, p1C, k4C, k1C, p1A, k3A, p1C, k5C, p1A, k2A, p1B, k6B,

p1A, p1B, k7B, p1D, k3D, p1B, k15B.

Row 127: Sl1B, k14B, k4D, k9B, k1A, k6B, k5A, k3C, k7A, k1A, k3C, k5A, k6B, k1A, k9B, k4D, k15B.

Row 128: Sl1B, k13B, p1D, k3D, p1B, k9B, p1A, p1B, k4B, p1A, k5A, p1A, p1C, p1A, k1A, k7A, p1A, p1C, p1A, k5A, p1A, p1B, k4B, p1A, p1B, k8B, p1B, p1D, k2D, p1D, p1B, k13B.

Row 129: Sl1B, k12B, k5D, k10B, k1A, k5B, k16A, k10A, k5B, k1A, k10B, k5D, k13B.

Row 130: Sl1B, k12B, p1D, k4D, p1B, k9B, p1A, p1B, k4B, p1A, k9A, k2A, p2C, p1A, k11A, p1B, k4B, p1A, p1B, k9B, p1D, k4D, p1B, k12B.

Row 131: Sl1B, k11B, k5D, k11B, k2A, k4B, k8A, k1B, k3A, k2C, k2A, k1A, k1B, k8A, k4B, k2A, k11B, k5D, k12B.

Row 132: Sl1B, k11B, p1D, k4D, p1B, k10B, p1A, k1A, p1B, k3B, p1B, p1A, k5A, p1B, k1B, p1B, p1A, k1A, p1C, k1C, p1A, k1A, p1B, k1B, p1B, p1A, k5A, p1B, k4B, p1A, k1A, p1B, k10B, p1D, k4D, p1B, k11B.

Row 133: Sl1B, k10B, k6D, k11B, k2A, k6B, k4A, k3B, k2A, k4C, k1A, k1A, k3B, k4A, k6B, k2A, k11B, k6D, k11B.

Row 134: Sl1B, k10B, p1D, k4D, p1B, k11B, p1B, p1A, p1B, k5B, p1B, p1A, p2B, k3B, p1A, k1A, p1C, k3C, p1A, k1A, p1B, k2B, p2B, p1A, p1B, k6B, p1A, p1B, k11B, p1B, p1D, k4D, p1B, k10B.

Row 135: Sl1B, k10B, k5D, k13B, k2A, k12B, k1A, k6C, k1A, k12B, k2A, k13B, k5D, k11B.

Row 136: Sl1B, k10B, p1D, k4D, p1B, k12B, p1A, k1A, p1B, k10B, p1A, k1A, p1C, k5C, p2A, p1B, k10B, p1A, k1A, p1B, k12B, p1D, k4D, p1B, k10B.

Row 137: Sl1B, k9B, k6D, k13B, k3A, k10B, k2A, k6C, k2A, k10B, k3A, k13B, k6D, k10B.

Row 138: Sl1B, k9B, p1D, k4D, p1B, k13B, p1B, p1A, k1A, p3A, p1B, k5B, p1A, k2A, p1A, p1C, k3C, p1A, k2A, p1A, p1B, k5B, p4A, k1A, p1B, k13B, p1B, p1D, k4D, p1B, k9B.

Row 139: Sl1B, k9B, k5D, k15B, k5A, k6B, k5A, k2C, k2A, k3A, k6B, k5A, k15B, k5D, k10B.

Row 140: Sl1B, k9B, p1D, k4D, p1B, k14B, p1A, k4A, p3A, p1B, k2B, p1A, k2A,

k2A, p2A, k5A, p1B, k2B, p3A, k5A, p1B, k14B, p1D, k4D, p1B, k9B.

Row 141: Sl1B, k8B, k6D, k15B, k9A, k2B, k9A, k3A, k2B, k9A, k15B, k6D, k9B.

Row 142: Sl1B, k8B, p1D, k5D, p1B, k14B, p1B, p1A, k7A, p1B, k1B, p1B, p1A, k1A, k8A, p1B, k2B, p1A, k7A, p1B, k15B, p1D, k5D, p1B, k8B.

Row 143: Sl1B, k8B, k7D, k15B, k4A, k7B, k8A, k2A, k7B, k4A, k15B, k7D, k9B.

Row 144: Sl1B, k8B, p1D, k6D, p1B, k14B, p1B, p1A, k2A, p1B, k6B, p1B, p1A, k2A, p2B, p1A, k2A, p1B, k7B, p1A, k2A, p1B, k15B, p1D, k6D, p1B, k8B.

Row 145: Sl1B, k8B, k7D, k16B, k3A, k9B, k1A, k4B, k1A, k9B, k3A, k16B, k7D, k9B.

Row 146: Sl1B, k8B, p1B, p1D, k5D, p1B, k15B, p1B, p1A, k1A, p1A, p1B, k7B, p1B, k4B, p1B, k8B, p1A, k2A, p1B, k16B, p1D, k5D, p1B, k9B.

Row 147: Sl1B, k9B, k7D, k16B, k3A, k14B, k8B, k3A, k16B, k7D, k10B.

Row 148: Sl1B, k9B, p1D, k6D, p1B, k15B, p1B, p1A, k1A, p1A, p1B, k6B, k13B, p1A, k2A, p1B, k16B, p1D, k6D, p1B, k9B.

Row 149: Sl1B, k10B, k7D, k16B, k3A, k13B, k7B, k3A, k16B, k7D, k11B.

Row 150: Sl1B, k10B, p1D, k6D, p1B, k15B, p1A, k2A, p1B, k6B, k13B, p1A, k2A, p1B, k15B, p1D, k6D, p1B, k10B.

Row 151: Sl1B, k11B, k7D, k16B, k3A, k6B, k1A, k4B, k1A, k6B, k3A, k16B, k7D, k12B.

Row 152: Sl1B, k11B, p1B, p1D, k5D, p1D, p1B, k14B, p1A, k2A, p1B, k4B, p1A, k1A, p1A, p1B, k1B, p1A, k1A, p1A, p1B, k4B, p1A, k2A, p1B, k14B, p1D, k6D, p1B, k12B.

Row 153: Sl1B, k12B, k8D, k15B, k2A, k4B, k2A, k1B, k1A, k2B, k1A, k1B, k2A, k4B, k2A, k15B, k8D, k13B.

Row 154: Sl1B, k12B, p1B, p1D, k6D, p1D, p1B, k13B, p1B, p2A, p1B, k2B, p1A, p1B, k1B, p1A, p1B, k1B, p1A, p2B, p1A, p1B, k2B, p1A, k1A, p1B, k14B, p1D, k7D, p1B, k13B.

Row 155: Sl1B, k14B, k8D, k14B, k2A, k3B, k1A, k7B, k1B, k1A, k3B, k2A, k14B, k8D, k15B.

Row 156: Sl1B, k14B, p1B, p1D, k6D, p1D, p1B, k12B, p1B, p2A, p1B, k1B, p2A, p1B,

k5B, p1A, k1A, p1B, k1B, p1A, k1A, p1B, k13B, p1D, k7D, p1B, k15B.

Row 157: Sl1B, k16B, k8D, k13B, k2A, k3B, k1A, k6B, k1A, k3B, k2A, k13B, k8D, k17B.

Row 158: Sl1B, k16B, p1B, p1D, k6D, p1D, p1B, k11B, p1B, p2A, p1B, k1B, p1A, p1B, k5B, p1A, p1B, k1B, p1A, k1A, p1B, k12B, p1D, k7D, p1B, k17B.

Row 159: Sl1B, k18B, k8D, k13B, k2A, k1B, k1A, k6B, k1A, k1B, k2A, k13B, k8D, k19B.

Row 160: Sl1B, k18B, p1B, p1D, k6D, p1D, p1B, k11B, p1B, p2A, k1A, p1A, p1B, k3B, (p1A, k1A) 2 times, p1B, k12B, p1D, k7D, p1B, k19B.

Row 161: Sl1B, k21B, k7D, k13B, k4A, k2B, k2A, k2A, k13B, k7D, k22B.

Row 162: Sl1B, k12B, p3D, p1B, k5B, p1D, k6D, p1B, k12B, p1B, p1A, k2A, p1B, k1B, p1A, k2A, p1B, k13B, p1D, k6D, p1B, k5B, p3D, p1B, k12B.

Row 163: Sl1B, k11B, k6D, k5B, k7D, k14B, k6A, k14B, k7D, k5B, k6D, k12B.

Row 164: Sl1B, k10B, p1D, k6D, p1D, p1B, k3B, p1B, p1D, k5D, p1B, k13B, p1B, p1A, k3A, p1B, k14B, p1D, k5D, p1B, k4B, p1D, k6D, p1D, p1B, k10B.

Row 165: Sl1B, k10B, k8D, k6B, k6D, k4B, k2D, k8B, k4A, k1B, k7B, k2D, k4B, k6D, k6B, k8D, k11B.

Row 166: Sl1B, k9B, p1D, k8D, p1D, p1B, k4B, p1D, k5D, p1B, k2B, p1D, k2D, p1B, k6B, p1A, k1A, p2B, p2A, p1B, k6B, p1D, k1D, p1D, p1B, k2B, p1D, k5D, p1B, k4B, p1D, k8D, p1D, p1B, k9B.

Row 167: Sl1B, k9B, k10D, k5B, k6D, k2B, k5D, k6B, k2A, k2B, k2A, k6B, k5D, k2B, k6D, k5B, k10D, k10B.

Row 168: Sl1B, k9B, p1D, k9D, p1B, k4B, p1D, k5D, p1D, p4B, p1D, k1D, p1B, k4B, p1A, k1A, p1B, k2B, p1B, p2A, p1B, k4B, p1D, k1D, p3B, k1B, p1D, k6D, p1B, k4B, p1D, k9D, p1B, k9B.

Row 169: Sl1B, k8B, k11D, k6B, k6D, k4B, k2D, k4B, k3A, k4B, k1A, k2A, k4B, k2D, k4B, k6D, k6B, k11D, k9B.

Row 170: Sl1B, k8B, p1D, k4D, p2B, p1D, k3D, p1B, k5B, p1D, k5D, p1D, p1B, k1B, p1D, k2D, p1B, k2B, p1A, k2A, p1B, k4B, p1B, p1A, k1A, p1A, p1B, k2B, p1D, k1D,

p1D, p1B, k1B, p1D, k6D, p1B, k5B, p1D, k3D, p2B, p1D, k4D, p1B, k8B.

Row 171: Sl1B, k8B, k4D, k3B, k4D, k5B, k12D, k3B, k2A, k8B, k2B, k2A, k3B, k12D, k5B, k4D, k3B, k4D, k9B.

Row 172: Sl1B, k8B, p1D, k3D, p1B, k2B, p1D, k3D, p1B, k4B, p1D, k6D, p1B, p1D, k3D, p1B, k1B, p1A, k1A, p1B, k2B, k8B, p1B, p2A, p1B, k1B, p1D, k3D, p1B, p1D, k6D, p1B, k4B, p1D, k3D, p1B, k2B, p1D, k3D, p1B, k8B.

Row 173: Sl1B, k8B, k4D, k1B, k5D, k6B, k5D, k4B, k2D, (k3B, k1A) 2 times, k6B, (k1A, k3B) 2 times, k2D, k4B, k5D, k6B, k5D, k1B, k4D, k9B.

Row 174: Sl1B, k8B, (p1D, k3D, p1B) 2 times, k6B, p1D, k4D, p1B, k3B, p2B, k3B, p1A, p1B, k2B, p1A, p1B, k5B, (p1A, p1B, k2B) 2 times, p2B, k4B, p1D, k4D, p1B, k5B, (p1B, p1D, k3D) 2 times, p1B, k8B.

Row 175: Sl1B, k8B, k4D, k2B, k2D, k7B, k6D, k9B, k2A, k1B, k1A, k7B, k1B, k1A, k1B, k2A, k9B, k6D, k7B, k2D, k2B, k4D, k9B.

Row 176: Sl1B, k8B, p1B, p1D, k2D, p1B, k1B, p2B, k7B, p1D, k5D, p1B, k8B, p1B, p2A, p1B, k1B, k7B, p1B, p1A, k1A, p1B, k9B, p1D, k5D, p1B, k6B, p2B, k2B, p1D, k2D, p1B, k9B.

Row 177: Sl1B, k9B, k4D, k9B, k7D, k20B, k14B, k7D, k9B, k4D, k10B.

Row 178: Sl1B, k9B, p1D, k3D, p1B, k7B, p1D, k6D, p1B, k14B, k20B, p1B, p1D, k5D, p1D, p1B, k7B, p1D, k3D, p1B, k9B.

Row 179: Sl1B, k10B, k5D, k5B, k8D, k21B, k15B, k8D, k5B, k5D, k11B.

Row 180: Sl1B, k10B, p1D, k4D, p5D, k7D, p1B, k15B, k21B, p1B, p1D, k6D, p5D, k5D, p1B, k10B.

Row 181: Sl1B, k11B, k15D, k23B, k17B, k15D, k12B.

Row 182: Sl1B, k11B, p1B, p1D, k13D, p1B, k16B, k23B, p1D, k13D, p1B, k12B.

Row 183: Sl1B, k14B, k8D, k1B, k2D, k24B, k18B, k2D, k1B, k8D, k15B.

Row 184: Sl1B, k14B, p3B, p1D, k3D, p1B, p1D, k2D, p1B, k4B, p5D, p1B, k7B, k14B, p5D, p1B, k4B, p1D, k1D, p1D, p1B, p1D, k3D, p3B, k15B.

Row 185: Sl1B, k17B, k4D, k1B, k3D, k4B,

k7D, k13B, k7B, k7D, k4B, k3D, k1B, k4D, k18B.

Row 186: Sl1B, k16B, p1D, k3D, p1B, p1D, k2D, p1B, k3B, p1D, k7D, p1D, p1B, k5B, k12B, p1D, k7D, p1D, p1B, k2B, p1B, p1D, k1D, p1D, p1B, p1D, k2D, p1D, p1B, k16B.

Row 187: Sl1B, k16B, k4D, k1B, k3D, k4B, k10D, k11B, k5B, k10D, k4B, k3D, k1B, k4D, k17B.

Row 188: Sl1B, k16B, p1D, k3D, p1B, p1D, k2D, p1B, k2B, p1D, k10D, p1D, p1B, k3B, k10B, p1D, k10D, p1D, p1B, k2B, p1D, k2D, p1B, p1D, k3D, p1B, k16B.

Row 189: Sl1B, k16B, k4D, k1B, k3D, k3B, k12D, k10B, k4B, k12D, k3B, k3D, k1B, k4D, k17B.

Row 190: Sl1B, k15B, (p1D, k3D, p1B) 2 times, k2B, p1D, k11D, p1B, k3B, k10B, p1D, k11D, p1B, k2B, (p1D, k2D, p1D, p1B) 2 times, k15B.

Row 191: Sl1B, k15B, k4D, k1B, k3D, k3B, k5D, k2B, k6D, k10B, k4B, k6D, k2B, k5D, k3B, k3D, k1B, k4D, k16B.

Row 192: Sl1B, k15B, p1D, k3D, p1B, p1D, k2D, p1B, k2B, p1D, k3D, p1B, k2B, p1B, p1D, k4D, p1D, p1B, k2B, k9B, p1D, k5D, p1B, k2B, p1B, p1D, k3D, p1B, k2B, p1D, k2D, p1B, p1D, k3D, p1B, k15B.

Row 193: Sl1B, k15B, k4D, k1B, k3D, k3B, k4D, k5B, k5D, k9B, k3B, k5D, k5B, k4D, k3B, k3D, k1B, k4D, k16B.

Row 194: Sl1B, k15B, (p1B, p1D, k2D) 2 times, p1B, k2B, p1D, k3D, p1B, k4B, p1D, k4D, p1B, k2B, k9B, p1D, k4D, p1B, k4B, p1D, k3D, p1B, k2B, (p1D, k2D, p1B) 2 times, k16B.

Row 195: Sl1B, k16B, k3D, k1B, k3D, k3B, k4D, k5B, k5D, k9B, k3B, k5D, k5B, k4D, k3B, k3D, k1B, k3D, k17B.

Row 196: Sl1B, k16B, (p1D, k2D, p1B) 2 times, k2B, p1D, k3D, (p1B, k1B, p1D) 2 times, k4D, p1B, k2B, k9B, p1D, k4D, (p1B, k1B, p1D) 2 times, k3D, p1B, k2B, (p1D, k2D, p1B) 2 times, k16B.

Row 197: Sl1B, k16B, k3D, k1B, k3D, k3B, k7D, k2B, k5D, k9B, k3B, k5D, k2B, k7D, k3B, k3D, k1B, k3D, k17B.

Row 198: Sl1B, k16B, p1D, k2D, p1B, p1D, k2D, p1D, p1B, k1B, p1B, p1D, k5D, p1B, k1B, p1D, k4D, p1B, k2B, k9B, p1D, k4D,

p1B, k1B, p1D, k5D, p1B, k2B, p1D, k3D, p1B, p1D, k2D, p1B, k16B.

Row 199: Sl1B, k17B, k2D, k1B, k4D, k3B, k6D, k2B, k5D, k9B, k3B, k5D, k2B, k6D, k3B, k4D, k1B, k2D, k18B.

Row 200: Sl1B, k17B, p1D, k1D, p2B, p1D, k2D, p1B, k2B, p1B, p1D, k3D, p1B, k1B, p1D, k5D, p1B, k2B, k9B, p1D, k4D, p1D, p2B, p1D, k3D, p1B, k3B, p1D, k2D, p1B, k1B, p1D, k1D, p1B, k17B.

Row 201: Sl1B, k17B, k3D, k1B, k3D, k5B, k2D, k3B, k6D, k5B, k2C, k2B, k3B, k6D, k3B, k2D, k5B, k3D, k1B, k3D, k18B.

Row 202: Sl1B, k17B, p1D, k2D, p1B, p1D, k2D, p1D, p1B, k3B, p2B, k3B, p1D, k5D, p1B, k2B, k2B, p1C, k1C, p1B, k4B, p1D, k5D, p1B, k2B, p2B, k4B, p1D, k3D, p1B, p1D, k2D, p1B, k17B.

Row 203: Sl1B, k17B, k3D, k2B, k4D, k7B, k7D, k5B, k2C, k2B, k3B, k7D, k7B, k4D, k2B, k3D, k18B.

Row 204: Sl1B, k17B, p1B, p1D, k1D, p1B, k1B, p1D, k3D, p1B, k5B, p1D, k6D, p1B, k3B, k1B, p1C, k2C, p1C, p1B, k3B, p1B, p1D, k5D, p1D, p1B, k5B, p1D, k3D, p1B, k1B, p1D, k1D, p1B, k18B.

Row 205: Sl1B, k18B, k2D, k2B, k6D, k2B, k9D, k5B, k4C, k1B, k4B, k9D, k2B, k6D, k2B, k2D, k19B.

Row 206: Sl1B, k11B, p3D, p1B, k3B, p1D, k1D, p1B, k1B, p1B, p1D, k4D, p2D, k9D, p1B, k3B, p1C, k4C, p1C, p1B, k3B, p1D, k8D, p2D, k5D, p1B, k2B, p1D, k1D, p1B, k3B, p3D, p1B, k11B.

Row 207: Sl1B, k10B, k5D, k3B, k3D, k2B, k15D, k5B, k6C, k5B, k15D, k2B, k3D, k3B, k5D, k11B.

Row 208: Sl1B, k9B, p1D, k5D, p1B, k2B, p1D, k2D, p1B, k1B, p1B, p1D, k13D, p1B, k3B, p1C, k6C, p1C, p1B, k3B, p1D, k13D, p1B, k2B, p1D, k2D, p1B, k2B, p1D, k4D, p1D, p1B, k9B.

Row 209: Sl1B, k9B, k6D, k3B, k3D, k4B, k12D, k4B, k8C, k2C, k4B, k12D, k4B, k3D, k3B, k6D, k10B.

Row 210: Sl1B, k8B, p1D, k6D, p1D, p1B, k1B, p1D, k2D, p1B, k3B, p1B, p1D, k9D, p1B, k3B, p1C, k2C, k8C, p1C, p1B, k2B, p1B, p1D, k9D, p1B, k4B, p1D, k2D, p1B, k1B, p1D, k6D, p1D, p1B, k8B.

Row 211: Sl1B, k8B, k4D, k2B, k2D, k2B, k3D, k6B, k8D, k5B, k9C, k3C, k5B, k8D, k6B, k3D, k2B, k2D, k2B, k4D, k9B.

Row 212: Sl1B, k8B, p1D, k3D, p1B, k1B, p1D, k1D, p1B, k1B, p1D, k2D, p1B, k5B, p2B, p1D, k3D, p2B, k4B, p1C, k3C, k9C, p1C, p1B, k3B, p2B, p1D, k3D, p2B, k6B, p1D, k2D, p1B, k1B, p1D, k1D, p1B, k1B, p1D, k3D, p1B, k8B.

Row 213: Sl1B, k8B, k4D, k2B, k1D, k2B, k4D, k18B, k10C, k4C, k18B, k4D, k2B, k1D, k2B, k4D, k9B.

Row 214: Sl1B, k8B, p1D, k3D, p1B, k1B, p1B, k2B, p1D, k3D, p1B, k17B, p1C, k3C, k10C, p1B, k17B, p1D, k3D, p1B, k1B, p1B, k2B, p1D, k3D, p1B, k8B.

Row 215: Sl1B, k8B, k4D, k5B, k4D, k17B, k11C, k5C, k17B, k4D, k5B, k4D, k9B.

Row 216: Sl1B, k8B, p1D, k3D, p1D, p1B, k2B, p1D, k4D, p1B, k16B, p1C, k4C, k11C, p1B, k16B, p1D, k3D, p1D, p1B, k2B, p1D, k4D, p1B, k8B.

Row 217: Sl1B, k9B, k12D, k17B, k11C, k5C, k17B, k12D, k10B.

Row 218: Sl1B, k9B, p1D, k11D, p1B, k16B, p1C, k4C, k11C, p1B, k16B, p1D, k11D, p1B, k9B.

Row 219: Sl1B, k9B, k11D, k19B, k10C, k4C, k19B, k11D, k10B.

Row 220: Sl1B, k9B, p1B, p1D, k9D, p1B, k18B, p1C, k3C, k10C, p1B, k18B, p1D, k9D, p1B, k10B.

Row 221: Sl1B, k7B, k1A, k3B, k8D, k21B, k9C, k3C, k21B, k8D, k3B, k1A, k8B.

Row 222: Sl1B, k7B, p1A, p1B, k2B, p1D, k6D, p1B, k12B, p1C, p1B, k7B, p1C, k2C, k9C, p1B, k7B, p1C, p1B, k11B, p1B, p1D, k6D, p1B, k2B, p1A, p1B, k7B.

Row 223: Sl1B, k6B, k2A, k5B, k4D, k8B, k1C, k5B, k2C, k7B, k9C, k3C, k7B, k2C, k5B, k1C, k8B, k4D, k5B, k2A, k7B.

Row 224: Sl1B, k6B, p1A, k1A, p1A, p1B, k3B, p4B, k8B, p1C, p1B, k4B, p1B, p2C, p1B, k5B, p1B, p1C, k1C, k8C, p1B, k6B, p1C, k1C, p1B, k5B, p1C, p1B, k7B, p4B, k4B, p1A, k2A, p1B, k6B.

Row 225: Sl1B, k6B, k4A, k15B, k1C, k6B, k3C, k6B, k8C, k2C, k6B, k3C, k6B, k1C, k15B, k4A, k7B.

Row 226: Sl1B, k4B, p1A, k5A, p1A, p1B, k12B, p1C, k1C, p1B, k5B, p1C, k2C, p1C, p1B, k4B, p1B, p1C, k7C, p1B, k5B, p1C, k3C, p1B, k5B, p2C, p1B, k12B, p1A, k4A, p2A, p1B, k4B.

Row 227: Sl1B, k4B, k8A, k12B, k2C, k5B, k5C, k6B, k7C, k1C, k6B, k5C, k5B, k2C, k12B, k8A, k5B.

Row 228: Sl1B, k4B, p1A, k7A, p1B, k11B, p1C, k1C, p1B, k4B, p1C, k4C, p1B, k5B, p1C, k7C, p1B, k5B, p1C, k4C, p1B, k4B, p1C, k1C, p1B, k11B, p1A, k7A, p1B, k4B.

Row 229: Sl1B, k3B, k10A, k11B, k2C, k5B, k5C, k6B, k7C, k1C, k6B, k5C, k5B, k2C, k11B, k10A, k4B.

Row 230: Sl1B, k3B, p1A, k9A, p1B, k10B, p1C, k1C, p1B, k3B, p1C, k5C, p1C, p1B, k4B, p1B, p1C, k5C, p1B, k5B, p1C, k5C, p1C, p1B, k3B, p1C, k1C, p1B, k10B, p1A, k9A, p1B, k3B.

Row 231: Sl1B, k3B, k11A, k9B, k3C, k4B, k7C, k6B, k6C, k6B, k7C, k4B, k3C, k9B, k11A, k4B.

Row 232: Sl1B, k3B, p1A, k10A, p1B, k8B, p1C, k2C, p1B, k3B, p1C, k5C, p1B, k6B, p1C, k5C, p1B, k5B, p1B, p1C, k5C, p1B, k3B, p1C, k2C, p1B, k8B, p1A, k10A, p1B, k3B.

Row 233: Sl1B, k3B, k11A, k9B, k3C, k3B, k7C, k7B, k6C, k7B, k7C, k3B, k3C, k9B, k11A, k4B.

Row 234: Sl1B, p3A, k11A, p1B, k7B, p1C, k3C, p1C, p1B, k1B, p1C, k6C, p1B, k6B, p1C, k5C, p1B, k6B, p1C, k6C, p1B, k1B, p1C, k3C, p1C, p1B, k7B, p1A, k10A, p3A, k1A.

Row 235: Sl1A, k14A, k8B, k5C, k2B, k6C, k8B, k6C, k8B, k6C, k2B, k5C, k8B, k15A.

Row 236: Sl1A, k14A, p2A, p1B, k4B, p1C, k5C, p1B, k1B, p1C, k5C, p1B, k7B, p1C, k5C, p1B, k7B, p1C, k5C, p1B, k1B, p1C, k4C, p1C, p1B, k4B, p2A, k15A.

Row 237: Sl1A, k17A, k4B, k7C, k1B, k6C, k8B, k6C, k8B, k6C, k1B, k7C, k4B, k18A.

Row 238: Sl1A, k16A, p1B, k4B, p1C, k6C, p1B, p1C, k5C, p1B, k6B, p1C, k6C, p1C, p1B, k6B, p1C, k5C, p1B, p1C, k6C, p1B, k3B, p1B, p1A, k16A.

Row 239: Sl1A, k16A, k5B, k7C, k1B, k6C, k7B, k7C, k1C, k7B, k6C, k1B, k7C, k5B, k17A.

Row 240: Sl1A, k14A, p2B, k5B, p1C, k6C, p1C, p1B, p1C, k4C, p1B, k6B, p1C, k7C, p1B, k6B, p1C, k4C, p1B, p1C, k7C, p1B, k4B, p2B, p1A, k14A.

Row 241: Sl1A, k14A, k7B, k15C, k5B, k8C, k2C, k5B, k15C, k7B, k15A.

Row 242: Sl1A, k13A, p1B, k7B, p1C, k14C, p1B, k3B, p1C, k2C, k8C, p1C, p1B, k3B, p1C, k14C, p1B, k6B, p1B, p1A, k13A.

Row 243: Sl1A, k12A, k9B, k16C, k3B, k9C, k3C, k3B, k16C, k9B, k13A.

Row 244: Sl1A, k10A, p2B, k9B, p1C, k15C, p3C, k3C, k9C, p3C, k16C, p1B, k8B, p2B, p1A, k10A.

Row 245: Sl1A, k9A, k13B, k27C, k21C, k13B, k10A.

Row 246: Sl1A, k9A, p1B, k12B, p1C, k20C, k27C, p1B, k12B, p1A, k9A.

Row 247: Sl1A, k9A, k14B, k26C, k20C, k14B, k10A.

Row 248: Sl1A, k9A, p1B, k13B, p1B, p1C, k18C, k25C, p1B, k14B, p1A, k9A.

Row 249: Sl1A, k49A, k44A.

Row 250: Sl1A, k43A, k50A.

Break all yarns. Weave in all ends before working the border.

BORDER - SHORT EDGES
(2 WORKED THE SAME)

With RS facing, and using color D and smaller needle, pick up and knit 106 sts along 1 short edge.

Change to larger needle.

Setup Row (WS): Sl1 wyif, *p1, sl1 wyib; rep from * to last st, k1.

Row 1 (RS): Sl1 wyif, *k1, sl1 wyif; rep from * to last st, k1.

Row 2 (WS): Sl1 wyif, *p1, sl1 wyib; rep from * to last st, k1.

Rep [Rows 1 and 2] 5 more times (12 rows total). Break color D.

Join color A; change to smaller needle.

Row 13 (RS): Sl1 wyif, knit to end.

With the WS facing, sl1 wyif, *k1, pass previous st over (1 st bound off); rep from * to end of row. Break yarn. Pull tail through the remaining loop and cinch closed to secure.

Repeat for other short edge.

BORDER - LONG EDGES
(2 WORKED THE SAME)

With RS facing, color A, and the smaller needle, pick up and knit 126 sts along 1 long edge, including the sides of the 2 short edges.

Setup Row (WS): Sl1 wyif, knit to end. Break color A.

Row 1 (RS): Sl1 wyif, join color D, knit to end.

Change to larger needle.

Row 2 (WS): Sl1 wyif, *p1, sl1 wyib; rep from * to last st, k1.

Row 3 (RS): Sl1 wyif, *k1, sl1 wyif; rep from * to last st, k1.

Rep [Rows 2 and 3] 4 more times (10 rows total).

Row 12 (WS): Sl1 wyif, *p1, sl1 wyib; rep from * to last st, k1. Break color D.

Join color A; change to smaller needle.

Row 13 (RS): Sl1 wyif, knit to end.

With the WS facing, sl1 wyif, *k1, pass previous st over (1 st bound off); rep from * to end of row. Break yarn. Pull tail through the remaining loop and cinch closed to secure.

Repeat for other long edge.

FINISHING

Weave in remaining ends. Gently wet block to dimensions. Once dry, trim all ends.

Using color A, make four 5¼ in. / 13.5 cm tassels, each weighing 0.35 oz. / 10 g (or made up of 72 strands). Attach 1 securely to each corner. Weave in remaining ends and trim.

CHARTS

KEY

☐	Knit (RS and WS)
⊟	Purl (RS and WS)
⋁	Slip stitch purlwise wyif

Color A
Color B
Color C
Color D

C

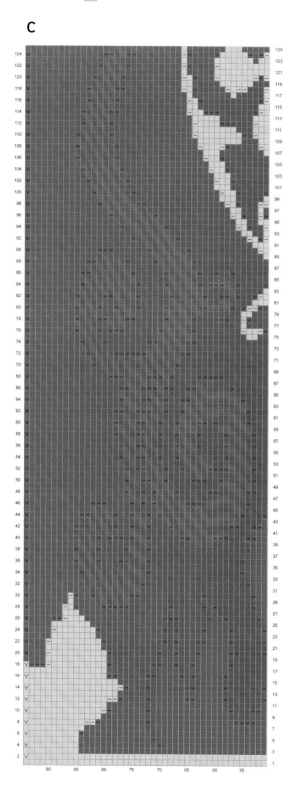

D

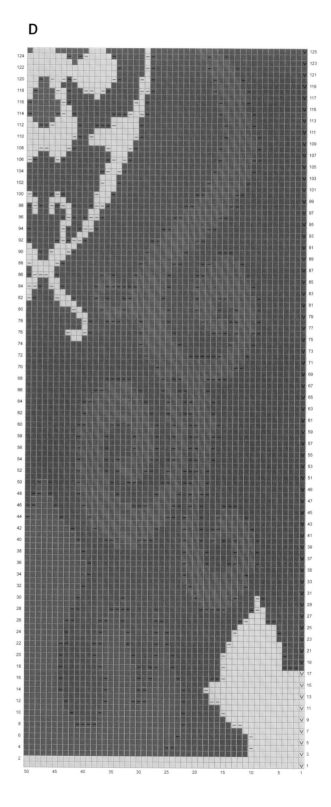

A

B

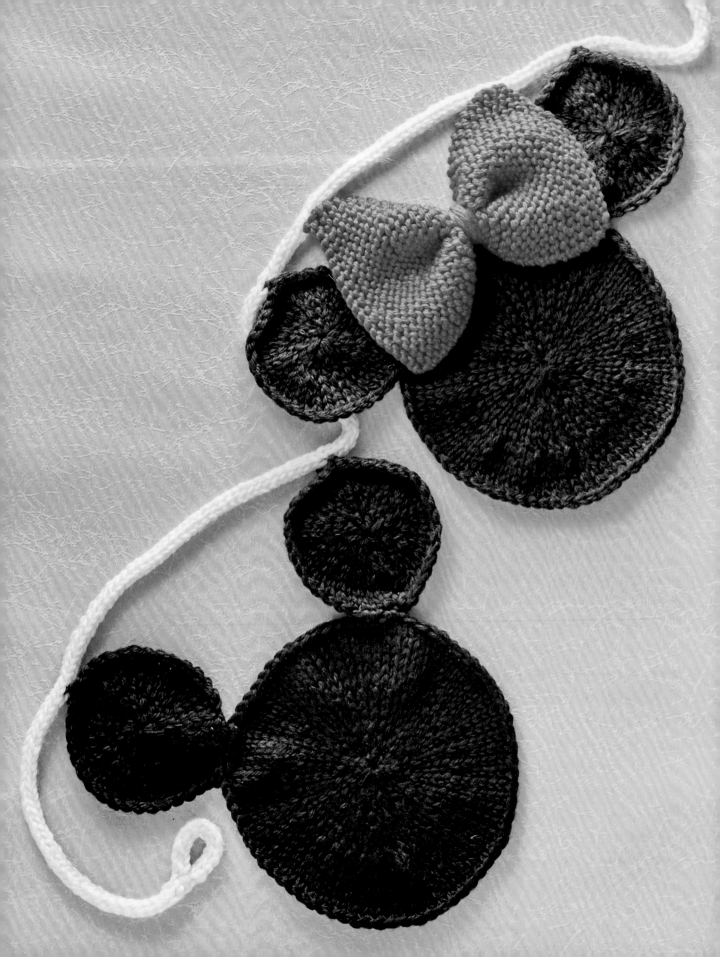

Mouse Ears Garland

Designed by TANIS GRAY

SKILL LEVEL ♥

Inspired by a mouse in his Laugh-O-Gram Films studio in Kansas City where Walt worked for a time, Mickey Mouse was designed in 1928 after Disney lost creative control over his previous signature character, Oswald the Lucky Rabbit, to another studio. Animator Ub Iwerks helped design Mickey's body, head, and ears out of simple circles to make him easier to draw. Dubbed "rubber hose" design, his simple and iconic shape made it possible to recognize him from any angle and gave him appeal to audiences everywhere. Similar in style and billed as Mickey's leading lady, Minnie Mouse is often the catalyst for Mickey's adventures (there's not much he won't do to try and impress her). Walt himself provided the voice for Mickey Mouse for many years—and briefly Minnie's also—and received a special Academy Award® in 1932 for creating the iconic character.

A stylish addition to any Disney fan's home, this adorable garland is worked in multiple pieces. Mickey heads are first worked in the round on double-pointed needles, moving outward with simple M1L increases topped with a suspended bind off to prevent curling. The ears are made the same way and attached using unwoven ends to make for less finishing to be done later. The optional extra step of blocking in a water and liquid starch mixture helps stiffen the pieces. Mickeys can be turned into Minnies with easy garter-stitch bows! A long i-cord is worked, then the ears are attached at even intervals. Add more Mickeys and Minnies for a long party garland, or create just a few to keep you company while dreaming of your next trip to Disneyland!

SIZE
One size

FINISHED MEASUREMENTS
Mickey/Minnie Heads
 Diameter: 6 in. / 15 cm
Mickey/Minnie Ears
 Diameter: 3¼ in. / 8 cm
Bows
 Width: 6 in. / 15 cm
 Height: 4 in. / 10 cm
I-cord
 Length: 102 in. / 259 cm

YARN
Aran weight (medium #4) yarn, shown in Cascade Yarns 220 *Superwash Aran* (100% superwash merino wool; 150 yd. / 138 m per 3½ oz. / 100 g hank)
Main Color (MC): #815 Black, 2 hanks
Contrast Color (CC1): #809 Really Red, 1 hank
Contrast Color 2 (CC2): #871 White, 1 hank

NEEDLES
- US 6 / 4 mm set of 2 double-pointed needles
- US 8 / 5 mm set of 4 double-pointed needles or size needed to obtain gauge

NOTIONS
- Stitch marker (optional)
- Tapestry needle
- Liquid starch (optional)

GAUGE
A specific gauge is not necessary for this pattern.
To achieve the finished sizes as listed, aim for a finished row gauge of 22 rows = 4 in. / 10 cm in St st worked in the rnd on the larger needle, taken after blocking.

continued on page 192

NOTES

- To keep the faces and ears of Mickey and Minnie flat, it is recommended to block with a 50/50 solution of water and liquid starch.
- Where possible, use the ends from the ears and bows to secure the finished Mickeys and Minnies onto the i-cord so there are fewer ends to weave in.

"It is understandable that I should have sentimental attachment for the little personage who played so big a part in the course of Disney Productions and has been so happily accepted as an amusing friend wherever films are shown around the world. He still speaks for me and I still speak for him."

Walt Disney

MICKEY/MINNIE HEAD (MAKE 6)

Using the larger needles and MC, CO 9 sts using the Circular CO method. Distribute the sts evenly over the dpns. Pm for BOR and join to work in the rnd.

Rnd 1: Knit.

Rnd 2 (inc): *K1, M1L; rep from * to end of rnd—18 sts.

Rnds 3 and 4: Knit.

Rnd 5 (inc): *K1, M1L; rep from * to end of rnd—36 sts.

Rnds 6–9: Knit.

Rnd 10 (inc): *K1, M1L; rep from * to end of rnd—72 sts.

Rnds 11–16: Knit.

BO all sts using the Suspended BO technique.

Weave in all ends.

MICKEY/MINNIE EARS (MAKE 12)

Using the larger needles and MC, CO 9 sts using the Circular CO method. Distribute the sts evenly over the dpns. Pm for BOR and join to work in the rnd.

Rnd 1: Knit.

Rnd 2 (inc): *K1, M1L; rep from * to end of rnd—18 sts.

Rnds 3 and 4: Knit.

Rnd 5 (inc): *K1, M1L; rep from * to end of rnd—36 sts.

Rnds 6–9: Knit.

BO all sts using the Suspended Bind Off technique.

Weave in the end at the CO; leave the end from the BO available for joining to the i-cord.

I-CORD

Using the smaller needle and CC2, CO 3 sts onto dpn using the Long Tail CO method.

Work a 3-st i-cord for approx 102 in. / 259 cm. BO all sts knitwise. Do not weave in the ends.

BOWS (MAKE 3)

Using the smaller needle and CC1, CO 20 sts onto 1 dpn using the Long Tail CO method. Do not join to work in the rnd.

Work in garter st (knit every row) until the bow measures 6 in. / 15 cm from the CO edge (approx 28 ridges / 56 rows).

BO all sts knitwise. Do not weave in the ends.

Cut a 12 in. / 30.5 cm length of CC1. Pinch the garter st rectangle in half in the middle and wrap yarn around this pinch point multiple times to cinch in the center to form bow. Secure ends on WS. Do not weave in ends.

FINISHING

Block Mickey/Minnie heads and ears well, using equal parts water and liquid starch if desired.

Thread the tapestry needle with the unwoven BO ends of the ears and whipstitch the ears to the heads to create the iconic Mickey/Minnie shape, following photo for placement if desired.

Thread the tapestry needle with the unwoven ends from the bows and attach the bow to the i-cord and top center of head on every other head so that your Mickeys and Minnies alternate across the garland.

Create a garland hanging loop at each end of the i-cord by folding over the end by 2 in. / 5 cm. Use the unwoven ends to secure.

Weave in any remaining ends.

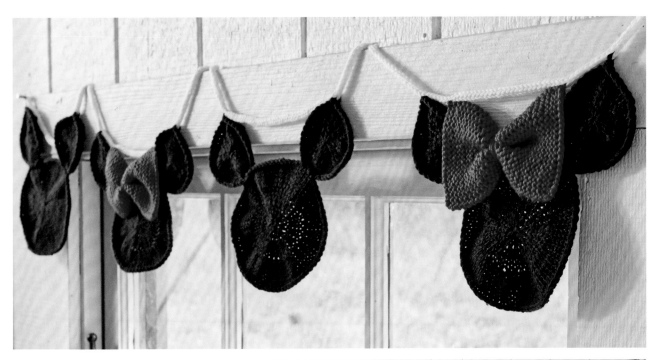

DISNEP
FUN FACTS

Walt originally thought of naming the character Mortimer, until his wife, Lillian, convinced him to rename him Mickey.

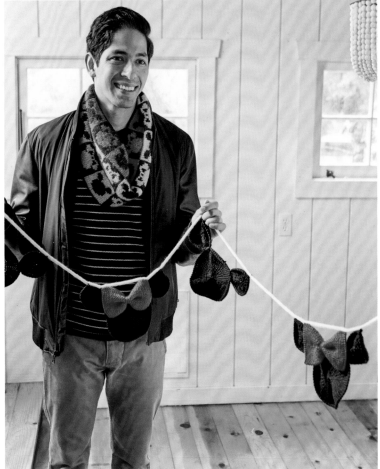

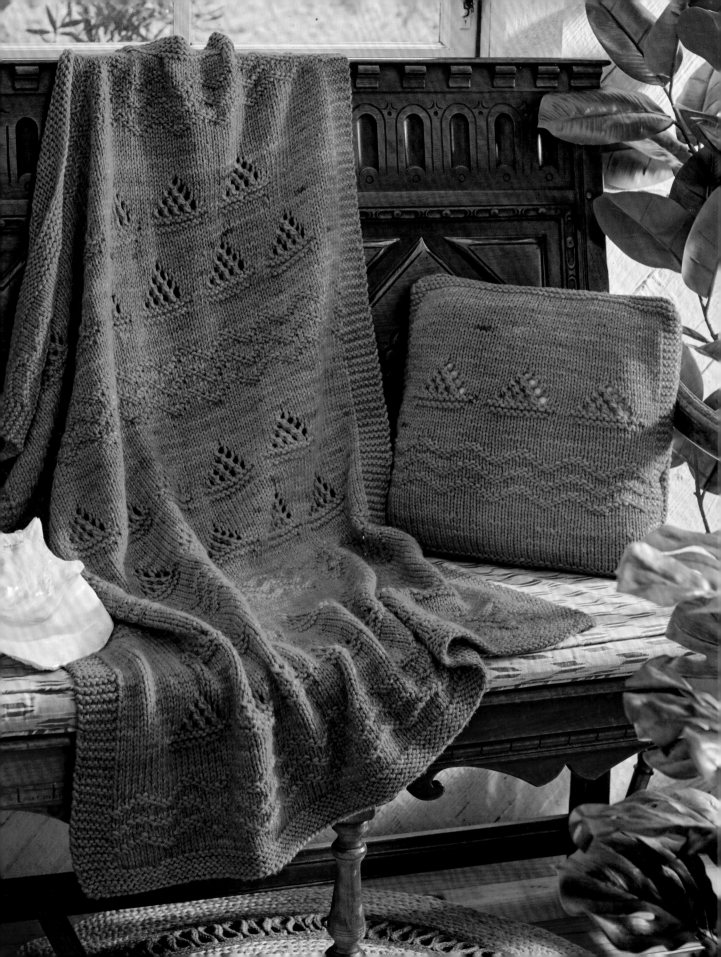

"We Know the Way" Pillow and Blanket

Designed by **SAUNIELL CONNALLY**

SKILL LEVEL ❤

In one memorable scene early in *Moana* (2016), Moana's grandmother takes her to a hidden cave on the island where the young girl learns a stunning secret: Her people were once oceanic voyagers. Part of the award-winning soundtrack written by Opetaia Foa'i, Mark Mancina, and Lin-Manuel Miranda and featuring lyrics in English, Samoan, Tokelauan, and Tuvalu, the song "We Know the Way" tells the tale of Moana's ancestors, who roamed the seas on their boats, discovering island after island and always finding their home. It is at this moment, inspired by her ancestors' remarkable skills and her own deep love for her people, that Moana starts to form a plan that will not only save her island but ultimately lead her people back to the ocean.

Knit with bulky yarn flat back and forth in rows, this matching pillow and throw blanket is the perfect gift for any budding voyager. Inspired by the paintings on the sails of Moana's ancestors' boats, wave motifs made up of easy knits and purls zigzag across the bright blue ocean, while boats made of knits, purls, k2togs, and yarn overs make you want to pack your bags and go explore. Squishy superwash is used for ease of care, so this comfy set is ready to face whatever adventures you throw at it.

SIZE
One size

FINSHED MEAUREMENTS
Pillow
16 x 16 in. / 40.5 x 40.5 cm
Blanket
36 x 46 in. / 91.5 x 117 cm

YARN
Bulky weight (bulky #5) yarn, shown in Emma's Yarn *Bodacious Bulky* (100% superwash merino; 106 yd. / 97 m per 3½ oz. / 100 g hank)
Pillow: Pure, 4 hanks
Blanket: Pure, 8 hanks

NEEDLES
- US 10 / 6 mm, 24 in. / 61cm long circular needle or size needed to obtain gauge

NOTIONS
- Stitch markers
- 16 x 16 in. / 40.5 x 40.5 cm pillow form
- Row counter (optional)
- Tapestry needle

GAUGE
13 sts and 19 rows = 4 in. / 10 cm in St st, taken after blocking
Make sure to check your gauge.

NOTES
- Both the pillow and blanket are knit flat using circular needles. The front and back of the pillow are worked separately and seamed after blocking.
- When joining a new skein of yarn, it is recommended to do it at the end of a row to avoid interrupting the stitch patterns.

continued on page 196

- It is important to note that the waves pattern is worked on both the right and wrong side.
- Begin reading/working all charts on Row 1. Read all odd-numbered (RS) rows from right to left and all even-numbered (WS) rows from left to right.

PILLOW
FRONT PILLOW POCKET PLACKET

CO 54 sts using the Long Tail CO method. Do not join to work in the rnd.

Row 1 (RS): Knit.
Row 2 (WS): Knit.
Rep [Rows 1 and 2] 11 more times (24 rows worked).
Row 25 (RS): Purl.
Row 26 (WS): Knit.

PILLOW BOTTOM EDGE

Rep Rows 1 and 2 of front pillow pocket placket 4 more times (8 rows worked).

PILLOW WAVES

Row 1 (RS): K5, pm, knit to last 5 sts, pm, k5.
Row 2 (WS): K5, sm, purl to m, sm, k5.
Row 3: Knit, sm as encountered.
Row 4: K5, sm, purl to m, sm, k5.
Rep [Rows 3 and 4] 4 more times (12 rows worked).
Row 13 (RS): K5, sm, work Row 1 of Waves chart 5 times, p1, k3, sm, k5.
Row 14 (WS): K5, sm, p2, k2, work Row 2 of Waves chart 5 times, sm, k5.
Row 15: K5, sm, work Row 3 of Waves chart 5 times, k1, p2, k1, sm, k5.
Row 16: K5, sm, k2, p2, work Row 4 of Waves chart 5 times, sm, k5.
Row 17: K5, sm, work Row 5 of Waves chart 5 times, k3, p1, sm, k5.
Row 18: K5, sm, p3, k1, work Row 6 of Waves chart 5 times, sm, k5.
Row 19: K5, sm, work Row 7 of Waves chart 5 times, k2, p2, sm, k5.
Row 20: K5, sm, p1, k2, p1, work Row 8 of Waves chart 5 times, sm, k5.

Row 21: K5, sm, work Row 9 of Waves chart 5 times, p2, k2, sm, k5.
Row 22: K5, sm, p3, k1, work Row 10 of Waves chart 5 times, sm, k5.
Row 23: K5, sm, work Row 11 of Waves chart 5 times, p1, k3, sm, k5.
Row 24: K5, sm, p2, k2, work Row 12 of Waves chart 5 times, sm, k5.
Row 25: K5, sm, work Row 13 of Waves chart 5 times, k1, p2, k1, sm, k5.
Row 26: K5, sm, k2, p2, work Row 14 of Waves chart 5 times, sm, k5.
Row 27: K5, sm, work Row 15 of Waves chart 5 times, k3, p1, sm, k5.
Row 28: K5, sm, purl to m, sm, k5.

PILLOW BOATS

Setup Row 1 (RS): Knit, sm as encountered.
Setup Row 2 (WS): K5, purl to m, sm, k5.
Rep Setup Rows 1 and 2 twice more (6 rows worked).
Row 1 (RS): K5, sm, k3, (work Boat chart 3 times, k1) 3 times, k2, sm, k5.
Row 2 (WS): K5, sm, purl to m, sm, k5.

Note: This WS row is worked in place of the WS rows of the chart.

Rep [Rows 1 and 2] 5 more times (12 rows worked); all 12 rows of the Boat chart are now complete.

Work Setup Rows 1 and 2 ten times, rm on the final repeat of Setup Row 2 (20 rows worked).

PILLOW TOP EDGE

Row 1 (RS): Knit.
Row 2 (WS): Knit.

Rep [Rows 1 and 2] 3 more times (8 rows worked).
With RS facing, bind off all sts knitwise.

BACK PILLOW

CO 54 sts using the Long Tail CO method. Do not join to work in the rnd.

Work Pillow Bottom Edge, Pillow Waves, Pillow Boats, and Pillow Top Edge as for the front.

With RS facing, BO all sts knitwise.

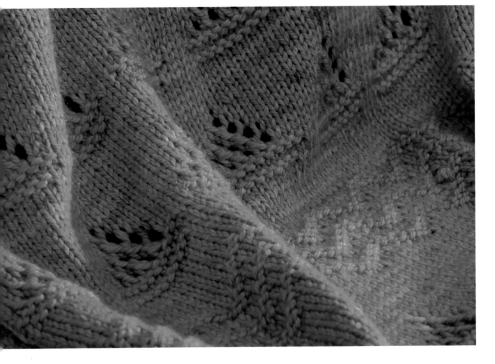

PILLOW FINISHING

Weave in all ends to the WS. Wet block both sides of the pillow. Once dry, trim all ends.

With RS facing (WS together), seam the sides of the pillow using mattress stitch, and seam the top edges of the pillow using the Horizontal Invisible seaming method.

Fold the placket up to the inside and whipstitch to the existing inside seam. This will create the pocket for the pillow form.

Stuff the pillow with the pillow form.

BLANKET
BLANKET EDGE

CO 118 sts using the Long Tail CO method. Do not join to work in the rnd.

Row 1 (RS): Knit.
Row 2 (WS): Knit.

Rep [Rows 1 and 2] 3 more times (8 rows worked).

Row 9 (RS): K7, pm, knit to last 7 sts, pm, k7.
Row 10 (WS): K7, sm, purl to m, sm, k7.
Row 11: Knit, sm as encountered.

Row 12: K7, sm, purl to m, sm, k7.

BLANKET WAVES

Row 1 (RS): K7, sm, work Waves chart 13 times to m, sm, k7.
Row 2 (WS): K7, sm, work Waves chart 13 times to m, sm, k7.

Rep [Rows 1 and 2] 7 more times (16 rows worked); all 16 rows of the Waves chart are now complete.

Row 17 (RS): Knit, sm as encountered.

Row 18 (WS): K7, sm, purl to m, sm, k7.

Rep Rows 17 and 18 twice more (6 rows worked).

BLANKET BOATS

Row 1 (RS): K7, sm, k7, (work Boat chart, k1) 7 times, k6, sm, k7.
Row 2 (WS): K5, sm, purl to m, sm, k5.

Note: This WS row is worked in place of the WS rows of the chart.

Rep [Rows 1 and 2] 5 more times (12 rows worked); all 12 rows of the Boat chart are now complete.

Row 13 (RS): Knit, sm as encountered.

Row 14 (WS): K7, sm, purl to m, sm, k7.

Rep Rows 13 and 14 once more (4 rows worked).

Row 17 (RS): K7, sm, k15, (work Boat chart, k1) 6 times, k11, sm, k7.

Row 18 (WS): K5, sm, purl to m, sm, k5.

Note: This WS row is worked in place of the WS rows of the chart.

Rep [Rows 17 and 18] 5 more times (12 rows worked); all 12 rows of the Boat chart are now complete.

Work [Rows 13 and 14] 4 times (8 rows worked).

BLANKET REPEATS

Repeat Blanket Waves and Blanket Boats twice more (6 sections total, worked alternately).

BLANKET WAVES TOP EDGE

Row 1 (RS): K7, sm, work Waves chart 13 times to m, sm, k7.
Row 2 (WS): K7, sm, work Waves chart 13 times to m, sm, k7.

Rep [Rows 1 and 2] 7 more times (16 rows worked); all 16 rows of the Waves chart are now complete.

Row 17 (RS): Knit, sm as encountered.

Row 18 (WS): K7, rm, purl to m, rm, k7.

BLANKET EDGE

Row 1 (RS): Knit.
Row 2 (WS): Knit.

Rep [Rows 1 and 2] 3 more times (8 rows worked).

With RS facing, BO all sts knitwise.

BLANKET FINISHING

Weave in all ends to the WS. Steam or wet block both, if desired. Once dry, trim all ends.

CHARTS
KEY

☐	Knit on RS, purl on WS
⊟	Purl on RS, knit on WS
╲	ssk
⊙	YO
▭	Pattern repeat

WAVES

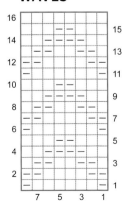

BOAT

Glossary

CAST ONS

ALTERNATING CABLE CAST ON

This is a variation of the Cable Cast On method that is geared toward projects that begin with a ribbed edge. Stitches are cast on alternately knitwise and purlwise to mimic that of the subsequent ribbing.

Make a slipknot and place it on the needle. Holding the needle with the slipknot in your left hand, insert the right needle into the stitch. Knit but do not drop the stitch from the left needle; place this new stitch onto the left needle—1 new stitch made.

*Step 1: Insert the right needle between the first 2 stitches on the left needle from the back and purl, place the new stitch on the left needle—1 new stitch made.

Step 2: Insert the right needle between the first 2 stitches on the left needle from the front and knit, place the new stitch on the left needle—1 new stitch made.

Repeat from * until the required number of stitches is on the needle.

BACKWARD LOOP CAST ON

*Holding the yarn over your left thumb with the end coming from the ball held by your last three fingers and at the outside of the thumb, insert the needle up under the yarn next to the outside of your thumb. Remove your thumb from the loop, and pull the end to tighten the yarn slightly to snug the yarn up on the needle.

Repeat from * until the required number of stitches has been cast on.

CABLE CAST ON

Make a slipknot and place it on the needle. Holding the needle with the slipknot in your left hand, insert the right needle into the existing stitch. Knit, but do not slip the stitch from the left needle. Place this new stitch on the left needle. *Insert right needle between the first 2 stitches on the left needle and knit, place the new stitch on the left needle. Repeat from * until the required number of stitches is on the needle.

KNITTED CAST ON

Make a slipknot and place it on the needle. *Holding the needle with the slipknot in your left hand, insert the right needle into the stitch. Knit, but do not slip the stitch from the left needle. Place this new stitch on the left needle. Repeat from * until the required number of stitches is on the needle.

CIRCULAR CAST ON

Stitches are cast on around a large loop that is subsequently pulled tight to close any gap. This is best worked on double-pointed needles.

Note: Stitches will be cast on to the needle alternately, loading the stitches with the needle above the loop and loading the stitches with the needle inside the loop. The final stitch will be cast on with the needle inside the loop.

Create a loop of yarn that is approximately 1–2 in. / 2.5–5 cm in diameter by crossing the short tail (enough to weave in at the end) in front of the working yarn (the yarn attached to the working ball), and pinch this crossing point between the thumb and middle finger of the left hand. Tension the working yarn over the pointer finger and under the ring finger of the left hand so that your fingers look like they are creating a lowercase b.

To begin, insert the right-hand needle through the front of the loop, and yarn over counterclockwise around the needle; pull the needle back through the loop toward you—1 stitch cast on.

*To cast on a stitch above the loop, leave the right-hand needle outside/above the loop and yarn over counterclockwise around the needle (secure the new loop by placing the pointer finger of the right hand on top of this new loop)—1 stitch cast on.

To cast on a stitch inside of the loop, insert the right-hand needle through the front of the loop (swinging the needle counterclockwise and down), and yarn over counterclockwise around the needle; pull the needle back through the loop.

Repeat from * until the required number of stitches is on the needle. Once all the stitches are cast on, pull the short tail to cinch up the loop. As the stitches are worked on the first few rounds, the loop may loosen; you can cinch the loop closed again by pulling the short tail and securing to the wrong side once enough fabric is established.

LONG TAIL CAST ON

Make a slipknot with the yarn, leaving a tail long enough to cast on the required number of stitches (usually about 1 in. / 2.5 cm per stitch), and place the slipknot onto the needle. Holding the needle in your right hand, clasp both strands in your lower three fingers with the long tail over your thumb and the end coming from the ball over your index finger.

*Spread your thumb and index finger apart to form a V. Insert the needle tip up between the two strands on your thumb. Bring the needle tip over the top of the first strand around your index finger, then down to draw a loop between the strands on your thumb. Remove your thumb and tighten the stitch on the needle—1 stitch cast on. Place your thumb and index finger between the strands of yarn again. Repeat from * until the required number of stitches has been cast on.

TWISTED GERMAN CAST ON

Make a slipknot with the yarn leaving a tail long enough to cast on the required number of stitches (usually about 1 in. / 2.5 cm per stitch), and place the slipknot onto the needle.

*Holding the needle and yarn as for a Long Tail Cast On, bring the needle toward you, under both strands around your thumb. Swing the tip up and toward you again, down into the loop on your thumb, then up in front of the loop on your thumb. Swing it over the top of the loops and over the first strand on your index finger, catch that strand,

and bring the needle back down through the thumb loop and to the front, turning your thumb as needed to make room for the needle to pass through. Remove your thumb from the loop, then pull the strands to tighten the stitch. Repeat from * until the required number of stitches has been cast on.

JUDY'S MAGIC CAST ON

This is a cast on to create a closed starting point, such as the toe of a sock.

Hold two double-pointed needles (or two needle tips of the Magic Loop method) parallel in the right hand with the tips pointing to the left. The needle closer to you will be the front needle, and the needle farther from you will be the back needle.

With the left hand, drape a length of yarn over the back needle so that the tail falls between the two needles and the end attached to the ball of yarn drapes over the back needle.

Make a half twist of the strands counterclockwise so that the end attached to the ball is now in front and the tail is in the back. This twist secures the first stitch on the back needle.

Split the yarn tails so that the shorter tail is over your thumb and the end attached to the ball is over your pointer finger; both tails should be caught by the last three fingers of your hand (like the setup for the Long Tail Cast On).

*Keeping the left hand stationary, swing the needles clockwise over the back tail, then down, under, and back up to catch the back tail with only the front needle—1 new stitch on the front needle.

Swing the needles counterclockwise and down over the front tail so that the front yarn moves up between the two needles and backward over the back needle—1 new stitch on the back needle.

Repeat from * until you have the total number of stitches, minus one, on the needles (you will have one more stitch on the back needle than the front needle).

To complete the cast on, place the final stitch on the front needle as above. Give the yarn tails one more half twist to secure. Rotate the needles so that they are in the left hand, with the tips pointed to the right, to begin knitting.

PROVISIONAL CAST ONS
CROCHET PROVISIONAL CAST ON

With waste yarn, make a slipknot and place on the crochet hook. Hold the needle in your left hand, the waste yarn over your left index finger, and the crochet hook in your right hand.

*Hold the needle above the yarn coming from the hook. With the crochet hook, reach over the top of the needle and make a chain, making sure the yarn goes around the needle—1 stitch cast on. Repeat from * until the required number of stitches has been cast on. Cut the yarn and fasten off the last chain, being careful not to tighten the stitch.

Change to the working yarn, ready to work across the cast-on stitches per the pattern.

When finishing the edge or picking up the stitches to continue working in the other direction, pull the waste yarn tail out of the last stitch cast on and pull carefully to unzip the edge, placing the resulting stitches onto the needle as you go.

BIND OFFS
ELASTIC BIND OFF

The elastic bind off creates a stretchy finished edge suitable for the edge of shawls. Each stitch is worked twice to create more yarn usage, which allows for an elastic edge.

Knit 1 stitch, *knit 1 stitch, slip both stitches purlwise back to the left-hand needle and knit the 2 stitches together through the back loop—1 stitch bound off. Repeat from * (working any stitches that are wrapped as brk1 as necessary) until all stitches have been worked and 1 stitch remains on the right-hand needle. Cut yarn and fasten off the remaining stitch.

K2TOG BIND OFF

Worked similarly to the Elastic Bind Off—where stitches aren't passed over and off a needle, but rather worked together similar to standard k2tog decreases—the K2tog Bind Off is a simple way to finish an edge cleanly.

*K2tog, slip remaining stitch purlwise from right-hand to left-hand needle; repeat from * until 1 stitch remains. Cut yarn and fasten off the remaining stitch.

THREE-NEEDLE BIND OFF

The Three-Needle Bind Off is a way of joining two sets of live stitches in a bound-off edge, creating a firm seam. This method of seaming is ideal for seams that need the firmness to support the weight of the body and sleeves of a garment.

Place each set of stitches to be joined on separate needles, making sure the needle tips are at the right-hand edge of the stitches to be bound off.

Hold both needles in your left hand with needle tips pointing to the right.

Insert the right needle knitwise into the first stitch on both needles, then knit them together—1 stitch from each needle has been joined. *Knit the next stitch on both needles together, lift the first stitch worked over the stitch just worked and off the needle—1 stitch bound off.

Repeat from * until all stitches have been worked and 1 stitch remains on the right needle. Cut yarn and fasten off the remaining stitch.

I-CORD BIND OFF

The i-cord bind off is a lovely way to prevent a project from rolling while providing a clean, finished edge. The combination of always working on the right side and sliding stitches (rather than turning the work), creates the tube.

With the right side facing, and using the Cable Cast On method, cast on the required number of stitches. *Slide the sts back to the right needle tip (without turning the work), pulling the working yarn behind into place to work the right side. Knit to the last of these cast-on stitches, then slip, slip, knit (ssk) the remaining cast-on stitch to the live stitch from the edge of the knitting—1 stitch bound off. Repeat from * until all sts have been bound off. To finish the i-cord, knit the remaining stitches together as one, break the yarn, and pull the tail through the remaining loop to secure. Alternatively, bind off the remaining stitches knitwise and seam the remaining live stitches of the tube to the cast-on edge with the Horizontal Invisible seaming method for a seamless join.

JENY'S SURPRISINGLY STRETCHY BIND OFF

A sufficiently stretchy bind off for the brim of a hat or the cuff of a sock, this bind off is also structural enough for a collar or button band of a sweater.

SPECIAL TECHNIQUE

Yarn over backward: Move the working yarn over the top of the right-hand needle from back to front (the opposite of a standard yarn over) and to the back again between the needles, creating a new stitch on the right-hand needle.

To process a knit stitch: yarn over backward, knit 1 stitch.

To process a purl stitch: yarn over, purl 1 stitch.

To begin binding off, knit or purl the first stitch (as it presents) without any yarn overs. *Process the next stitch with its yarn over. There will now be 3 stitches on the right-hand needle. With the left-hand needle, pull the 2 rightmost stitches (the original stitch and the yarn over) over the leftmost stitch and off the needle—1 stitch remains on the right-hand needle. Repeat from * until all stitches are bound off. Cut yarn and fasten off the remaining stitch.

SEWN TUBULAR BIND OFF

Also known simply as the Tubular Bind Off, this method creates a seamless yet stretchy edge to ribbed fabric. This method uses two working needles and a tapestry needle to graft the live stitches together.

Cut a tail of working yarn that is four times the length of the stitches to be bound off.

Tubular Setup Round 1: *K1, sl1 wyif; rep from * to end of rnd.

Tubular Setup Round 2: *Sl1 wyib, p1; rep from * to end of rnd.

Slipped Stitch Round: Without knitting any stitches, slip all of the stitches purlwise onto two needles, placing all of the knit stitches on the original working needle and all of the purl stitches on a second circular needle that will be inside/behind the working needle. Each needle will now hold half of the stitches.

Thread a tapestry needle with the tail and, using Kitchener stitch, graft all the stitches between the two needles.

SUSPENDED BIND OFF

This is a knitted bind off that creates structure for the finished, visible edge of a project without becoming too tight. This can be worked at regular tension.

Knit 2 stitches, *using the left-hand needle, pick up the first stitch and lift it up and over the second and off the right-hand needle without dropping the stitch off the left-hand needle (suspend it); k1, drop suspended stitch off left-hand needle; repeat from * until 2 stitches remain. Pass the first stitch over the second and off the needle. Break yarn and pull the tail through the final stitch to secure.

DUPLICATE STITCH

Duplicate stitch is a way of adding sections of color to a knitted piece without having to work stranded knitting or intarsia. The technique covers each stitch completely. Large areas can become thick and stiff, so it's best used in small areas.

With the color to be stitched threaded into a tapestry needle, insert the needle from wrong side to right side in the stitch below the first stitch to be covered.

*Insert the tapestry needle under both legs of the stitch in the row above the stitch to be covered, and pull the yarn through, being careful not to pull the yarn too tightly. Insert the needle back into the same spot where you initially brought it to the right side, and pull the yarn through to completely cover the first stitch. Bring the needle up through the stitch below the next stitch to be covered.

Repeat from * to continue covering stitches.

DOUBLE KNITTING

Double knitting is a method of creating two-sided fabric, such as for a scarf or a coaster, without having an exposed wrong side. The front and back of the fabric are created simultaneously, knitting all stitches with one color and purling all adjacent stitches with the opposite color, so that the front and back of the project are mirrors of one another. As such, double knitting is done in multiples of 2 stitches. The colorwork charts provided for double knitting indicate the color of the stitch that will be knit; the opposite color will be worked on all purl stitches and is not charted.

TO WORK IN THE ROUND

*Move both yarns to the back between the needles as if to knit (if not already in position) and knit 1 stitch using the color indicated in the chart square. After completing the knit stitch, move both yarns to the front between the needles as if to purl, and purl the next stitch with the opposite color as what is indicated for the knit stitch. Repeat from * to end of round.

TO WORK FLAT

With the right side facing: *Move both yarns to the back between the needles as if to knit (if not already in position) and knit 1 stitch using the color indicated in the chart square. After completing the knit stitch, move both yarns to the front between the needles as if to purl and purl the next stitch with the opposite color as what is indicated for the knit stitch. Repeat from * to end of row.

With the wrong side facing: *Move both yarns to the back between the needles as if to knit (if not already in position) and knit 1 stitch using the *opposite* color indicated in the chart square. After completing the knit stitch, move both yarns to the front between the needles as if to purl and purl the next stitch with the color indicated in the chart square. Repeat from * to end of row.

APPLYING/PLACING BEADS
CROCHET HOOK METHOD

Using abbreviated letters to indicate the color of bead, (i.e., G – green, R – Red, or Y – yellow), AB-X indicates to apply a bead to the fabric.

Using a crochet or bead hook appropriate for the size of bead being used, insert the hook through the bead and leave the bead on the hook. Pick up the loop of the stitch over which you want to place the bead with the crochet hook, and let it drop off your knitting needle. Pull this loop through the bead, place the loop back onto the left-hand needle, and remove the crochet hook. Knit this stitch in pattern to secure the bead.

KITCHENER STITCH

Very often referred to as grafting, Kitchener stitch joins two sets of live stitches without a visible seam. This seaming method is not well suited for joining shoulder seams, which need to support the weight of the body and sleeves of the garment. It should be used for smaller seamed areas or for joining sections of a cowl or the toe of a sock that is expected to be stretched.

Work a few stitches at a time, pulling the yarn loosely, then adjust the length of each stitch to match the tension on each side of the join.

Place each set of stitches to be joined onto two separate needles, making sure the needle tips are at the right-hand edge of the stitches to be joined.

Hold both needles in your left hand, parallel, with needle tips pointing to the right.

Step 1: Insert tapestry needle purlwise through first stitch on front needle and pull the yarn through, leaving stitch on front needle.

Step 2: Insert tapestry needle knitwise through first stitch on back needle and pull the yarn through, leaving stitch on back needle.

Step 3: Insert tapestry needle knitwise through first stitch on front needle, slip stitch off front needle, and pull the yarn through.

Step 4: Insert tapestry needle purlwise through next stitch on front needle and pull the yarn through, leaving stitch on front needle.

Step 5: Insert tapestry needle purlwise through first stitch on back needle, slip stitch off back needle, and pull the yarn through.

Step 6: Insert tapestry needle knitwise through next stitch on back needle and pull the yarn through, leaving stitch on back needle.

Repeat Steps 3–6 until the yarn has been threaded through the last stitch of each needle once. Insert tapestry needle knitwise into last stitch on front needle, slip stitch off front needle, and pull yarn through. Then insert tapestry needle purlwise into last stitch on back needle, slip stitch from needle, and pull yarn through. Weave in ends on the wrong side to secure.

MATTRESS STITCH

Mattress stitch creates an invisible seam along vertical edges.

Place the pieces being sewn together side by side on a flat surface with the right sides facing you. Thread a piece of yarn about three times longer than the seam to be sewn into a tapestry needle.

Beginning at the bottom edge, insert the tapestry needle under one bar between the edge stitches on one piece, then under the corresponding bar on the other piece.

*Insert the tapestry needle under the next two bars of the first piece, then under the next two bars of the other piece. Repeat from *, alternating sides until the seam is complete, ending on the last bar or pairs of bars on the first piece. Weave in ends on the wrong side to secure.

HORIZONTAL INVISIBLE SEAMING

A method of seaming two horizontal pieces of knit fabric together, such as a cast-on edge to a bind-off edge (or two cast-on/two bind-off edges).

Align the two edges to be seamed so that they are lined up, stitch by stitch, with the right side facing up.

Thread a tapestry needle with a length of yarn approximately three times the length of the seamed edges.

Step 1: Insert the needle under both legs of the first stitch of one piece and pull the yarn through (leaving a tail for weaving in).

Step 2: Insert the needle under both legs of the lined-up stitch on the opposite edge (the piece you are joining to) and pull the yarn through.

Repeat these two steps (without leaving a tail for weaving in on each subsequent stitch) until all the stitches are seamed. Once the seaming is complete, you may adjust the tension of the seaming yarn so it lays flat and the stitches appear the same size as the joined edges. Trim ends and weave in.

RUNNING STITCH

Running stitch can be used to decorate knitted fabric such as adding eyes or mouths as a visible technique or can be used to cinch sections of work and be less visible. It can even be used for sewing two items together.

RUNNING STITCH (FOR SEWING)

Thread the tapestry needle with the working yarn. Starting at the rightmost point of the smaller item to be sewed to the larger piece of the project, from the wrong side, push the tapestry needle through to the right side of the larger item, catch a stitch of the smaller item on the wrong side (or hidden behind an edging detail), and then push the needle back through to the wrong side of the larger piece of the project. Move over 1 stitch and repeat this process until all edges of the smaller item are secured to the larger piece of the project. Ensure the yarn isn't loose or saggy. Cut yarn and weave tails to the wrong side to secure.

RUNNING STITCH (FOR CINCHING)

Thread the tapestry needle with the working yarn. Starting at the rightmost point of the designated cinching section, with the right side facing, pick up the right leg of each of the required stitches. At the stopping point, remove the working yarn from the tapestry needle and pull the tails tight to cinch the section. Secure with an overhand knot. Trim tails or secure to wrong side.

I-CORD

It is best worked on double-pointed needles or a circular (a needle with tips at each end; a straight needle with a stopper at one end will not work).

Cast on the number of stitches listed in the pattern (usually between 2 and 4 stitches). Slide the stitches to the right edge of the needle and pull the working yarn behind the back of the work, ready to knit the first stitch closest to the right needle tip. This will create a tube.

Row 1: Knit, then slide stitches back to right end of needle. Do not turn; pull the working yarn behind.

Repeat Row 1 until the cord is the desired length. Finish off the cord as directed in the pattern.

CROCHET CORD

This method creates a long, narrow cord, similar in structure to that of a traditional knit i-cord, but is worked with a crochet hook.

Measure out a length of yarn that is eight times the length of the desired finished cord length. Make a slipknot in the middle of this length so that four times the length of the desired finished cord length is on each side of the slipknot. Place the slipknot on the crochet hook. Chain 1 with the yarn farthest from you.

*With the tail of yarn closest to you, wrap the yarn from front to back over the crochet hook (this creates a second loop over the hook); with the yarn farthest from you (the working yarn), wrap the yarn from back to front around the hook and pull this yarn through both loops on the hook.

Repeat from * until the cord is the desired length. Pull the remaining working yarn through the final loop to secure.

SHORT ROWS
WRAP AND TURN (W&T) SHORT ROWS

Slip all stitches purlwise in the following sequences.

On knit rows: Knit to instructed turning point. With the yarn in back, slip the next stitch to the right needle, move the yarn to the front between needles, slip the stitch back to the left needle, and move the yarn back between needles to the purl side. Turn work.

On purl rows: Purl to the instructed turning point. With the yarn in front, slip the next stitch to the right needle, move the yarn to the back between needles, slip the stitch back to the left needle, and move the yarn to the front between needles to the purl side. Turn work.

To process the wrap on a subsequent row: Work to the wrapped stitch, pick up the wrap from front to back for a knit stitch (and from back to front for a purl stitch), and place the wrap on the left needle. Work the wrap together with the stitch as a k2tog or p2tog.

GERMAN SHORT ROWS

Double stitches are creating by distorting the stitch at the end of the previously turned row.

On knit rows (following a turn): Move the working yarn to the front between the needles. Slip the first stitch purlwise to the right-hand needle. To create the double stitch (DS), pull the working yarn up and over the back of the right-hand needle so the stitch now looks like an upside-down V with two legs. Keep the yarn in back, ready to knit the next stitch, and work across the row in pattern.

On purl rows (following a turn): With the working yarn still in front, slip the first stitch purlwise to the right-hand needle. To create the double stitch (DS), pull the working yarn up and over the back of the right-hand needle so the stitch now looks like an upside-down V with two legs. Move the working yarn to the front between the needles, ready to purl the next stitch, and work across the row in pattern.

To process a double stitch on a subsequent row: Work to the double stitch and knit (or purl) the two legs together as a k2tog or p2tog as if it were one stitch.

TWISTED HEEL FLAP

With the wrong side of the flap facing, and working from the top of the heel flap toward the live stitches on the needle at the bottom of the heel flap, pick up the innermost leg (the left leg of the stitches along the right edge of the heel flap; the right leg of the stitches along the left edge of the heel flap) of each stitch with a spare double-pointed needle. You will pick up one leg for each slipped edge stitch.

Turn the work so the right side is facing, and knit each new stitch through the back loops to twist closed.

STRANDED COLORWORK

Sometimes referred to as Fair Isle knitting, stranded colorwork uses two (or more) colors per round, with the color not currently being

used stranded, or carried, loosely across the wrong side of the work. Whichever method you use, make sure to maintain even tension and keep the position vertically to maintain color dominance. The bottom strand carried will have more dominance than the top; it's best practice to carry the contrast colors as the dominant (or bottom) yarn.

When rounds of stranded colorwork are placed between rounds of stockinette, make sure to check both gauges before you begin; most knitters will work the stranded colorwork section more tightly than plain stockinette. Adjust your needle size when switching to the stranded section as needed to match gauge, and remember to change back to the smaller needle(s) when beginning the next section of plain stockinette.

As you work across a round of the pattern, spread the stitches just worked apart slightly before knitting the next stitch with the color that has been carried across the wrong side. The float across the back should be relaxed, not sagging, and should also not be tight as to avoid puckering of the fabric.

If floats between color changes will be more than ½–¾ in. / 1–2 cm long, it's a good idea to catch the unused color to reduce the risk of snagging the float later. The easiest way to do this is to hold the color to be caught in your left hand and the working color in your right hand. Insert the right needle into the next stitch and *under* the floated yarn, then knit as usual, allowing the floated yarn to come back down behind the needles so the working yarn will lie over the top of it on the next stitch. Catching floats more regularly than is necessary uses more yarn and can create a stiffer fabric.

INCREASES

Kfb: Knit into the front of the next stitch, but do not remove it from the left needle. Bring the right needle to the back of work and knit into the back of the same stitch, then drop the stitch from the left needle—1 stitch increased.

Kfbfbf: Knit into the front of the next stitch, but do not remove it from the left needle. *Swing the right needle to the back of the work and knit into the back of the same stitch, but still do not remove it from the left needle. Bring the right needle to the front of the work one more time and knit into the front of the stitch again, still not dropping the stitch. Repeat from * once more, and on the final knit into the front, drop the stitch from the left needle—4 stitches increased.

LR1 (Lifted Right Increase): Using the right needle, pick up the right leg of the stitch 1 row below and place it on the left-hand needle, knit this new loop—1 stitch increased.

M1BL (Make 1 stitch, backward loop): Cast on 1 stitch using the Backward Loop method—1 stitch increased.

M1L (Make 1 stitch, left leaning): Insert left-hand needle under the strand between the stitch just worked and the next stitch from front to back, knit this through the back loop—1 stitch increased.

M1R (Make 1 stitch, right leaning): Insert left-hand needle under the strand between the stitch just worked and the next stitch from back to front, knit this through the front—1 stitch increased.

Make 4 on WS: Into the yarn-over loop created on the previous right-side row: k1, p1, k1, p1, k1—4 stitches increased.

Pfb: Purl into the front of the next stitch, but do not remove it from the left needle. Bring the right needle to the back of work and purl into the back of the same stitch, then drop the stitch from the left needle—1 stitch increased.

BOBBLES

MB (Make a 5-stitch bobble): Into 1 stitch: Kfbfbf—4 stitches increased. Turn the work to the wrong side and purl across 5 sts. Turn the work to the right side and across the 5 sts: (k2tog) twice, k1—3 sts remain. Without turning the work, pass the second stitch over the third and off the needle; then pass the first stitch over the third and off the needle—1 stitch remains.

TASSELS

Cut a piece of cardboard or firm plastic to the dimension of the longest length of your tassel. To avoid wrapping the yarn the wrong way around the piece, it is best practice to cut a square that is the same dimension both ways. For example, if the instructions say to make a 6 in. / 15 cm long tassel, cut a square that is 6 in. x 6 in. / 15 cm x 15 cm.

Cut one 20 in. / 51 cm length of yarn; this will be used to bind all your strands together and will be visible, so it should match the color of your tassel.

Cut one 10 in. / 25.5 cm length of yarn; this will be used to secure your tassel to your project and will be somewhat visible, so it should also match the color of your tassel or project.

Lining up your working yarn in the middle of the cut square, with the tail of the yarn lined up with the bottom edge, wrap the yarn around the cut piece from bottom to top, and then top to bottom (creating complete wraps around the cut square) until the required amount of yarn is used (if a weight of tassel is provided) or the required number of times (if a numbered count of strands is provided).

Using a pair of sharp scissors, cut *only* the bottom of the wraps at the base of the cut square so that you have multiple strands of yarn, all the same length: twice the length of your cut square. For example, if you cut a 6 in. / 15 cm square and wrapped the yarn thirty times, you will have thirty 12 in. / 30.5 cm strands.

Using the 10 in. / 25.5 cm length of yarn, tie the all the strands together with a loose knot in the middle of the strands. Fold the cut strands over this tie so that the ends are aligned. Your tassel count will now be doubled. If you wrapped the yarn thirty times, you would now have sixty tassel ends.

Using the 20 in. / 51 cm length, wrap the yarn multiple times around the strands, approx 1 in. / 2.5 cm below the existing tie, and secure. Hide the tails left from this wrap by threading the tails onto a tapestry needle and pushing them to the inside of the tassel.

Secure the tassel to the project using the tails remaining from the 10 in. / 25.5 cm length of yarn that is tied to the top center of your tassel.

Trim all ends of the tassel to the same length.

Abbreviations

1/1 LC - sl 1 st to cn and hold to front, k1; k1 from cn

2/1 LPC - sl 2 sts to cn and hold to front, p1; k2 from cn

2/1 RPC - sl 1 st to cn and hold to back, k2; p1 from cn

2/2 LC - sl 2 sts to cn and hold to front, k2; k2 from cn

2/2 LPC - sl 2 sts to cn and hold to front, p2; k2 from cn

2/2 RC - sl 2 sts to cn and hold to back, k2; k2 from cn

2/2 RPC - sl 2 sts to cn and hold to back, k2, p2 from cn

approx - approximately

beg - beginning

BO - bind off

BOR - beginning of round/row

brk (brioche knit) - knit the stitch together with its wrap

brkyobrk - (brk1, yo, brk1) into the same stitch (2 stitches increased)

brp (brioche purl) - purl the stitch together with its wrap

CC - contrast color

ch - chain stitch

cm - centimeter(s)

cn - cable needle

CO - cast on

cont - continue

dec - decrease(s/d)

dpn(s) - double-pointed needle(s)

DS - double stitch (used in German short rows)

est - established

EOR - end of round/row

g - gram(s)

inc - increase(s/d)

k - knit

k2tog - knit 2 stitches together (1 stitch decreased)

k3tog - knit 3 stitches together (2 stitches decreased)

k3tog below - insert right-hand needle under both strands created on the previous two slipped strand rows and then into the stitch on the left-hand needle knitwise; knit the three loops / strands together (1 stitch remains)

k7tog - knit 7 stitches together (6 stitches decreased)

kfb - knit into front and back of same stitch (1 stitch increased)

kfbfbf - knit into front, back, front, back, and front of same stitch (4 stitches increased)

kyok - (k1, yo, k1) into 1 stitch (2 stitches increased)

LHN – left-hand needle

LR1 - lifted right increase

m - meters

m - marker

M1BL - make one backward loop (1 st increased)

M1L - insert the left-hand needle under the running thread from front to back, knit this new loop through the back loop (1 stitch increased)

M1LP - insert the left-hand needle under the running thread from front to back, purl this new loop through the back loop (1 stitch increased)

M1R - insert the left-hand needle under the running thread from back to front, knit this new loop (1 stitch increased)

M1RP - insert the left-hand needle under the running thread from back to front, purl this new loop (1 stitch increased)

MB - make bobble

MC - main color

p - purl

p2tog - purl 2 stitches together (1 stitch decreased)

patt - pattern

pfb - purl into front and back of same stitch (1 stitch increased)

pm - place marker

prev - previous(ly)

ppso - pass previous stitch over (1 stitch decreased)

p2so - pass second stitch on needle over

psso - pass slipped stitch(es) over

rem - remain(s/ing)

rep - repeat

RHN – right-hand needle

rm - remove marker

rnd(s) - round(s)

RS - right side

s2kp - slip 2 stitches knitwise, knit 1, psso (2 stitches decreased)

sc - single crochet

sk2p - slip 1 stitch knitwise, knit 2 together, pass slipped stitch over (2 stitches decreased)

skp - slip 1 stitch knitwise, knit 1, pass slipped stitch over (1 stitch decreased)

sl - slip stitch purlwise (unless otherwise noted)

sl1yo – with yarn in front, slip 1 stitch purlwise, then move working yarn into position over the right-hand needle to work next stitch (creating the yarn over)

slide - slide stitches from one end of the needle to the other

sm - slip marker

ssk - slip 1 stitch knitwise, slip second stitch knitwise, move these 2 stitches back to left-hand needle purlwise and knit 2 together through the back loop (1 stitch decreased)

sssk - slip 1 stitch knitwise, slip second stitch knitwise, slip third stitch knitwise, move these 3 stitches back to left-hand needle purlwise and knit 3 together through the back loop (2 stitches decreased)

SSM - side seam marker

ssp - slip 1 stitch knitwise, slip second stitch knitwise, move these 2 stitches back to left-hand needle purlwise and purl 2 together through the back loop (1 stitch decreased)

st(s) - stitch(es)

tbl - through back loop(s)

tog - together

turn - turn work so opposite side of work is facing

w&t - wrap and turn (short-row method)

WS - wrong side

wyib - with yarn in back

wyif - with yarn in front

yd(s) - yard(s)

yo - yarn over (1 stitch increased)

/ - used to separate inches from metric measurements, with additional sizes in parentheses ()

() - used to indicate the beginning of a length of instructions to be repeated

Yarn Resources Guide

ANZULA LUXURY FIBERS
www.anzula.com

BERROCO
www.berroco.com

BROOKLYN TWEED
www.brooklyntweed.com

CASCADE YARNS
www.cascadeyarns.com

EMMA'S YARN
www.emmasyarn.com

FILCOLANA
www.filcolana.dk

FREIA FINE HANDPAINTS
www.freiafibers.com

HAZEL KNITS
www.hazelknits.com

JUNKYARN
www.junkyarn.com

KIM DYES YARN
www.kimdyesyarn.com

KNITCIRCUS YARNS
www.knitcircus.com

LEADING MEN FIBER ARTS
www.leadingmenfiberarts.com

THE LEMONADE SHOP
www.thelemonadeshopyarns.com

LITTLE FOX YARNS
www.littlefoxyarn.com

LOLABEAN YARN CO.
www.lolabeanyarnco.com

LORNA'S LACES
www.lornaslaces.net

MISS BABS
www.missbabs.com

NEIGHBORHOOD FIBER CO.
www.neighborhoodfiberco.com

O-WOOL
www.o-wool.com

PLYMOUTH YARN
www.plymouthyarn.com

QUINCE & CO.
www.quinceandco.com

ROWAN
www.knitrowan.com

SPUN RIGHT ROUND
www.spunrightround.com

SWEETGEORGIA YARNS
www.sweetgeorgiayarns.com

URBAN GIRL YARNS
www.urbangirlyarns.com

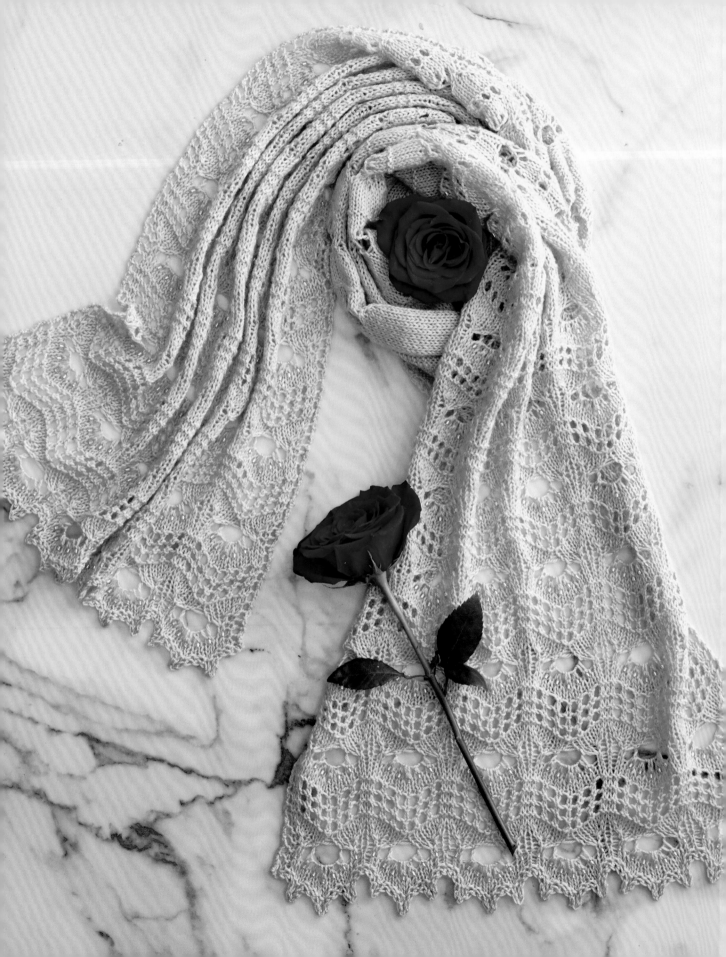

For Roger, my Prince Charming.

Acknowledgments

Some people are worth melting for.

Gratitude to my favorite Fairy Godmother, editor Hilary VandenBroek, for all your Bibbidi-Bobbidi-Boo-Ing. Thank you for making my decades-long dream of working with Disney a reality. I owe you some glass slippers.

Roger, Callum, and Astrid, you keep both my imagination and my world bright and sparkly with pixie dust. I love that you're always ready to go on an adventure with me, watch a zillion Disney films, offer opinions, and keep me well caffeinated. I look forward to our next stroll around the Magic Kingdom together and making you ride "it's a small world" over and over and over.

For Mom and Dad who sent me to RISD to study animation and encouraged me from day one, thank you. I love you both.

My deepest thanks to my wise technical editor, Meaghan Schmaltz, demigod of knitting and math.

As always, I am truly honored to be in the company of such talented designers from all corners of the globe. Your ingenuity makes my job something I look forward to every single day, and I am so grateful for your hard work and expertise. Cheers to you all!

Kudos to wonderful sample knitters Beth Leath and Nicole Heslin for their hard work.

So much appreciation to the yarn companies who offered yarn support and were as excited as I am to work on something that means so much to so many people. Thank you for your talents.

To the magnificent folks at Insight Editions who made my dream come true, as Walt Disney himself said, "There is more treasure in books than in all the pirates' loot on Treasure Island . . ." You're forever my 'ohana.

INSIGHT EDITIONS

PO Box 3088
San Rafael, CA 94912
www.insighteditions.com

Find us on Facebook: www.facebook.com/InsightEditions
Follow us on Twitter: @insighteditions

Library of Congress Cataloging-in-Publication Data available.

ISBN: 978-1-64722-180-5

Publisher: Raoul Goff
VP of Licensing and Partnerships: Vanessa Lopez
VP of Creative: Chrissy Kwasnik
VP of Manufacturing: Alix Nicholaeff
Editorial Director: Vicki Jaeger
Senior Designer: Judy Wiatrek Trum
Editor: Hilary VandenBroek
Editorial Assistant: Anna Wostenberg
Senior Production Editor: Jennifer Bentham
Production Manager: Sam Taylor
Senior Production Manager, Subsidiary Rights: Lina s Palma

Technical Editor: Meaghan Schmaltz

Photography by: Ted Thomas
Prop Styling by: Elena Craig

Special Thanks to our models Adrianne, Ashley, Carlos, Chloe, Elena C., Elena E., Elijah, Jaya, Krystle, NJ, Paige, and Phillip

A very special thank you to everyone at Rusty Hinges Ranch and Petaluma Valley Ranch in Petaluma, California, for providing such a spectacular backdrop to many of the photos in this book.

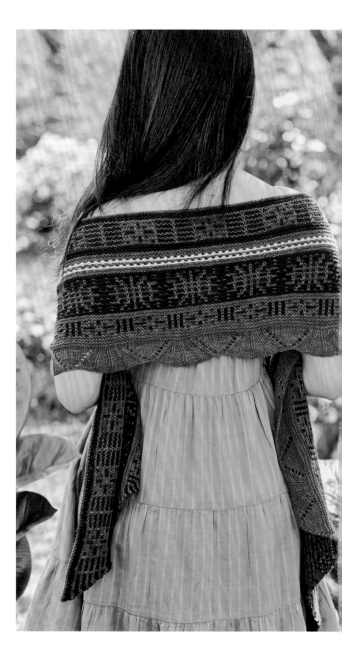

ROOTS of PEACE REPLANTED PAPER

Insight Editions, in association with Roots of Peace, will plant two trees for each tree used in the manufacturing of this book. Roots of Peace is an internationally renowned humanitarian organization dedicated to eradicating land mines worldwide and converting war-torn lands into productive farms and wildlife habitats. Roots of Peace will plant two million fruit and nut trees in Afghanistan and provide farmers there with the skills and support necessary for sustainable land use.

Manufactured in China by Insight Editions

10 9 8 7 6 5 4 3 2